3D STUDIO MAX:

Building Complex Models

3D STUDIO MAX:
Building Complex Models

R. Shamms Mortier

CHARLES RIVER MEDIA, INC.
Rockland, Massachusetts

Production: Publishers' Design and Production Services
Cover Design: The Printed Image
Cover Image: Shamms Mortier
Printer: InterCity Press, Rockland, MA.

CHARLES RIVER MEDIA, INC.
20 Downer Avenue
Suite 3
Hingham, MA 02043
781-740-0400
781-740-8816 (FAX)
www.charlesriver.com

This book is printed on acid-free paper.

3D Studio Max: Building Complex Models
Shamms Mortier
ISBN: 1-58450-029-8
Printed in the U.S.A.

Printed in the United States of America
01 7 6 5 4 3 2 First Edition

CHARLES RIVER MEDIA titles are available for site license or bulk purchase by
institutions, user groups, corporations, etc. For additional information,
please contact the Special Sales Department at 781-740-0400.

Requests for replacement of a defective CD must be accompanied by the
original disc, your mailing address, telephone number, date of purchase and
purchase price. Please state the nature of the problem, and send the
information to CHARLES RIVER MEDIA, INC., 20 Downer Avenue, Suite 3, Hingham, MA
02043. CRM's sole obligation to the purchaser is to replace the disc, based on defective materials or
faulty workmanship, but not on the operation or functionality of the product.

DEDICATION

THIS BOOK IS DEDICATED TO DAVE AND JEN BOYER
& THE ORCHARDS THAT THRIVE IN ALL WORLDS

Contents

Foreword

In mid-November of 1999, I received a note from Discreet Logic's PR firm that reported that 3D Studio Max had reached the magic number of 100,000 units shipped to registered users. That's quite an achievement for a software application that started marketing product in March of 1996. In fact, as of the writing of this book, the number of registered 3DS Max users has climbed to over 120,000.

It would be one thing if we were referring to 3D software that was designed for hobbyists alone, with copies being distributed for free or next to nothing. But 3DS Max has become a major design tool for high-end professional users. Max has been used to create content for films that include *South Park, City of Angels, Godzilla, Lost in Space, Anaconda, Contact, The Ghost and the Darkness, James and the Giant Peach, Deep Rising, The Craft, The Sweet Hereafter*, and many more. You can appreciate 3DS Max work on television with such productions as *"King of the Hill," "The Simpsons," "Ally McBeal," "Storm of the Century," "Pandora's Clock," "The Visitor," "The Outer Limits," "The Real Adventures of Johnny Quest," "Van-Pires,"* and even in the 1998 Winter Olympics event simulations. Computer gaming enthusiasts and designers know Max as the engine behind interactive games like *Tomb Raider I, II, and III, The New Superman Adventures, Madden NFL, Need for Speed, Jet Moto III, NCAA Final Four 99*, and many more titles.

All of this has been going on while 3DS Max has also attracted artists and animators new to 3D, whether self-taught or more formally educated in academic settings. Across the board, for new and seasoned computer artists and animators of all ages, 3DS Max continues to gain popularity as a startling and comprehensive creative environment in which all visions imagined are made possible. In that spirit, and with the intention of enhancing the learning curves needed to use the tools involved, this book has been lovingly crafted.

Shamms Mortier

Introduction

From the moment you open the heavy shipping box that safeguards the 3DS Max software and documentation, you realize that you are in possession of a product that is going to require some study and exploration to use as a creative tool. Experienced electronic artists and animators will have a jump on new and intermediate 3D users, but even they cannot expect to jump into the software without at least a cursory examination of the documentation. 3DS Max is deep and carefully designed to give you an unlimited arena for creative expression, and so demands some invested study. The 3DS Max documentation has about 2500 pages of references and tutorials. Commonly, just as you wouldn't read a dictionary from front to back in one sitting, users read the documentation one part at a time, and intersperse their study with interactive explorations of the software.

3DS Max contains several interconnected content areas, each of which has its own levels of mastery and use. Briefly, these content areas can be segmented as follows:

- **3D Modeling** This is the core process for using 3DS Max, or any other 3D computer graphics application. Your models are the primary content of 3D scenes. They are the actors in the plays that you create.

- **Materials Creation and Management** Materials can be separated into two basic groups, *Procedurals* and *Bitmaps*. Procedural materials are patterns that are mathematical in nature, while Bitmaps are pixelated images. Materials can be placed in any of the available material Channels (Ambient, Diffuse, Specular, Opacity, and the other available choices) to craft the "clothing" for your 3D objects. You may have modeled a 3D sphere, for instance, but a 3D sphere without an applied material has no personality. Making it appear to be constructed of steel, rubber, plastic, wood, glass, or an infinite number of other choices, however, gives the object an implied "voice" and attitude as it relates to other objects in your scenes. Materials contain color and, in most cases, patterns, and can be either Procedurally or Bitmap based.

- **Animation** Creating alterations in any or all objects' translation (position, rotation, size) or apparent composition (Materials) over time so that the audience

appreciates the transitions involved is called *animation*. Animated sequences can be appreciated in 2D, as compared with the animated films that are part of the popular idiom, or in virtual 3D. Most 3D mediums are new, having come into existence because of the growing attraction to interactive 3D display on the World Wide Web. 3DS Max has the capacity for creating both 2D and 3D animations from your scenes.

- **F/X** F/X, or "Effects," is a special category when it comes to 3D work on the computer. Whether targeted to Rendering F/X, Particle F/X, or Object F/X, the concept is similar. F/X add various degrees of believable, and sometimes magical, content to a 3D production. Sometimes, F/X may actually define the entire content of an animated piece, but more often, F/X are used as a supporting element.

- **Scripting** 3DS Max has the capacity to allow you to use a special scripting function and language to generate scene content, materials, animations, and F/X. This is a separate area of learning that has to be studied and explored to be understood, though it also requires mastery of the other Max areas to be effective.

Within these five separate but interconnected areas of learning, all 3DS Max tools and processes can be explored. There are many Max books on the market that allow you to learn more about these processes, some more well-crafted than others. This book is different from other Max books, however, in that it concentrates on one central area of Max endeavors: Modeling. Other related areas of Max involvement are treated as subsidiaries of the main concept. After all, how could you really expect a thorough exploration of the entire gamut of Max possibilities in one volume, when the Max documentation itself is separated into three thick books? Here is how this book looks at the five previously mentioned areas of design in Max:

- **3D Modeling** On the topic of 3D Modeling in Max, this book is the most comprehensive available. We cover not only the internal modeling options, but also those available from external developers, both as commercial plug-ins and as shareware/freeware, available at the time this book was being prepared. The general details are supported by tutorial examples that allow you to get a sense of exactly how and where to use various tools.

- **Materials Creation and Management** This book does not cover the way Materials are created and customized in Max, expecting that you will have read the overview of that topic by reading (and if necessary, re-reading) Chapters 18 to 20 in the Max (R3) documentation. Instead, this book details how to use additional Materials Creation and Management tools. This includes a detailed look at Displacement Mapping (a way to use a Material channel to deform object geometry), the Digimation Texture Lab and MaxMatter (Bricklayer & TypeMapper) plug-ins, Right Hemisphere's Deep Paint 3D, and Darkling Simulations' Simbiont Max.

- **Animation** We do not detail Max animation here, however, you can animate the content of this book by reading the Animation sections in the documentation.

- **F/X** This does not target F/X creation, except for those F/X that deal with Modeling and Rendering. The book does look at R3's new Render Effects options in detail, but not at Video Post effects. Particle System F/X, except where they deal with creating a final mesh object, are also not covered. R3 has a new feature that makes the translation of Particles into a geometric object very simple, so Particle Systems can now easily be used to create 3D modeled elements.

- **Scripting** This book does not cover Max Scripting. You can find an introduction to this topic in the Max documentation.

It would be a mistake, and in fact, an impossibility, to deal with everything in Max in one book. It is far better for your learning curve to cover one topic in as much detail as possible, leaving other areas for future volumes.

You will notice that Section C: Chapter 11 is about plug-ins for Max version 2.x. Although most Max users have either already upgraded to version 3.x, or are planning to, there are reasons for including 2.x plug-ins:

- Many of the mentioned plug-ins also have R3 counterparts that can be downloaded. You can find out which ones by visiting the www.max3d.com plug-ins site every week or so.

- Descriptions of what the 2.x plug-ins can do are important to those users who want to contact the developers to plead with them to upgrade specific plug-ins to 3.x.

The commercial plug-ins described in Section B and in other chapters in the book are all R3 or higher targeted, so you have to be running version 3/x or higher to make use of these descriptions and tutorials.

The book is broken up into discreet (no pun intended) sections, the contents of which are:

A. Internal Modeling Tools
B. Plug-Ins Bazaar
C. Shareware/Freeware Modeling Plug-Ins
D. Particle System Modeling
E. Modeling with Fire and Lights
F. Twisted Reality
G. Shaking Hands
H. Miracles with Materials

I. Render My World
J. Color Plate Details
K. Unique Modeling Projects

Each section contains a number of chapters that are related to the general section topic. The content and level of experience required to make use of these sections, as well as the chapters involved, will be looked at later when we speak about *"How to Use This Book."*

SYSTEM REQUIREMENTS

The Max documentation states the following as system requirements to run the software. The author's comments are folded in.

- **Computer**: A minimum of a Pentium II running at 200 MHz. Max will recognize dual processors.

Author's Note: You should upgrade to a Pentium III, running at the fastest available speed. These days, 500 MHz systems are easy to come by at bargain prices.

- **Display**: A graphics card that supports a minimum resolution of 1024 x 768 at "high" color. The recommended resolution is 1280 x 1024 and True Color.

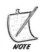

Author's Note: If at all possible, search for a graphics card that has features dedicated to 3DS Max, and to graphics in general. Many are available with diverse options.

- **Operating system**: A minimum of Windows NT4 with Service Pack 3+ or Windows 98. Windows 95 is not supported.

Author's Note: Although the Max standard has always been Windows NT, Windows 98 offers more intuitive and updated features in general. This includes extensive built-in plug-and-play compatibility. The best thing to do, however, if you are using Windows 98 for Max, is to reserve a partition on your drive for Windows NT startup. This will allow you to purchase and use various support applications that are only Windows NT compatible. As far as Windows NT Service Packs, the latest one available as this book is being written is version 6.1. You can download Service Packs for free from the Microsoft website, or better yet, order the CD (about $15) so you have it on hand in case things go amiss in the download. Of special importance is that users running under Windows 98 will want to get the free upgrade to Max 3.1. This version is optimized for Windows 98.

- **RAM**: From a 128MB minimum to 256MB recommended.

Author's Note: Actually, you should plan on a minimum of 512MB to make creative use of Max. RAM, as of this writing, is comparatively inexpensive as far as what it was priced

at a year or two ago, although prices fluctuate. If you load extensive plug-ins, or if you plan to use many of the plug-ins covered in this book, make sure you buy as much RAM as you can possibly afford. Max will love it, as will your graphics and animation software in general. Remember that you are using a high-end professional tool, and that stunting your creative intuition, or crashing in the middle of a project, is too heavy a price to pay. Besides, we are already at the point where computers can hold a Gigabyte of RAM, and that will move much higher in the coming years.

- **Hard disk space**: 350MB of HD space is recommended as a minimum.

Author's Note: If you plan to install any major plug-ins, be prepared to have at least 512MB available. I actually recommend having at least a Gigabyte of HD space for Max, with even more for handshaking applications. Hard drives are fairly inexpensive, and when it comes to Material and Texture bitmaps, you'll want to be worry free. A 30GB gig hard drive costs about what a 5GB drive did a few years ago, so budget for maximum HD space.

- CD-ROM. Needed for software installation.

Author's Note: Look into getting a CD-ROM burner. They are fairly inexpensive at this point, and in addition to reading all of your installation CD volumes, you'll also have the capability to archive your Max projects on nearly indestructible media.

- **Sound card and speakers**: Obviously needed if you plan to work with soundtrack data.
- **Pointing device**:. A three-button mouse (Microsoft Intellimouse) is highly recommended. This is because R3 has many new features that support a three-button mouse.

Author Note: You should also have a suitable graphics tablet that you can draw with comfortably.

- **Network**: For optimizing render times for high-end output, setting up a render farm is the way to go.
- **Parallel port**: Needed to hold the Max Hardware Lock.

Author's Note: Invest in an A/B or A/B/C/D parallel port switchbox. Many of the newest creative software applications come with hardware locks, which allow you to switch to the one you need without trying to chain them all together. At the same time, you can reserve one of the outputs for a printer or other parallel port device.

- Internet Explorer 5.x or higher. needed to use the online help system.

 Author's Note: *It really is necessary in Max. Perhaps future versions will be OK with other browsers, but don't look for a change in the near future.*

SYSTEMS USED FOR THIS BOOK

Two different Max systems were used in the research and testing stages for this book:

- A Pentium II 200 MHz system with 512MB of RAM running Max 2.5 with an AGP graphics board was used to test the 2.x plug-ins, but not for much else. This system has 8GB of hard drive space.

- A Pentium III 750 MHz system with 750+ MB of RAM running Max 3.1 and an AGP Rage graphics board was used as the main engine, testing and working with R3 and all of the R3 compatible plug-ins, and handshaking applications. This system has 60+ GB of hard drive space.

Both systems are hooked up to the same monitor, a 19″ high-res multiscan with the display set to 1280 x 1024 and True Color.

HOW TO USE THIS BOOK

The way that you will use this book depends upon the following:

- How much experience you have had in 3DS Max, especially in versions 2 plus, and concentrating upon version 3.x plus. This also entails how much you use Max every week.

- How much experience you have had in working with computer graphics and animation applications in general, especially 3D applications.

- What your creative work habits are, and under what circumstances you learn best.

With these three categories in mind, let's break the readership down further into: the 3D novice, the 3D intermediate user unfamiliar with Max, the 3D professional user unfamiliar with Max, the 3D professional user with previous Max 2.x familiarity, and the 3D professional user with Max R3 and higher familiarity. We will look at each of these user categories as they apply to the data found in the sections of the book, and suggest ways that the book can serve best as a learning tool.

THE 3D NOVICE

As someone new to computer graphics and animation, you will want to delay your use of this book until you have read and worked through the Max documentation. The exact time it will take you to do this will vary, depending on how driven you are to learn, and how accessible and helpful you find the documentation. A rough estimate would be from one to two months of diligent reading and practice, though some individuals may be able to be up and running quicker. After that, you will want to use the sections of this book as follows:

A. Internal Modeling Tools

Chapters 1 through 6 are vital for you to read, understand, and work through. Some items will demand less of your time than others will, because the exercises in the documentation will be fresh in your memory, and the concepts intuitively understood. The material in Chapters 4 to 6 is a bit more complex, and will demand more of your time. Pay special attention to Chapter 4 on lofting options, Chapter 5 on Booleans, and Chapter 6 on creating and using patches.

B. Plug-Ins Bazaar

In this section, since it concerns plug-ins that you will have to purchase separately, read the material that pertains to the plug-ins you own. You can always return to items of interest as your Max plug-ins library grows. You can also use this section of the book to get an idea of what external plug-ins you'd like to own because of what they do.

C. Shareware/Freeware Modeling Plug-Ins

As a new Max user, you will no doubt want to expand your creative options. Downloading and exploring the usefulness of freeware and shareware plug-ins is usually the first step, so browse this section to discover what plug-ins are right for you. After that, you can download them. Please realize that dozens of new Max plug-ins are made available each year, so this section is necessarily incomplete. You have to check all of the available Max plug-in sites on a regular basis to stay informed. Just type the phrase "3DS Max Plugins" (including the quotes) into your search engine, and surf the available sites.

D. Particle System Modeling

This section focuses upon Particle System plug-ins that have to be purchased separately. Exploring Particle Systems' use and modification is an advanced modeling topic. The new user should reserve the study of these chapters until the time when basic modeling usage is thoroughly understood. After that, working through this section should provide another level of creative excitement and an invitation to explore.

E. Modeling with Fire and Lights

Chapters 16 to 20 center on external Max plug-ins and utilities that have to be purchased separately. Chapter 21 is concerned with readily available Max processes. The new user will want to bypass Chapters 16 to 20, except as a possible reference for future purchases, and work through Chapter 21.

F. Twisted Reality

Of the three chapters in this section, the first one is the most important for newbies. Modifying objects is the heart of modeling, and must be understood thoroughly. Time should be taken to apply this knowledge in extended practice sessions. The second chapter in this section deals with Modifiers that can be downloaded and added to Max. The new user should do this only after having a working understanding of what is already available inside Max with its own Modifiers. The third chapter in this section demands the purchase of a commercially available package.

G. Shaking Hands

This section details software that can "Handshake" with 3DS Max R3.x and higher, all of which must be purchased and learned separately. By "Handshaking," we mean the capacity to pass Max models and/or textures back and forth. Unless the new user is familiar with any of these packages, this section might serve as a planning aid for future purchases.

H. Miracles with Materials

Although it may offend the modeling "purist," the fact is that many scenes created with any professional computer 3D art and animation application contain "canned" elements; that is, models that are available for separate purchase. This points out the importance, especially for the new user, of having a thorough understanding of Section F of this book on Modifying Models. The idea is to add your own personality to an imported model, to tweak it so that you can use it exactly as needed in a 3D scene. This section looks at a number of diverse model collections, available on CD-ROM media for purchase. You can also find models on the Web that can be freely downloaded by surfing the 3D sites every so often. This book does not detail those sites, nor does it provide their addresses—that is left to the Max user.

I. Render My World

Read the chapter on Displacement Mapping. The other chapters require that you purchase additional software. You can browse these chapters to make purchasing decisions, and then read them afterward to get specific details for use. Browse the list of available bitmap textures CD volumes for content info and later purchase.

J. Color Plate Details

Pay special attention to this section; it deals with two internal Max R3 topics: Environmental and Render Effects. Also be sure to work through the tutorials.

THE 3D PRO USER UNFAMILIAR WITH MAX

A person in this category is one who has already used, or even mastered, another 3D application, but is new to Max. Max does things differently than other 3D applications, so the first thing you have to understand is how to navigate the interface—read the documentation for this knowledge. Some of the modeling processes Max allows are very similar to those used in other 3D applications, but with different tool options. Some modeling options can't be found anywhere else. Expand on your present modeling knowledge, but at the same time be aware of new ways to accomplish your modeling objectives.

A. Internal Modeling Tools

As someone who already has a working knowledge of 3D processes, you can skim Chapter 1, but do the PrimBot tutorial at the end. Chapter 2 is important because it targets R3 upgrades, with the most important part of the chapter being the details on new Compound Object creations. Chapters 3 to 6 should be read carefully, since they detail processes fairly prioritized to Max use.

B. Plug-Ins Bazaar

Read these chapters to get the news about additional plug-ins you gotta have.

C. Shareware/Freeware Modeling Plug-Ins

Read these chapters to find out about shareware/freeware plug-ins, but also know that you have to stay tuned to plug-in sites for the latest upgrades and plug-in products.

D. Particle System Modeling

If you have experience in other 3D applications that allow for Particle System generation, then you already have some idea of what is involved. Max Particle Systems, however, are unique and more extensive than those found on any other 3D application, so you should plan to read all of the chapters in this section.

E. Modeling with Fire and Lights

The first five chapters here focus on external Max plug-ins and utilities that have to be purchased separately. The last chapter in this section is concerned with readily available Max R3 processes. Read the first five chapters if you own or plan to own the plug-ins that are detailed. Work through the last chapter in this section if you need further detail on the topics involved.

F. Twisted Reality

You will find it useful to read all of the chapters contained in this section, paying special attention to the unique way Max does things compared to any other 3D software you may be familiar with. The last chapter on Space Warps is especially important.

G. Shaking Hands

No 3D application works in a vacuum. 3D artists and animators use a wide array of products to create content for any production. If any of these products are new to you, but you find them interesting, save your pennies.

H. Miracles with Materials

Augment your knowledge of 3D model libraries that are available by reviewing these selections.

I. Render My World

Take a careful look at the available extra products here that allow you to develop new approaches to placing Materials and Textures on your Max objects.

J. Color Plate Details

You should at least glance at the chapter in this section and be sure to work through the tutorials.

THE 3D PRO USER UPGRADING TO MAX R3

As a Max 2.x user upgrading to Max R3, you will have the advantage of knowing how most of the tools work. New options will have to be learned, as well as the new R3 interface design. You will want to use the sections in this book in the following ways:

A. Internal Modeling Tools

Go straight to Chapter 2 in this section for review info on R3 modeling options. In Chapter 3, review the material about the new R3 Rectilinear option for spline creation. Make sure you are familiar with the new "Draw in All Viewports" capability in R3.

B. Plug-Ins Bazaar

This section will be valuable to you if you are considering a purchase of any of the mentioned plug-ins, or if you already have some of them and need an overview of their use.

C. Shareware/Freeware Modeling Plug-Ins

Check this section for available R3 freeware/shareware plug-ins.

D. Particle System Modeling

These chapters detail the ways in which a selection of Particle System add-ons function. The importance of the R3 Particle Snapshot function is also discussed.

E. Modeling with Fire and Lights

Read these chapters thoroughly for a detailed look at a variety of plug-in and external options for creating Light F/X for R3 productions.

F. Modifying Reality

Pay special attention to "Plugging the Gaps," for R3 use. Read "Meta Pursuits" for details on Sisyphus *MetaSurface Modeler*. Skim the other chapters as necessary.

G. Shaking Hands

You may be surprised by the number and variety of external applications that handshake with Max. Read these chapters to find out more about them, and to help you make future purchasing decisions.

H. Miracles with Materials

If 3DS model collections on CD volumes are important to you, read the details in this section.

I. Render My World

In addition to a thorough presentation of Displacement Mapping, this section offers you detailed looks at an array of Material editing and creation options. The last chapter in this section also lists texture content CD volumes that you may wish to investigate further.

J. Color Plate Details

Read all of this chapter to familiarize yourself with R3 plug-in rendering options, and try out the tutorials at the end.

THE 3D PROFESSIONAL USER WORKING-FAMILIAR WITH MAX

The fact that 3D Studio Max offers even high-end professional users an endless opportunity for more creative growth is both exciting and a bit overwhelming. To continue to stay ahead of the curve, read specific sections and chapters in this book to remain aware of new possibilities.

A. Internal Modeling Tools

Skim the chapters in this section, since you are probably more than well aware of their content in most cases.

B. Plug-Ins Bazaar

Read any of the chapters, or parts of chapters, in this section that deal with plug-ins you are considering for purchase, or to augment your learning if you already own any of the mentioned items.

C. Shareware/Freeware Modeling Plug-Ins

Peruse this section and read any of the information that relates to freeware/shareware R3 plug-ins you are interested in.

D. Particle System Modeling

As an experienced Max R3 user, you are no doubt aware of Particle System creation and use, but may not yet own or be aware of the specific Particle System plug-ins mentioned here. Peruse this section and read any of the information that relates to the R3 Particle System plug-ins you are interested in.

E. Modeling with Fire and Lights

Read the chapters in this section that concern products or product uses that are new to you.

F. Twisted Reality

Read the chapters "Plugging the Gaps" and "Meta Pursuits" for information that may be new to you.

G. Shaking Hands

Read this section carefully to determine whether to investigate or purchase any of the mentioned applications that may help you in your R3 enterprises.

H. Miracles with Materials

If you find any 3D Model collections of interest here, underline them for eventual purchase.

I. Render My World

Skim the first chapter in this section, which probably contains information you are already familiar with. Read the rest of the chapters to determine whether you should purchase any of the plug-ins or applications.

J. Color Plate Details

Review this section to get some new ideas and be sure to work through the tutorials.

This book uses the same path convention indications as the Max documentation. For example: Create>Standard Primitives>Tube means go to the Create panel, then to the Standard Primitives listing, and select the item Tube. This convention will be used wherever possible, giving you a way of understanding directions in this book that are the same as those used in the Max documentation. Most of the files for tutorials are included on the CD-ROM, but be sure you have all of the necessary plug-ins before you begin.

MOVING ON

Now that we have detailed how this book is structured and how you might put it to use, let's jump into the pool and take a swim. Get ready for Chapter 1, "Basic Training," and its concentration on basic Max modeling tools.

SECTION A

Internal Modeling Tools

CHAPTER 1

Basic Training

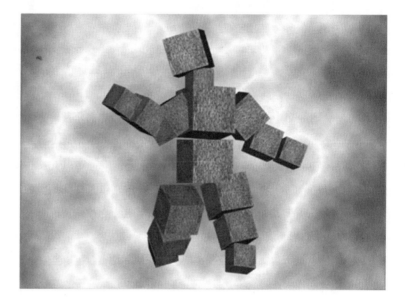

WHAT IS THIS CHAPTER ABOUT?

This chapter concentrates upon the modeling "Primitives" shared by 3D Studio Max in versions 2.x and 3.x. In version 3.x (called R3 from this point in our text), you will find the icons used to select these primitive objects by clicking on the Objects tab in the Max toolbar. (See Figure 1.1.)

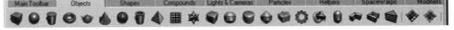

FIGURE *You can find icons for both the Standard and Extended Primitives under the Objects tab*
1.1 *in the top toolbar.*

In order to understand the terminology and exercises used in this book, you must have read and worked through the Max documentation beforehand. Then you can use this book as a convenient reference and an idea generator.

In this chapter, we are going to look at both *Standard Primitives* (Box, Sphere, Cylinder, Torus, Teapot, Cone, GeoSphere, Tube, Pyramid, and Plane) and *Extended Primitives* (Hedra, Chamfer Box, Oil Tank, Spindle, Gengon, Torus Knot, Chamfer Cylinder, Capsule, L-Ext, C-Ext, Prism, and the RingWave primitive). We'll look at each in terms of applying *Transforms* (Move, Rotate, and Scale) to entire Primitives, and to selected Primitive parts. Each Primitive will be shown to be useful in the construct of more complex composited models, as well as playing a part in Linked *PrimBot* constructs.

If you look at the graphics in this book that display any of the Maxviewports, you will see that they are set against a white, and in some cases, a light-gray background. The very first thing you should do in Max is to set the UI (User Interface) colors to suit your tastes and eyesight requirements. To do this, go to Configure>Preferences, and select the Colors tab. When all of the colors are set the way you like, click the APPLY COLORS NOW button. Then quit Max and reboot, just to make sure all of your changes have taken hold.

If you like, you can also alter the backdrop of the viewports by doing the following:

1. Create a solid-color BMP or TIF bitmap in Photoshop, or another similar application. 640 x 480 is a good size.

2. Open Max. Select Views>Viewport Background. The Viewport Background window will appear. (See Figure 1.2.)

3. Click on Files, and load the whole background you just created. Check Display Background and All Views, and then click OK. The white backdrop is now seen in every viewport.

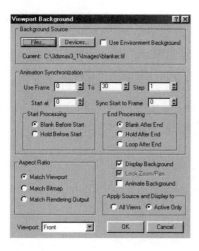

FIGURE *The Viewport Background window.*
1.2

NOTE

Your new viewport background is used for on-screen designing purposes only. When you need to re-place or remove it, just select another image, or turn off Display Background in the Viewport Background window. The background does not show up in renderings unless you load it into one of your Materials as an Environmental backdrop, and then select it as the Rendered background in the Environment window.

STANDARD PRIMITIVES

There are 10 *Standard Primitives* in R3. Each can be used as is, though it is more common to use them as starting places for creating more complex modeling elements.

BOX

The Box can be used to create a child's block, a brick, or a literal blockhead. Resized, it can easily become a wall, a floor, a table, a house base, or many other objects and object elements. When you place the Box in a Max viewport, it is sized according to the extent that you drag the mouse. First, it creates a flat place parallel to the viewport you are working in, and the second time you drag the mouse after the plane is finished gives the Box height. Immediately after selecting the Box, before even dragging the mouse, if you look at the Rollout in the Create panel, you will see the dimensions of the selected Box and other options. The moment that you move the Box or Cube, however, you will have to go to the Modify panel to see the Rollout. (See Figure 1.3.)

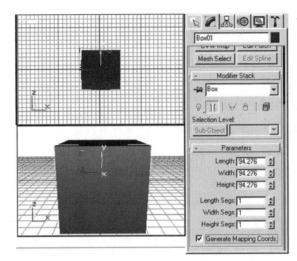

FIGURE *The Box Rollout appears in the Modify panel as soon as the Box or Cube is moved.*
1.3

If you check the Cube option instead of Box, a single drag in any of the viewports creates a cubic volume. As you drag and create either a Cube or a Box, the length/width/height parameters in the Rollout display the sizes involved. You also have Length/Width/height Segment areas for input. Changing them from their default of 1 creates more surface areas on the Box or Cube that can be used later for deformation, and also for applying Material mapping. Always leave the Generate Mapping Coordinates item checked. After a Box or Cube is created, altering the Length/Width height values in the Rollout alters the Box or Cube accordingly.

Linking Primitive Parts

In many of the exercises in this chapter, we are going to use the Linking operation to create more involved models from Standard and Extended Primitives. Though you should already understand Linking from the Max documentation, here's a reminder of what it is and how to use it: Linking connects two or more objects in a Child/Parent relationship. That means that the first thing you have to have in your scene is at least two objects.

Though we don't explore all of the Linking possibilities in this book, especially those that involve animation procedures, realize that "Object" is defined beyond simply "Models." An object can also include the camera, lights, and other Max scene elements.

NOTE

When you have two or more objects in your scene (in this case, we are talking about Primitive Models), click on the Linking tool. It can be located on the Main toolbar tab, four icons from the left. It resembles the chained boxes shown in Figure 1.4.

Once activated, you click on a Child Object and drag the mouse to a Parent Object. The Child can be transformed separately from the Parent, but the Linking guarantees that when

FIGURE *The Linking tool.*
1.4

the Parent Object is transformed (moved, rotated, or scaled), the Child Object inherits the transformations. Parent Objects can be Linked to other Parent Objects, making them children of their Parents. Child Objects can be Parents of their own Linked children. This whole chain of Linked Objects is a called a *Hierarchy*.

The best way to learn is by doing, so if you are new to the Linking process, do the following:

1. In the Front viewport, create two Cubes as shown in Figure 1.5.

2. Select the Linking tool, and click-drag from the Cube on the left to the Cube on the right.

3. Select the Move tool, and click on the Cube on the left. Move it. You can see that it moves independently. This Cube is the Child of the Cube on the right, and like all children, it demands independence.

4. Now click on the Cube on the right, with the Move tool still selected, and move it. The Child also moves. When the parent demands it, the Child obeys. This Child Object is probably not a teenager.

FIGURE *A front view of the Linked Cubes.*
1.5

Build a CuBot

OK, time to build your first PrimBot (Robot created from Primitive Model elements). This one is all Cubes. Using the Create>Cube tool in the Front viewport, create a form composed of 16 Cubes, resembling the one displayed in Figure 1.6.

5. OK. Time to Link-think. The Pelvis Cube will be the parent of parents. Link the Head to the Neck, the Neck to the Chest, and the Chest to the Pelvis.

6. Link the Left Hand to the Forearm, Left Forearm to Shoulder, and Shoulder to Chest. Do the same with the Right Arm elements.

7. Link the Left Foot to the Left Shin, the Left Shin to the Left Thigh, and the Left Thigh to the Pelvis. Do the same with the Right Leg elements.

8. This is a very important step. All of the Pivot Points of the Cubic elements act as centers of rotation. By default, they are placed at the center of the Cubes. But, what if the Pivot Point of your forearm was placed at the center. It wouldn't rotate at the elbow, but at the middle, making you look very strange. Therefore, all of the Pivot Points of the Cubes in the CuBot (except for the pelvis) have to be moved where rotation would normally occur. To do this, you must select each Cubic element, and activate the Hierarchy panel. Select the Pivot tab, and click on Affect Pivot Only. Now you can move the Pivot Points where they belong. When you are finished, rotating a Cubic part of the CuBot will act as expected.

That should do it! Congratulations! You can tell if everything is the way it should be if you click on the Pelvis and move it. The whole model should move accordingly. If not, retrace your steps. By selectively rotating Parent elements, you can now pose your CuBot. (See Figure 1.7.)

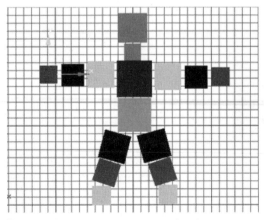

FIGURE
1.6 *The CuBot's parts are created and moved/rotated into place.*

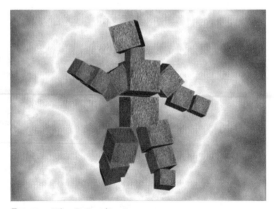

FIGURE
1.7 *The CuBot lives!*

SPHERE

More options are involved when you create a Sphere. First, the Sphere can be generated from either an Edge or the Center (default). Dragging the mouse in any viewport with Create>Sphere selected produces a standard Spherical volume, as expected. But there are additional options in the Create>Standard Primitives>Sphere Rollout to be aware of.

If you set Hemisphere to 0.5 before you drag the mouse to create a Sphere, you will create a hemisphere that is cut at the 50% volume of the Sphere. Try it. Draw in the Top view. The flattened part of the Sphere is always drawn parallel to the viewport you draw in, but on the other side of the Sphere, facing away from the view. (See Figure 1.8.)

You can create Hemispheres at values between 0 and 100% (0 to 1 in the input box). At values approaching 1, the slice enlarges, so at a value of 1, the object is all sliced away and is invisible. If you check Slice, you can cut away slices of the Hemisphere that are perpendicular to the flattened side. Slice ranges in value from 0 to 360 degrees. Selecting a Slice that ranges from 90 to 180, for example, removes 1/4 of the Hemisphere, as displayed in Figure 1.9. You can readily see the variety of Model volumes that can be created by using just these basic controls.

Build a SpherBot

Using the same principles of multiple Linked objects presented in the CuBot tutorial, build a SpherBot. With Spheres, you don't have to be concerned about moving Pivot Points. (See Figures 1.10 and 1.11.)

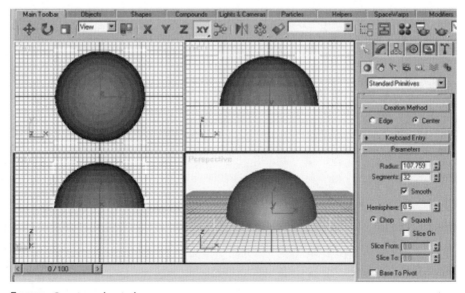

FIGURE *Creating a hemisphere.*
1.8

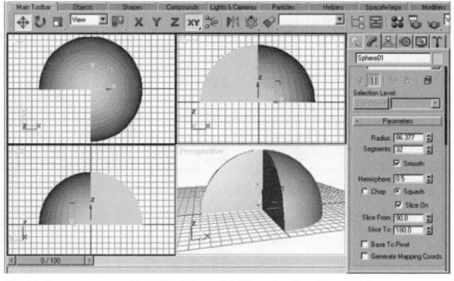

FIGURE *Here you can see a Sliced Hemisphere with Slice values from 90 to 180 degrees.*

1.9

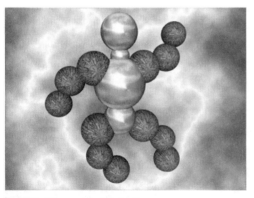

FIGURE *The rendered SpherBot.*

1.10

FIGURE *The SpherBot design shown in all viewports,*

1.11 *with Links activated.*

CYLINDER

Click-dragging to create a Cylinder is very straightforward. You can create variable segments in a Cylinder, and more segments can generate smoother bending later on, as well as variable mapping possibilities. The Cylinder also has the Slice option, already covered in our details about the Sphere. (See Figure 1.12.)

FIGURE *A Cylinder, with Slicing values of -120 to 180, showing a Slice of 60 degrees.*
1.12

Build a CylBot

Use the same principles to Link the parts of the CylBot together. You do have to move Pivot Points when you use Cylinders as rotating elements in a Hierarchy. (See Figures 1.13 and 1.14.)

FIGURE *A multi-viewport look at the CylBot design.*
1.13

FIGURE *A rendered CylBot.*
1.14

TORUS

You can activate Slice for the Torus as well, just in case you need to model a cleanly bitten bagel! You can also add a Twist to the polygons, and decide what (if anything) should be smoothed. Definitely play around and explore different settings here. Otherwise, click-drag is a two-step affair, once for each radial dimension. (See Figure 1.15.)

One of the obvious uses of the Torus is to create chains, just by rotating every other Torus in a string of 90 degrees or less on its comparative axis.

Build a TorBot

Use the Linking skills you have mastered to create a TorBot from Torus Primitives.

FIGURE **1.15** *Talk about complex models, this example was created from the Torus Primitive by using the following setting parameters: Radius 1=18, Radius 2=4, Rotation 2222, Twist 12, Segments 8, Sides 12, Smoothing All, and Slice from 80 to 135.*

FIGURE **1.16** *The famous Ringed-TorBot is really not extinct.*

CONE

Cones can be Sliced, similar to other Standard Primitives. Unique Cone parameters can be forced when you make the radius 2 value anything other than zero. This flattens out the Cone's apex. If you want to, build a ConeBot the same way you built the CylBot. (See Figure 1.17.)

GEOSPHERE

At first glance, the GeoSphere might be mistaken for a Sphere substitute, but that wouldn't be doing it justice. In its parameters Rollout, there are three options not found on the Sphere:

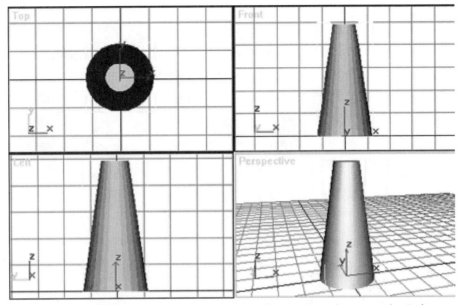

FIGURE *If you set the Radius 2 value to anything other than zero (5 in this case, with a Radius 1*
1.17 *of 12), the apex of the Cone is flattened out. This can then be used as a column for a*
palace or temple.

Tetra(hedron), Octa(hedron), and Icosa(hedron). These are three of the "Platonic Solids."
By using any of these three settings with different "Segments" values, you can create a wide
array of geometric solids. The polygonal faces of these solids are triangular. (See Figure 1.18.)

With a single mouse click, you can create instant Hemispheres of these solids, just right for Buck-
minster Fuller's Geodesic Domes.

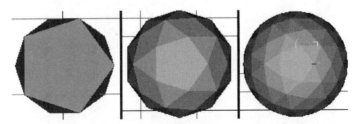

FIGURE *From left to right, an Icosahedron with 1, 2, and 3 Segments.*
1.18

GeoBot

You can substitute Geospheres for Spheres and build a PrimBot similar to the Spherical one.
The difference is, the elements can appear much more faceted, similar to sheet metal. (See
Figure 1.19.)

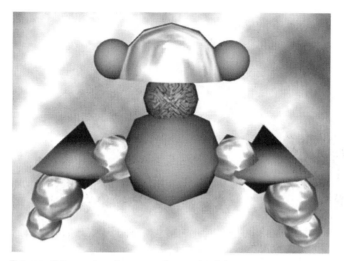

FIGURE **1.19** *Using various Segment values and Solids types, you can create spectacular robotic forms easily with the GeoSphere Primitive.*

TUBE

A Tube has three draggable dimensions: Radius, Thickness, and Height. Tubes can also be Sliced. (See Figure 1.20.)

You can use Tubes and build a PrimBot similar to the Cylindrical one if you like.

FIGURE **1.20** *Sliced Tubes with exposed internal geometry, mapped with rock materials, make great components for medieval scenes.*

FIGURE *The Pyramid is mystery incarnate.*
1.21

PYRAMID

The best use you can make of the Pyramid is to create ... a Pyramid! The Pyramid is unique and evocative enough by itself, or in the company of other Pyramids. (See Figure 1.21.)

PLANE

The Plane Primitive is most often used as a Ground Plane, as can be seen in Figure 1.21.

TEAPOT

The last Standard Primitive we'll look at is the Teapot. The Teapot is already an identifiable object, and is placed in the list out of the respect owed to it from a historical perspective about computer graphics objects. It does give us the opportunity, however, to create a special PrimBot that uses the Teapot and all of the other Standard Primitives at the same time.

Build a TeapotBot

OK. Time to construct the last Standard PrimBots, one that combines your choice of any or all of the Standard Primitives we've looked at so far. You know the drill as far as Linking. Select any components you like, but make sure to fold the Teapot into the mix somewhere. The TeapotBot displayed in Figure 1.22 is only one of a zillion possibilities. DO NOT use this figure as a template for your TeapotBot. Stretch out. Call upon your own creative juices, and create a TeapotBot that lives happily in your own universe. (See Figure 1.22.)

FIGURE *One example of a TeapotBot, constructed by Linking many other Standard Primitives.*
1.22 *What does yours look like?*

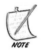

You can choose to create separate parts of the Teapot, as well as the whole model. This gives you more opportunity to use those parts as elements of your own creations.

EXTENDED PRIMITIVES

There are 12 Extended Primitives listed under Create>Geometry, and also accessible from the R3 Objects tab in the Toolbox. Like the Standard Primitives, they are usually used as the starting point for more complex modeling, but can also be used on their own when and if your project demands the forms they present. We'll look at each of them, and then create a composite composition using a combination of Extended Primitives after that.

HEDRA

The Hedra Primitive is capable of generating a number of alternate forms, dependent upon your settings. Select from Tetra, Cube/Octa, Dodeca, Star 1 (pointy) and Star 2 (planar). These objects are as unique as the Standard Primitive Teapot, so they are less commonly placed in projects than more basic forms. They can, however, be used as components and parts-and-pieces of a scene, providing visual interest in a composition. (See Figure 1.23.)

CHAMFERED BOX

The Chamfered Box also has a Cube setting. The parameter that adds variance to this form is "Filet," which rounds the corners. The higher the value, the more rounded the form be-

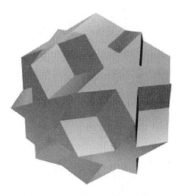

FIGURE *The Star 2 Hedra.*
1.23

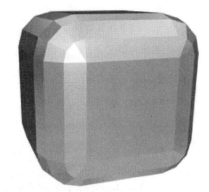

FIGURE *The Chamfered Box with a Filet value of 22*
1.24 *and Smoothing off.*

comes. With Smoothing checked, the form is continuous. Unchecked Smoothing results in a multi-plane layered look. With Smoothing off, this form becomes an excellent choice for a jewel, as long as you add the right Material (Ruby, Diamond, Sapphire...).(See Figure 1.24.)

OIL TANK

The Oil Tank Extended Primitive can be described as a Cylinder with rounded ends. You can control the extent and size of the end caps. This Primitive also allows for Slicing. Use an un-Sliced Oil Tank Primitive when you need to create an industrial scene with standing tanks in the background. (See Figure 1.25.)

SPINDLE

The Spindle is a cousin of the Oil Tank Primitive. The Spindle has extended end caps as well, but they are pointed instead of rounded. Slicing can be activated in this Primitive. Use it as a variant form wherever you might use the Oil Tank. (See Figure 1.26.)

FIGURE *A Sliced Oil Tank Primitive.*
1.25

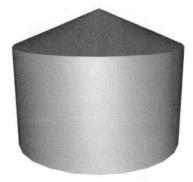

FIGURE *The Spindle with Smoothing on.*
1.26

GENGON

The Gengon can be described as a Columnar form whose end caps can have any number of sides. For example, with four sides, the column becomes rectangular. You can add a Filet to the edges, creating a rounded look. The Gengon might be a good starting point in the development of architectural columns. (See Figure 1.27.)

The Filet values are whole numbers only here, and setting them above 1 creates cylinders, losing the polygonal appreciation of the end caps.

TORUS KNOT

The Torus Knot is an intriguing form, but you may be hard-pressed to find a use for it in most scenes. It is so unique that seeing it more than once can be overkill. It can, however, be used effectively in more esoteric scenes, and even as a component in logo design. By exploring the Eccentricity, Twist, and Lumpiness parameters, you can create a host of variable forms. (See Figure 1.28.)

CHAMFERED CYLINDER

This Cylinder Primitive is a variation of the Spindle, the difference being that you can control the shape of the end caps. Filet parameters allow a range of end cap "sharpness," from sharp to flattened. Slicing is also allowed. (See Figure 1.29.)

CAPSULE

Use the Capsule Primitive any time you need a lozenge form. This Primitive also works wonderfully as a external component of a spaceship. (See Figure 1.30.)

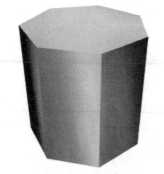

FIGURE **1.27** *This Gengon features a seven-sided end cap, with Filet set to 1 with Smoothing.*

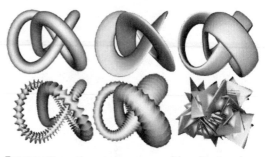

FIGURE **1.28** *Torus Knot variants, created by adjusting the Eccentricity, Twist, and Lumpiness parameters.*

FIGURE
1.29 *The Chamfered Cylinder with a Filet value of 20 and Smoothing on.*

FIGURE
1.30 *The Capsule reminds viewers that they should take their allergy medicine.*

L-Ext

Think of the L-Ext as an extruded carpenter's square, and you'll remember what its form looks like. You control the size parameters. This form is a useful architectural component, perhaps for support columns for an overhanging balcony. (See Figure 1.31.)

C-Ext

The C-Ext Primitive just adds a bottom arm onto the L-Ext. (See Figure 1.32.)

Prism

The Prism Primitive is a three-sided column. (See Figure 1.33.)

FIGURE
1.31 *The L-Ext Primitive is an architectural form.*

FIGURE
1.32 *The C-Ext Primitive is also an architectural form.*

RINGWAVE

This Primitive was introduced in R3. It is an animated Primitive, and as such, is out of the scope of this book. There is a way to use it as a model component, however. Do the following:

1. Activate the RingWave Primitive. Explore the settings until you configure something you like.

2. With the RingWave selected, open the Modifier panel. Click on the Edit Stack option, and select Editable Mesh. This transforms the animated RingWave effect into a stable object, which can now be used as a component in a larger construct, or on its own. (See Figure 1.34.)

FIGURE **1.33** *The Prism can be used for just that, or as a component of a larger, composited model.*

FIGURE **1.34** *The RingWave is a Primitive animation effect that can be transformed into an object.*

AN EXTENDED PRIMITIVE COMPOSITION

The Extended Primitives are more useful as components of buildings or statues, and less likely to be used in their unaltered form as parts of PrimBots. With that in mind, it's time for you to explore the possibilities. Using a mix of Extended Primitives, create a composite scene of your own design. See Figure 1.35 for one possibility.

Unless you need your Extended Primitives model to look like it has moving parts, there's no need to Link any of the elements together. Instead, use the Group tool (Group>Group) to attach everything together so it can be moved, resized, and rotated as needed.

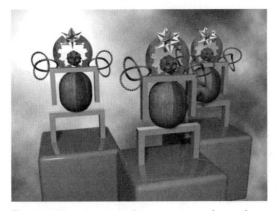

FIGURE *These Cosmic Kachinas were created entirely*
1.35 *from Extended Primitive parts.*

FIGURE *The Non-Uniform Scaling tool.*
1.36

SCALING TRANSFORMATIONS

By using the basic Scaling Transform operation on any of the R3 Standard or Extended Primitives, you create limitless additional modeling components. The catch is that you have to use a specific Modifier to do it the right way. Just to prove it, place any Standard or Extended Primitive in your scene. Now go to the Uniform Scaling tool, and select the Non-Uniform Scaling tool from the Flyout. (See Figure 1.36.)

1. Select the Y-axis in the toolbar, and try to resize the selected object on its Y-axis. You get a caution flag, warning you that this is not recommended. Click NO.

2. Go to the Modifier panel, and select More>X-Form from the list.

3. Now try the same thing. It works perfectly. This must be done when you want to resize a selected Primitive in a non-uniform manner.

A FINAL BOT EXERCISE

With all of the Standard and Extended Primitives in your control, and knowing about X-Form Non-Uniform scaling, you are ready to create one last PrimBot in this chapter. Use all of your creative intuition to model a unique PrimBot, one that would be proud to call you its parent! You can use Grouping to put together the separate components in each part, and then Link the parts together that can be rotated and posed. Do this exercise when you have some relaxed time to dream it into reality. See Figures 1.37 and 1.38 for just one of an infinite number of possibilities.

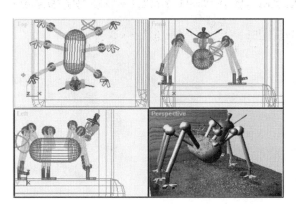 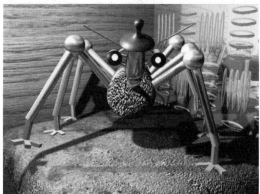

FIGURE **1.37** *Here's just one way of using a selection of Standard and Extended Primitives to create a unique PrimBot.*

FIGURE **1.38** *A rendered PrimbugBot, with a Teapot head.*

MOVING ON

In this chapter, we have explored the creative possibilities connected with using both Standard and Extended Primitives to create models in 3D Studio Max R3. In the next chapter, we will look at creating models from Shapes.

CHAPTER 2

Splinediferous

I n this chapter, we are going to explore the model-making capabilities that start with the Splines options in the Create>Shapes panel. *Splines* are shapes that can be transformed into objects or animation paths. Our concentration will be on modeling, so we will look at the ways that Splines can be used in the object-making process. The Spline types include Line, Circle, Arc, NGon, Text, Section, Rectangle, Ellipse, Donut, Star, and Helix.

Although Splines are usually used as either base components for other operations, like Extrusion and Lathing, that translate them into 3D objects, or as animation paths, you can also render a Spline as it is. *This makes it an object like any other. To do this, select the General heading in the Modify panel for the selected Spline, and check Renderable. Add whatever Thickness is appropriate for your needs.*

A BASIC EXERCISE

Before we detail what each Spline provides for the 3D modeler, we have to jump ahead a bit. Section F of this book (*Modifying Reality*) deals with the modeling options found in the Modify panel. To transform Splines into 3D objects, however, we have to allude to a few of these modifiers here. So first, take a peek at the items under the Modify tab in the Command panel. You will see a number of default selections named on the buttons below the heading. (See Figure 2.1.)

In this chapter, we have to make use of three of the named Modifiers: Extrude, Lathe, and Edit Spline, along with some associated options. Once these three Modifiers are thoroughly understood, you'll be able to use the Create>Spline options to quickly create all types of 3D objects. Start by doing the following:

1. Go to Create>Spline, and click on the Circle option.

2. In the Left View, click-drag the mouse to create a circle about 1/3 the size of the viewport.

FIGURE *The Modify panel.*
2.1

3. With the circle selected, go to the Modify panel.

You will repeat these three basic steps for each of the explorations of the three Modifiers.

EXTRUDE

Extruding a Spline pulls the shape in a set direction for a determined distance, creating a shell or skin in the process. Do the following:

1. With the circular Spline selected, click Extrude. Look at the circular Spline. It has become a flat disk.

2. Move down to the parameter indicator in the Extrude Modifier panel that reads "Amount." It reads 0, so the extrusion has no thickness. Input the number 25, and hit Enter.

3. Now the circle has generated a 3D cylinder, 25 units in depth.

4. Below the parameters area in the Extrude Modifier panel is an area called "Output." There are three options here: Patches, Mesh, and NURBS. Mesh is the default. Clicking on either of the other two will create either a Patch or NURBS surface. For now, leave the setting at Mesh. The Extrude modification process automatically creates an object with one of these three choices.

If you weren't familiar with the Max method of performing an extrusion, you now have that knowledge.

LATHE

The next operation we'll tackle is *Lathing*. Lathing creates a 3D surface by spinning a shape on an axis. The position of the axis in relation to the shape being lathed is extremely important. Place a circular Spline in your scene the same way you did previously, and then do the following:

1. With the circular Spline selected, go to the Modify panel and click Lathe.

Lathing spins a shape on its axis to create an object of revolution, a 3D surface based upon the placement of the XYZ-axis and the degrees (from 0 to 360 in this case) that the shape is being revolved. The default position of the axis is at the center of a Circle shape, and the default degree of revolution is 360, so the result of an initial lathing of a Circle is a sphere. That is what you should see in your viewports after this initial lathing process. Now comes the fun part.

2. With your new sphere still selected, look at the rest of the Rollout under the Lathe heading in the Modify panel. Under parameters, change Degrees from 360 to 180. You would think you'd be transforming the sphere into a hemisphere, but instead you still see a sphere. Why?

Think for a moment, and visualize what is really occurring. The Circle that is Lathed 180 degrees around a center creates a sphere, because both edges create hemispheres. At 180 degrees, the hemispheres meet and form a sphere. You cannot use the lathing process on a Circle to create a hemisphere, because you are always creating two mirrored volumes. To prove this, set the revolution amount to 90 degrees. The result is an object of revolution that has two mirrored quarter-slices, as can be seen in Figure 2.2.

FIGURE *The result of lathing a circular shape around an axis placed at the center of the shape,*
2.2 *with the revolution amount set to 90 degrees on the left, and 50 degrees on the right.*

3. More fun awaits. In the Modifier stack, with Lathe still selected, move down to the Sub-Object button and click it. The word "Axis" is highlighted. This means that you can now perform translations on the axis, the same axis used as a center of revolution for your Circle-based Sphere. Click on the Move tool, and move the axis to the right in the Front viewport. The sphere becomes half of a Torus, with the hole at the center getting larger the farther away you move the axis from the original lathed object.

But why not an entire Torus? Again, time to think. If you are using a revolution amount of 180 degrees, that's fine for creating a sphere from an axis at the center of a circle. When the axis is moved away, however, the result of the lathing process set to 180 degrees is only half of the resulting object, just as 180 degrees is half of 360. To create the entire Torus by moving the axis, you'll have to reset the Amount to 360 degrees again. If this seems confusing, it's because you are trying to understand a visual experience through verbal understanding. You'll just have to spend some time playing in Max to get an intuitive feel for the process.

Farther down in the Lathe Modifier panel parameters indicators, you will see an area called "Direction." Under it are three buttons: X, Y, and Z. These determine what axis the lathing addresses; in this case, the default is Y. Clicking on either Z or X, and moving the axis away from the original lathed shape as you did previously, can create some unique and bizarre 3D objects. Experiment, and see what happens.

EDIT SPLINE

This is the last of the three Modifiers we will look at in this chapter. Edit Spline does not by itself create a 3D object, but instead allows you to reshape any splined shape you created initially. Do the following:

Important Note! *To understand how to edit a Spline, you must understand the terminology that indicates what part of the Spline you are editing. There are three terms: Spline, Vertex, and Segment. The Spline means the whole Spline. A Vertex is a point on the Spline used to determine the curve at that point. A Segment is a section of the Spline between any two Vertex points. If you look at the Circle shape you have been using as an example, you will see that it is a closed Spline with four Vertex points and four Segments.*

1. Start by placing a Circle on the screen again. Work in the Front viewport.

2. With the Circle shape selected, go to the Modify panel and click the Edit Spline button.

3. In the Sub-Object Selection level, select *Vertex*. Use the Move tool and click on a Vertex on the Circle shape. Move it anywhere you like to reshape the Circle. See what variations you can create just by moving selected vertices.

4. Use the Rotate tool and click on a Vertex. Note that handles appear and are connected to the selected Vertex. Rotate the Vertex with the Rotate tool, or use the Move tool to adjust the size and position of the Vertex handles. This gives you more opportunities to reshape the Circle.

5. Select Segment from the Sub-Object category, and use the Move tool to re-position selected Segments of the Circle. Explore these possibilities until you are satisfied that you have a command of these reshaping methods.

Advanced Spline Editing Options

There are a number of additional options in the Edit Spline Modifier Rollout that can help you create very complex Splines, which can then be used for Extrusion or lathing operations to create complex 3D objects.

By clicking on a Spline, Vertex, or Segment with the Right mouse button held down, you can access the Edit Spline operands faster than selecting them from the Rollout.

All of the options contained in the Edit Splines Rollout are detailed in the R3 documentation, so what we will do here is provide some interesting and useful tips and reminders that are important to keep in mind.

- Use *Refine* to add Vertex Points to the shape. This is definitely one of the most-used options, since adding Vertex points allows you to create more editing variables for any shape.

 To add new Vertices to a Segment, select Segment in the Sub-Object list. Then click Divide after setting a division value. This adds Vertices that are equally spaced on that Segment.

- Hitting the Delete key with any Vertex selected removes that Vertex from the shape and adjusts the shape accordingly.

- Clicking *Break* with any Vertex selected breaks the link of the closed shape at that point. This allows you to move the Vertex (which is actually now two overlaid vertices) to manipulate the open shape, or to add more Segments to either of the two ends.

- To alter the type of Vertex, select the Vertex with the Right mouse button down. This brings up the Options menu. Select from four Vertex types: Smooth, Corner, Bezier, and Bezier Corner. Using the Circle shape as an example, making all four Vertices Corner types will transform the Circle into a Square.

- Use *Attach* to create "holes" in Splines that will be used for Extrusion. The result is great for creating "gasket" objects and other mechanical elements. Do the following:

 1. Create any closed Spline shape.

 2. Create one or more closed Spline shapes inside of the first one.

 3. Select the first shape, and go to the Modify panel. Click on Edit Spline.

 4. In the Rollout, with the first shape still selected, click *Attach*. It remains highlighted until clicked off.

 5. With Attach on, click on the other shapes or shapes enclosed in the first shape. When finished, turn Attach off. Note that you can also use *Attach Multi*, and select multiple shapes from the list all at once.

 6. Click on Extrude, and your gasket is created. To add thickness, increase the Amount value to more than zero. (See Figure 2.3.)

- Check *Show Vertex Numbers* to aid you in seeing the location of all Vertices, and also the direction of their placement. This can be important later, when we look at *Lofting*.

- Activate the Vertex Sub-Object, select a Vertex, and use *Create Line* to begin adding a new shape to extend the parameters of your original shape. Use this process to create new parameters for Extrusion and Lathing.

Now we are ready to look at the different shapes in the Create>Spline list, and how they can be used to generate a wide array of different 3D forms.

FIGURE *A gasket-like object created by using the steps indicated.*
2.3

SPLINE-BASED 3D MODELING

Extrusion and Lathing are two of the most common ways to develop 3D modeled elements from Splined shapes. Now that you are aware of how to access and apply both Extrusion and Lathing, let's investigate the variety of initial shapes that you can apply these processes to. The Spline options include Line, Circle, Arc, NGon, Text, Section, Rectangle, Ellipse, Donut, Star, and Helix.

LINE

Creating a splined Line is a two-step process, involving the clicking of the mouse (LMB) to create a point, and the dragging of the mouse to create an line Segment extending from that point. When you select Create>Splines>Line, the Rollout allows you two options for clicking the point (Corner and Smooth), and three options for dragging to create the line Segment (Corner, Smooth, and Bezier). As we have already seen, Smooth and Corner points can be interchanged and mixed in the Edit Spline step. The Linear process can be used to create either *Open Shapes* or *Closed Shapes*. A Closed Shape is one whose last point coincides with its first point. When you click the last point of a Lined shape over the first point, you are asked whether you want to create a closed shape.

As you can imagine, a truly infinite variety of shapes can be generated by using the Create>Splines>Line process, which allows for an infinite variety of 3D Extruded and Lathed objects. You can extend your creative options even farther (farther than infinity?) by combining your initial Linear shapes with any of the Edit Spline processes we have already covered. Explore the creation of both Extruded and Lathed objects from your linear shape components. (See Figures 2.4 and 2.5.)

FIGURE
2.4 *A selection of Line shapes that were Extruded.*

FIGURE
2.5 *A selection of Lined shapes that were lathed.*

CIRCLE

Probably the most basic use of the Circle is to create extruded cylinders, but both extruded and lathed possibilities are far richer than that, especially after you apply Edit Spline options. Drawing the initial Circle is simple. Just click to position the center, and drag to create the perimeter. It's how you apply alterations with the Edit Spline Modifier that makes all the difference as far as providing content for Extrusion and Lathing transformations. (See Figures 2.6 and 2.7.)

FIGURE
2.6 *Extruded objects based upon the Circle.*

FIGURE
2.7 *Lathed objects based upon the Circle.*

ARC

Drawing an Arc can be accomplished with several options. The Arc can be a Pie Slice (good for 3D pie graphs), and it can be reversed. It can be drawn by placing the ends, or by working from the center point. Extruded Arcs resemble curved sheets, while Lathed Arcs can be used to create elegant 3D forms. (See Figures 2.8 and 2.9.)

FIGURE **2.8** *Extruded Arcs resemble curved sheets of whatever material is used on them.*

FIGURE **2.9** *Lathed Arcs create elegant forms. By lathing at less than 360 degrees, you can appreciate the Arcs' lack of thickness.*

NGON

NGons are polygons with a variable number of sides. When the sides are set above 12, the NGon starts to resemble a Circle. In fact, this is a use for the NGon, since a Vertex is placed at every NGon Vertex, you can create a Circle shape with a predetermined number of sides with this tool. Many Extruded and Lathed objects variations can be created using NGon shapes, especially after they are edited with the Edit Spline Modifier. (See Figures 2.10 and 2.11.)

TEXT

Using Text shapes, you can type any text message you need in any available font. You can adjust the size, message content, justification, and alter the type style on the fly. Text shapes

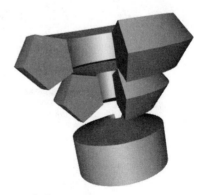

FIGURE **2.10** *By Attaching shapes in the Edit Spline Rollout, you can nest NGons inside each other for extrusions.*

FIGURE **2.11** *Lathed pentagons.*

FIGURE *Extruded Text is used to create title content.*
2.12

FIGURE *By lathing a Text block with Amount set below*
2.13 *40 degrees, you can create some interesting Text*
F/X. In this example, the Text was lathed 33
degrees, with the axis at the center.

are usually extruded, but lathing can create some interesting variations. (See Figures 2.12 and 2.13.)

Important! Note that Text characters are just closed Spline objects, and can be used to model any type of 3D-object content that their individual shape is suited to.

NOTE

SECTION

A Section is a Spline that is used to create a cutaway of a 3D mesh form at whatever placement it has in relation to the 3D mesh. Trained graphics artists know what a chore it is to create sections of complex 3D forms, using the rules of projection. Not any more. Simply place the Section Spline in the right position and rotation on a 3D mesh object and click Create Shape. The result is a true cross-section taken at the required angle and cut. (See Figure 2.14.)

FIGURE *A Section taken of the Teapot object, made renderable with a thickness of 3.*
2.14

RECTANGLE

You can select either Cube or Rectangle, and use the resulting Closed Splines as extrusion or lathing components. Of course, you could also round the corners by selecting their Vertices and using the Smooth option in Edit Spline. (See Figures 2.15 and 2.16.)

FIGURE **2.15** *A series of Attached Rectangles extruded and mapped with a Wood Material.*

FIGURE **2.16** *A 3D surface formed by lathing the same Rectangles shown in Figure 2.15 by an amount of 90 degrees.*

ELLIPSE

The Ellipse may be used like its cousin, the Circle, although by using the Edit Splines Modifier on a Circle, you can create the Ellipse by pulling on a selected Vertex.

DONUT

The Donut is really two Circles, with the "hole" Circle attached to the larger Circle.

STAR

The Star Spline has several parameter options. You create the initial Star by clicking and dragging the mouse, and watching the screen at the same time to see how your movements are interpreted by the Spline. Once done, you can alter the parameters. The Distortion parameter indicates how the points are offset from a common center, producing what used to be called a "Flyfot" in ancient times (literally "flying feet"). The Filet parameter adds roundness to the Star points at any values other than 0. (See Figure 2.17.)

HELIX

The helix is a three-dimensional Spline. Other than making it Renderable and adding a thickness, it isn't very valuable for extrusion or lathing. Its value comes into play when we talk about Lofting and Path Extrusion later in the book. (See Figure 2.18.)

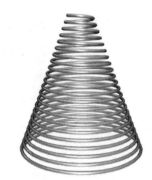

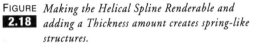

FIGURE **2.17** *A Star object created by making the Spline Renderable with a thickness of 3, and adding an Outline Modifier in the Edit Splines Rollout.*

FIGURE **2.18** *Making the Helical Spline Renderable and adding a Thickness amount creates spring-like structures.*

AUTOGRID

AutoGrid is new to R3, but what is it? Described in the simplest terms, AutoGrid allows you to place Splines and/or 3D objects on any selected 3D object's surface, using the targeted object's geometry. More specifically, what is targeted is the surface "Normal" of the polygon the cursor passes over (or the surface Normal at that point if it is not a Mesh object). The implementation of this process is extremely elegant. As you move the mouse, an XYZ cursor attached to it changes its direction according to the Normal of the target object at that point.

WHY IS AUTOGRID IMPORTANT IN MODELING?

One of the most time-consuming tasks in modeling is to align the components of a composite model so that they are in the relationship you need. AutoGrid allows you to place added elements with ease, and the alignment is perfect. This is especially valuable when the targeted object has a curved surface, since the Normals vary according to each point on the surface.

WHAT CAN AUTOGRID HELP YOU DO?

Let's focus on placing Splined shapes on a 3D object. You might want to do this so that you can extrude the Splined shapes to create appendages for the object, or you might want to just surface the shapes and use them as flat symbols that look "pasted" to the surface at that point.

On curved surfaces, the Shape you paste on to a 3D object with AutoGrid does not automatically bend to fit the curved surface; it maintains its flat geometry. You will have to use the Conform command (see Chapter 3) to bend the shape. You also have to either Link or Group the shape to the 3D object if you want them to move together.

AN AUTOGRID EXERCISE

To explore one possibility for AutoGrid, do the following:

1. Place a Cube in your scene.

2. Go to Create>Shapes>Splines, and select the Text option. Check AutoGrid on.

3. Create a text message of one word. Move the cursor over the Cube to place the text. Notice that each face of the cube affects the orientation of the axis attached to the cursor. Place the Text on the front face of the Cube. You may have to resize it to fit.

4. Make the Text an Editable Mesh, and map it with a color that stands out from the Cube. The Test has no thickness, so it will have to be moved just a bit above the Cube's face so it can be seen. When it is in position, Group the Text and Cube together.

You have just placed a symbol—in this case, readable text—on a 3D object. You can use variations of this theme to create messages on billboards or insignia on planes. (See Figure 2.19.)

FIGURE *Text placed on the face of a Cube hints at many other possibilities for using AutoGrid.*
2.19

RECTILINEAR LINES

Holding the Shift key down while clicking Vertex points with the Line tool allows you to drag out Segments that are at a 90-degree angle from the previous Segment. Holding down the Control key allows you to create Segments at the current Angle Snap value. To set the Angle Snap value, go to Customize>Grid and Snap Settings>Options.

IMPORTING INFINITE SHAPES

The Create>Splines list is based upon the construction of 2D shapes, shapes drawn as vectors. Many computer 2D drawing applications can be used to create vector-based content

that Max can import. The 2D vector file formats that Max is able to import include Adobe Illustrator (.AI), AutoCAD (.DWG), IGES, 3D Studio Shape (.SHP), and a few others. The most important of these is the Adobe Illustrator format, because it is an industry standard and because so many artists are familiar with the use of this application. Adobe Illustrator's drawing tools, in both quantity and variety, outweigh those found in Max. This allows you to create shapes that are more complex initially, so that the extrusion and lathing process in Max can translate them into more complex 3D data.

CREATING A COMPLEX SPLINEBOT

OK. Time for another PrimBot exercise to challenge the knowledge and skills you have accumulated in this chapter. The actual design is up to you. The only ground rule is that you must use only Spline-based objects, created by Extrusion, Lathe, and Edit Spline. You might find it useful to create the various body parts first from Grouped elements, and then Link those elements together to form the final figure. Figure 2.20 is just one example of how complex this model can be, though you will of course create your own unique model.

FIGURE *Here is one possible complex SplineBot, created by using Splines as the basic modeling*
2.20 *element.*

MOVING ON

This chapter attended to Splines, and how they are used in the construction of Extruded and Lathed objects. We also investigated the Edit Spline Modifier. In the next chapter of Section A, we'll look at how 3D objects are created by using Lofting processes.

CHAPTER

3

Lofty Ambitions

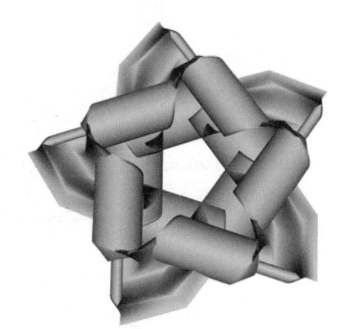

37

Having covered the use of basic 3D primitives and shapes previously, it's time to move on to some modeling tools and processes that offer you opportunities for more organic designs. Lofting is the first step on that path.

WHAT IS LOFTING?

Lofting is the name given to the process that allows you to place *cross-sections* on a *Path*, and to generate a surface or a "skin" that connects them. Lofting can be thought of as Extrusion raised to another level. When you use basic Extrusion to create a 3D object from a shape, the extruded object has the same cross-section at any point on that object (as long as the comparative "cuts" are perpendicular to the extrusion axis). This is not true with most lofted models. For one thing, the "axis of extrusion" is replaced by a Path in Lofting. That Path can take any shape, closed or open, that you prefer. Lofting can be considered as a form of *Path Extrusion*. All of the shape tools in the Create>Shapes panel can also be considered as Paths for lofting, so you can see that the last chapter prepared the groundwork quite well to understand this chapter's contents.

BASIC LOFTING TOOLS IN R3

1. Open Max, and use the Create>Shapes>Splines panel to select the Line tool. Draw a curved line that reaches vertically from the top to the bottom of the Top viewport. It can be any shape you like, but keep it open.

2. Away from what is now our Path, create a Circle and a Square. Make them about 1/10th the size of the Top viewport.

3. Go to the Create>Geometry>Compound Objects panel, select the Circle shape in the Top viewport, and click on Loft. The Loft Rollout appears. (See Figure 3.1.)

4. Your first option in the Rollout is to choose between Get Path and Get Shape. The shapes we have drawn can be classified as either, depending upon the model we want to create. The Circle could be a Path for the Line, which would create one structure; in this example, we will use the Circle as Shape and the Line as Path.

5. After this option, and right below it, you see three possibilities: Move, Copy, and Instance. For this example, select Copy. This will leave our original in place, while copying it to the Path.

6. For now, we'll want to make one more decision. Click on Surface Parameters, which opens another level of the Rollout. Under Output, there are two options: Patch and Mesh. Make sure Mesh is selected.

FIGURE *The Loft Rollout.*
3.1

7. Now go back to the top of the Rollout. Make sure the Circle is selected, and click on Get Path. Click on the Line in the Top viewport. The Lofted object is created. (See Figure 3.2.)

8. Note that the Path has jumped to the Shape, so that the new object is seen as rendered on the Y-axis in the Perspective window. Also notice that the Lofted object is rather angular—don't be concerned about that now.

9. Select the Square, and Loft it to the Path. Now you have two Lofts next to each other, one based upon the Circle, and one on the Square cross-section. At this point, both objects can be considered as created by Path Extrusion, a basic version of Lofting. This is because their cross-sections do not vary in shape. (See Figure 3.3.)

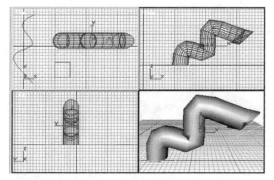

FIGURE *The new Lofted object.*
3.2

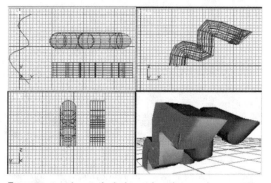

FIGURE *Another Lofted object, based upon the square*
3.3 *cross-section.*

THE NEXT STEP

The real magic behind Lofting takes place when two different shapes are placed on the same Path, so let's create a class-A Loft. Do the following:

1. Delete both initial lofted objects from your workspace.

2. Select the Path, and go to Create>Geometry>Compond Objects>Loft.

3. In the Rollout, with the Path selected, click on Get Shape, and select the Circle. Under Path Parameters, the value should read 0. This means that the Circle has been placed at the start of the Path (0% along the Path). Since there is no other Shape selected, the entire Path references the Circle, but we are going to change that.

4. Get Shape should still be highlighted. Select the Square, and change the Path Parameter value to 99%. What did we just instruct the process to do? We told it to start a Lofted object with the Circle (0%), and end it with the Square (99 to 100%). The resulting object has a Circular cross-section at the start of the Path, and a Square cross-section at the end. (See Figure 3.4.)

Important Note! *It's best to use the value 99% instead of 100% for the final shape, so that the preceding shape isn't still trying to transform itself at the last cross-section. This allows the Circle, in this case, to hold true as a cross-section from 99 to 100% of the Path.*

You can locate Shapes on a Loft path by percentage, Distance, or Path Steps.

5. If there are unwanted wrinkles along the Lofted object, try placing another Shape at a point along the Path to smooth them out. (See Figure 3.5.)

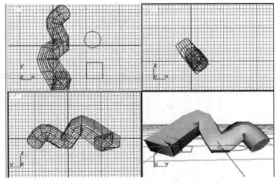

FIGURE **3.4** *A Lofted object with both Circular and Square cross-sections.*

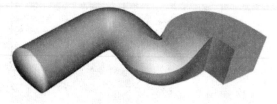

FIGURE **3.5** *The same Loft with Path Steps increased to 35, and another Square cross-section placed at 25% on the Path.*

To smooth out the Loft, select the Skin Parameters area of the Rollout. The default Path Steps value is set to 5. Try increasing it to 35 as a start, while watching what that does to the Loft in the Perspective viewport. Explore different values until the Loft appears as you want it to.

6. You can alter the original Shapes and place the new versions at different places on the same Loft path. Try this now. Select the Lofted object, and Get Shapes. Select the Circle, and place it on the Path at a different point or points from the initial cross-sections. Select the Square and do the same. Select the Loft, and Sub-Object>Shapes in the Modify panel. Select any shape on the Path and resize, reposition, or rotate it. See how this affects the Loft in the Perspective viewport. At the places where the smaller Shapes are placed, the Lofted object shows the smaller cross-section sizes. You can do this multiple times to resculpt the Loft. (See Figure 3.6.)

MORE LOFT EXPLORATIONS

Loft Paths can be open or closed, and the same is true for a Loft's cross-section Shapes. Here are some things to try:

- Create a squiggly Line and a Circle. Select the Line as the Shape, and the Circle as the Path, and Loft. (See Figure 3.7.)

- Create a squiggly Line and a Square. Select the Line as the Shape, and the Square as the Path, and Loft. (See Figure 3.8.)

- Use a five-sided NGon Shape on a Square Path to create exquisite frames. These can be used for holding virtual pictures or photos, or as architectural elements. (See Figure 3.9.)

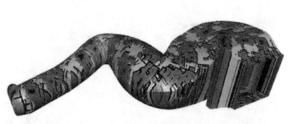

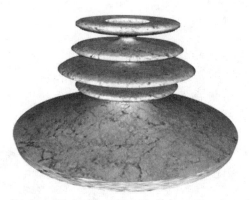

FIGURE **3.6** *The Loft is reshaped according to the new resized cross-section shapes used on its path. The square end is left uncapped.*

FIGURE **3.7** *An open Line Shape Lofted to a Circular Path creates a 3D form that resembles a Lathing operation.*

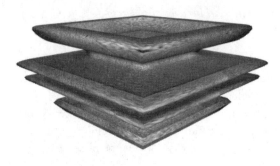

FIGURE **3.8** *The same open Line Shape used in Figure 3.7, when used on a Square Path, creates a different 3D object.*

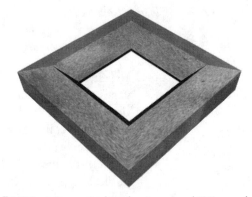

FIGURE **3.9** *A Square Path with a Pentagonal NGon used as a Shape makes a great frame.*

- Draw a winding Path with the Line Shape, and use a Donut Shape to Loft it. This makes a great garden hose or pipe object. (See Figure 3.10.)

- Use a Star as a Path, and Loft a Circle or Square to it. This makes great Christmas tree ornaments, and can also serve as an element in a logo design. (See Figure 3.11.)

- Here's an idea with near-infinite possibilities. Use any single letter or number from the Text Shape option, and Loft it to any closed or open Path. Don't use more than one letter or number at a time. This technique can create a wide array of very diverse 3D forms. (See Figure 3.12.)

- The Helix Spline option is one of my favorite Lofting Paths, because it helps you create springs. Use a Circle or Square for best results, though you can also explore the use

FIGURE **3.10** *A Donut Shape is Lofted to a curving Line Path, creating a hollow tube.*

FIGURE **3.11** *A Circle Lofted to a Star Path. Make sure to increase the Path Steps to get rid of any unwanted anomalies.*

FIGURE
3.12
This 3D form was created by using a number "3" as the Shape, and Lofting it to a Circular Path. It makes a great wheel or machine part.

FIGURE
3.13
On the left, a conical spring is the result of Lofting a Circle to a Helical Path with a smaller radius at the top. On the right, a long, thin rectangle is used as the Shape, resulting in a very different object.

of a variety of open shapes. Shape the Helical height and turns any way you like. (See Figure 3.13.)

- The helix is a three-dimensional open Shape. You can Loft it to a closed Path to create some interesting 3D forms. (See Figure 3.14.)

- When it comes to creating columns, nothing beats Lofting. Many digital artists simple Lathe a shape to create a column. That's OK, but it's awfully symmetrical. Using different Shapes on a straight Lofting path allows you to add far more visual interest to the resulting 3D object. (See Figure 3.15.)

FIGURE
3.14
Here, a Helix with only two turns is Lofted to a five-sided NGon. This would make a great component of a logo.

FIGURE
3.15
This column was Lofted using Circles, NGons, and Star Shapes at selected positions along its vertical Path.

DEFORMATIONS EDITING

You have already discovered that Lofting Shapes on a Path can result in the creation of a wide variety of 3D objects, but there is much more. Using the Sub-Object options in the Modify dialog, and selecting either Path or Shape for the selected Loft, you can resize, rotate, and reposition selected elements of the Loft. But what if you want to alter the Loft more visually, instead of using transformation options on selected Shapes? Max makes that easy, with the use of Deformation Curves.

ACCESSING DEFORMATIONS

With a Loft object selected, go to the Modify panel. At the bottom of that panel is a button labeled "Deformations." Clicking it extends the Rollout information. (See Figure 3.16.)

We are going to explore the application of different Deformation options on a basic Loft object, a Hexagon Shape lofted to a straight line Path. (See Figure 3.17.)

The Deformations include Scale, Twist, Teeter, Bevel, and Fit.

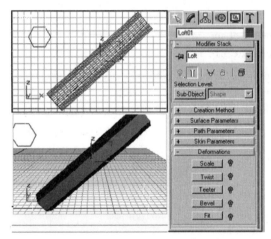

FIGURE **3.16** *The Modify panel, displaying the Deformations options for a selected Loft.*

FIGURE **3.17** *Refer to this undeformed Loft, and compare it with the following figures that display the Loft after various Deformations have been applied.*

Scale Deformations

Clicking on the Scale option while the Loft is selected brings up the Scale Deformation dialog. (See Figure 3.18.)

At the top of the dialog is a series of controls. At the bottom right are zoom controls for magnifying the work area. In the work area, there is a red line at the 100% marker. This line represents the current scaling of your selected Loft. The top control buttons are important to understand so that you can effectively edit the scaling of your Loft on either or both its X- and Y-axis (See Figure 3.19.)

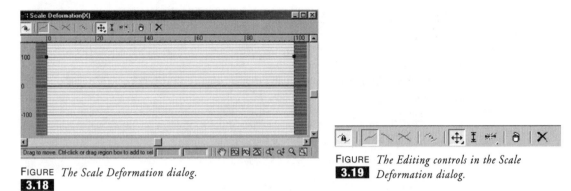

FIGURE *The Scale Deformation dialog.*
3.18

FIGURE *The Editing controls in the Scale*
3.19 *Deformation dialog.*

From left to right in Figure 3.19, the Deformation controls (which remain the same in all Deformation dialogs) are as follows:

- **The Symmetry Toggle** This button is normally defaulted to ON (selected). When this control is selected, whatever editing you do will affect both the X- and Y-axis of your Loft equally. When it is off, you can deform the Loft's A- and Y-axis parameters individually.

- **X active/Y active/XY active** Selecting one of these options allows you to work on the X-axis, the Y-axis, or on both simultaneously. These options work in combination with the Symmetry Toggle. With Symmetry on, working in either the X- or Y-axis causes both to be affected by the changes. Working with Symmetry on and XY on doesn't make much sense, because no matter which of the three options is chosen, you will always be working on both X and Y at the same time with Symmetry on. With Symmetry off, however, it's a different matter. With Symmetry off, you can work on the X- and Y-axis individually, giving you much more editing control for the development of unique Lofted forms.

- **Swap Deform Curves** The next button Swaps the Deform Curves when clicked. Again, you'll want Symmetry off, so that swapping the XY curves means something (as long as they have both been edited differently).

- **Move Control Point** There is a Flyout available from this button. By default, the tool is set to allow you to move control points horizontally and vertically, but you can select either direction individually as well, constraining the movement.

- **Scale Control Point** No explanation needed.

- **Insert Corner Point/Insert Bezier Point** You can insert one of two types of Control Points: Corner (produces sharp angles), or Bezier (creates curves by the adjustment of Bezier handles).

- **Delete Control Point** No explanation needed.

- **Reset Curve** Clicking this button returns the Loft to its original condition.

A Scale Deformation Exercise

You have to engage in hands-on exploration in order to see exactly what Deformation editing can do. A Loft is created from three components: the Shape cross-sections, the Path, and the XY Profiles. All of the Deformation options address the XY Profiles of a Loft. Do the following:

1. Create a Loft. Make it a basic example for this exercise, a single Shape addressing a straight line Path, perhaps like the one displayed in Figure 3.17.

2. With your Loft selected, go to Modify>Deformations, and click Scale. The Scale Deformations dialog appears.

3. Leave all of the defaults. Place some new Control Points (Corner or Bezier) on the Profile line (red). Move them to rescale the Loft at that point. Do this until you are satisfied with the new form. (See Figure 3.20.)

In the following Deformation options, the Controls remain the same as previously described, so their detail descriptions will not be repeated.

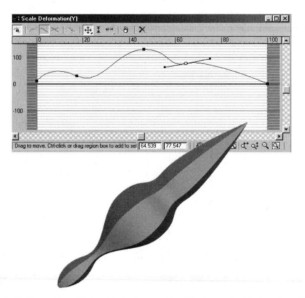

FIGURE *The Scale Deformation dialog with the new Profile Curve is displayed at the top, and the*
3.20 *resulting change in the Loft (compare to Figure 3.17) appears at the bottom.*

Twist

The Twist Deformation is best applied with Symmetry on, though you are encouraged to explore applying it to the X- or Y-axis alone. Use Twist Deformation to create screw threads and similar object attributes. (See Figure 3.21.)

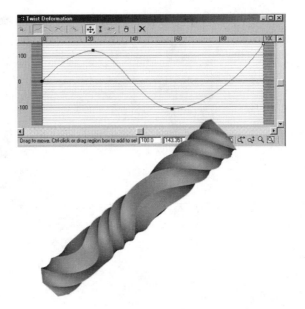

FIGURE *At the top is the Twist Deformation dialog displaying the edited Profile curve, and below*
3.21 *that is the resulting Loft.*

Teeter

Teeter rotates the cross-section shape on the X-, Y-, or XY-axis at the Control Point by the
amount the curve is above zero. It's best to use this Deformation option in smaller incre-
ments, since unexpected results can occur. In order for any changes to be noticed, the cross-
section Shape should be angular. (See Figure 3.22.)

Bevel

One control is added to the end of the Control Buttons for Bevel Deformations. This is the
Bevel type options Flyout: Normal, Adaptive Linear, and Adaptive Cubic. Beveling is simi-
lar to scaling the Profile, though the results are more suited for adding a base to a Loft (like a
table lamp, for example). (See Figure 3.23.)

Fit

Fit Deformation is not as intuitively mastered as the other Deformation processes, and it
works very differently. Fit Deformation requires that you select a closed Spline as a deforma-
tion curve (or possibly one for the X-axis and another for the Y-axis). The closed Spline(s)
is/are then interpreted and applied to the Loft. The results are often totally unexpected, but
can lead to some pretty nifty creative accidents. Controls are included to flip the imported
Spline(s) and to rotate it. The procedure is as follows:

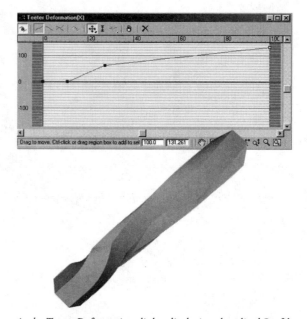

FIGURE *At the top is the Teeter Deformation dialog displaying the edited Profile curve, and*
3.22 *below that is the resulting Loft.*

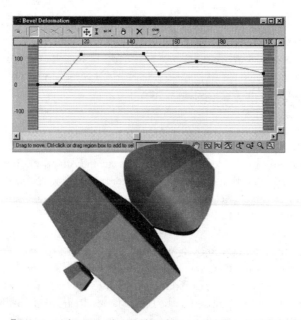

FIGURE *At the top is the Bevel Deformation dialog displaying the edited Profile curve, and*
3.23 *below that is the resulting Loft.*

1. With a Loft selected, click the Fit Deformation button, bringing up the dialog.

2. Decide whether you want to import only one Fit Spline, or one for each axis. Click on the pre-drawn Fit Spline in a viewport to bring it in.

3. Edit as desired, manipulating either or both the imported curve and the Control Points.

4. Check the Perspective viewport regularly to see what your machinations are creating. Stop when you like what you see (See Figure 3.24).

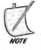

The important thing to remember when working with Deformation Curves is that working with more than one for a selected Loft has the most potential for creating unique 3D objects. The order that you apply various transformations is also important.

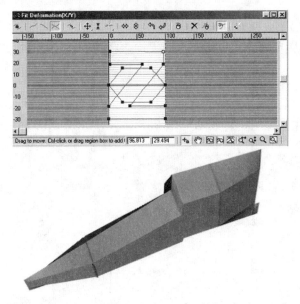

FIGURE **3.24** *At the top is the Fit Deformation dialog displaying the edited Profile curve, and below is the resulting edited Loft. A letter "Z" and a six-sided NGon were used as the Fit curve Splines.*

LOFTING TO A 3D NURBS POINT CURVE

Except for the Helix Shape, we have been dealing with 2D Splines as Paths. There is another attribute of R3, however, that can be used to create true 3D Paths: the NURBS Point Curve. Due to a process new to Max in R3 called "Draw in All Viewports," you can explore 3D Path creation. Here's how:

1. Go to Create>Shapes>NURBS Curves>Point Curve.

2. At the bottom of the Rollout, you will see a checkbox for Draw in All Viewports. Make sure it is checked.

3. Start in any viewport and begin to draw a Shape curve. Do not click the RMB, which would end the Shape. Instead, move to another viewport. Magically, the Shape continues along that viewport's axis references.

4. Draw a small Circle in a viewport, and Loft it to the NURBS Path. (See Figure 3.25.)

FIGURE **3.25** *Here are some examples of Paths created with the NURBS Points "Draw in All Viewports" option.*

ANOTHER BOT

OK. Time to create another Bot model. This time, we'll use only Lofted elements. Though this exercise may seem repetitive at this point, there is an important tactile and visual lesson involved. It is that by doing a version of the same thing with different tools, you can begin to appreciate exactly what the tools are capable of, how they differ, and what tools are best for specific modeling tasks. Lofting, for example, allows you to create 3D forms that are potentially much more organic than the basic 3D Primitives we started with. As we move into the next chapters, that appreciation will be underlined.

Making sure that you understand all of the Lofting principles and processes we have covered so far, create a Linked Bot of your own design (I'm calling it a LoftBot, but you can call it Fred). Try to challenge yourself by using as many Lofting variables that you can incorporate into the design. My LoftBot (I call it LoftSpace) can be seen in Figure 3.26.

FIGURE *Building a 3D model exclusively from Lofted elements enhances your appreciation of the*
3.26 *creative processes and challenges involved.*

MOVING ON

We targeted Lofting in this chapter, from its basic elements to the more complex Lofting deformations. In the next chapter, we'll move on to a detailed look at the use and variety of Compound Objects.

CHAPTER

4

Compound Interest

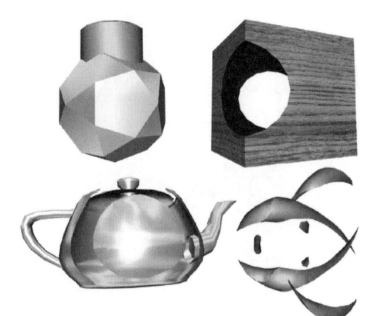

Compound objects, unlike the other object creation methods we have investigated so far, cannot be created from nothing (what the philosophers call "*ex nihilo*"). Instead, you must already have object elements in your workspace that provide the resources for Compound object creation. Take Lofts, for example, a Compound object type that we have already explored in detail. The Lofting process requires pre-drawn Shape and Path content in order to carry out its alchemical task. Compound objects are located in Create>Geometry>Compond Objects. They include Morph, Conform, Shape Merge, Terrain, Scatter, Connect, Boolean, and Loft. Since we already covered Loft in great detail in the last chapter, this chapter will focus on the others. The list of options for these tools are found in Create>Geometry>Compound Objects. (See Figure 4.1.)

FIGURE *The Compound Object panel. "Boolean" is ghosted here because no 3D object is selected.*
4.1

MORPH

Morphing, the transformation of the structure of one object into another over a set time, is an animation feature in Max. As such, it is not covered directly in this book. The process of "*Snap-shotting,*" however, is an important Max feature when it comes to developing content for models and scenes. At any point in an object's animated changes, taking a Snapshot of a particular frame freezes the object at that state. For example, let's say that your selected object started its existence in Frame 1 as a cube, and was displayed fully morphed to a sphere in the last frame. That would mean that in the intervening frames, the object would be part cube and part sphere, like catching Dr. Jeckle mid-way to Mr. Hyde. Taking a Snapshot of any frame in the transition phase would create a true object of the targeted item at that point. It would be like creating another personality in the Jeckle-Hyde analogy, one that was permanently stamped with a blend of the source and some of the target personality. Because of this

attribute, the ability to take a Snapshot of an animated transition, the Compound Object>Morph selection might be a valuable modeling tool for you to consider.

You have to have two models in your workspace to create a Morph between them. They must have the same number of polygons, and must have been converted to either Mesh or Patch objects. The way this is usually done is to create one object, and then clone it (with the *Copy* option selected). The *Source* object (also called the *Seed* or *Base* object in Max) remains untouched, but the *Target* object can be reconfigured using any number of geometry modifications. It is also possible, though less common, to use two different objects, and to adjust one or the other's polygon count so that they are the same. The reason that this is less common is that in the transition from one geometric configuration to another, different objects whose polygon counts have been reduced can exhibit strange behaviors in the morphing transition.

The basic Morphing process is quite simple.

1. Create your two Mesh or Patch objects, making sure they have the same number of polygons.

2. Go to Create>Geometry>Compond Objects, and select Morph.

3. Set the time slider at the start (or wherever you want Morphing to commence), and click Pick target in the Morph panel. Select the Source object.

4. Move the time slider to the frame that the object is to completely assume the geometry of the Target, and Pick target again, this time selecting the Target geometry.

That's it. As you move the slider, you will see one object change its geometry. For our purpose, which is to create object elements rather than an animation, there is one more step.

5. Go to the frame that displays the Morphing object with a geometry that you would like to capture.

6. In the R3 Utilities panel, select Snapshot Plus from the More list. Snapshot the selected object at that frame.

Now as you move the time slider, you will discover that you have two separate objects in the same place: one is your Morphing object, and the other is the Snapshot object, which does not change geometry. Delete the Morphing object (unless you want to capture more separate Snapshots of it from other frames), and use the Snapshot object as a stable model in your scenes.

CONFORM

Conform allows you to take one object or Patch Grid (flat plane mesh) and cause it to assume the geometry of a targeted 3D object. Depending upon the geometry of the wrapping object and that of the Wrap-To object, some interesting configurations can result. Conform is useful when you need to develop clothing and hairpieces for a 3D form, as well as

experimental 3D designs. You need two objects when activating Conform: the Wrapper and the Wrap-To object. (See Figure 4.2.)

HOW TO CREATE A CONFORMED OBJECT

The steps involved in creating a Conformed object are very straightforward, and feel intuitive after just a little practice. Do the following:

1. Place two objects on the screen. One can be a flat Patch Grid if you prefer to wrap it to a 3D form.

2. Select the Wrapper, and go to Create>Geometry>Compond Objects>Conform.

3. Make sure the Wrapper is in some relational distance and position relative to the Wrap-To object. They can share the same center. They should at least be in close proximity.

4. In the Conform panel, click Pick Wrap-To Object, and select the Wrap-To object in your workspace.

5. Open Modify, which should display the same Conform panel. Select the Operands Sub-Object. Now you can move or rotate your Wrapper, and watch it change shape according to the geometry of the Wrap-To object. Select Hide Wrap-To Object so you can see just the Wrapper.

6. Explore changing the Default Projection Distance and Standoff Distance, as well as the ways that the Conformation addresses the Wrap-To object, and watch the screen. When you reach an object you like, do a Snapshot to freeze it. (See Figure 4.3.)

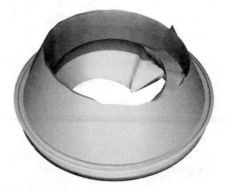

FIGURE **4.2** *The Conform panel in Create>Geometry>Compound Objects.*

FIGURE **4.3** *This Conformed object began as a Torus Wrapped-To a Sphere, and the result was then Wrapped-To a Cylinder. The rough edges can be cleaned up later.*

SHAPE MERGE

ShapeMerge is a lot like a Boolean Subtract or Union operation, the difference being that one or both operands can be Shapes. If both items are Shapes (Splines or other Shape options), then combining them into one creates all sorts of new possibilities for extrusion and lathing later on. If the item being acted upon is a 3D object, then the resulting Shape merge is best selected as a Cut (Cookie Cut). The ability to cut a 3D object with a Shape allows you to do things like cut away an object with a Text Shape. Material should always be Two-Sided when applied to a resulting 3D object, and Force Two-Sided should be checked in both the Perspective or Camera viewport and in the Rendering dialog. (See Figure 4.4.)

One possible way to use this operation for unique results is to create and Edit a Shape first. Then apply it as a Shape merge/Cookie Cut to a 3D object.

FIGURE *The Create>Geometry>Compound Objects>Shape Merge panel.*
4.4

SHAPE MERGING TWO SHAPES

Shape merging two Shapes will result in:

- One Shape placing a Segment in the area that the Shapes overlap if Merge is selected.

- One Shape deleting the area where the Shapes overlap if Cookie Cutter is selected. A new Segment will join the cut edges of the new Shape.

SHAPE MERGING A 3D OBJECT WITH A SHAPE

The angle and placement (overlap) of the Shape as it relates to the 3D object is all-important for the results. The more parallel the Shape is to the Edge lines of the 3D object, the smoother the cut. There is not much reason to use a Merge between a Shape and a 3D object, but you might find some interesting uses by doing that. Usually, Cookie Cutter is selected, allowing the Shape to slice away parts of the 3D object. (See Figure 4.5.)

SCATTER

Using Scatter, you can place any number of 3D objects in relation to a selected *Distribution Object*. This can help you place rocks and trees on a terrain, or even configure a herd of digital beasts from one selected model. First, you set the object to be Scattered, and then its Distribution Object. You can control the number of clones (always select Instanced for higher values), their size, and how they are placed on the Distribution Object. (See Figure 4.6.)

CONNECT

Connect can be compared to a form of Boolean Union, though with a third element involved. This element is called a *Bridge*, a tensioned surface that joins two selected surfaces. The selected models are joined where each evidences a hole, so the first thing you have to do is to create a hole in each, and then face the holes toward each other. The easiest way to do this is to create one object with a hole in it (make it a Mesh and delete one of its side polygons). Then Shift/Clone and mirror, so the holes face each other. (See Figures 4.7 and 4.8.)

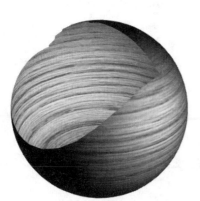

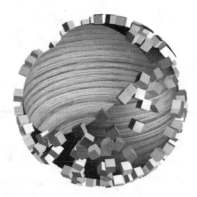

FIGURE **4.5** *In this example, a Circle was Cookie-Cut away from a GeoSphere, using the Shape Merge operation. The jagged edges can be smoothed using Vertex Editing later.*

FIGURE **4.6** *In this example, a Cube was instanced 300 times and Scattered around a Distribution Object using "Edge." The Distribution Object shown is the same Shape merge object used in Figure 4.5.*

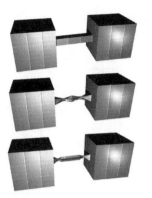

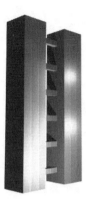

FIGURE **4.7** *These Connected Cubes show a bridge with a Tension of .5 with Segments 0 (top), Segments 1 (Middle), and Segments 2.*

FIGURE **4.8** *Stacking Connected Cubes creates a basic twin-towered skyscraper.*

BOOLEAN

This is the Compound Object option that you will likely use most of the time. Boolean operations are not meant for Shapes—use Shape Merge for that. Booleans are meant for 3D objects. Using one of the three standard Boolean operators (Union, Subtract, or Intersection), you can create unique model elements. The two targeted operands (objects) in a Boolean operation MUST intersect.

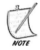

The more that the Boolean objects are subdivided, the smoother the resulting object will be after a Boolean operation. You can go overboard on this, however, by using objects that are so intensely subdivided that you crash the system because of the necessary Boolean calculations involved. Work for a happy medium.

- **Union** Objects A and B are joined, sharing the intersecting vertices and their Material maps. Although you can't break them apart with an UnGroup command as you can Grouped objects, you can access their components by selecting the Sub-Object Operators in the Modify panel. Once that is done, you can resize, position, and rotate either of the components.

- **Subtract** Object A is subtracted from B, or vice versa. This is the most called-upon Boolean operation. It allows you to chisel away at an object until its form meets your requirements. Whether cutting away holes for eye sockets or making cheekbones more prominent, Boolean Subtraction is a very necessary process.

You cannot Subtract a Group from an object with a Boolean Subtraction operation. The Grouped element will automatically UnGroup, and only the first created element in the Group will be used in the Boolean calculations. Join the Grouped members together as a Boolean Union first, translate them into a singular Mesh, and then subtract them from the targeted item.

- **Intersection** Except for the volume of intersection, the rest of objects A and B is deleted. This is probably the most under-used Boolean operation, but it can be essential for creating object elements too difficult to sculpt. It calls for you to have some 3D intuition about the resulting object to be created, by looking at the operands involved.

- Max R3 adds a Boolean refinement operation: *Cut*. Cut is used when B is subtracted from A, and allows to control the process more effectively. *Refine* adds new faces to Operand A where the slicing takes place. *Remove Inside* deletes all faces of Operand A where the slice occurs, essentially creating a hole like performing a Shape Merge. *Remove Outside* deletes all of Operand A but the intersect area, and is somewhat similar to performing a Boolean Intersection, but cleaner.

Multiple Boolean Operands

You can create Boolean constructs that have any number of separate 3D elements, but there's a rule: If you are going to create a Union between a Boolean Union object and another object, select the other object first, and go to the Boolean panel. Select the Boolean as the targeted object. There are two other ways this can work in the opposite, where the already constructed Boolean is asked to Unite with another object:

- If the Boolean object has been transformed into a singular Mesh first.

- If an intervening Modifier has been applied to it in the Modifier stack after it has been Boolean operated upon.

If this sounds too complex, don't be concerned. You'll get the hang of it by exploring the possibilities. (See Figure 4.9.)

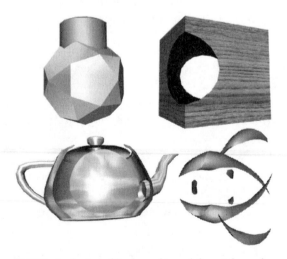

FIGURE *A selection of Boolean objects. left to right, and top to bottom: Boolean Union between a*
4.9 *Dodecahedron and an Oil Tank primitive; Cylinder subtracted from a Cube; Torus*
subtracted from a Teapot; Intersection between two Torus Knots.

The best way to understand Boolean operations is to work with them. Devote a day to nothing but creating diverse objects with Boolean operations. Make sure you use all of them with several different configurations, and save your work.

TERRAIN

I saved the details on this Compound Object for last because it is unique. Using the Terrain Compound Object, you can build Mesh objects from slices of their elevation profiles. The technique is as follows:

1. Draw a Spline Linear object in your Top viewport. Turn Smoothing on for both Initial Type and Drag Type. (See Figure 4.10.)

2. Shift-Clone the Spline twice, creating a Copy of the original. Raise each of these clones on the Z-axis so that the third one reaches the top of the Front viewport, and the second one is about halfway between the base and the top clone.

3. Reduce the size of the center clone by about 1/4, and then do the same to the top one, making the top one about 1/2 the size of the base Spline. (See Figure 4.11.)

4. Select all three slices, and go to Create>Object>Compond Object>Terrain. A "skin" will be created connecting all three slices. (See Figure 4.12.)

5. In the Terrain panel, set the Reference Elevation at 35, and click Defaults. This creates a range of connected contours. (See Figure 4.13.)

6. In the Modify panel, transform the model into an Editable Mesh. Select Tessellate from the More list, and apply it. Add a Noise Modifier that has the following settings: Scale 85, Strength XYZ of 45 each. Apply a UVW Map and texture it with any Material you like. Render the results. (See Figure 4.14.)

FIGURE **4.10** *Start by drawing a Linear Spline in the Top viewport.*

FIGURE **4.11** *Create a stack of three similar Spline slices, reducing the size of each of the two Clones.*

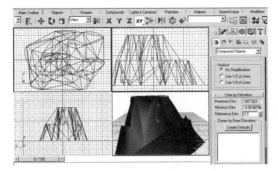

FIGURE
4.12
A skin joins all three Spline slices, or "contours."

FIGURE
4.13
A gradient tells you that the Terrain contours are activated.

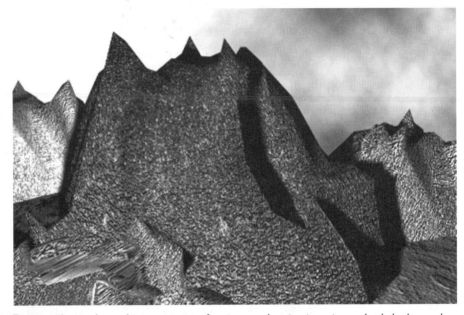

FIGURE
4.14
Cloning the resulting mountain a few times, and setting it against a cloudy background, results in this brooding scene.

A FINAL PROJECT

It's time again for you to take all of the tools and processes covered in this chapter, and create something from your understanding of their use. This time, however, you are given permission to use all of the 3D modeling options covered in all previous chapters, along with the items detailed in this chapter. That gives you a wide canvas for expression. You don't have to create another robotic character if you'd rather not, but whatever you do, spend some time

exploring the variety and power of the Max creative options detailed so far. One possible outcome is displayed in Figure 4.15.

FIGURE *Here's one project that was created by using Boolean and Lofting Composite Object*
4.15 *elements.*

Details of Figure 4.15

The model developed for Figure 4.15 makes use of extensive Boolean Unions and Subtractions. Other components were attached by both Linking and Grouping. The "hair" was created by generating one extruded Helix. Then a selected top portion of the model's scalp was Sub-selected, and duplicated. This acted as a surface to Scatter the Helix on. This section was then made invisible in the Scatter Rollout. Spheres were used throughout the model for developing the overall sculpted look, although the appendages were created by lathing first, wide spheres Boolean Unioned to the lathes later. The sharp teeth were created by using primitive cones. A row of teeth was joined as a Group, and then Linked to the head from inside the mouth. The lips were created from a Lofted sphere, and Size Deformed in the Rollout. Several textures were created and explored until one was found that had the appropriate look. All appendages are linked, making the model fully poseable.

MOVING ON

By this time, you should have accumulated a wealth of experience concerning the development of 3D models in Max. This chapter guided you through the ways to create Compound Objects from a wealth of combined elements. In the next chapter, we'll deal with Patches, and introduce you to NURBS.

Patching Reality

WHAT IS THIS CHAPTER ABOUT?

This chapter focuses on NURBS (Non Uniform Rational B-Spline) Surfaces and Patch Grids. No 3D artist feels ambivalent when it comes to NURBS. NURBS use either is applauded loudly or is the target of dissatisfaction because of its complexities. That's because NURBS modeling is quite a bit different from polygonal modeling, calling for new skills and a different way of thinking. In large measure, however, if you already have a good grip on working with Splines in general (see Chapters 2, 3, and 4), you should be ready to tackle NURBS. NURBS are used to create curved flowing surfaces, just the right components for modeling creatures of all sorts.

Although R3.x boasts more extensive NURBS modeling tools than any previous version of Max, many 3D artists who prefer to model with NURBS gravitate toward Rhino 3D, an application that concentrates on NURBS and nothing but. There is also a plug-in available on the Rhino site that allows you to work with Rhino to develop a NURBS model, and then translate it for export to Max (www.rhino3d.com).

This chapter is by no means a complete resource on modeling with NURBS in Max. Rather, it is a reference concerning some of the techniques and implications of NURBS modeling, and what specific tools and processes are provided for that purpose in Max.

Other applications may handle NURBS differently than Max does, especially when it comes to specific terminology and the tool options involved.

If you are new to NURBS modeling, this chapter will allow you to get started and, with diligent practice, to reach a comfortable level of creative use. Beyond that, you will have to devote months of disciplined exploration, researching everything about the topic that you can, as well as reach out to experienced NURBS modelers. The three core target areas we will dwell on here are Primitive-to-NURBS models, NURBS Surfaces (Create>Geometry> NURBS Surfaces), and NURBS Curves (Create>Shapes>NURBS Curves). We'll also look at the options in the Modify Rollout for NURBS, and how to use them.

PRIMITIVE TO NURBS TRANSFORMATIONS

Having already covered the use of the Primitive models available to you in Chapter 1, your question might be *"why would I want to transform a Primitive 3D form into NURBS?"* Fair question. The reason is not obvious at first, until you get to the point where you want to push and pull the original form to create a modified surface. The initial action itself is quite simple:

1. Go to Create>Geometry>Standard Primitives, and create a sphere in the Top viewport.

2. With the sphere selected, go to the Modify Rollout.

3. Click the Edit Stack button, and select NURBS.

That's it. The primitive sphere is now a NURBS model. It no longer exhibits polygons, but just a few confining splines. (See Figure 5.1.)

If you were to select individual polygons from the model on the left in Figure 5.1, and pull them away from the sphere, you can intuit that the result would be blocky-looking extended surfaces. This is because polygons are inherently blocky. But what would happen if you pulled on the vertex points of the NURBS form on the right? Let's give it a try, and create an apple in the process:

1. Transform a primitive sphere into a NURBS model as discussed previously.

2. With the NURBS form selected, go to the Modify Rollout. Select the Surface CV Sub-Object category. Notice that the Rollout changes, and that the NURBS model now displays many Control Vertices (CVs). These points are not "on" the form, but "around" it on a control lattice. (See Figure 5.2.)

3. In the Rollout, find the area titled "Selection." There you will see five button options. Select the middle one, which is the *Column of CVs* choice.

4. Using the Move tool, draw a rectangular marquee around the CVs on the right of the NURBS control lattice. Then use the Move tool to pull the lattice upward. Do this until you form an apple-shaped form. When satisfied, turn Sub-Object off to reveal the new model. (See Figure 5.3.)

5. Under Tessellation Presets in the Rollout, click Medium. This causes the Mesh we will create to adhere to the NURBS surface with some smoothness. The Low setting would look too blocky in the conversion, and the High setting would create too many polygons (though it would follow the NURBS surface more closely).

FIGURE **5.1** *The original primitive sphere is on the left, and the transformed NURBS sphere is on the right.*

FIGURE **5.2** *CV points appear around the NURBS form, and the Rollout changes to reveal new controls.*

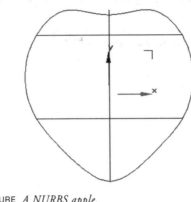
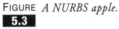

FIGURE *A NURBS apple.*

5.3

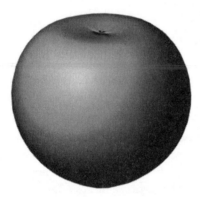
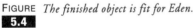

FIGURE *The finished object is fit for Eden.*

5.4

FIGURE *Grouped in a Boolean bowl with lofted stems*
5.5 *and extruded leaves, we're ready for a light*
lunch.

6. Now go to the Edit Stack options, and select Editable Mesh. The apple is now a Mesh object. Add a Material colored bright red in the Diffuse channel. (See Figures 5.4 and 5.5.)

Take this single example of how starting with a basic Primitive, translating to NURBS, and modeling can lead to more complex objects, and extrapolate it in your explorations of other primitive-to-NURBS transformations.

NURBS SURFACES

NURBS Surfaces are activated by going to Create>Geometry>NURBS Surfaces. There are two options: Point Surface and CV Surface. NURBS Point Surfaces are controlled and mod-

ified by points that lie on the NURBS Surface itself. NURBS CV Surfaces are controlled by points that exist on a control lattice around the actual surface. The quantity of initial points on both the Length and Width axes for Point Surfaces, and the quantity of initial points for both the Length and Width CVs on a CD Surface, are set and augmented in the Create Roll-out, leaving Modify panel options for other tasks. (See Figure 5.6.)

Points can be set initially, but altering them while the initial grid is drawn will add or subtract them as the Length/Width parameters are modified. (See Figure 5.7.)

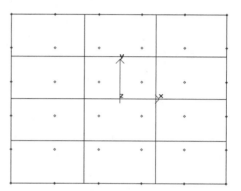

FIGURE **5.6** *The initial Point and CV Surface parameters that govern the quantity of control points are set in the Create>Geometry>NURBS Surfaces panel Rollouts.*

FIGURE **5.7** *A Point Surface with 6 Width and 6 Length points specified. Note that the points are spread evenly, and do not reference the grid crossings.*

AUTOGRID OPTION

You can check AutoGrid on before creating either a NURBS Point or CV Surface. When checked, you can create a NURBS Surface that references the surface point of another object, whether it's a 3D object primitive, an imported object, or another NURBS Surface. An XYZ reference axis shows you how the NURBS Surface you are creating is referencing the target object already in the scene. This allows you to follow up by using Attach to connect the two objects together, building a more complex overall construct. (See Figure 5.8.)

It is important to remember that objects and/or surfaces attached to other objects or surfaces by using AutoGrid and Attach are defined as one single surface for mapping and modification purposes.

Using AutoGrid, you can create very interesting NURBS models built on any number of individual Surface elements. Here are the steps to follow:

1. Create a NURBS Point or CV Surface in a viewport of your choice, with AutoGrid off.

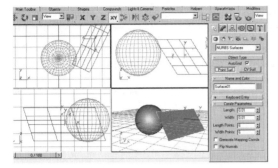

FIGURE
5.8
Here, a NURBS Point Grid was created with AutoGrid on, so that its starting point referenced a point of the sphere primitive.

FIGURE
5.9
This construct started as a series of NURBS Point Surfaces, joined together by AutoGrid and followed by Attach. They can now be treated as a single Surface.

2. Click AutoGrid on, and select a point on your present object in a viewport other than the one that shows the Surface face on. Draw a grid. It will be connected to the first Surface at a 90-degree angle.

3. Select the first Surface and go to the Modify panel. Click Attach, and select the second Surface. Both are now joined as one unit. (See Figure 5.9.)

NURBS CREATION TOOLBOX

When you create a NURBS Surface and then move to the Modify panel, the Rollout displays a small button that resembles a grid. It is located under the General heading, on the right of the Display options. This is the toggle for the NURBS Creation Toolbox. (See Figure 5.10.)

The activated toggle places the NURBS Creation Toolbox on the screen. (See Figure 5.11.)

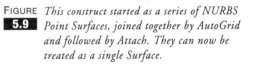

FIGURE
5.10
The toggle that activates the NURBS Creation Toolbox.

FIGURE
5.11
The NURBS Creation Toolbox.

All of the tools contained in this toolbox are dedicated to modifying the presently selected NURBS Surface. Once you understand this thoroughly, you will be well on your way to mastering the use of NURBS models in Max. This cannot be emphasized too strongly. For this reason, we are going to spend some time detailing the tools involved. The three groups of tools are Points, Curves, and Surfaces.

POINT TOOLS

The six Point tools can be found in the top row of the NURBS Creation Toolbox. (See Figure 5.12.)

The six Point tools are Create Point, Create Offset Point, Create Curve Point, create Curve-Curve Point, Create Surface Point, and Create Surface Curve Point.

FIGURE *The Six Point tools.*
5.12

- **Create Point** These are independent points. Place them anywhere in the scene, and they will still be connected to the targeted NURBS Surface. Use them to control the Surface from any place in the scene. Their main purpose, however, is to act as points on a Fit Curve, an operation we'll allude to later. This allows you to create independent points first, perhaps in reference to a model part you are building, and later to connect them with a Curve. This is the opposite way one usually works, but it can provide a needed process for specific modeling goals.

- **Create Offset Point** An Offset Point is tied to another selected point already created, on or off the NURBS Surface. It starts as coincident with the selected point, and can be Offset in any XYZ direction by adjusting the values in the Rollout. Clicking on Replace Base Point causes the new point to replace the Parent point.

- **Create Curve Point** Curve points are to be placed on an already existing curve, or relative to it (by Tangent, Offset, or Normal settings). Checking Trim Curve deletes the Curve from the Curve Point to the end. To Trim the opposite part of the curve, select Flip Trim.

"Normal" refers to a direction perpendicular to the surface.

- **Create Curve-Curve Point** Although the terminology might at first seem confusing, a Curve-Curve Point should be read as "Curve to Curve Point." This option creates a point on each of two selected independent curves, bonding them together.

- **Create Surface Point** A Surface Point can be placed anywhere on the base NURBS Surface. Later, you'll see that it can serve as one point on a newly created Curve. You can, however, use Offset, Tangent, or Normal to move it away from the surface, though it remains tied to it.

- **Create Surface Curve Point** Creates a point where a Curve intersects the Surface.

Selecting and Transforming Points

Points are selected from the Surface's Modify options in the Modify panel, with the targeted Surface selected. Switching on Sub-Object allows you to enter Point mode. The Rollout will display a number of options. (See Figure 5.13.)

FIGURE *With Sub-Object set for Points, the Modify Rollout displays the editing options.*
5.13

 You can click on any of the options in the Selection display to choose a Single Point, Row or Column of Points, Row and Column of Points, or All Points. Next, you place a marquee around the point or points you want to alter, and take whatever action is necessary. The more important editing tools include:

- **Extend** By clicking on the end point of an open Curve, Extend allows you to drag to create new segments.

- **Fuse** By clicking on one point and then a target point, you can Fuse the points together to create a new closed Curve.

- **Delete** By clicking on any point, or selecting a row or column of points, and then clicking the Delete button, the targeted points are removed and the Curve is reshaped accordingly.

- **Refine** Refine adds points to Curves, Rows of a Surface, Columns of a Surface, or Rows and Columns of a Surface. When your editing work needs to be finely detailed at a zoomed-in range, add points to allow for more detailed Surface sculpting.

If you need to modify a Curve CV, the Rollout will display somewhat different options for manipulating the CVs, but they will be similar.

A Point Modification Exercise

Do the following:

1. Go to Create>Geometry>NURBS Surfaces>Point Surface, and draw a Surface in the Top viewport. Set Length and Width points to 4 each.

2. With the Surface selected, click on the Modify tab in the Control panel, which brings up the NURBS Surface Rollout. If the NURBS Creation Toolbox does not display on the screen, click on the toggle so it is visible.

3. Go to Sub-Object>Point, and click on the Create Point icon in the NURBS Creation Toolbox. Click the mouse over the Surface object to outline any Curve you like.

4. Under the Curve listing in the NURBS Creation Toolbox, click on the Fit Curve selection (third from the left).

5. Click on each of your points in succession, so that a new Curve is drawn from point to point.

With this exercise, you've actually jumped ahead a bit to the next part on Curves, but this allows you to experience how all of the items in the NURBS Creation Toolbox are interdependent and integrated. (See Figure 5.14.)

FIGURE *The independent points are joined in a new Curve.*
5.14

The documentation does not emphasize the fact that you can create Curves in any order of points, and can even create new Curves that cross over the initial one. This allows you to create complex Curve grids of any shape for later modification.

CURVE TOOLS

There are 18 Curve tools listed under Curves in the NURBS Creation Toolbox. The Curve types are CV, Point, Fit, Transform, Blend, Offset, Mirror, Chamfer, Fillet, Surface to Surface Intersection, U Iso, V Iso, Normal Projected, Vector Projected, CV Curve on Surface, Point Curve on Surface, Surface Offset, and Edge. (See Figure 5.15.)

- **CV** This tool allows you to draw a CV Curve. It can be either on or off the Surface, or both.

- **Point** This tool enables the creation of a Point Curve, either on or off the Surface, or both.

- **Fit** We have already done an exercise based on the Fit Curve. The Fit Curve is used to connect free-standing points.

- **Transform** Use a Transform Curve to clone any Curve already placed in relation to the Surface. Transform can be used to create a clone that will become a separate "cap" of a 3D object. Just connect the source and target Curves, after moving the Transformed Curve a perpendicular distance from the source Curve.

- **Blend** The NURBS Blend tool creates a Spline bridge between selected Curves. The Curves can be clones or totally dissimilar.

- **Offset** The Offset Curve resembles the Size Transform operation. Using it on an existing Curve clones the source Curve and resizes it at the same time, yet the new Curve remains on the same Surface plane as the source Curve. Offset can be used on both open and closed Curves.

- **Mirror** Using this tool, you can instantly create a cloned Curve that mirrors the source Curve on any selected axis. Mirroring, whether applied to Splined or 3D mesh objects, is often used to create the symmetrical other half of a construct.

FIGURE *Icons for the 18 Curve types in the NURBS Creation Toolbox.*
5.15

- **Chamfer** This tool is used to create a straight line (Curve) between two separate points on separate Curves. The Curves must be coplanar.

- **Fillet** The Fillet tool is used to create a rounded Curve between two Parent curves that are coplanar. The connecting points on either Parent Curve can be moved and trimmed. Although the Parents remain separate unless Joined, moving either Parent Curve stretches the Fillet Curve.

- **Surface to Surface Intersection** This is a wonderful tool, but the documentation is muddled as to its use. To save you from pulling your hair out, the secret is to create one NURBS Surface in the Create phase, and another intersecting Surface when you are in the Modify phase. Then you can apply this tool and Trim either or both Surfaces according to the Curve that represents their Intersection. This is very useful when building complex NURBS models.

- **U Iso / V Iso** U Iso Curves are the Longitudinal lines on a NURBS sphere or other NURBS Surface. V Iso Curves are the latitudinal lines. When used on a NURBS sphere, these tools allow you to trim slices of the form away. When seen on a NURBS Surface that has been created in the Front viewport, the U Iso Curves (lines) run horizontally, and the V Iso Curves (lines) run vertically. Use these tools to Trim selected NURBS Surfaces.

- **Normal Projected** You will find this tool to be one of the most useful in creating complex modeling elements from NURBS. Using this tool, you can select a Curve as a cutter to trim a selected NURBS Surface. Just select the Curve, and then the Surface to which it applies. You can cut the Curve from the Surface, or vice versa. (See Figure 5.16.)

- **Vector Projected** Use as an alternative when trimming a Surface. If the target Surface is a 3D NURBS object, you may have to rotate it to see the results. (See Figure 5.17.)

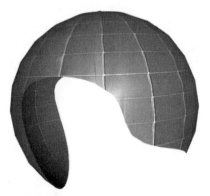

FIGURE **5.16** *Normal Projected Curves can slice a hole in a Surface, or the process can be inverted to cut away the rest of the Surface.*

FIGURE **5.17** *A NURBS sphere transformed to a Mesh, showing the results of a Vector Projected Curve Trim.*

- **CV Curve on Surface / Point Curve on Surface** This tools allows you to create a CV or Point Curves that can only be developed on the NURBS Surface. If the Curve is a CV Curve, and you select Sub Object>CV, you can use the Move tool to spin it around a 3D NURBS object (like a Primitive sphere transformed into a NURBS sphere).

- **Surface Offset** The Surface Offset Curve tool allows you to clone a Curve already on the Surface, and offset its position in 3D space by any selected distance.

- **Edge** This NURBS Curve tool does wonders to cut away sections of a 3D NURBS object. You select the required Edges that will be removed or just moved, and that's it. Explore its use with a primitive sphere that has first been translated to a Patch and then to NURBS. (See Figure 5.18.)

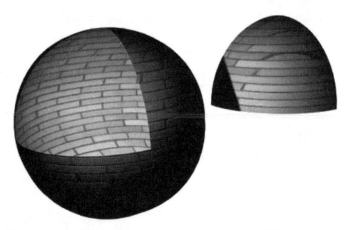

FIGURE *Using the Edge Curve tool, a section was trimmed from a NURBS sphere and moved away*
5.18 *from it.*

When you want to create a Curve that will later serve as an extrusion or lathing spline, and plan to get rid of the initial NURBS Surface, create the Surface very small and distant from where the Curve is created. That way, after translation to a Mesh, you can easily select the initial Surface elements and delete them. Just make sure not to create Point or CV Curves on the Surface itself.

TIP

Now we'll move on to the Surface options in the NURBS Creative Tools panel. But first . . . a news flash!

Hot Tip !!! *When you translate a Primitive 3D object into a NURBS object, Max translates it from a Mesh to NURBS. This gives you somewhat limited Surface points. If you want more points, try this: Translate it to a Patch object first, and then to NURBS. This will give you more interesting points to explore. It works especially well on a primitive sphere.*

TIP

NURBS SURFACE TOOLS

Points are used to configure Curves, and Curves are the basic element from which Surfaces are created. As the traditional geometers say ..., "point to line to plane." There are 17 Surface options in the NURBS Creation Toolbox: CV, Point, Transform, Blend, Offset, Mirror, Extrude, Lathed, Ruled, Cap, U Loft, UV Loft, 1-Rail Sweep, 2-Rail Sweep, Multisided Blend, Multicurve Trimmed, and Fillet. Each plays a part in fostering the creation of complex 3D NURBS objects.

- **CV and Point** A CV or Point Surface can be created at any angle, and is automatically connected to the initial Surface (whether CV or Point type). This is especially useful for creating Intersection Curves and Trims, as detailed earlier.

- **Transform** This is a clone of a targeted Surface that can be scaled, rotated, and resized. It compares to the Shift-Transform Cloning operation, except that holding down the Shift key is unnecessary.

- **Blend** Blend attempts to create a smooth Surface that blends two selected Surfaces (or a Surface and a Curve) together. This creates objects with more 3D depth, and more complex as well. For example, Blend two rectangular Surfaces that are spaced apart to create a book cover whose spine is automatically rounded.

- **Offset** An Offset Surface is a clone of a selected Surface, created by referencing the original Surface's Normals. Once created, all parameters can be adjusted to make it unique.

- **Mirror** Mirrored Surfaces are extremely useful, even vital, when creating NURBS models that evidence axis symmetry. This could be the appendages of a creature, a face, a football, or the wings of an aircraft. You can alter the axis of symmetry after the Mirrored Surface is created. (See Figure 5.19.)

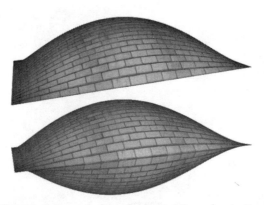

FIGURE *Before and after a Surface is Mirrored on its Z-*
5.19 *axis.*

- **Extrude** NURBS Surface extrusion is the same as NURBS Curve extrusion, which we have already detailed. The tool works on any selected Curve related to the Surface. Once extruded, you can alter the direction by clicking an axis button. If the selected Curve is closed, you can select Cap and enclose it. (See Figure 5.20.)

- **Lathe** Any selected Curve, open or closed, related to a NURBS Surface can be lathed. You do not have access to the same Lathing parameters as you do when lathing a Spline. For instance, lathing is set to 360 degrees and no slicing. By selecting Sub-Object Curve however, after the lathing is complete, you can resize, rotate, and move the original Lathed section to create a number of different objects from the same Lathing operation. (See Figure 5.21.)

- **Ruled** Ruled Surfaces are created by referencing two Surface Curves already present. A Surface is generated between them, using them as edge reference. This is a great way to create soft-folded material, like blankets, as well as terrain elements.

- **Cap** Capping is the process that adds a Cap on the open end of an extruded Surface, and it is called for often. Clicking on an open NURBS extruded surface (as long as the Curve used to create it was a closed Curve) adds the necessary Surface Cap.

- **U Loft** What this tool provides, along with the UV Lofting tool, is the most elegant Lofting operation in Max. You don't have to select a Path and a Shape. Instead, you just create the Shapes (Point or CV Curves), and with the U Loft tool active, select the Shapes and watch as they are automatically lofted to create an object. Since this process does require Point or CV Curves, it was a toss-up whether to cover this here or in the section on NURBS Curves that follows. I selected this place, figuring that we can always refer back to it later. Besides, U Loft and UV Loft are Surface tools that are found in the NURBS Creation Toolbox.

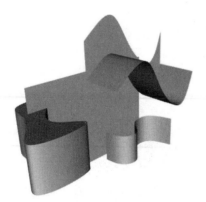

FIGURE **5.20** *A selection of Extruded Curves, all referencing the same initial NURBS Surface (the rectangle).*

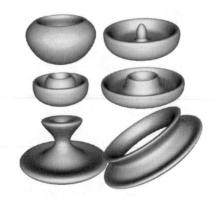

FIGURE **5.21** *By simply transforming the original lathing Curve, diverse objects can be created, as shown here.*

Be sure to explore the use of both CV and Point Curves in the creation of your U Loft, since even with similar Curves, they create different results. Also explore different selection orders for your Curve sections. You can select the shapes in any order, although this will affect what your model looks like. Be aware that using Curves with different numbers of Points or CVs can produce unexpected results . . . but explore this anyway. Always add non-coplanar space between your U Loft Curve sections. (See Figure 5.22.)

If you transform the Lofted models into Meshes after creating the forms you want, you should run the Optimize option (found in the Modifier list) on them a couple of times. Otherwise, you'll see that the Mesh will have far too many polygons.

CAUTION

- **UV Loft** UV Lofts allow you to create Surfaces from two sets of Curves. I find this tool far less intuitive to work with than U Loft, though it's worth exploring. To sculpt a form in two directions, I prefer to use the Deformation options with Lofted Splines.

- **1-Rail Sweep** A 1-Rail Sweep Surface is constructed from a Sweep Path and two cross-section Curves. You have to spend some time working with this tool to get a feel of what will result before it's actually rendered. This process creates interesting mechanical elements for machines, robots, and logo elements. (See Figure 5.23.)

- **2-Rail Sweep** A 2-Rail Sweep Surface is built from two Paths and two or more cross-section NURBS Curves. The result is always surprising, and can resemble gently curving modern sculpture. (See Figure 5.24.)

- **Multisided Blend** This tool creates Surfaces that are composed of three or four open or closed NURBS Curves that enclose an area. Use is not intuitive, and neither are the results.

- **Multicurve Trimmed** Using a series of Curves that have been joined into a loop, this

FIGURE
5.22 *Non-coplanar space should be added between your U Loft sections.*

FIGURE
5.23 *This rather bizarre object was created as a 1-Rail Sweep Surface. The path is a Circle, and the two ends are Spline Stars transformed to NURBS.*

tool trims targeted Surfaces much like the Normal and Vector Projected Curves already discussed.

- **Fillet** A Fillet Surface adds a smooth transition from one Surface to another. Use is by selecting the tool, and clicking on one Surface and then the next. (See Figure 5.25.)

FIGURE **5.24** *Four 2-Rail Sweep Surfaces are placed in a group around a common center in this construct.*

FIGURE **5.25** *A Fillet Surface is added to bridge a plane and a sphere.*

Sub-Object Editing

Once you have created a Surface with the NURBS Creation tools, your modeling can be further customized. By selecting CVs, Points, or Curves, you can pull and stretch the NURBS construct until it exhibits a form associated with an organic element, perhaps part of a creature.

When you create a Curve related to a Surface and use Sub-Object Surface, and move the cursor until the original Surface turns red, you can delete the Surface with the Delete key and have just the Curve left to transform as you like.

IMPORTING AND TRANSFORMING MAX OBJECTS TO NURBS

If you have a model previously created by using Mesh elements, or if you import a Mesh model from another source, you can transform any or all of its parts into NURBS. One thing you will notice immediately is that the transformed elements will tend to become more spherical and smoother, since the transformed parts are now CV Surfaces. This opens the model up to CV modifications, giving you different levels of creative freedom than Mesh modeling can provide. Compare the top and bottom models in Figure 5.26.

Clicking on the Torso, and then going to the Modify panel, after all elements have been translated to NURBS, is interesting. With Sub Object>Surfaces selected, what looks like a

FIGURE **5.26** *At the top is a model whose elements have been translated to NURBS from their original Mesh counterparts pictured below.*

FIGURE **5.27** *After selecting some of the Surfaces of the torso, they have been deleted, altering the character.*

unified geometric form, the torso, reveals itself as a group of connected NURBS Surfaces. Selecting them separately, they can be modified or deleted, creating new form possibilities. That's because the torso was created with a geometry other than a primitive sphere like the other parts, and the only way Max can translate the form is to break it up into a group of singular surfaces. Some of the front panels of the torso can be removed by selecting them as Sub-Object Surfaces, and hitting the Delete key. (See Figure 5.27.)

Using Sub-Object>CV Curve modifications on the rest of the elements, and pulling out selected vertices, creates a smoother, more organic construct. (See Figure 5.28.)

Explore any of the Mesh models that come with Max, or your own saved models. Translate them to NURBS and explore their modification.

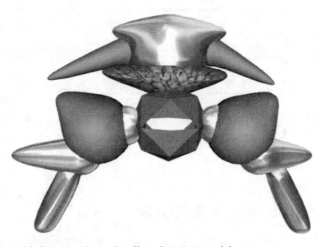

FIGURE **5.28** *The remodeled GeoBot shows the effect of NURBS modifications.*

NURBS CURVES

Under Create>Shapes>NURBS Curves, there are two selections: Point Curves and CV Curves. These are the same basic Curves we looked at extensively earlier in this chapter, when we covered the material referencing the NURBS Creation Toolbox. However, there is one important difference when you create Curves in the Create>Shapes panel: You can switch on *Draw In All Viewports*. That extra possibility allows you to prepare a very different Curve for use with the NURBS Creation Toolbox later in the modification process.

We have already touched on this capability a bit when we discussed Lofts in an earlier chapter. Now we'll look at this capability in reference to NURBS Creation Toolbox uses. To recap, Draw In All Viewports allows you to jump to any viewport as needed to continue the creation of a NURBS Curve. That means the Curve can take on a true 3D personality. Try it. Select the CV Curve and begin to draw in any viewport. At any time, jump to another viewport. When the 3D Curve is done, click the RMB. (See Figure 5.29.)

From this point, it's up to you. In the Modify panel, with the Curve selected, click on the Surface Extrude option in the Surfaces section of the NURBS Creation Toolbox. First Extrude the Curve in the Front viewport, and then in the Left viewport. You have created a 3D ribbon in 3D space. Use the Surface Lathe tool on it to see what the resulting object looks like. Use other Surfacing tools to see what happens. You'll be surprised to find how many delicate and convoluted 3D forms can be created in this manner.

FIGURE *If you keep your eye on the Perspective viewport as you draw,*
5.29 *you'll get a better sense of the 3D nature of your NURBS Curve.*

PATCH GRIDS AND OBJECTS

Whether you select Create>Geometry>Patch Grids and use the Quad-Patch or Tri-Patch Surfaces, or start with a Mesh or Editable Mesh object and translate it to a Editable Patch, you will wind up with a Patch Surface. Think of a Patch as similar to a bicycle patch: a sur-

face used to attach to another surface to make it complete. That's really what Patches are for, to be shaped into segments of models that are finally all glued together to form a finished 3D form. When translating back and forth, however, there are a few things to be aware of:

- Primitives can be transformed directly to Editable Patches in the Modify panel by selecting the Edit Stack list.

- If you translate a primitive to a Editable Mesh and then to an Editable Patch, it will have far more polygons than if you go directly to an Editable Patch.

- If you translate to NURBS, you cannot translate to an Editable Patch after that. Once transformed into a NURBS object, you must translate into a Editable Mesh and then an Editable Patch.

- Patch objects have their own list of customizing and reshaping tools in the Modify panel.

MODIFYING EDITABLE PATCHES

Patches work best when they have triangular faces. If you have created a quadrangular Patch Grid, it's best to use Modify>More>Tesselation on it before editing. The very best primitive object to use to create Patch objects is definitely the Geosphere (Create>Geometry>Geosphere). This is because it already has triangular faces, so transforming it to an Editable Patch is a snap with no surprises (and no needed Tessellation either). Using the Geosphere, you can explore the two most useful modeling tools in the Editable Patch Modification panel: Extrude and Bevel. Do this:

1. Create>Geometry>Geosphere, and create it using the Top viewport.

2. Modify>Edit Stack>Editable Patch, with Segments set to 3, and Smoothing checked.

3. Select the Patch Sub-Object in the Modify Panel. (See Figure 5.30.)

4. Click inside of one of the triangular Patches in the Front viewport with the Select and Move tool. The edges turn red.

5. Under Extrude and Bevel, click Extrude. It turns yellow. Now drag on the red Patch with the Select and Move tool, and you'll see that you are controlling the Patch's extrusion away from the Geosphere. You can also input extrusion values, positive and negative, in the Extrusion input box, and hit Return. (See Figure 5.31.)

Explore the Bevel tool in the same way, selecting either one or a group of face patches at the same time. Extrude and Bevel are the two main Patch modeling processes. Take a little time to create a unique model from a Geosphere using these methods. (See Figure 5.32.)

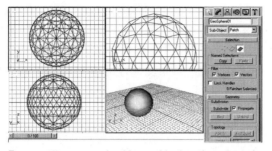

FIGURE *Your screen should resemble this after selecting*
5.30 *the Patch Sub-Object in the Modify panel.*

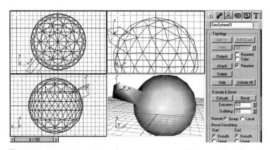

FIGURE *You can Extrude one Face Patch at a time by*
5.31 *using this method.*

FIGURE *Patches are great for creating sculpted stone*
5.32 *items.*

THE NURBOT

OK. It's that time again. So that you can compare models of a similar type, take some time to develop a robot model, with the following rule in mind: It should be composed for the most part of NURBS elements. You can use some extruded and beveled parts if you like. Use whatever design comes to mind. Link the parts so you can pose the figure. The author's answer to this challenge is displayed in Figure 5.33.

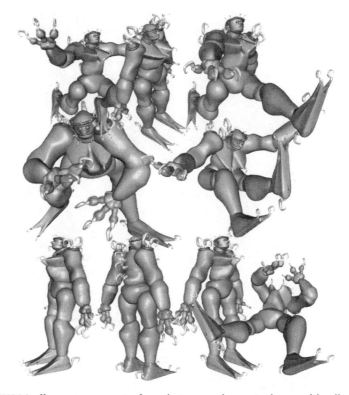

FIGURE *NURBS offer great opportunity for sculpting smooth organic elements, like all of the body*
5.33 *parts in this image.*

Creating Heads with NURBS

Every designer has her or his own secrets when it comes to the task of designing a creature's head with NURBS. The steps I generally follow are these:

1. Start with a Primitive Sphere (some designers prefer a Cylinder) drawn in the Top viewport. It would be nice to start with an Extended Object>Capsule, but Extended Objects do not translate directly to NURBS. There are a number of convoluted steps to get them there . . . too many. In the Sphere's Create panel, click on Slice, and set the values from –90 to –270. This creates a half Cylinder as seen in the Top view, which will be the right side of the head. This allows you to create half of a head and Clone-Flip the other half later.

2. Translate the hemisphere to NURBS. Consider turning the Grid off so you can see the CVs better.

Continues

Creating Heads with NURBS *(Continued)*

3. Work in Single CV mode to shape the head. Make sure that the flat surface that delineates the split Sphere remains flat.

4. Elongate the back of the head by pulling on a row of CVs, and flatten the front.

5. Use either or both Refine and Insert to add Rows and/or Columns of CVs to the areas of the model that will need the most work; typically, the lips and nose.

6. To make sure the CVs you select are the ones you want, without mistakenly moving CVs that should remain in place, use Alt Selection marquees to deselect unwanted CVs in the proper viewport. Always check the Perspective viewport for a glimpse of what the 3D construct looks like, and UNDO when you need to.

7. When half of the head is complete, Shift-Clone, and Mirror it to the other half. Turn off Sub-Object, make sure that both halves are as exactly matched up as possible (usually in the Top viewport), and then glue the halves together with the Attach command. If you have a seam running down the middle, you may have to use the Fuse operation to fuse the points.

8. Save your basic NURBS head to disk, so that you can tweak it later to create different characters.

MOVING ON

In this chapter, we took a journey of discovery into the world of NURBS and Patch modeling. The next chapter is the first in a new section on Max Plug-Ins.

Plug-Ins Bazaar

CHAPTER
6
Surf's Up!

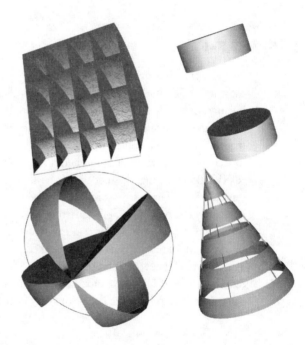

This chapter begins Section B of the book; four chapters devoted to commercially available plug-ins for Max. "Commercially available" means that you have to pay for the plug-ins and get them authorized for Max by registering them. The chapters are "Surf's Up!" "Digimation Nation," "Sisyphus Succeeds," and "The Nature of Things." Each chapter targets the plug-ins of different developers.

The number of plug-ins available for Max keeps increasing as new developers jump on board, and experienced developers upgrade their previous offerings. Software that accepts plug-ins from external developers is said to be *extensible*, and Max is one of the most extensible 3D environments you will ever run across. This first chapter focuses on a plug-in called *Surf-iT* from Ghost3D (www.ghost3d.com).

WHAT IS SURF-IT?

Surf-iT contains a number of modular and parametric components that are primarily located in the 3D Studio MAX Create and Modifier panels. Even though we won't be detailing most of the Modifier components until Section F of this book (*Twisted Reality*), we have to talk about the Surf-iT Modifiers in this chapter in order to describe Surf-iT's modeling magic. Surf-iT is a complete Max modeling kit, and provides fast and extremely diverse 3D modeling using parametric Spline and surface construction tools. Though somewhat similar to NURBS modeling, the modeling is far more flexible and intuitive. The basis for understanding Surf-iT is to have some experience with Max Spline modeling, a topic we covered previously in Chapter 2, "Splinediferous." Surf-iT gives you tools for creating models based on Surf-iT proprietary *S-Objects* (Surf-iT Spline objects) and Editable Splines. By tapping into your Max knowledge of drawing and editing Splines in 3D space, you can quickly and easily create all types of 3D models with Surf-iT. This chapter assumes that you have a registered copy of Surf-iT loaded into Max R3 in order to do any of these tutorials, or that you are just browsing the chapter to decide upon a future Surf-iT purchase.

THE BASIC COMPONENTS

The Surf-iT components are located in two places, one for creating forms and the other for editing them.

CREATING SURF-IT FORMS

Create>Shapes>Surf-iT (Ghost 3D) contains the initial 3D Splined forms to be placed in your workspace. There are S-Grid, S-Sphere, S-Cylinder, S-Box, and S-Cone. Take a few moments to place each of these Surf-iT primitives in your scene to get a feel for the shapes. (See Figure 6.1.)

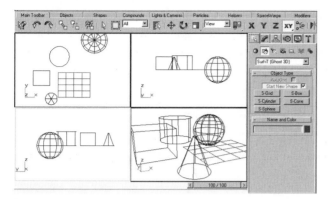

FIGURE **6.1** *The Surf-iT forms can be found in the Create>Shapes Rollout.*

FIGURE **6.2** *All of the Surf-iT forms are renderable.*

 All of the Surf-iT forms are renderable. Just open the General Rollout, select Renderable, and set the size. (See Figure 6.2.)

NOTE

EDITING SURF-IT FORMS

When a Surf-iT form has been created and is selected, the Modify panel contains all of the necessary Surf-iT editing options. These can be found by clicking the More button, and selecting them from the list. They include:

Spline Editor

The Spline Editor is configured as you might expect, with separate Sub-Object options available for Vertex, Segment, and Spline editing. The Surf-iT Spline Editor has many tools that will be familiar to users who have experience using Max's Edit Spline Modifier on standard Splines, but Surf-iT's Spline Editor has been optimized to work with Surf-iT forms.

Vertex Editing

When it comes to Vertex editing with the Spline Editor, here are some important things to keep in mind:

- Each Vertex responds to an RMB click exactly as you are accustomed to, by allowing you to change the Vertex Type (Smooth, Corner, Bezier, and Bezier Corner). This gives you immediate control over the editing of the basic 3D form.

- Control-Click on any selected Vertices, and then select Fuse to attach them together at a central Vertex.

- Snapping and Welding are excellent options for quickly reshaping a 3D form. Once they are activated, a tolerance is set, and a marquee is drawn around the Vertices you

want to Snap or Weld. With some exploration, Snap and Weld can be used to create the global dimensions of your models from S-Objects.

Do the following to explore Snap and Weld:

1. Create a Surf-iT Cone with a truncated top. (See Figure 6.3.)
2. Set Snap and Weld to 1000. Select all of the Vertices on the top of the Cone, and click on Weld. Vertex pairs will be welded.
3. With all of the pairs selected, RMB click on any one and make it a Corner type. All of the pairs will now be Corner types. (See Figure 6.4.)
4. With all of the pairs still connected, click Snap. The first selected pairs Snap to the last pair. (See Figure 6.5.)
5. Click on Weld again, which glues all of the Vertices together. The new apex Vertex is now one. Move the Vertex so that it centers on the base of the Cone (X-axis). Now make all of the vertices that connect the apex with the base Corners, which straightens out the side segments. You have remodeled a truncated Cone into a standard Cone in a few easy steps. (See Figure 6.6.)

Segment Editing

When editing Segments with the Spline Editor, here are some important things to keep in mind:

- Each Segment responds to an RMB click by allowing you to change its default Curve type into a straight Line This gives you immediate control over the editing of the basic 3D form via Segments, allowing you to instantly flatten out a curved section.

Figure **6.3** *A truncated Surf-iT Cone as seen in the Perspective viewport.*

Figure **6.4** *The Vertex pairs are welded.*

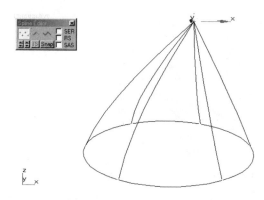

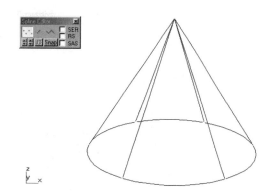

FIGURE
6.5
Snap moves the first selected pairs to the last pair's position.

FIGURE
6.6
The Cone is no longer truncated, but normalized.

- Use Divide with one or more Segments selected to add Vertices. The number will be determined by the Spinner. When more Vertices are present, the Segment can be shaped into a wider variety of curved or straight sections.

- Extrude closed Segment parts of the form in either a positive or a negative direction. Extruded Segments automatically close caps when transformed to Meshes or Patches.

Do the following to explore Surf-iT Segment Extrusion by creating a gear:

1. Place a default Surf-iT Cylinder on the screen, creating its base in the Top viewport. Size it so that its height is about half of its diameter.

2. Go to Modify>Spline Editor, and select Segment as the Sub-Object.

3. By default, the Cylinder has six closed-loop sides, each made up of four Segments. Select each closed-loop Segment boundary in turn, using Control-Clicks. As each closed side is selected, go to the Extrude option. Extrude 35 units inward, and Extrude again 70 units outward. Use the Spinner to set these values. Do this for each of the six sides, and you will create the form shown in Figure 6.7, as seen in the Top viewport.

4. Click off the Sub-Object option, and select Surf-iT Patch from the Modify>More list. Your hexagonal gear is complete. You should UVW Map it, and can then use any Material on it. (See Figure 6.8.)

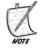
NOTE

You can also transform it into a Surf-iT Mesh, but all of the rounded surfaces will be squared off.

Spline Editing

The third Sub-Object possibility is *Spline* in Modify>Spline Editor. When editing Splines with the Spline Editor, here are some important things to keep in mind:

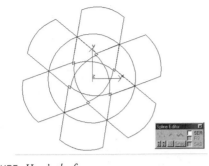

FIGURE
6.7 *Here's the form.*

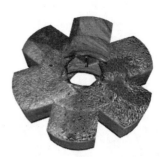

FIGURE
6.8 *The finished Surf-iT Patch hexagonal gear. I have mapped it with one of my favorite Materials from the Metals library (UVW Cylindrical with Caps): Metal Rust.*

- Use *Outline* to make a copy of any selected Spline, and use the accompanying Spinner to set the offset diastase in Max units. The cloned Splines can then become attached extensions of the present S-Object, or separate objects on their own. (See Figure 6.10.)

- Use Boolean Union, Subtraction, or Intersection to create new Splines from any two overlapping Splines on the same plane. This is a fast way to create a new form from a Surf-iT primitive. You can use Mirroring to flip any selected Spline horizontally, vertically, or both.

- Change Spline Curves to Lines to create variable object forms. (See Figure 6.11.)

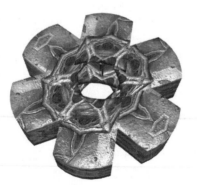

FIGURE
6.9 *The same material has been used here for the Diffusion channel, but my own tiled image was used for a Bump map. Infinite variations are possible. This looks like a brass artifact from some earlier age.*

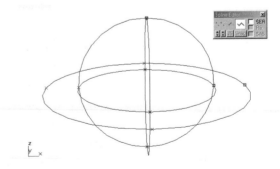
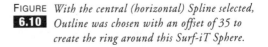

FIGURE
6.10 *With the central (horizontal) Spline selected, Outline was chosen with an offset of 35 to create the ring around this Surf-iT Sphere.*

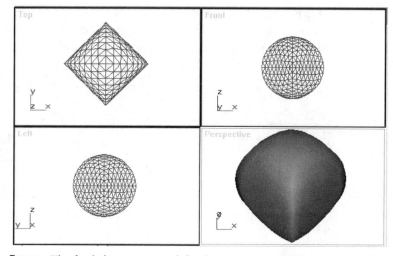

FIGURE *This final object was created by altering the central Spline on a Sphere from Curve to*
6.11 *Line in the Spline Editor, before transforming a Surf-iT Sphere to a Surf-iT Patch. Note*
that it is a rectangle cross-section in the Top viewport, and a circle in the Front and Side
viewports, creating an object that resembles a child's spinning top.

Connect-iT

The Connect-iT Modifier, as its name implies, is used to connect elements of a Surf-iT object. It connects selected Splines by bridging them together with Segments. Connect-iT is best used to connect Cloned Splines that are parallel, allowing you to build extruded "walls" that enclose the shapes. You can use it on any Max open or closed Spline, or on selective Splines taken from a Surf-iT S-Object. The best way to do this is as follows:

1. Create a standard Spline object from Create>Shapes>Splines, or create a Surf-iT object from Create>Shapes>Surf-iT.

2. Go to Modify>Spline Editor, and with the Spline Sub-Object selected, Shift-Move a Spline so that the clone is some vertical (Y-axis) distance from the original. If this is a Surf-iT object, consider deleting the nonselected parts of the object.

3. Close Sub-Object list. Click Connect-iT. Automatically, a Connecting lattice of Segments will connect the vertices of one Spline with the other. If you use Surf-iT Mesh or Patch at this point, you will create a 3D surface with no thickness.

4. Consider the following to augment the new object:

- Before you go to the Sub-Object>Spline option in Connect-iT, use a value of more than 1 in the Spinner next to U-Splines, with U-Splines checked. As you raise this value, you will be adding new cloned cross-sections to the new object lattice. This makes for more refined editing possibilities later on.

- Click on Source Splines, and select one of the three options: Knots per Segment, Knot Spacing, or Knots per Spline. Any value other than the defaults will add new vertical connecting Segments to the object, also beneficial for later Vertex-level editing. (See Figure 6.12.)

FIGURE **6.12** *This figure displays an original and a Shift-Moved Ellipse Spline, joined by Connect-iT Segments. U-Splines are set to 4, and Knots per Spline to 12.*

Segment-iT

Segment-iT is really an option you would use only if you don't plan to Segment the Splines in an object with Connect-iT. It contains the same controls for Knots per Segment, Knot Spacing, or Knots per Spline.

Surf-iT Mesh and Surf-iT Patch

Most times, you will want to use Surf-iT Patch as a final step in creating your solid objects from Surf-iT components, because the results are immediately smoother. Explore both, depending upon your needs. If you need a Mesh, you can always do Surf-iT Patch to Editable Patch to Editable Mesh. You can also go from Surf-iT Patch to Editable Patch to NURBS.

EXTRUDING AND LATHING SURF-iT FORMS

A technique for Surf-iT use as yet unexplored is to use standard Extrude and Lathe modifiers on Surf-iT objects, by using Surf-iT Mesh or Extrude, or any of the Extrude options in the Spline Editor. Strange 3D objects result from these explorations. Remember, before you translate a Surf-iT form into a Mesh or a Patch, you are working with pure 3D shapes, vectors that have no real substance until transformed. As such, using the standard Extrude and Lathe Modifier on them will create thin-skinned constructs in 3D space. (See Figure 6.13.)

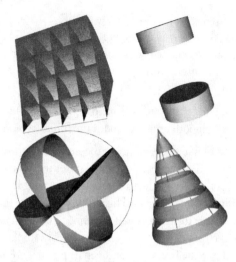

FIGURE *A selection of Surf-iT constructs created by Extruding and Lathing the Surf-iT 3D objects.*
6.13 *Explore this possibility on your own. Displayed left to right and top to bottom are Lathed*
 Grid with Degrees set to 60; Surf-iT Cylinder extruded at 35 (only the Splined end-caps
 are extruded); Surf-iT Sphere lathed at 30 on the X-axis; Surf-iT Cone with 10 height
 Segments extruded at 3 (Mesh). Also explore Extrusion as a NURBS object.

FREEHAND MODELING A HUMAN TORSO WITH SURF-IT

By Paul Bloemink

Author's Note: *Please note that in many of the figures that accompany this chapter, I deleted the standard Max gray background to make the images clearer for this book.*

This tutorial shows how you can easily create a very flexible and well-designed 3D human torso (or other character bodies for that matter) using the Surf-iT modeling kit for Max. The techniques explained here reveal some of the powerful modeling tools in the Surf-iT package, and also demonstrate that Surf-iT ensures quick, professional, and organized geometry that is exceptionally well suited to animation by using parametric creation tools. You'll find that the editing is simple, so you can easily increase detail and realism in your models, and later convert them to Patches, Meshes, or NURBS-based objects.

This tutorial requires a strong understanding of 3D Studio Max's basic modeling techniques, thorough knowledge on how to use and edit the modifier stack, and a good understanding of display and viewport navigation techniques. Nonetheless, the tutorial is detailed enough for almost anyone to perform. Do the following:

1. Start a new Max scene, with the typical default 4 views. Click in the Left viewport to activate it. You are going to create a freehand contour shape that describes one side of

a male torso figure. This line will be used by the Surf-iT S-Lathe object creation tool (this tool is only included in Surf-iT versions 1.10 and above). The S-Lathe tool will allow you to instantly create a lathed lattice of Splines comprised of connecting and intersecting lines ready for instant surfacing as a solid-looking object with the Surf-iT Patch modifier.

2. Go to Create>Shapes, and pick Splines from the Shapes drop-down list. Click the Line tool, and select the Smooth option for both the Initial Type and the Drag Type.

3. Click to create the first Spline shape vertex in the Left viewport several grid squares above the World Y-axis and a few squares to the right of the World Z-axis (you want to visualize that the World Z-axis is like a mirror line for your freehand shape—you can then use it to position the lathe axis). This first vertex will be the vertex at the top side of the neck for the male torso figure you are going to create. The reason you want to create the shape in the Left viewport is because eventually, this line will be the center line running up and down the front view of the male torso figure as viewed from the Front view. This will make more sense after you create the S-Lathe object and set a useful number of segments.

4. Moving the cursor down and to the right in the Left view, click to create the second vertex of the line at what will be the base of the neck. The next few steps describe the basic steps used to create the profile shape of one side of a torso figure, as shown in Figure 6.14.

5. Moving the cursor to the right and slightly down, click to create the third vertex near where you want the shoulder to be. Click another vertex to the right of this vertex, which will be the very edge of the shoulder or the top vertex for an arm stump/socket. To set the initial depth/girth of what will eventually be the arm, create the fifth vertex by moving the cursor directly below the fourth vertex (horizontally aligned with the fourth vertex), and far enough below that the segment between the fourth and this fifth vertex is proportionately long enough to look like an arm stump/socket.

You should not create the profile of an arm. You only want to draw the profile of the side of the torso.

6. Continue down to create vertices to describe the profile of the side of the chest, waist-line, hip, and side of the thigh. You should create a total of 13 vertices. You want to add enough detail for the chest line, and a few extra curves for the muscles and in-dentation along the lower side of the torso, waistline, and just down to the upper thigh area. You do not want to create an extension for the leg—you'll do this later. Your shape should now look like Figure 6.14.

7. Deselect the Shape, and click on the Create panel. Select the Shapes Category and pick Surf-iT (Ghost 3D) from the Shapes drop-down list, then click the S-Lathe button.

FIGURE *Your initial shape should look*
6.14 *like this.*

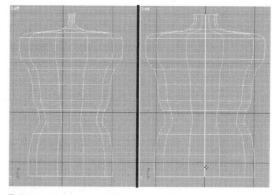

FIGURE *Correct the neck.*
6.15

8. By default, the Create Spline button is active; however, since you already created the shape of the torso side profile, you can now click the Attach Shape button. Then, select the Reference radio button option underneath the Attach Shape button, and click to select the Line Shape (the torso side profile shape) in the Left viewport. This will create a Spline lathe object of the Spline shape, called SplineLathe01. See the left side of Figure 6.15.

When you create a shape to attach and lathe with the S-Lathe Attach Shape button, choosing the Reference option means that the S-Lathe object will update to reflect (reference) any edits you perform on the original Spline shape you attached. The effect is like using the S-Lathe object as a referenced modifier on a copy of the shape.

9. Right-click in any viewport to end the creation of the S-Lathe object. With the S-Lathe object selected, switch to the Modify panel, and in the SplineLathe Parameters Rollout, ensure that each of the following parameters are set accordingly: Degrees = 360, Segments = 10, Connecting Knot Type Smooth. In Cap Shapes, both Start/First and End/Last check boxes should be unchecked

With the Segments set, to 10 you should have enough intersecting Spline vertices in the lattice to make several detailed edits using the Spline Editor to sculpt the details in the torso.

10. At this point, you'll probably notice that the neck part of the figure is too narrow. To correct this, switch to the SplineLathe Sub-Object Axis selection level, and in the Left viewport, move the yellow Axis gizmo to the left so that it is aligned with the black World Z grid line (or so that the girth of the neck looks proportionately wide enough). See the right side of Figure 6.15.

If your S-Lathe object does not look properly shaped from the Left view, you can select and edit the original Spline Shape you attached to make the lathe. You simply move the vertices in the Left viewport to change the shape of the Spline, as you watch the changes get reflected in the referencing S-Lathe object until you are satisfied with resulting shape of the S-Lathe object. Don't worry that the S-Lathe object looks too cylindrical for a torso—you'll change that later.

Now, you are ready to non-uniform scale the profile of the torso, and perform comprehensive edits with the Surf-iT Spline Editor to artistically shape the details of the torso figure.

11. Choose and add (from the full-list Modifier list) a Surf-iT Spline Editor modifier to the S-Lathe object, and switch to the Vertex Sub-Object selection level.

12. In the Left viewport region, select all the vertices in the object, except for all the intersecting vertices along the top and lower ring of the neck area. Refer to Figure 6.16 left for the appropriate selection.

13. Click on the Non-Uniform Scale tool in the Max main toolbar, and choose the Use Selection Center option (by clicking and dragging down to choose it in the drop-down tool/menu directly to the right of the Reference Coordinate System drop-down menu in the Max main toolbar). Also, choose the Restrict to Y option in the Max main toolbar.

14. In the Top viewport, click and drag to Non-Uniform scale the selected vertices closer together, along the Top view Y-axis, to approximately 60–63% of the selection's original size (so that the object looks ovular from the Top view, and more narrow like a torso would look from the Left or Right views). (See Figure 6.16 right.)

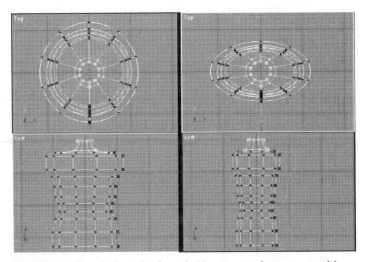

FIGURE *The object looks ovular from the Top view, and more narrow like a torso would look from*
6.16 *the Left or Right views.*

15. To extrude the first leg extension, you'll want to connect the lowest front/center vertex to the lowest back/center vertex of the torso figure in order to establish a line along the crotch/seat of the torso. Using the Spline Editor's Join Segs operation, you can do this more comprehensively by establishing a C-shaped segment selection, joining them into one Spline, closing the Spline, and then using the closed Spline shape selection to extrude.

You may first want to select and hide the original line shape object you created and attached to make the S-Lathe object. This will help reduce screen clutter, after which you should reselect the SplineLathe01 object to continue.

16. Switch to the Segment Sub-Object level in the Spline Editor, and then select the five lowest horizontal segments that wrap around the figure's left thigh area (these segments would be along the lower right side of the figure if looking at the figure from the Front viewport). These segments may be more easily selected from a quarter-rotated Perspective or User view.

17. Now, click the Join Segs button in the Spline Editor command panel (or the JS button in the Spline Editor floating toolbar). The segments will be joined as a Spline. (See Figure 6.17.)

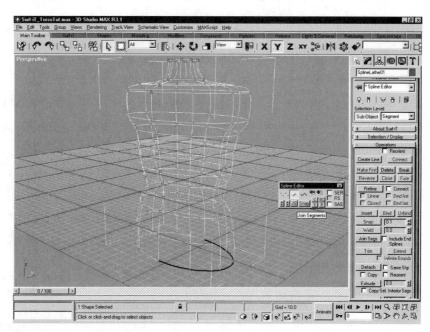

FIGURE *The segments will be joined as a Spline.*
6.17

18. Switch to the Spline Level and click to select the Spline you just joined. Now click the Close button, and you should see a segment created along the crotch/seat area of the torso figure that closes the selected Spline.

19. Click the Put Selection To (black arrow) button in the Selection/Display Rollout (or the Spline Editor floating toolbar) to activate it, and then switch to the Segment selection level. Each of the segments (including the closing segment) in the Spline should be selected.

20. Next, click to activate the Surf-iT Extrude (Extrude Closed Shapes) button in the Spline Editor Operations Rollout, and in the Front viewport, click and drag so that the segment selection extrudes down proportionately to create the first short leg extension (see Figure 6.18 left). Right-click to end the Extrude operation.

21. Switch to the Vertex selection level, and region select the vertices (and intersecting vertices) along the extruded closed shape at the bottom of the torso. Then, in the Front viewport, move these vertices to the right so that the leg extension (and its extrusion lines) is diagonally directed away from the vertical center line of the torso. (See Figure 6.18 right.)

If you prefer, you could now make the same leg extension on the opposite side. Simply select the same segments on the opposite side, but you do not need to Join Segs or close the Spline, because you can use the same line along the crotch/seat of the torso that was already created (in the previous Close operation). Just make sure to select a closed set of segments (there should be six segments), and then extrude them. However, since it is more efficient to perform most of these edits on one side of the symmetrical figure, and then mirror them (which you'll do later after you do all the editing

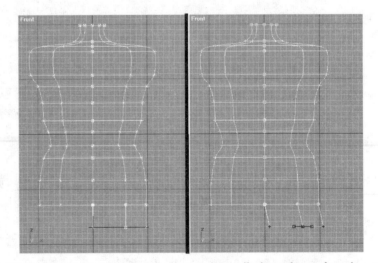

FIGURE *The leg extension (and its extrusion lines) is diagonally directed away from the vertical*
6.18 *center line of the torso.*

and sculpting to one side), you do not need to make the other leg extension/extrusion at all. Instead, let's continue by extruding the arm on the same side as you did the leg extension.

22. Switch to the Segment selection level, and in a quarter-rotated perspective or user view, select the four segments (in a closed shape pattern) around the stump of the arm area on the same side of the figure as you made the leg extension—it should be the right side of the figure when looking at the figure from the Front viewport. To get an idea of the appropriate selection, you can refer to Figure 6.19 (which is the same selection after performing the following step).

23. The selected segments form a closed shape/pattern that looks a little too square, because each segment belongs to a different Spline. Since you'll extrude this shape/pattern several times, here is a time-saving Surf-iT trick to make the shape have a more rounded curvilinear shape by default: Simply click the Join Segs button (JS in the Spline Editor floating toolbar) to make the segments belong to a single common Spline, click the Put Selection To (black arrow) button in the Selection/Display Rollout, and switch to the Spline selection level. Next, right-click on the selected Spline (it should be the same four-segment shape that you selected in the Segment level) to bring up the right-click menu, and then pick the Curve option (pick Curve even though it may already be checked). You should notice that the shape is now more rounded instead of the previous square-looking shape.

24. Now, switch back the Segment selection level, with the same four segments selected around the stump of the arm, click the Extrude button in the Operations Rollout, and then click drag in the Front viewport so that the segments are extruded to the right away from the rest of the torso figure (you can do this in the Perspective viewport, but you should watch the Front viewport so that you can see more accurately how far you are extruding). You want to drag only so far as to where the biceps of the arm would be located. Let go of the left mouse button to finalize the first extrusion, and then click and drag so that the newly selected extruded segments are extruded farther to the right about where the elbow of the arm should be. Release the left mouse button, and then click and drag the newly selected segments to extrude them slightly more to the right of the elbow. Again, release the left mouse button, click and drag the selection to extrude once again to where the midpoint along the forearm would be, and do this once more to extrude the selection to where the wrist (or end of the forearm) would be. Release the left mouse button, and click the right mouse button to end the entire extrusion operation. You should have completed a total of five extrusions in one operation, so that there are plenty of Splines to sculpt the arm. Two of these Spline sections should be near the elbow to provide for better animation of the final model. Refer to Figure 6.19 right to see the result of the extruded arm (shown in the Perspective view).

In just a few minutes, you have created a complex structure of intersecting Splines describing a basic shape of a humanoid torso. Now the artistic part really begins. You'll make several edits to shape the detail and contours of the torso figure. But first, let's give the torso

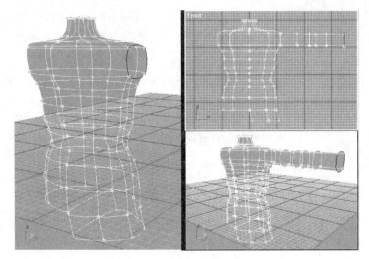

FIGURE *The result of the extruded arm.*
6.19

figure a real surface to make the Spline editing easier and more visually informative. This can be done in one step by adding a Surf-iT Patch modifier. However, with the Surf-iT modeling kit there are several powerful previewing tools for creating a reference surface that updates as you edit and view all the elements and sub-object selections associated with Splines. Before doing this, you'll delete the segments on one half side of the object, and then mirror the remaining half so that any edits you perform on one side will be symmetrically duplicated to the mirrored side.

25. In the Front viewport, select all the segments on the left side of the torso (the opposite side from the side with the arm and leg extrusions), as shown in Figure 6.20. Make sure not to select any of the segments that run up and down the front and back of the torso's vertical center line. Then, hit the Delete key to remove all of the selected segments.

26. Before mirroring the half torso, select all the segments that run up and down the front and back of the torso's vertical center line (don't forget to select the Segment along the crotch/seat of the torso figure), as shown in Figure 6.20 on the right. Then, click the Join Segs button (JS in the Spline Editor floating toolbar). This will join the segments into a single Spline, which will be useful when attempting to select all the vertices along this centerline, and will make snapping the two separate object halves together extremely easy. In Figure 6.20 on the right, you can see the segments joined together to form a single Spline along the vertical center line of the torso. (See Figure 6.20.)

27. Now, maximize the Front viewport, make sure the Reference Coordinate System is set to View, and then click the Mirror tool button on the main Max toolbar. In the Mirror: Screen Coordinates dialog box, change the Mirror Axis option to X, and the

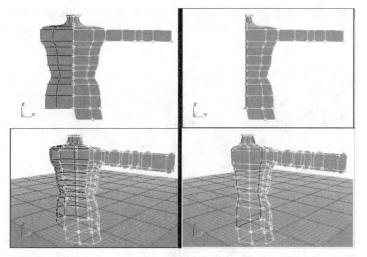

FIGURE *The segments are joined together to form a single Spline along the vertical center line of*
6.20 *the torso.*

Clone Selection option to Reference. You can use the Offset Spinner to offset the object as necessary to make sure that the mirrored object's center line is perfectly overlapped with the original torso object's center line (such that halves fit together as if a whole torso). Finally, click the OK button to finish the mirror operation.

28. With the mirrored copy of the SplineLathe object selected, add a Surf-iT Patch modifier to the object by choosing it from the More modifiers list and clicking OK. You should see the torso surface in a shaded viewport. If the shaded surface appears inverted (facing inward), check the Flip Normals check box in the Surf-iT Patch Parameters Rollout. In the same Rollout, increase the View Steps Spinner to 5.

29. If you do not already have all the Surf-iT.cui macros loaded (version 1.10 and above), or your own custom toolbar with the SurfiT_Ref_Preview_Controls macro button, then choose Load Custom UI... from the Customize menu in the Max menu bar. Use the load ui dialog to browse to the \3dsmax\ui\ subdirectory of your Max root, and load the Surf-iT.cui file. This will open a new toolbar with all the Surf-iT macros (shown along the lower portion of viewports in Figure 8). Click on the Surf-iT Ref Preview Controls button to open the Surf-iT Ref Preview Controls floater (floating command panel shown in Figure 6.21. Then, minimize the viewport (so that all four are showing), and select the Perspective viewport.

30. Select the original half torso object (if you are in a Sub-Object mode, you will need to click the Sub-Object mode button to exit to Object mode first), and then click the Create Surf-iT Ref Preview button in the SRP Parameters rollout of the Surf-iT Ref Preview Controls floater. Wait a few seconds or so until the macro is completely finished creating a reference object and until it selects the original source object again.

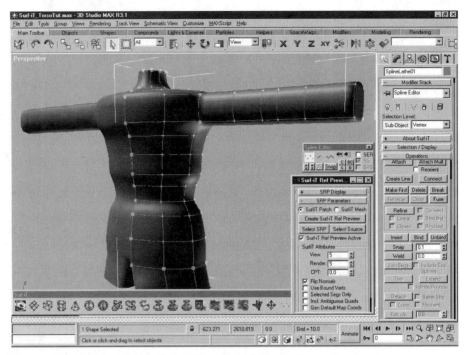

FIGURE *The selected original half of the Torso is shaded in the Perspective viewport.*
6.21

The macro should also put you into the Vertex selection level of the Spline Editor modifier in the original source object's modifier stack, so you'll want to wait until that happens before proceeding. If the shaded surface of the Surf-iT Reference Preview object appears inverted (facing inward), check the Flip Normals check box in the SRP Parameters Rollout of the Surf-iT Ref Preview Controls floater.

You should now see that the selected original half of the torso figure is surfaced and shown shaded in the Perspective view, as shown in Figure 6.21. Since you have not yet attached the mirrored half torso object (because you want to take advantage of all your edits being instanced/duplicated in the mirrored object), there will be a subtle seam in the two adjacent objects' surfaces. Don't worry about that now, because you will easily be able to attach and snap these two halves together later.

The Create Surf-iT Ref Preview macro does several things, including the addition of a disabled Surf-iT Patch modifier to the selected object, the creation of a referenced object copy that is specially named, and is set up with an active Surf-iT Patch modifier that is controlled from the Source object with all of the other Surf-iT Reference Preview controls. The SRP (Surf-iT Reference Preview) floater controls allow you to adjust the settings for the SRP object while the original Source object is selected and being edited. This means you work on the source object at the Spline level, and view

the Surf-iT Reference Preview as a surfaced preview that updates as you edit the Source object. You'll find this workflow and the SRP controls very handy. You are now ready to do some fine-tuning of the vertices in the original torso half to shape the details in the figure as you desire.

31. First, you'll notice from the Left view that the chest and upper back of the torso figure look a little too box-like. To correct this, in the Left viewport, select the two pairs of vertices along the center line of the upper back (as shown in Figure 6.22 left). Then, move them along the Left view X-axis to the right so that they are somewhat aligned with the pair of vertices directly below them. (See Figure 6.22 right.)

TIP

When selecting and moving vertices, you can check the RS (Radial Selection) check box in the Spline Editor floating toolbar, so that when you click and Ctrl + click on individual vertex intersection, all coincident vertices are selected automatically. You do not want to separate coincident vertices at Spline intersections created by the S-Lathe object; otherwise, you will break open the automatic surface created by the Surf-iT Patch modifiers.

32. Next, select the eight pairs of vertices in the upper back and chest areas (four pairs are located front and back for a total of 16 selected vertices) as shown in Figure 6.23 left. Click on the Non-Uniform Scale tool in the Max main toolbar, select the Restrict to X-axis option, and choose the Use Selection Center option (by clicking and dragging down to choose it in the drop-down button/menu directly to the right of the Reference Coordinate System drop-down menu in the Max main toolbar). Then, in the Left view, click and drag to Non-Uniform scale the selected vertices along the Left view X-axis closer toward the center of the torso figure (approximately 80%). (See Figure 6.23 right.)

33. In the Left view region, select a group of vertices existing along the three Spline columns in middle section of the back. Include only the ones that are below the ver-

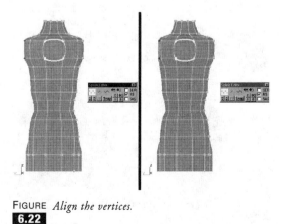

FIGURE **6.22** *Align the vertices.*

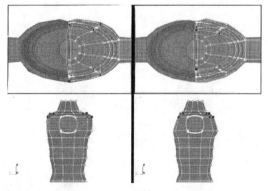

FIGURE **6.23** *Scale the selected vertices.*

tices you just scaled (don't include any of the vertices too close to the sides or front of the torso figure). Then, Non-Uniform scale these vertices closer together approximately 60% (similar to the way you did in the previous step). This will flatten the contours of the back a little. Use your own judgement to shape the back as you see fit.

34. Now, you'll probably want to drop the chest and indent it along the vertical center line. To do this, first select the six pairs of coincidental vertices in the chest area, surrounding the largest quadrangular shape of the chest and the adjacent quadrangular shape above it (which would be the collar bone area), as shown in Figure 6.24 left. Choose the Restrict to XY Plane option in the Max main toolbar, click on the Move tool, and move the selected vertices down and to the left in the Left viewport slightly back toward the center of the torso figure. This should reduce the chest protrusion and give a nice line to the lower chest area, as shown in Figure 6.24 right.

35. In the Top view, hold down the Alt key and click and drag a region around the vertices that do not lie on the vertical center line of the torso figure, in order to subtract them from the selection set. Then, while still holding down the Alt key, click and drag a region to subtract from the selection the two coincidental vertices closest to the upper neck area (so you only have the two pairs of coincidental vertices from the previous selection that lie along the center line of the upper chest). Now move them in the Top viewport along the Y-axis slightly back toward the neck. You can watch the shaded perspective view as you do this, to make a proper indentation for the center of the chest, as shown in Figure 6.25 (note that Figure 6.25 shows Bezier Corner vertices as explained in the following Tip).

TIP

To really enhance the indentation and the shape of the pectoral muscles, you can click the BC button on the Spline Editor floating toolbar to change the selected vertices to Bezier Corner. This gives you a few tangent handles for each vertex, so that you can move them down along the Y-axis in the

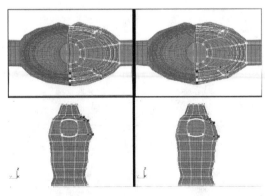

FIGURE **6.24** *Reduce the chest protrusion.*

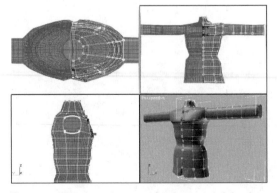

FIGURE **6.25** *Make the indentation for the center of the chest.*

Top view and enhance the way the pectoral muscles protrude from the center of the rib cage (the vertical center line of the torso figure).

36. Now you'll contour the arms by scaling and adjusting the rings of vertices around the currently very cylindrical arm extensions. Switch to the Front viewport, and region select the two cross-sectional rings of vertices nearest the elbow area of the arm extension (there should be 16 vertices in your selection). Lock the selection by pressing the Spacebar on your keyboard. Change the Non-Uniform Scale tool to the default Uniform Scale tool in the Max main toolbar. Also, make sure that the Use Selection Center option is still activated, and then uniform scale the vertices to about 80% of its size. You may also want to adjust the Bezier tangent handles or Non-Uniform scale the vertices along the Y-axis of the Top view. Use your artistic judgement here (although Figure 6.26 is in reference to the following step, you can still see the results around the elbow area).

37. Unlock the selection by pressing the Spacebar, and then select the ring of vertices at the end of the arm, where the wrist of the figure would be. Lock the selection, and then Uniform Scale this vertex selection about its selection center to 60% of its size. You may also want to use your artistic judgement here by using the Non-Uniform scale tool to scale along the Front view Y-axis to slightly flatten the selection of vertices around the wrist. (See Figure 6.26.)

38. Continue to adjust vertices in the arm by moving them in different views and adjusting the Bezier tangent handles to make unique and shapely muscle curves.

TIP

Much of the artistic part of modeling is using Surf-iT and Max to adjust vertex positions, their types, and Bezier or Bezier Corner vertex tangent handles. This is a "sculpting" process, and the Surf-iT Spline Editor gives you several tools for quick and comprehensive selection, vertex type changes, selection transfers, joining, and many other tools to help you get the job done easily and

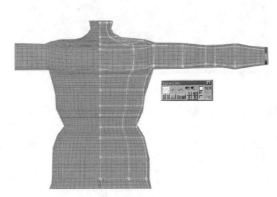

FIGURE
6.26
Slightly flatten the selection of vertices around the wrist.

intuitively. Also, don't forget to make use of the Surf-iT Reference Preview options in the Surf-iT Ref Preview Controls floater, to change the face Normals, Steps resolution, or various display settings in the Surf-iT Reference Preview surface. This will help you better visualize the results as you adjust and modify the Spline topology.

Now, you'll probably want to want to do a few simple adjustments to the crotch, pelvis, and gluteus areas to complete the basic anatomy of your torso figure.

39. First, in the Left viewport, use region select (or check the RS button in the Surf-iT Spline Editor floating toolbar) to select the front and back coincidental groups of vertices at the end points of the segment running along the crotch of the two leg extensions. There are two locations, front and back of the torso, and each location should have three coincident vertices. You can see the selection in Figure 6.27.

40. Now, make sure that you change these vertices to Bezier Corner vertex type (you can use the right-click menu to do this, or click the BC button in the Spline Editor floating toolbar—Surf-iT v1.10 or above). Then, in the Top viewport, use the Move tool with the Restrict to X option to move the tangent handle, at either the front or back location of vertices, which is pointing left and toward the center of the object in the Top view. Move the tangent handle so that it is perfectly aligned with the center line of the Torso figure, as shown in Figure 6.27 right. Do the same for the similar tangent handle at the other location (front or back) of the two vertex selections. This will straighten the segment running along the crotch/seat area of the torso figure.

41. In the Left viewport, observe the two horizontal tangent handles (one each at front and back of the torso figure) that are pointing perfectly horizontally toward the center of the torso figure, and move each down along the view Y-axis so that they are now

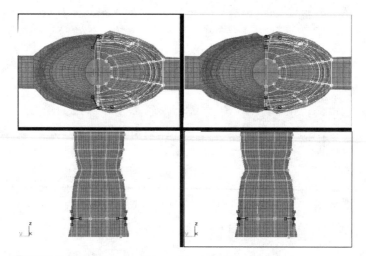

FIGURE *Each selection should have three coincident vertices.*
6.27

pointing down about 45 degrees. This will give some curvature to the side profile of the segment along the crotch of the torso figure. (See Figure 6.28 left.)

42. While still looking at the Left view, observe the two vertical tangent handles (one each at front and back of the torso figure) that are pointing 90 degrees upward along the front and back sides of the torso figure. Move each of these tangent handles horizontally away from the torso figure along the Left view X-axis so that they are now pointing out about 10 to 20 degrees off vertical, and away from the front and back of the torso figure. (See Figure 6.28 right.)

43. Also in the Left view, Region Select the two sets of vertices in the gluteus area at the back side of the torso figure, as shown in Figure 6.29 left. They are just one row above the vertex selection from the previous step. Then, move these vertices in the gluteus area along the Left view X-axis to the left away from the torso figure a proportionate amount so that the figure's gluteus area protrudes an adequate amount. (See Figure 6.29 right.)

44. Use the Front viewport to Region Select all the vertices along the bottom row around the leg extension (this is the same selection as shown in Figure 6.18 right). Select and activate the Uniform Scale tool, and the Use Selection Center tool in the main Max toolbar. Press the Spacebar to lock the selection, and Non-Uniform scale the selection of vertices to about 90% of their original area. This should make the leg extensions a little narrower, and will help separate the legs from each other.

45. Unlock the selection and Region Select the vertices around the hip area. There are two rows on which to select two sets of coincidental vertices (total of four sets of vertices = eight vertices). Choose the Select and Move tool from the Max main toolbar, and move the vertices in the Front viewport left toward the center of the object. This should produce a more natural transition between the waist and the hip. (See Figure 6.30.)

FIGURE **6.28** *Move the tangent handles horizontally.*

FIGURE **6.29** *Make the gluteus area protrude.*

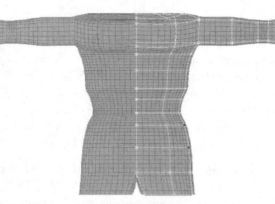

FIGURE *A more natural transition between waist and*
6.30 *hip is created.*

46. Now, open the Surf-iT Ref Preview Controls floating command panel, expand the SRP Display Rollout, and click the Hide/Unhide button. This will hide the Surf-iT Reference Preview object for the selected Spline object you are working on. The idea is to get a better look at the Spline cage, without the cutter of the Patch display.

47. In the Front viewport, again Region Select all the vertices along the bottom row around the leg extension. Now switch to the Top viewport, hold the Alt key down, and Region Select around the selected vertices except the two sets toward the inner leg area, so that you subtract these other vertices from the selection. You should be left with two locations of two coincidental vertices toward the inner thigh, as shown in Figure 6.31 left. Select and activate the Non-Uniform scale tool from the Max toolbar, and make sure that the Use Selection set option is still chosen. Click on the Restrict to Y button, and Non-Uniform scale the vertex selection along the Top view Y-axis to about 60% of its original area, as shown in Figure 6.31 right.

FIGURE *Non-Uniform scale the vertex selection.*
6.31

48. Once more in the Front viewport, Region Select all the vertices along the bottom row around the leg extension. Then, select the Restrict to X option from the Max toolbar, and in Left viewport Non-Uniform scale the vertex selection along the Left X-axis to about 110%, or enough to properly add back the proportionate amount of depth to the upper thigh area.

49. While still in the Left viewport, select the coincident vertices that exist at the crotch/intersection of the front side of the two mirrored leg extensions. Switch to the Front viewport and zoom in on the crotch area. Select the Select and Move tool, choose the Restrict to XY Plane option, and then use the Move tool to move the tangent handle that controls the Spline segment running down the inner thigh. Move the tangent handle up and slightly to the right so that it creates a gentle curvature from the inner thigh segment to the crotch intersection, as shown in Figure 6.32. You may also want to make this modification to the same vertex tangent handle at crotch/intersection area below the gluteus area (the back of the figure).

50. In the Left viewport, Region Select the two sets of coincidental vertices along the front side of the upper pelvis Spline, as shown in Figure 6.33 left. Then, open the Surf-iT Ref Preview Controls floating command panel, expand the SRP Display Rollout, and click the Hide/Unhide button to unhide the shaded Surf-iT Reference Preview copy of the Spline torso you are working on. This will allow you to see the entire torso shaded in the Perspective viewport. Using the Restrict to XY option, move the selected vertices down along the Y-axis in the Left viewport (Figure 6.33 right), as you watch the shaded Perspective view. Move the vertices down just enough to flatten out the pelvis area as viewed from the Perspective view.

At this point, you should have a well-shaped and proportionate male torso figure. You can continue to edit the Spline object, by moving vertices, changing the vertex types to Bezier

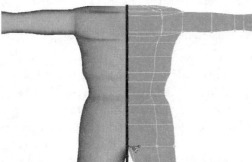

FIGURE **6.32** *Move the tangent handle upward so that it creates a gentle curvature.*

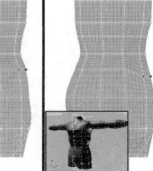

FIGURE **6.33** *Left: Two sets of coincidental vertices along the front side of the upper pelvis Spline are selected. Right: The selected vertices are moved down along the Y-axis.*

and Bezier Corner, and by moving the Bezier tangent handles to shape the figure. You may want to start by moving the vertices and tangent handles in the groin area to create a groin crease. You may also want to provide more detail to the arms and abdominal areas to sculpt more musculature in the figure to suit your own taste. These artistic modifications can be done in a similar manner to the edits you performed in the last several steps. When you are finished making all the symmetrical modifications to one torso half, you can proceed to the final few steps to join the two halves using the Surf-iT's Snap tool, which is designed to perform multiple snapping of vertices with just one click.

51. To join the two mirrored halves of the torso figure together, first exit Sub-Object mode of the Spline Editor, and select the opposite mirrored object (the other half of the torso that you mirrored). The active Surf-iT Patch modifier should be selected at the top of the modifier stack. Delete this Surf-iT Patch modifier at the top of the modifier stack, and make sure that the other Surf-iT Patch modifier is still present but disabled in the modifier stack.

52. Next, right-click on the Edit Stack button, and choose Collapse All in the Edit stack dialog, or use the Convert to Editable Spline in a right-click menu. You want to convert this half of the torso to an Editable Spline object without affecting the original half.

53. Now select the original S-Lathe torso object that you have been editing throughout most of this tutorial, and, in the modifier stack, select the Spline Editor modifier that you worked with previously.

If you accidentally select the Surf-iT Reference Preview object, you can then click on the Select Source button in the Surf-iT Reference Preview Controls floater, or use the Select by Name tool to select the S-Lathe01 object.

54. Click the Attach button in the Spline Editor Operations>Geometry Rollout. Then, click on the mirrored half of the torso figure to attach its geometry to the original half. You should now have both halves of the torso figure in one Spline object, and you'll see that the Surf-iT Reference Preview object now surfaces the attached geometry as well. (See Figure 6.34.)

55. Select the Vertex Sub-Object selection level, and in the Selection/Display Rollout, check the Select All in Spline check box. Also, check the Radial Selection check box if it is not already checked, and set the Radial selection Spinner value to 0.5 (you may need to increase this value slightly, but do not make it greater than the distance between the closest distance between two Spline rows created by the S-Lathe object). Now you can click on just one vertex along the Spline that runs up and around the torso figure's center line (i.e., the vertex location between the chest), and you should notice that all the vertices along the center line are selected, as well as all their coincident vertices. This is exactly what you want—a selection of all vertices in the two co-

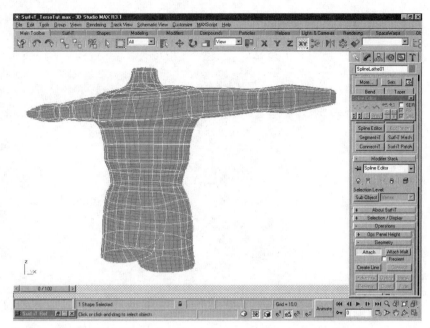

FIGURE *The Surf-iT Reference Preview object now surfaces the attached geometry.*
6.34

incidental Splines (one for each of the original and attached/mirrored half) that run
along the center line of the torso figure.

56. Next, look for the Surf-iT Snap button in the Operations Rollout of the Spline Edi-
tor. In the Spinner field next to the Snap button, change the value to match the value
of the Radial Selection Spinner (in this case, it should be set to 0.5). Then, click the
Snap button. If your mirrored halves were aligned fairly well, and not overlapping too
much, you will now notice that they are perfectly joined together, and that the vertices
along the center line of the figure are snapped in clusters of coincidental points that
create a seamless center line to the model. (See Figure 6.35.)

57. Switch to the Spline Sub-Object selection level, and click on the Spline that runs up
and around the torso figure's center line (it runs along a plane that the two torso halves
were mirrored previously). You'll remember that you previously joined all of the seg-
ments to combine them into one Spline, before you created the mirrored copy. This
allows for easy selection, which is especially useful since there are actually two Splines
along this center line—one for the original half of the figure and one for the mirrored
half. This means that these Splines are redundant, and one of them can be deleted.
After clicking to select one of the center line Splines (as shown in Figure 6.36), hit the
Delete key to delete it.

You should now have a perfectly symmetrical Spline model of a male torso figure, ready
for final surfacing, texturing, and animation. Of course, you may want to attach a head,

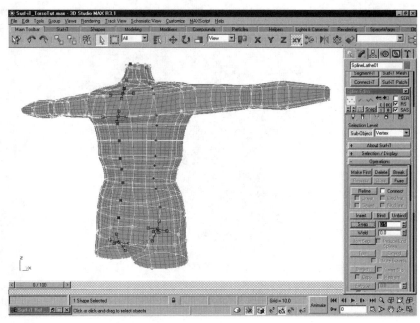

FIGURE *Snap joins the mirrored halves together seamlessly.*

6.35

hands, feet, and legs, but we'll leave that to another tutorial. To wrap up this project, you can either hide or delete the Surf-iT Reference Preview copy. Then, select and activate the inactive Surf-iT Patch modifier on the original torso figure object, as shown in Figure 6.37. You can change the color or add some materials to the figure in the same manner as you would with a Max Patch object, or you can convert the object to a mesh and add textures at the mesh face level.

SUMMARY

You have now seen that Surf-iT S-Objects are the quickest way to creating sophisticated ready-to-surface Spline objects. In the first several steps up until the point where you mirrored one half of the object, you used the S-Lathe object and Spline Editor to easily create a complex but organized Spline lattice representing a torso figure with arm and leg extensions. Only Surf-iT can help you do these tasks so quickly and easily, with a result that is an optimally designed Spline structure. The remainder of the tutorial was intended to show you how simple Spline modeling is with the Spline Editor and the Surf-iT Ref Preview controls. You used very logical and organized selections and manipulations on Spline elements, because the S-Object supplies you with a parametric and organized framework. At the end of this tutorial, you should have a great-looking torso model. However, if you further the project or have other similar projects, you can make such a torso look more cartoon-like or ex-

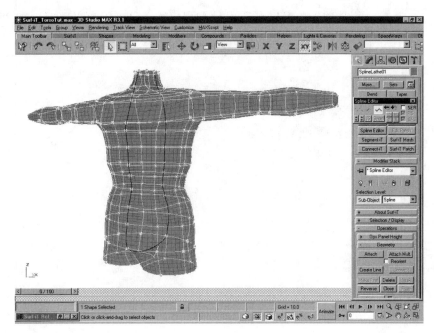

FIGURE *Select one of the center Splines and delete it.*
6.36

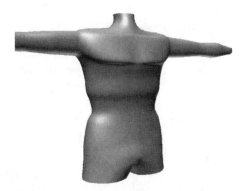

FIGURE *The symmetrical Spline model of the torso.*
6.37

ceptionally more realistic. Either way, this tutorial should have shown you enough of the
Surf-iT process and types of edits that you can do, to help make even the most realistic char-
acters a quick and fun process. Figure 6.38 is a nontextured image of this same male torso fig-
ure, but with a few more artistic edits to the shape the musculature in the abdomen, arms,
and gluteus areas—ready to animate with Character Studio or other Max animation tools.
Whether you are a 3D artist, animator, or a product designer, using some of these

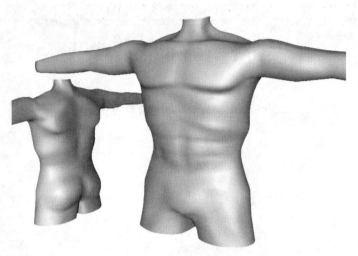

Figure *The final model with details added.*
6.38

techniques, the S-Objects and the powerful editing tools, Surf-iT will make your job much easier—and a lot of fun!

Moving On

This chapter was devoted to Surf-iT from Ghost 3D, a Max modeling plug-in that all serious Max professionals and intermediate 3D modelers will want to explore. The Surf-iT tools and Modifiers push Spline-associated modeling options where they have never ventured before. In the next chapter, we'll take a look at four modeling plug-ins from world famous developer Digimation.

7

Digimation Nation

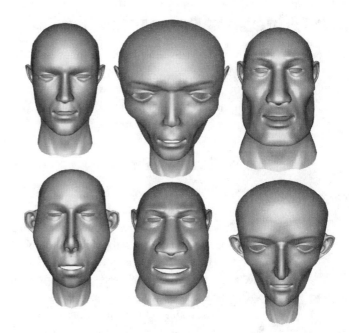

Digimation is the largest purveyor of plug-ins for 3DS Max in the world. The plug-ins they market come from three different sources. First, there are the plug-ins that Digimation's staff of programmers creates on its own, featuring a wide array of choices. Second, Digimation purchases plug-ins developed by outside sources, plug-ins that are unique and that represent the quality that fits the Digimation line. Third, Digimation also acts as a distribution arm for Max plug-ins that remain under the ownership of other developers. In reference to that third category, it is safe to say that most, if not all, of the commercially available plug-ins mentioned in this book can be purchased through Digimation. www.digimation.com

FOUR MODELER'S DELICACIES

In this chapter, we will be detailing four of Digimation's offerings: Clay Studio Pro, daVinci 3D, Head Designer, and Spray Master. These plug-ins are all associated with Max modeling options. It is assumed that you own these plug-ins if you are interested in working through the tutorials, or that you are exploring this chapter in order to see what they do to get the information needed (and the motivation) for possible future purchase.

CLAY STUDIO PRO

Clay Studio Pro is a Metaball modeler. Metaballs are "sticky objects," objects that automatically blend with other metaballs at set distances. Metaballs are traditionally used when modeling human or animal figures, because the resulting blended composites are so smooth and curvy. Sticking Metaballs together is very pleasing, somewhat reminiscent of grabbing globs of clay and building a structure. Metaballs can have positive influences so they blend, or negative values that make them create depressions in other Metaballs in their vicinity.

Clay Studio Pro was created by Orbaz Technologies for Digimation. Clay Studio Pro features some tools and component options that other Metaball modelers do not possess. Clay Studio Pro is accessed by going to Create>Geometry>Clay Studio Pro, which brings up its Rollout.

Clay Studio Pro Components

The four initial components of Clay Studio Pro are Clay Sphere, Clay Spline, Clay Surface, and Clay Clone.

Clay Sphere

This is the most basic component, and one that all Metaball modelers are familiar with, though there are a few options contained for customizing it in Clay Studio Pro (noted by CSP from here on in) not found in other Metaball modeling systems. Sphere contains both a Sphere and Ellipsoid option. The most common way to place a CSP Sphere or Ellipsoid on screen is to switch on the button and click-drag. A numeric data option is provide for those

wishing to configure the dimensions beforehand in the Keyboard Entry Rollout. If you have CSP installed, explore the Sphere and Ellipsoid options by placing a few of each in your scene. Try both the click-drag and Keyboard Entry methods.

After placement of a few Sphere and/or Ellipsoid CSP primitives, go to the Modify Rollout with one of the primitives selected. New options for the primitive are available here. (See Figure 7.1.)

In the Modify panel is a control named Cube Edge. The Spinner value determines the actual edge shape of a selected elliptical primitive (CSP Spheres are not included here). With one Ellipsoid primitive selected, explore different Cube Edge values, and watch what happens to the selected object in the Perspective viewport. (See Figure 7.2.)

A similar procedure is available for CSP Spheres through a Segments Spinner. (See Figure 7.3.)

What all of this means is that the metaball objects you work with, though starting as Spheres or Ellipsoids, can take on a wide variety of forms.

Clay Spline

Clay Splines can be Round or Oval, and similar to Clay Spheres and Ellipsoids, they respond to Segment and Cube Edge settings, respectively. But what is a Clay Spline? A Clay Spline is a form that is created using a Spline as a skeleton. It can even be compared to an automatically skinned Spline, something new in your toolkit. Clay Splines have *Knots*, nodes that indicate their diameter at specific points. Clay Splines are especially useful in creating serpentine figure elements (like actual serpents or tentacles), and also for creating appendages like arms and legs for a human or animal figure. As a Clay Spline is click-dragged in a viewport, extended sections are added from one clicked Knot to the next. Interactively moving the mouse while extending the Spline sizes the Knot's diameter accordingly. (See Figures 7.4 to 7.6.)

Once Knots are selected, they can be immediately modified with Move, Rotate, and Resize tools. This alters the overlaying skin of the Clay object as you might surmise. By careful

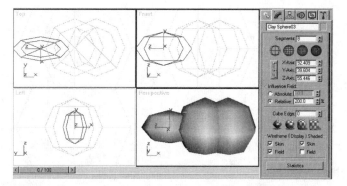

FIGURE *The initial look of a Clay Studio Pro screen, showing placed Sphere and Ellipsoid*
7.1 *intersecting primitives and the accompanying Modify Rollout.*

FIGURE **7.2** *Left top to right bottom, the Cube Edge values for this CSP Ellipsoid are –3, 0, 3, and 6.*

FIGURE **7.3** *Left top to right bottom, a variety of Segment Spinner values: 4, 6, 10, and 25. Increasing values create smoother spherical surfaces.*

FIGURE **7.4** *An example of a Clay Spline based on a Round Open selection with 12 Knots and 20 Segments. As the Knots are set larger or smaller, they control the diameter of the skinned Spline at that point.*

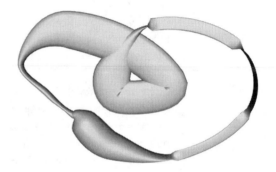

FIGURE **7.5** *An Oval Closed Clay Spline with a Cube Edge of 0.*

FIGURE **7.6** *By making the Skin invisible in either or both Shaded and Wireframe viewports, you can see and customize Knot positions, Rotations, and Sizes with the standard Transform tools.*

modification of the Clay Knots, Clay objects of any kind can be crafted. Knots can be Inserted at any point on the Spline, and resized. Each Knot can be given an individual name and color, making selection and editing clearer.

Clay Surface

The Clay Surface item in CSP is a gizmo with a special purpose. It controls many of the parameters of what will become Clay objects, and what the level of rendered detail will be. Make sure you do not work with a white background (Customize>Preferences>Colors>main UI>Viewport Background) if you need to see the Clay Surface gizmo, because it is an unchangeable white itself. You can see it when the background setting is darker. (See Figure 7.7.)

Make sure that Render Clay Surface is always unchecked.

What tasks does the Clay Surface gizmo perform? The Clay Surface gizmo "absorbs" all of the Clay objects, Spheres/Ellipsoids and Splines, in a scene, and generates a surface using all of the individual Clay components. For this reason, the Clay Surface is usually not added to a scene until all of the separate components have been placed in position and resized. After that, placing the Clay Surface gizmo in a scene allows you to fine-tune all of the components while viewing the interactive skin of the model-to-be. Using the Clay Surface gizmo, you can also select various Clay primitives for inclusion in a group, further extending your metaball modeling options. With one click in Clay Surface (on *Create Snapshot Mesh*), you can also create an Editable Mesh from Clay elements.

Clay Surface Grouping is an important part of sculpting CSP models, and has to be mastered in order for you to control CSP modeling. By Grouping sets of Clay primitives, members of one group will not create surfaces stretched to another group, so you can create elements of a figure that are sculpted on their own but are not influenced by members of another surface group. Selecting what primitives will belong to an individual group is done in the Group Workshop window, accessed easily through the Clay Surface Rollout. (See Figure 7.8.)

FIGURE *The Clay Surface Gizmo can be seen against a darker viewport*
7.7 *background.*

FIGURE *The Group Workshop window.*
7.8

The Clay Surface Groups *do not show up as separate selectable objects in Max, but are only configured for Clay Studio Pro internal use.*

Clay Clone

The Clay Clone gizmo can be used to clone any selected element in your scene, but is most useful when you need to clone Clay primitives for use elsewhere in a model.

The Clay Utilities

You will find three Clay options listed in Utilities>More: Clay Contour, Clay Converter, and Clay Global Settings.

Clay Contour

This utility is used when you want to connect other modeling elements to a Clay Spline at a specific Knot point. Connecting another Clay Spline at the Knot, as an example, allows you to move and otherwise transform the added component, yet it will still remain connected at the targeted Knot. This acts a bit like a pivot point on a multiple element model. You can also disconnect using the same utility. Meshes can also be connected to the selected Clay Spline at selected Knot points. A curious Parent/Child relationship develops when a mesh is connected to a Clay Spline in this manner. You can Rotate or Resize the Mesh, but you cannot move it. To move it, the Spline must be selected and moved. (See Figure 7.9.)

When connecting a Sphere Mesh to a Clay Spline, the next logical step would be to convert it to a Clay Sphere using the Clay Converter utility.

Clay Converter

The Clay Converter utility is one of the best modeling features of CSP. It converts any selected Mesh into a Clay Sphere or an Ellipsoid. If you model a basic 3D form with spheres,

FIGURE *The Sphere has been connected to the Clay Spline*
7.9 *using the Clay Contour utility.*

Convert the Spheres to Clay Spheres, and then use Absorb all Primitives from the Clay Surface Rollout, you will wind up with a metaball object whose elements can then be tweaked and refined to form a final model. Once a Mesh that has been attached to a Clay Spline is converted to a Clay Sphere or Ellipsoid, they are formally joined, so moving either moves the other.

Clay Global Settings
This means exactly what it says. From this utility panel, you can access and alter all of the Clay parameters in a scene.

CREATE A CLAYBOT

You didn't think we were through creating "bots," did you? Surely you jest. Besides, what a wonderful way to test the organic modeling capabilities of a CSP modeling exploration. As you proceed with this exercise, observe the following cautions:

- Model a head by first using standard Sphere Primitives to put the parts together. Next, access the Clay Converter utility and convert the Primitives to Clay Spheres, adjusting the quality as you need to. Last, use a Clay Surface gizmo to "absorb" all of the Clay Spheres.

- Do not try to model an entire figure at once with Clay parts, unless it is a fairly non-complex model. I have found that doing this taxes the system too much, no matter the speed or amount of RAM.

- Do a sketch first to get the general parameters of the model you will create. This is always a good idea, no matter the modeling tools, but is especially useful with Metaballs.

- Explore adjusting the strength of the Clay Primitives, so that your composited Clay model will have features that don't look too much like blobs of fat.

- Explore different Influence Field values while you are moving a Clay object relative to its neighbors. Sometimes an increment of just 1 will alter the form dramatically.

- **This is very important**: When an element of your design is complete, like a head for instance, Group the components with the standard Group command. Then go to the Modify>Clay Surface panel. Select Create Snapshot Mesh, and you will have created a Mesh object whose curves match your Clay composite. Do not use any other Snapshot utility. (See Figure 7.10.)

- Always Optimize the resulting Clay Mesh, because it will have far too many polygons.

- NEVER attempt to do everything with Clay components. Some things, like cutting holes for the eyes and mouth and shaping/attaching ears are best left to other Mesh procedures like Boolean operations.

- Save your work often. This modeling technique can put a lot of pressure on your system. Max is not perfect, and neither is Windows, so saving often is the only way to prevent the loss of hours' worth of creative effort.

Using all of these tips, and keeping all of the CSP tools and techniques in mind, your model will be a unique example of your creative intuition, and will resemble nobody else's efforts. This is the way it should be. One example of a CSP ClayBot model created by the author can be seen in Figure 7.11.

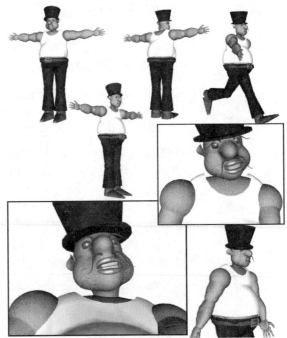

FIGURE **7.10** *On the left is the original Clay composite, and on the right is the translated Snapshot Mesh with a UVW Map applied.*

FIGURE **7.11** *One ClayBot concept given 3D life.*

Details on the ClayBot

The body and head were created with Clay Studio Pro, by first using standard spheres and then converting them to Clay Spheres. Then a Clay Surface absorbed them all into one element. The head and body were created separately. The eyes are standard spheres, and the lips are created from a Deformed Spline Loft. Teeth were "borrowed" from the Primitive Head model described later in this chapter. Clothes are just cloned from the underlying body parts and resized larger. Boolean subtraction was used to cut the necessary holes in the resulting Mesh. The eyebrows and mustache are clones of each other, created from a Deformed Spline Loft. The shoes are a Boolean Union of a Cylinder and half of a Cone primitive.

DAVINCI 3D

daVinci 3D is different from any other modeling system you will run across, in Max or elsewhere. daVinci allows you to create 3D models from "Minimal Surfaces," a proprietary paradigm, which can be compared to a soap bubble. daVinci calls these surfaces *TEMS* (*Triangular Elastic Membrane Surfaces*). Though TEMS feel a bit like working with NURBS, they are more friendly once you get the hang of them. TEMS modeling takes advantage of Curve, Point, and Force controls. daVinci models are composed of a hierarchical Parent/Child composite of TEMS. The Points, Curves, and Forces are sub-objects of a surface.

Curves

daVinci has four types of Curve controls: Free Curves, Embedded Curves, Pivot Curves, and Clamping Curves.

Free Curves

Free Curves are used for constructing Curve geometry. Free Curves can be moved within the boundaries of a daVinci surface, but not beyond it. (See Figure 7.12.)

Embedded Curves

The core use for Embedded Curves is to act as a cutting shape for the surface on which they rest. With one click, an Embedded Curve can cut the surface. (See Figure 7.13.)

Pivot Curves

Pivot Curves are best described as acting like a hinge constrain, although they have other uses for texture mapping and slicing. (See Figure 7.14.)

FIGURE **7.12** *Free Curves can be added anywhere on a daVinci surface. They can be open, as shown here, or closed.*

FIGURE **7.13** *An Embedded Curve was used to cut this surface.*

FIGURE **7.14** *The Pivot Curve displayed here is the straight line connecting the perimeter of the surface. Curves with points on the perimeter cannot be freely moved. Movement of perimeter-connected Curves results in the distortion of the daVinci mesh.*

FIGURE **7.15** *Here is a closed Clamping Curve in action. The surrounding mesh can move, but the area inside of the Clamping Curve remains anchored*

Clamping Curves

Clamping Curves are used to force the localization of any deformations applied where the curve resides. Clamping Curves limit the extent of surface deformation. (See Figure 7.15.)

Curve Control Points

Each time you click the mouse when creating a Curve, you create a Curve Control Point. These points can be either Smooth or Corner points. After the Curve is completed, Curve Control Points can be added or deleted at any time to refine the shape of the Curve.

Tangent Control Points

Tangent Control Points exist only on Clamping Curves, and act to limit the extent of deformation.

Forces

Forces act upon a region or an inactive Control Point to modify the extent of deformation. Forces have direction and magnitude.

THE REAL DEAL

The most confusing aspect of daVinci 3D is its documentation. It is poorly organized, unclear, and even wrong in some places. For instance, it states that a Point should be Rotated into place, when the truth is that it should be Moved. daVinci 3D is a great choice for the development of Patches for a 3D model, but you would not use it to develop a entire model. For instance, it is great for crafting sliced views of faces, but not a whole head. It excels even further for developing specific facial features like noses and eye details. Although all of the detailed controls mentioned can be used to develop extremely organic modeling patches, the short of it is this:

- Use Points to move the mesh in and out, giving it 3D dimension.

- Use Pivot Curves to create boundaries, on the other side of which opposite movement for selected points will occur. For example, placing a Point on one side of a Pivot Curve will cause the mesh on the other side to move in the opposite direction when you move the Point.

- Use Clamp Curves to severely constrain where Point movement affects the mesh.

- Use anything but Free Curves to activate the Hole function.

- Always set the Display Precision Height (10 is my default). You may think it only affects the display, but it really affects the mesh that is created when you transform a daVinci surface into an editable mesh or patch, giving you smoother results. Then you can Optimize a couple of times to decrease the polygon count.

- I would suggest always selecting a Circular surface when you work on developing a face (which is daVinci's best use). The Circle can be pulled out into a hemisphere by merely placing a point at its center and tugging perpendicular to the plane. The facial patch can then be attached to a spherical head form, even joined to a sphere by Boolean Union (though you will want to transform it to an editable mesh or patch first and optimize the polygon count). If the daVinci surface is on a hemispherical shape, you can embed that shape in the sphere before performing a Boolean Union, creating a pretty smooth model. (See Figure 7.16.)

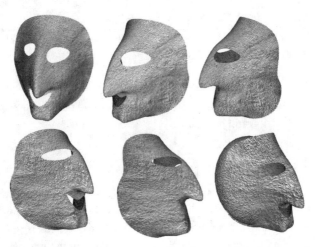

FIGURE *daVinci patches allow you to craft unique facial elements that can be later joined to other*
7.16 *3D forms.*

HEAD DESIGNER

Once this plug-in is purchased and authorized, you can find it in Create>Geometry>Parametric Heads. It was created for Digimation by Applied Ideas, Inc. Head Designer is the answer to many Max artist and animators' prayers, in that it gives you the instant ability to design and modify an array of human head forms. There are modification parameter controls for Head Shape, Nose, Chin/Jaw, Cheeks, and Eyes/Ears/Mouth. A collection of head types are included as presets, including Default, Alien, Musclehead, Geek, Cave Dweller, and Mad Scientist. Once you are finished customizing a head, it can be translated to an editable patch or an editable mesh for further modification. You can also save your own Head Designs as Presets for future use. (See Figure 7.17.)

Modification Parameters

You access the modification parameters by going to the Modify panel with one of the heads selected. Separate control Rollouts exist for Head Shape, Nose, Chin/Jaw, Cheeks, and Eyes/Ears/Mouth.

Head Shape

Head Design starts with one of two versions of a Generic Man, or one of two versions of a Generic Woman. From there, you can adjust Deformation on any XYZ combination of axes, Scaling (including Skewing) on any axis, Compression, Flat Top, and Forehead Slope. Even with these basic settings, there are unlimited possibilities for head variations. (See Figure 7.18.)

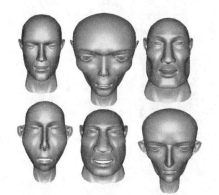

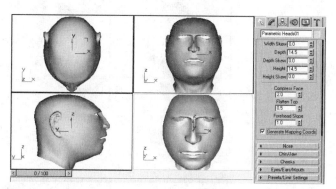

FIGURE **7.17** *The Head Designer Presets (top left to bottom right): Default, Alien, Musclehead, Geek, Cave Dweller, and Mad Scientist.*

FIGURE **7.18** *A design session in Head Designer starts with selecting basic components.*

Nose

Next, the Nose parameters are configured, with special controls for Width, Length, Bridge, and Hook/Pug. (See Figure 7.19.)

Chin/Jaw

The next step is to decide upon the shape of the Chin and Jaw, with controls for each. (See Figure 7.20.)

Cheeks

Cheek modification is next, with controls for both extrusion and position. (See Figure 7.21.)

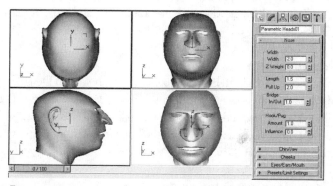

FIGURE **7.19** *The Nose is given its own personalization touches.*

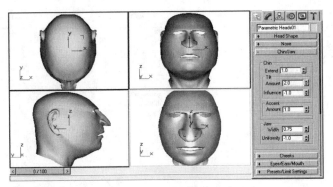

FIGURE *The Chin and Jaw are next to be shaped.*
7.20

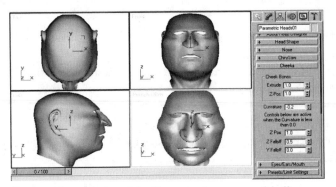

FIGURE *The protrusion of cheekbones can have a powerful effect on a*
7.21 *character's personality.*

Eyes/Ears/Mouth

Parameters for the Ears, Eyes, and Mouth are set last. These include Ear position, size, lobe length, and rotation, Eye separation, bulge, roundness, and brow bulge, and Mouth protrusion. (See Figure 7.22.)

Eyeballs and Teeth

You will notice that the head has no eyeballs or teeth, but Head Designer is prepared for that need. If you select File>Merge, and find the Head Designer folder in the Scenes directory, you will see Eyes, Teeth, and Fangs. Merge the selected files, and move/resize the elements as needed. Last, link the eyes and teeth to the head. The result is a pretty impressive unique head model. (See Figure 7.23.)

A Typical Head Designer Session

A typical Head Designer session goes like this:

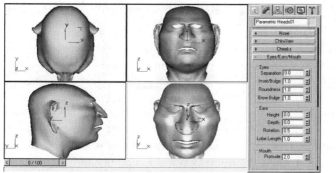
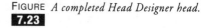
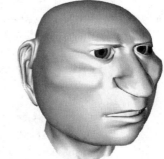

FIGURE 7.22 *The final head parameters to be set are for Ears, Eyes, and Mouth.*

FIGURE 7.23 *A completed Head Designer head.*

1. Open Head Designer, and place a Head on the screen (usually from the Top viewport).

2. With the head selected, go to the Modify panel.

3. Make all of the necessary adjustments to the necessary parameters.

4. Load and Link eyes and teeth.

5. Save the unique head as a preset.

6. Apply materials and render.

Further Modification Options

But what if you want to animate the features, adjusting them for new expressions? The best way to accomplish this is to transform the head into an editable Mesh or Patch, and do Sub-Object editing. This allows you specific controls over vertices and polygons. (See Figure 7.24.)

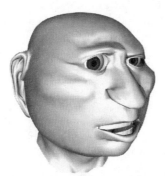

FIGURE 7.24 *After a few moments of Editable Patch Sub-Object editing on selected polygons, the emotional expressiveness of a head can be fine-tuned.*

See Section F (Twisted Reality) for other modification procedures that can be applied to a Head Designer head.

SPRAY MASTER

You might think of Spray Master as a cross between a particle system and the Scatter option found in Create>Geometry>Compound Object (which we detailed previously). With Spray Master, you can "spray" particles onto the surface of other selected objects, and then tell it to convert those particles into your choice of geometry types. You can use the Spray Master freehand spraying tool or Splines. Effects like creating groups of bugs or people, rocks on a landscape, hair on a face, and many other creative options suddenly become not only possible, but fairly simple.

The Spray Master Process

A basic rundown of how Spray master works is as follows:

1. Go to Create>Geometry>Digimation Particles>Spray Master.

2. Click on Spray Master to highlight it, and click-drag in the Top viewport to place the Spray Master icon.

3. Under Setup, set the Spray Radius. Set the Drops per Second, limiting the number of particles that will be sprayed per second from the Freehand Sprayer. Set the Alignment of the spray (Drops Orientation Rollout) to conform to your choice or World axis, which aligns the sprayed particles to that axis.

4. If you want to spray one of the geometric items already in your scene, open the Custom Drop Object Rollout. Select the object after clicking on Pick Geometry Object. Set its spray size and variation percentages. Try a default of 50 for each of these values, though selection will vary according to the effect you are looking for and the geometry chosen.

Spray Master output is similar to using a standard Scatter routine, the difference being that you have much more control over the target area.

MOVING ON

In this chapter, we focused upon four super modeling plug-in offerings from Digimation. In the next chapter, we look at the modeling plug-ins offered by Sisyphus.

CHAPTER

8

Sisyphus Succeeds

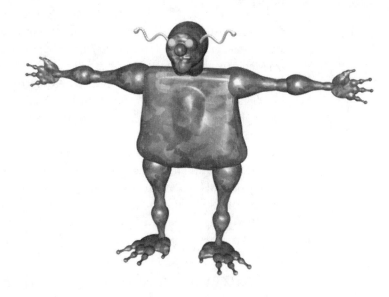

The myth of Sisyphus remains alluring through the centuries, since its inception in Greece in an ancient age. As a punishment for defying the gods, Sisyphus is doomed for eternity, forced to push a boulder up a steep hill, without ever being allowed to quite reach the top before having to start pushing it up again. If there is a Sisyphus staring at this world through the abyss of time, surely he is at least cracking a smile. The software company that bears his name, Sisyphus Software, continues to create some of the most innovative plug-ins for 3D Studio Max. Most of their plug-ins are covered in this book, this being the first. In this chapter, we'll look at Sisyphus Proteus, a new approach to metaball modeling.

PROTEUS PRIMITIVES

Once you have purchased and installed it, most of Proteus is accessed by going to Create>Geometry>Sisyphus Proteus. A few important components, however, are to be found in the Modify panel under the More button (unless you have placed the Proteus Modifiers in the standard Modify button's list). In Create>Geometry, five Proteus "primitives" are listed: MetaSphere, MetaCone, MetaBox, MetaTorus, and the all-important ProteusGeometry. Although the four 3D forms look solid enough when seen in a viewport, they do not render as they are. Instead, they act as parameter constructs for a Proteus model. The Proteus model centers around the parameter configuration of the ProteusGeometry primitive, which looks like a peanut. This Proteus element also does not render. The Proteus model is a result of adding the MetaPrimitives to the ProteusGeometry's resource collection. It all sounds rather complex, and it is a different way of thinking, but we'll march you through a tutorial or two to get you going. If you have Proteus, you can do the tutorials along with the book. If not, then perhaps seeing some of what it can do will motivate your purchase.

A PROTEUS HAND

If you have Proteus, do the following:

1. Select Proteus MetaSpheres from the Create>Geometry>Sisyphus Proteus Rollout. From the Top viewport, create a series of MetaSpheres that resemble the graphic shown in Figure 8.1.

2. Flatten out the large MetaSphere in the Front viewport, reducing the Y-axis to 25%. You can either use an X-Form Modifier, or better yet, just right-click on the Size icon and do it numerically.

3. Place a ProteusGeometry object on the screen (make it nonrenderable).

4. With the ProteusGeometry object selected, go to the Modify panel. Select Edit Selection List from the Rollout, and Include all of the MetaSpheres, moving them to the right column and selecting OK. (See Figure 8.2.)

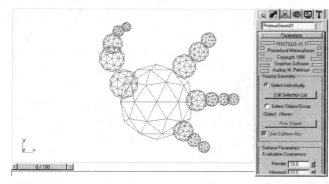

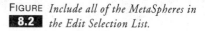

FIGURE **8.1** *Create this arrangement of MetaSpheres in the Top viewport.*

FIGURE **8.2** *Include all of the MetaSpheres in the Edit Selection List.*

5. The MetaSpheres are now acting as resources for a Proteus construct, as you will see when you look at the Shaded Perspective viewport, and a MetaBall hand is the result.

6. To smooth out the geometry, set the Evaluation Coarseness for both Render and Viewport in the ProteusGeometry Modify Rollout to 3. (See Figure 8.3.)

Normally, you could set the Coarseness of the viewport higher, perhaps to 6. When you plan to translate the MetaBall object into a Mesh later on, however, remember that it takes its mesh cue from the viewport value.

7. Translate the ProteusGeometry to an Editable Mesh, and Optimize. Select a UVW Mapping Modifier with Shrink Wrap Mapping. Find an interesting Material to apply

FIGURE **8.3** *The ProteusGeometry Hand looks very smooth with a Viewport and Render Coarseness setting of 3.*

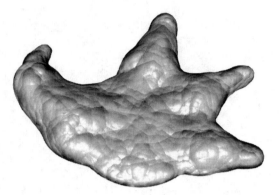

FIGURE *The result is a very organic-looking modeled*
8.4 *hand.*

to the hand (the one shown is Bumpy from the Elemental textures collection). (See Figure 8.4.)

If you want to use this basic Proteus method to model a collection of body parts that will be linked together, use a separate ProteusGeometry object for each body part group of Meta-Objects.

TIP

This Proteus technique doesn't use all of its bells and whistles, but it is still extremely effective and super-quick for developing very organic-looking modeled components. But wait, there are other super features that Proteus possesses.

PROTEUS METASPLINES

The simplest definition of a Proteus MetaSpline is that it is an object that results from the marriage of a Spline and Metaballs, allowing you even more MetaBall modeling functionality as a result. Unlike the Proteus elements we have covered so far, MetaSplines are activated from the Modify panel. Here's a basic MetaSpline tutorial. Do the following:

1. Go to Create>Shapes>Splines>Circle, and draw a Circle centered on the origin in the Front viewport that takes up about ⅓ of the screen.

2. Draw a Line that extends in a double curve from the Circle's perimeter outward. With the line selected, go to the Main toolbar and the Transform Center tool, and select Use Transform Coordinate Center. This makes the transformation point of the curve the center of the Circle. (See Figure 8.5.)

3. With the Rotate tool selected, shift-click and drag on the Curved Line in the Front viewport. Watch the Z readout at the bottom of the screen, and rotate the new Curve to 30 degrees. Release the mouse button.

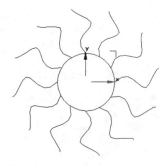

FIGURE
8.5
Create a Circle and a Curved Line arranged like this, with the Center Point of the Curve equal to the Center of the Circle.

FIGURE
8.6
The resulting form.

4. The Clone Options window appears. Select the Instance option, and place a value of 11 in the input area. Click OK, and you should see the graphic displayed in Figure 8.6.

5. Click on the Circle, go to the Modify panel, and select More. Select Edit Spline from the list. In the Edit Spline Rollout, click Attach, and select each of the Curved Lines that surround the Circle. You can also use the Selection List (press "H") to do this all at once.

6. Place a ProteusGeometry object in the scene from Create>Geometry>Sisyphus Proteus, and make sure rendering is switched off. Go to the Modify panel. Select MetaSplineMod from the More Modifiers list. Select a Thickness of 10. Although you won't see anything happen immediately, you have just transformed your Spline construct into a MetaSpline construct.

7. Select the ProteusGeometry object, and open the Edit Selection List in the Modify Rollout. Include the Circle MetaSpline by moving it to the right-hand column. Click OK. Now look at the shaded perspective viewport. Select a Render and Viewport Coarseness of 3, and turn Smoothing on. (See Figure 8.7.)

8. Select the ProteusGeometry, and translate to an Editable Mesh. Apply a UVW Map and a Material of your choice. (See Figure 8.8.)

By setting the Tension parameter of a Meta-Object, you determine its ability to literally reach out to its neighbors, to attract or repel. You can set negative Tension, causing selected Meta-Objects to cause depressions and holes in other objects. Personally, I am not a proponent of using negative MetaBalls to do this; it's far too complex and nonintuitive. I prefer to use Booleans or Mesh Editing to create negative spaces in an object, but each artist will have an opinion about this. Adjusting the positive Tension of Meta-Objects on extremely complex ProteusGeometry models does allow you to fine-tune the look of a model. Proteus provides you with an elegant way of setting Tension. The color of the wireframe equates with Tension values, with grays and black being negative

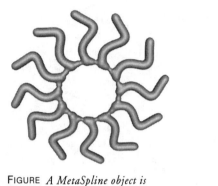

FIGURE **8.7** *A MetaSpline object is created from Splines.*

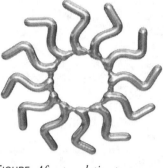

FIGURE **8.8** *After translation to an Editable Mesh, a Material is applied.*

Tension. I prefer using MetaBalls to create basic forms, and then embellish and fine-tune them with other tools and processes.

THE CHALLENGE . . .

Yep! One more time. Your challenge is to create a ProtoBot, using any of the tools and processes contained in Sisyphus Proteus. If you take this on, try to use both standard Meta-Objects and MetaSplines in combination. One possibility out of trillions is shown in Figures 8.9 through 8.14.

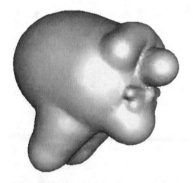

FIGURE **8.9** *Start of ProtoBot Head, created from MetaSpheres.*

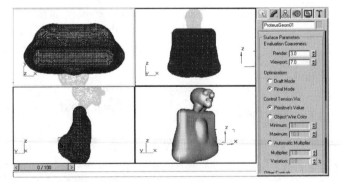

FIGURE **8.10** *Body created from MetaBox and MetaSpheres.*

FIGURE
8.11
Arms and Legs are added from the same cloned elements, created from two MetaSpheres and a MetaCone.

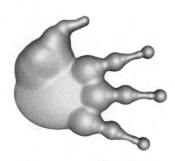

FIGURE
8.12
A Proteus Hand, created with MetaSpheres.

FIGURE
8.13
The almost-finished ProtoBot, mapped with a Galvanized Metal material. Hands were used as feet as well, and everything is Linked for posing.

FIGURE
8.14
For the final touch, two MetaSpline antennae are added, and some eerie eyes linked to the head. The ProtoBot rules the Meta-worlds.

STRETCHING THE LIMITS

Remember the chapter that started off this section, the chapter on Surf-iT, the Spline Modeling plug-in from Ghost 3D? Well, stop and think a minute. Surf-iT addresses a handful of 3D Spline forms. Proteus addresses Spline shapes through the MetaSplineModifier. Is it possible then to get the MetaSplineModifier to turn a Surf-iT 3D Spline into a MetaBall object? That's what I wondered, so I began some explorations. The answer (drum roll . . .) is a resounding YES!

WHAT DOES IT MEAN?

It means that any edited 3D Spline shape that you configure in Surf-iT can be translated into a MetaBall object, using the Sisyphus MetaSplineModifier. That opens up a whole new area for exploration, discovery, and complex MetaBall modeling. It gets even more interesting when you combine Meta-Objects with Surf-iT 3D Splines, and then perform a ProteusGeometry operation on them. Some examples are shown in Figures 8.15 through 8.20

 There's only one caveat with any MetaBall geometry: It is polygon intensive after translation to a Mesh, even with optimizing applied. That's why Metaballs are seldom the modeling tool of choice for game designers, because games require low polygon count models. If you use Proteus and also design game elements, consider the purchase of Digimation's Multi-Res plug-in.

FIGURE **8.15** *A MetaSphere sits on top of two Surf-iT Cone primitives, one of which is inverted.*

FIGURE **8.16** *MetaCone, Surf-iT Sphere, and a standard Star Spline, all combined into one MetaBall construct with ProteusGeometry.*

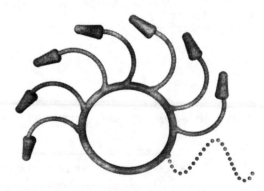

FIGURE **8.17** *A MetaTorus sitting on top of a Surf-iT Box, with standard Ellipse Splines attached.*

FIGURE **8.18** *A MetaTorus connected to standard Splines. At the end of the circular group of Splines are Surf-iT Cones. Everything is composited by ProteusGeometry.*

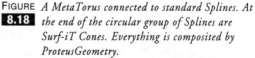

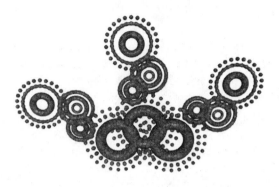

FIGURE 8.19 *Spline Donuts and MetaToruses.*

FIGURE 8.20 *Surf-iT Sphere with nine segments, processed through ProteusGeometry.*

As far as new modeling alternatives, Ghost 3D's Surf-iT and Sisyphus' Proteus work together like hand and glove. If you own one, consider the purchase of the other.

Also see the following for more Sisyphus plug-in details: Chapter 9, "The Nature of Things"; Chapter XX, "Sisyphus Climbs Again," in Section D (Particle System Modeling); and Chapter XX, "Plugging the Gaps," in Section F (Twisted Reality).

MOVING ON

This chapter was devoted to one of the many great Max plug-ins available from Sisyphus Software. More Sisyphus plug-ins, as well as plug-ins from other developers, are covered in the next chapter, "The Nature of Things."

9 The Nature of Things

Modeling the natural world imposes a new way of thinking on the digital artist and animator as compared to character creation or the fabrication of other objects—and it certainly demands a new set of tools. That's what this chapter is concerned with, the tools necessary for creating believable natural-world components, tools that are commercially available. In this chapter, we'll walk through Onyx' *Tree Pro/Storm*; Digimation's *Tree Factory, Splash!* and *Seascape*; Sisyphus' *Druid, Grass-o-Matic, Digital Nature Tools* and *Thor*; Itoosoft's *Forest*; Virtual Reality Labs' *Vista Pro*; and Animatek's *World Builder*.

More tools for modeling natural-world components can be found in Section C: Shareware/Freeware Modeling Plug-Ins.

ONYX TREE PRO/STORM

Tree Professional from Onyx was the first software application to allow you to create tree and other related forms based upon accurate scientific data, and it still holds its own in these areas. Tree Professional is a stand-alone application. (See Figure 9.1.)

Tree Pro includes all of the parameter controls you need to create real-world models of virtually any tree form you might need. Separate components address Conifers, Deciduous, and Palm types. To create a tree with Tree Pro, the following procedure is the most common:

1. Open Tree Pro. Select a tree from the hundreds of presets contained in the Tree Library.

2. Adjust any of the parameters to customize the tree to your needs.

3. Save the Tree, either as a Tree Pro parameter or a DXF model, or both. You can also save an image of the tree (BMP or Targa), an important option for 3D Studio Max users we will get to later.

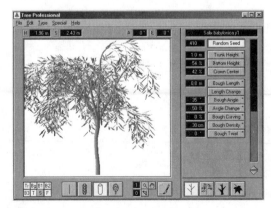

FIGURE *The Tree Professional interface.*
9.1

That's the short explanation. As for the details, there are many possible intervening steps along the way. For instance, "adjusting a tree's parameters" may involve a dozen or more steps, tweaking 60 or more parameters to get the tree unique to your needs. This is great news, because it means your tree model is absolutely guaranteed to be unique to your production. Tree parameter options are contained in four main windows: Trunk/Bough, Branch/Twig, Trunk Specific, and Leaf. (See Figure 9.2.)

Tree Pro also offers you the opportunity to custom color the leaves, with a separate window devoted to that purpose. (See Figure 9.3.)

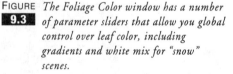

FIGURE **9.2** *The four window parameter dialogs used to alter a Tree Pro model. You can see that the options are quite extensive.*

FIGURE **9.3** *The Foliage Color window has a number of parameter sliders that allow you global control over leaf color, including gradients and white mix for "snow" scenes.*

One of Tree Pro's unique tools is a pruning saw. Using this tool, you can cut away branches from any tree model. As you might expect, the stump remains at the cut. Saving a tree as a DXF model means huge files if the tree has a lot of foliage or copious branches and twigs. For that reason, Tree Pro provides you with a DXF interface prior to saving the file that allows you to see how many polygons are involved, and what the projected model will require as far as your hard drive space. You can then access any of the specific components of the model and cut back selected tree parameters. (See Figure 9.4.)

Max can import DXF files, so Tree Pro can be used as a Max utility. You can also map images to planes in Max, so BMP and Targa output can be used as well.

Tree Professional is an excellent addition to your library of Max utilities, but Onyx also distributes another application based on Tree Pro that works inside Max itself: Tree Storm.

Mapping Tree Pro Images to Planes in Max

Actually, this information is about mapping any image to a plane in Max. Images mapped to a plane can be configured so that you can't tell whether the image is a 3D object or just the image of a 3D object. The secret is contained in two needed versions of the image: a color version for the Diffuse Mapping channel, and a two-color (black and white) version of the same image for the Opacity Mapping channel. This technique is not unique to Max, but holds for most professional 3D applications. The procedure is as follows:

1. Create a tree in Tree Pro that represents the content you need, as seen from an angle that you require.
2. Save the tree as an image (BMP or Targa). Import it into Photoshop or another suitable bitmap application.
3. Do not alter the image size or resolution. Use the Magic Wand tool on the background, and go to Select>Similar. This selects all places in the image where the background color appears. Make it solid black.
4. Go to Select>Inverse. This selects all of the nonbackground content.
5. Paint all of the included area (the tree data) solid white. You should now have a solid-white silhouette against a solid-black background.
6. Save the image as the same name as the color image of the tree, but add "opacity" in the name. For example, the name might be MyTree01_Opacity.BMP.
7. Open Max, and create a Rectangular Spline about the same proportion as your tree image that faces the Camera head on. Extrude it with a zero depth.
8. Go to the Materials window, and Map the Rectangle so that the Color image of the tree is in the Diffuse Map channel, and the Opacity image of the tree is in the Opacity Map channel. Use a UVW Planar Mapping type.

The result is an image of the tree in your scene that cannot be distinguished from a 3D model, as long as you look at it from a perpendicular angle. The background will have dropped away. This is a way to add crowds, flocks, and forests to a scene without the storage requirements demanded by 3D models. It does have a drawback in that facing the camera toward the plane or planes that use these images in other than a perpendicular manner will cause noticeable distortion of the content.

FIGURE
9.4
Using the DXF pre-save attribute options window, you can control the tree components to suit your available disk storage needs. The tree on the right, saved as a DXF model, would require almost 13MB prior to reducing some of the attributes in the pre-save DXF window.

ONYX TREE STORM

Onyx Tree Storm is a plug-in for Max. You must own Tree Pro to have access to Tree Storm. Once purchased and authorized, Tree Storm can be found by going to Create>Geometry>Tree Storm. Tree Storm accesses the same Tree Parameters Libraries as Tree Professional. (See Figure 9.5.)

Tree Professional is used to model and customize a tree's attributes. Tree Storm is used to bring tree models into Max where further modifications can take place. Tree Storm has a primary use as an animation plug-in, because it allows you to apply deformations to a tree model based on Wind calculations over time. (See Figure 9.6.)

As cautioned previously, this is not a book about animation in Max, so why be concerned about an animation device like Wind? Here's why. Wind causes the deformation of a tree at specific keyframes. If you go to those keyframes and Snapshot the tree, you will have created a new version of a tree for placement in your scene. This allows you to use Wind controls as a model modification alternative.

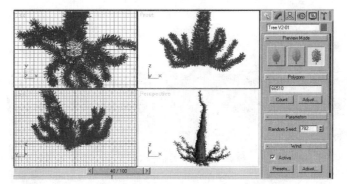

FIGURE *Tree Storm is a Max plug-in based on Tree Professional.*
9.5

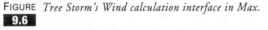

FIGURE *Tree Storm's Wind calculation interface in Max.*
9.6

Using Tree Storm

A typical Tree Storm session is as follows:

1. Open Tree Professional, and design the tree or trees you require, either from scratch, or by starting with one of the tree presets from the Tree Library.

2. Save the tree or trees as presets to your own folder in the Tree Library.

3. Open Max, and access Tree Storm. Load the tree or trees you designed from the Tree Library. Use Wind parameters if you like to modify a tree or trees at certain keyframes.

4. If you used Wind parameters, go to the keyframes that show discernible tree modifications, and Snapshot the tree at that point. Use as a modified model in your scene.

5. Place all of your trees in a Max scene where they serve to create the environment you are looking for. (See Figure 9.7.)

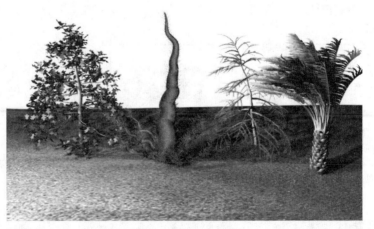

FIGURE *A collection of diverse Tree Pro/Storm models in a Max scene.*
9.7

DIGIMATION TREE FACTORY

Tree Factory is Digimation's offering to digital forestry. Once you own it and authorize it, Tree Factory can be found by going to Create>Geometry>Tree Factory. When it appears in the Create>Geomtery Rollout, it allows you to select from seven presets (Lucombeana, Pine Lo/High Res, Douglas Fir, Basic Tree, Palm A, and Cottonwood), or you may design your own tree model from scratch by selecting New.

NEW TREE PARAMETERS

Creating a New Tree Factory tree allows you to design the model (literally) from below the ground up, from roots to trunk to branches to leaves and flowers. You can base your new tree on any of the other presets mentioned, or call upon more presets that include Apple, Cottonwood, Joshua, Maple, Orange, Palm B, Weeping Pagoda, or Weeping Willow trees. A unique capacity of Tree Factory is its ability to offer you the opportunity to configure attributes by interactive curve painting. (See Figure 9.8.)

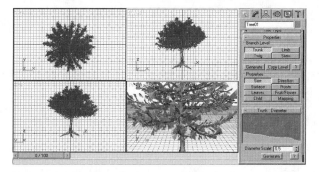

FIGURE *Tree Factory allows you to configure various tree attributes by drawing curves on a chart.*
9.8

Another unique property of Tree Factory allows you to generate tree roots. This can be useful in two situations:

- When you want to create cut-away views of trees for presentations that deal with environmental issues.
- When you are creating a scene that demands that tree roots be visible for emotional content. This happens in gothic stories and in trips through a bayou.

Tree Factory Session

A typical Tree Factory session in Max proceeds as follows:

1. Tree Factory is accessed by going to Create>Geometry>Tree Factory.
2. A tree model is configured in the Rollout, and a tree is placed in the scene (Top viewport).

3. Alterations are made as needed in the Modify panel.

4. New trees are added and modified if needed for the scene.

5. The file is saved and the scene is rendered.

(See Figure 9.9.)

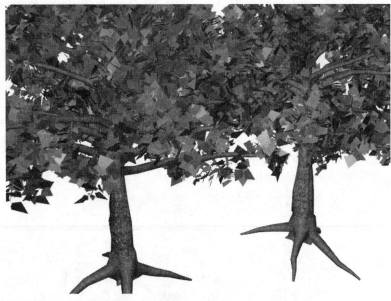

FIGURE *Two Tree Factory Apple trees.*
9.9

DIGIMATION SEASCAPE

Digimation's SeaScape is both a Geometry object and a collection of Space Warps (see Chapter 23, "Space Warp Speed," for more on Space Warps). The SeaScape Space Warps include RealSea, SeaRipple, SeaWave, and SeaWake. When you hear the term "Space Warp" in Max, it means that you are working with an animation effect. But, as we have said before, using Snapshot on any frame of a Max animation allows you to create a 3D model from the targeted contents of that frame. There is no reason you couldn't use a SeaScape object to create terrain effects as well. What really matters what Material is mapped to the SeaScape object. The SeaScape Space Warps act to deform the SeaScape surface in ways that emulate waves, ripples, and wakes. Do the following to create SeaScape data:

1. Go to Create>Geometry>SeaScape.

2. Input the parameters for the SeaScape Surface. This is a plane that will take on the Space Warp deformations. Configure it for the resolution needed.

3. Go to the Create>Space Warps>SeaScape panel, select one of the SeaScape Space Warps to apply, and click-drag it into place in the Top viewport.

4. Select the SeaScape Surface, and bind it to the selected Space Warp.

5. Preview the resulting animation to select a frame that looks interesting for a Snapshot.

6. Snapshot the frame, and modify the resulting mesh as you like. Render a preview after mapping with a selected Material, and save. (See Figure 9.10.)

FIGURE *This SeaScape Wave image was mapped with a corroded copper material, just right for a*
9.10 *polluted sea or rolling alien hills.*

SISYPHUS DRUID

Druid is a tree generator from Sisyphus Software. After you purchase it and authorize the plug-in, it can be found by going to Create>Geometry>Sisyphus Objects>Druid. A few of its special options include:

• The ability to include four leaf types on any single tree. They can be different sizes of the same one, or impossible combinations.

• Actual leaf shapes, instead of just x-sided polygons.

- The ability to save your creation to a selection list that is always loaded with the plug-in.
- The ability to add both twists to trunk and branches.

A typical Druid modeling session proceeds as follows:

1. Go to Create>Geometry>Sisyphus Objects>Druid, and click-drag in the Top viewport to place the tree.

2. Keep moving the mouse to configure the tree's initial height.

3. Configure all of the tree's components in the Modify panel Rollout.

4. Apply a UVW Map and a Material. I have had good luck applying a light wood material to a Druid tree.

5. Preview render and save. (See Figure 9.11.)

FIGURE *A group of Druid saplings sits on a grassy knoll.*
9.11

SISYPHUS GRASS-O-MATIC

This Sisyphus plug-in is an absolute gotta-have for all Max users. It comes with the Druid package. It's more fun to use than a bucket of oats. What it does is allow you to generate fields of grass with a number of parameter variables, including:

- Blade size and quantity
- Segments, Droop, Taper, Tilt, and Spin
- Clumps
- Smoothing options
- Ground Plane toggle
- Wind variables for animated effects
- Distribution Object

This last option is absolutely spectacular. Grass-O-Matic is a type of particle system, and like many other particle systems, you can select an Object of Distribution, so you can set grass growing on anything, even on a head model to act as hair or a beard (!). (See Figures 9.12 through 9.14.)

FIGURE *A field of wavy grass.*
9.12

FIGURE *The same grass as in Figure 9.12, but with Grass-O-Matic* Clumps *switched on.*
9.13

FIGURE *Mapped to a Head Designer head for hair.*
9.14

HOW TO CREATE A FIELD OF WHEAT

Here's how you can use Grass-O-Matic to create a field of wheat:

1. Set the quantity of blades to 12,000.
2. Turn Clumps on.
3. Make vertical size equal to 55.
4. Use just a 25% Droop, with a 50% variation.
5. Hide the Ground plane icon, and instead choose a more lumpy Distribution Object plane.
6. Use a planer UVW Map, and map with a golden-colored Material.

HOW TO CREATE A HEAD OF HAIR

Here's how you can use Grass-O-Matic to create a head of hair. You can use any head model you have, but this really works well with Head Designer:

1. Place your head model in the scene. Transform to an editable Mesh, if it is not in that form already.
2. Go to Sub-Object>Face, and use the Move tool to select the part of the scalp that will receive the hair.
3. Hold down the Shift key, and move the selected part of the head upward (Front viewport).
4. When the dialog appears, select to *clone to object*.
5. Open Grass-O-Matic, and click-drag anywhere in the scene from the Top viewport (but not over the head).
6. With the new Grass-O-Matic object still selected, go to the Modify panel. In the Grass-O-Matic Modify Rollout, set the quantity to 7500.
7. Set Droop to 100%, which will create hair that falls down. Set length to between 20 and 35.
8. Set the Distribution Object to be the cloned part of the head you created.
9. Make an appointment for your head model at the hair salon.

SISYPHUS (ARETE) DIGITAL NATURE TOOLS

This first edition of Arete Digital Nature Tools, distributed by Sisyphus, concentrates on Water, Air, and Clouds plug-ins. We will mention the unique attributes of each of these plug-in elements, and then walk through a couple of tutorial examples.

DNT WATER

The Water Objects are found by going to Create>Geometry>Arete DNT, and selecting the Object from the list. Seven items are included: *Water, Mirror, Ripple, Swell, Imprint,* and *Simple/Curved Wakes.* In much the same way that the ProteusGeometry Object in Proteus uses the other objects as forces that contribute to a shape, so the Water Object incorporates the other object-forces (called "Disturbances") to configure an animated water surface. Water is the necessary beginning step, while the other objects create animated effects (Disturbances). For this book's purposes (Modeling content, and not animation), concentration is focused on the Water Object only.

Modeling DNT Water
Do the following:

1. Go to Create>Geometry>Arete DNT. Click on Water, and drag out a grid in the Top viewport.

2. With the grid still selected, go to the Modify panel.

3. Set the Simple Grid Points to 24 x 24, if that's the Grid type you are using. At least explore the possibility of using a Radial Grid by checking it on.

4. Set Wind Direction and Speed. As a default, set Wind Direction to 35 and Speed to 15.

5. Go to Create>Lights, and select any light but an Omni Light. DNT Water uses a directional light to help in the creation of Water materials. When the light is created, position it and adjust its beam so that it illuminates the Water surface.

 The easiest way to place a light for DNT Water is to use Max Sunlight. Access Sunlight parameters by going to Create>Systems, and click Sunlight. Click and drag in the Top viewport to place the compass after configuring the parameters, and click again to determine the angle of the light.

6. Access the Material Editor. In any Material that is not yet being used, click on its Map Rollout to access it. Check Diffuse, and click the Diffuse Map button. From the New list, select DNT WaterRayMap. This is a special map for the DNT Water Object. The only setting I would recommend changing the defaults on, until you've had more time to explore, is under Water Color. Click to activate Manual instead of Automatic, and set the RGB values to 20 each. This may not be necessary for all conditions, but I have found that it works well.

7. Check Bump in the same Material Rollout to activate it. Click on the Image Map button. Select the DNT WaterBumpMap item under New. This is a special Bump Map for DNT Water.

8. In WaterRayMap, use the Edit Light button to select the directional light you placed in the scene.

9. Drag and drop this Material onto the Water Object.

10. You could record the animation at this point, and use it as an animated bitmap to place on any object in any scene. (See Figures 9.15 and 9.16.)

Any Object as Water?

One of the neatest attributes of the Water plug-in is that you can select an object and transform it into a Water Object. The reason that you might want to do this is that from the Top viewport, the transformed Water Object will maintain its shape. The other axes are flattened out. This allows you to draw a Spline shape in the Top viewport, extrude it (which automatically creates a Mesh), and use it as the shape of a body of water in your scene! Just do the following:

1. Go to Create>Shapes>Line. Draw a closed shape on the Top viewport that will be used as the shape of your lake or pond (or swimming pool).

2. With the shape selected, go to Modify>Extrude, and input a thickness value of 100. The shape is translated into a Mesh object.

FIGURE *A sphere floats on a wave of DNT Water.*
9.15

FIGURE *Talk about stunning complex models . . . Snapshot a DNT Water Object at any frame,*
9.16 *and map the resulting Mesh to create wonderful terrains.*

3. With the extruded Mesh still selected, go to the Modify panel. Under More, click the Water listing.

That's it. Not only is your new Water Object created, but it is instantly animated for waves as well, and can be targeted for a Snapshot Mesh.

AIR

The DNT Air option is an Atmospheric Effect. It is accessed by going to Rendering>Environment, and selecting AreteDNTAir from Atmosphere>Add. (See Figure 9.17.)

In order to work, DNTAir requires that there be at least one directional light in the scene. The easiest one to work with is a Max Sun (Create>Systems>Sun). All of the required parameters for configuring DNTAir are present in the Atmosphere Effects editing Rollout. As you configure the parameters, be aware of these points:

- Work with the Natural Air Color first, before exploring Set Manually or Use Light Colors options. This allows you to get a feel for the process.

- If your renderings are continually solid black, the first thing to check is horizon placement. Check where the horizon is in the Camera or Perspective viewport. DNTAir

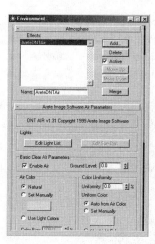

FIGURE *Add AreteDNTAir to the Atmosphere Effects list.*
9.17

works best when the horizon is set about 1/3 up from the bottom of the rendering viewport.

- Select Extend Effects Below Horizon to achieve a sky that works best when all you want to see is sky. You can also achieve this by moving the horizon out of the rendering viewport at the bottom.

- If you intend to use Haze, be aware that a haze placed between the viewer and the sun makes the sun look much larger.

- Set Haze to the following parameters to create an even layer of mist at the bottom of the screen, which might be just what is needed for a view out the window of an airship flying above a cloud layer: Filter Color of RGB = 222, 222, 222; Visibility at Ground Level 40,000; Height 3,500; Scatter of 100%.

- Your Sun color will be far more visible if you set the Air Color manually. A dark red works very well with a yellow Sun. Leaving the Air Color set to Natural causes the Sun to render white.

Try this to create an eerie night sky:

1. Make sure the Sun is in view, and set Edit Sun Disk parameters all to 100%

2. Set Air Color Manually to RGB = 112, 2, 182.

3. Set Color Uniformity to Auto from Air Color.

4. Enable Haze, and set the Filter Color to 40,000, 2,222, and 50 in the parameter input areas.

5. Extend Effects Below Horizon, and render to preview. If you like what you see, save to disk as a bitmap image.

- This is the ***Most Important*** point of all: Take a day to do nothing but create a variety of images with DNTAir, and save all of the sky images to disk as bitmaps. Use your choice of these sky images as Environment Map Backgrounds in Render>Environment. You'll save a lot of time the next time you need a personalized sky. (See Figure 9.18.)

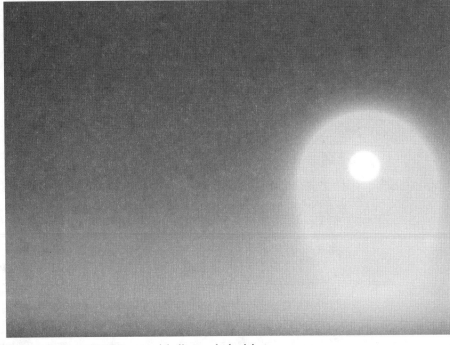

FIGURE *Use AreteDNTAir to model alluring sky backdrops.*
9.18

DNT CLOUDS

AreteDNTClouds are accessed by going to Rendering Environment, and adding AreteDNTCloud from the Atmosphere list. You have to add a separate DNTCloud for each separate cloud mesh in your scene. The DNTClouds look more like wispy fog banks, and suffer a lack of definition compared to real-world clouds, but they have their uses.

The settings are not intuitive, and take some exploration time to become comfortable with. Before creating Clouds, create a DNTAir sky. Here are some of the parameter values that I usually start with:

- NEVER set the Detail XYZ values above 3, or at most 4. If you set them higher, be prepared to hang up your system.

- Falloff to Moderate or Gradual. Gradual creates fuzzier edges.

- Falloff XYZ to 700 as a default.

- Cloud Size set to 1500 to 2500, though you'll have to experiment with this.

- Use a Target Direct light, and then select it from the DNTClouds Rollout in the Rendering Environment window. Point it at the mesh you are using as a bounding volume for the cloud.

- Use a Cylinder as a bounding Volume. Translate to an Editable Mesh, and give some Vertex randomness to it. Then select it as the Bounding Volume.

- Make sure that you have given some contrast to Illuminated Color and Shadow Color choices.

ELECTRIC WOOD

Sisyphus Thor is a lightning generator. You can set all of the bolts parameters, including branching and timed strikes, and also the source direction and target point. For animated lightning, you can't beat Thor. However, I want to talk about it for a very different reason, a modeling reason. Using a Snapshot on a Thor bolt at different frames of an animation creates exquisite tree forms that can be used for driftwood, or the blackened residue of trees caught in a forest fire, or in a no-man's-land scenario. Simply configure Thor's parameters and preview the animated result looking for bolt forms to Snapshot. Use these Mesh objects in an appropriate scene. See Figure 9.19.

Thor Snapshots also make great hanging vine objects, and add a perfect touch to gothic scenes.

ITOOSOFT FOREST

Itoosoft (www.itoosoft.com) markets a special nature-oriented package called *Forest*. If you recall the details provided on mapping images to a plane at the start of this chapter (in the section on Tree Professional), than you will understand how Forest works and what it can provide. Let's recap some of the details, and look at Itoosoft's Forest with them in mind.

The image maps that come with Forest depict a variety of trees and other items as seen from a front view. Two versions of an image are included: a JPEG Color Map meant for the Material Diffuse Channel, and a GIF black-and-white image meant for a Material Opacity Channel. The GIF image shows a white silhouette of the selected color image on a solid-black background. When Opacity mapped, the black is read as 100% transparent and renders invisible. The white renders as 100% opaque, and so allows that part of the color image that matches the white silhouette to be visible. That is the secret to opacity-mapped imagery. You can develop your own image content based on this technique. Opacity-mapped images are usually mapped to a plane that is positioned exactly perpendicular to the viewing camera.

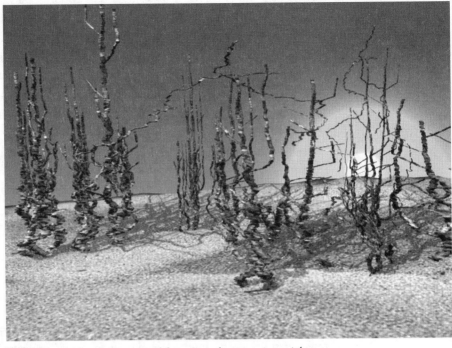

FIGURE *Remnants of a once proud forest struggle to remain upright.*
9.19

If the angle of view is altered, the plane will skew and the image will suddenly look thinner on the horizontal and/or vertical dimension. For this reason, opacity-mapped image content in a scene has limited use.

But what about the benefits? Well, because you can't distinguish the image of a opacity-mapped 3D model from its actual existence, as long as the angle of view remains consistent, opacity-mapped imagery saves a huge amount of render time and disk storage space. Its common use is for scenes that need a lot of "crowd" content, like herds or schools or flocks of animals and fishes and birds, or groups of people, or squadrons of flying craft . . . you get the idea. That way, a real 3D model of the same content can be used as the star actor and placed in the foreground. Most 3D-capable computers do not have the rendering power or storage capacity to handle hundreds of 3D models at once, but they do have what it takes to handle a few 3D models and almost any number of opacity-mapped elements. That is what Itoosoft's Forest is meant to be used for.

FOREST'S TOOLS

What makes Forest unique is that it was developed specifically for Max users, and features specific components to make a scene composed of Forest components easier to conceptual-

ize and render. There are four items involved: Forest Libraries, Forest Camera Utility, Forest to Planes Utility, and X-Shadow.

Forest Components

- **Forest Libraries**: A wealth of high-quality image content for Forest is included with the software, and also available with expanded Forest Packs for an additional cost. Content varies from flora to other imaged 3D objects.

- **Forest Camera Utility**: The Forest Camera Utility makes sure that the Camera is pointing at the right angles to make the mapped planes look like 3D objects.

- **Forest to Planes Utility**: With Forest Pro, you can translate a Forest Object into a Planar Object, and customize the content of each planar surface.

- **XShadow**: XShadow is a high-priority component of Forest. Using XShadow, Forest planar images cast believable shadows in a scene. (See Figure 9.20.)

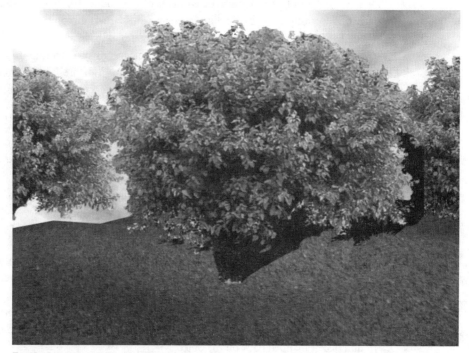

FIGURE *An Itoosoft Forest enabled scene.*
9.20

NATURAL SCENE DESIGNER DEM TERRAINS

If your Max obsession, or one of them, centers around the creation of terrain components, then you should explore Natural Scene Designer from Natural Graphics at the earliest opportunity. Version 2.5 was available at the time of this writing (www.naturalgfx.com).

Although Natural Scene Designer does not have any direct handshaking capabilities with Max, it does offer various forms of output that you can use in a Max environment, including:

- Extremely detailed bitmap renderings, still and animated, that can be used for Max backgrounds and for mapping objects.

- DXF object export, so that Max can import the modeling data. You can also select to export the terrain image maps for use in Max Material channels, or use any Max Material on the imported DXFs.

There is one attribute of Natural Scene Designer that makes it a veritable treasure for Max terrain buffs. Natural Graphics has developed this application so that it imports DEM (Digital Elevation Models) created by the International Geological Survey organization. The IGS DEM collection represents detailed maps of just about every location on the globe, originating from fly-overs by satellites and aircraft. Natural Graphics has translated a series of these maps for most locations in the United States so that they work seamlessly with Natural Scene Designer (volumes sold separately). This means you can import a DEM into NSD, tweak it as desired, and output it in DXF format for Max use, giving you Max access to detailed realistic terrain. You can develop Max projects for clients that demand geographical accuracy of definitive locations using this method.

NSD is more than that. It has a tremendously variable terrain engine that allows you to create your own terrain designs, including skies, lakes, forested hillsides, customizable elevation parameters, and much more. All of this data can make its way to Max as an image, an animation, or as a DXF model. (See Figures 9.21 through 9.24.)

INCORPORATING COREL BRYCE TERRAIN OBJECTS

Bryce 4+ allows you to export any of its 3D Terrains as DXF or WaveFront OBJ objects. Max can read OBJ if you download the OBJ2MAX plug-in from any Max website. I highly recommend that you use OBJ files as Bryce exports whenever possible, and avoid DXF models. DXF models have far too many polygons compared to other 3D file formats, and also are unable to export Material maps except that they can be saved separately in many applications and planar mapped back on the object.

Bryce ships with dozens of unique terrain maps that can be translated to 3D terrain in its Terrain Editor, and new features can be painted in. Just export to a OBJ file and import to Max for placement.

www.corel.com

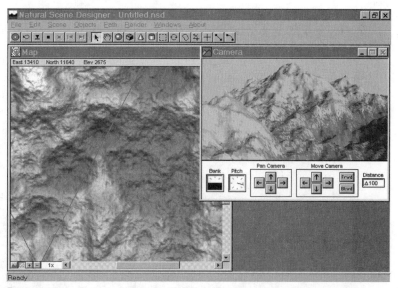

FIGURE
9.21
NSD offers you both a detailed elevation view and a Camera view of the terrain being designed for rendering or export.

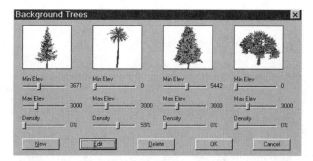

FIGURE
9.22
Trees are placed according to elevation and density parameters, and include four possible types: Redwood, Palm, Sweetgum, and Oak.

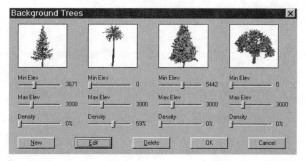

FIGURE
9.23
Separate Random generator engines are included for the creation of bushes and rocks.

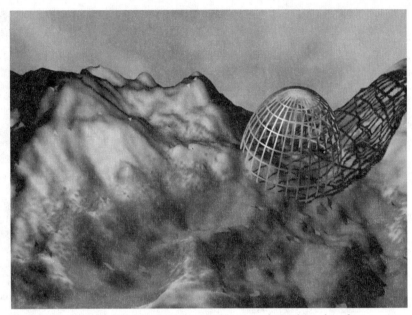

FIGURE **9.24** *Once a NSD DXF is imported into Max, it can be used as a base for integrating with all kinds of Max objects, like the wireframe sphere shown here.*

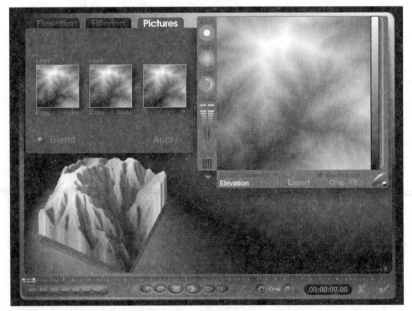

FIGURE **9.25** *The Terrain Map configuration window in Corel Bryce.*

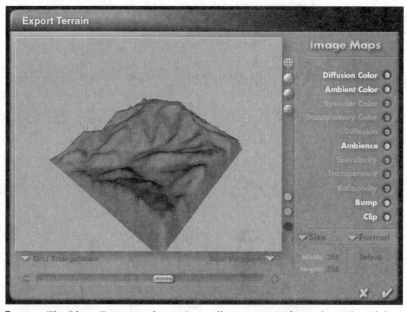

FIGURE **9.26** *The Object Export window in Bryce allows you to configure the quality of the model based on the number of polygons and size.*

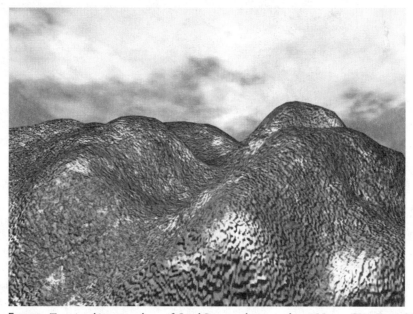

FIGURE **9.27** *Terrain objects saved out of Corel Bryce and imported into Max as WaveFront OBJ files create very nice modeled content.*

VIRTUAL REALITY LABS VISTA PRO

Though not as full featured as Natural Scene Designer or Bryce, Virtual Reality Labs Vista Pro also allows you to create terrain for Max. Simply save a DXF object from a DEM file in Vista Pro, and save the texture map that is associated with it (BMP or Targa). In Max, Import the DXF with all default parameters, and then apply the texture as a UVW Planar Mapping type. (See Figures 9.28 and 9.29.)

FIGURE *An image of Crater Lake created in Vista Pro.*
9.28

ANIMATEK'S WORLD BUILDER

No other natural-world content software works as seamlessly with Max as Animatek's World Builder does. Using World Builder by itself allows you to create Max natural-world environments with all of the trimmings. You can create everything from your personalized view of Eden to more contemporary worlds, and everything handshakes with Max along the way.

FIGURE *A DXF model of Crater Lake, saved from Vista Pro and imported into Max with the*
9.29 *texture map applied.*

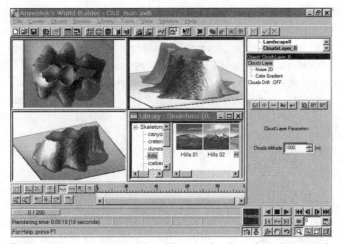

FIGURE *The Animatek World Builder interface has a look this reminds you of Max.*
9.30

TWO WORLD BUILDER TUTORIALS

In the following tutorials, AWB users will get some hints and tips from two master World Builder artists.

MASTERING THE AWB MAX COMMUNICATOR UTILITY

By Igor Borovikov

Overview

Every one who ever used z-buffer compositing to bring together images from different packages knows how laborious and time consuming the process can be. Almost every change in the scene or camera layout requires re-rendering of the entire sequence. Matching objects in two different packages can also be quite tedious and is always error-prone. Yet, this traditional method is the main method to compose output from most of the packages on the 3D market—fortunately not in World Builder.

The Max *Communicator* utility offers a much more efficient way of compositing. It relies on Microsoft's COM technology. This technology allows exchanging and sharing of data between applications during runtime. The most common examples of COM-enabled applications can be found in Microsoft Office. To edit an Excel spreadsheet or Access database inside a Word document, you just double-click on the object inside the text, and immediately the other application becomes available for editing of the alien data. In the case of MS Office, external applications (COM servers) are integrated very closely with the client application so that they can even substitute the interface of the client application.

In 3D graphics there are not many examples of such close interaction. AWB-Max Communicator is one of the most sophisticated and advanced examples. When World Builder works together with 3DS Max, it uses the Communicator to enable a COM interface connecting the two programs. Just as in the case of MS Office, each program remains responsible for its part of the 3D document. World Builder keeps and handles data relevant to the natural environment, and 3DS Max works with all the rest of the data, including characters, architecture, etc.

In MS Office, when you print the compound document with text, spreadsheets, and databases, all the applications responsible for the data in the document participate in formatting and creating the elements of the document for the final output. In the same way, AWB works together with Max to produce the composite output. It requires a lot of information to be sent back and forth between applications. For example, cameras and lights must match, their animation must be identical, and shadows and reflections have to be composited to give realistic physically correct output. All this data exchange is transparent to the user.

The two applications exchange data through memory, skipping time-consuming disk operations. Besides speed, it gives other additional advantages. At runtime, a lot more data is

available when the programs can query each other about any vital scene characteristics. This is either difficult or impossible in offline file operations. Due to additional data available for the compositing, the composition of the two images is practically seamless. Compositing covers not only shadows and reflections (a 3DS Max character can be reflected in AWB water, and cast and receive shadows to and from the environment as we will see later in this tutorial project), but can also treat edges of the objects in a more accurate way than in the offline z-buffer compositing.

This runtime data exchange also provides a huge advantage for the design process itself. AWB and Max can visualize meshes, cameras, and lights in the editor. This makes navigation in the composite scene very simple. Even 3DS Max gizmos can be visualized in AWB, so that placing 3DS Max fire on a AWB tree is much easier than using the offline approach. An animation can also be updated in real time with automatic matching of time segments. Each application can automatically track the change of the current frame in the other one.

The overall functionality of Max Communicator makes the integration of AWB with 3DS Max even closer than some internal Max plug-ins. Communicator converts the two programs into plug-ins for each other (hence the joke that 3DS Max is the best-selling plug-in for World Builder!). Yet both applications are standalone and fully functional. After starting a project in both programs, you can turn the Communication utility on and off at your discretion. Both programs save files separately.

An Example of Max Communicator Usage

Communicator works in a very similar way in both versions 2.x and 3.0 of AWB. Version 3 of AWB will be out by the time this book reaches the readers, so we will use version 3 to show how the two applications work together.

The Initial Handshake

Models created in 3DS Max can be architectural, characters, or many other types of forms. Let's look at an example with an animated droid in a 3DS Max3 Scene. You can find it in the folder with IK samples. The droid makes several steps and moves its arms. This animated character will need some additional tweaking to be placed on the ground level in World Builder. Do the following:

1. Create a simple flat mesh in Max that roughly outlines the path of the droid. It will not be rendered, but will be used as a reference object inside AWB. Use the Top view to make the outline, and the side views to make sure that the mesh is exactly on the ground level. (See Figure 9.31.)

If you are using AWB 2.x, there is a problem with importing and displaying completely flat meshes. You should move one or two vertices out of the plane to make the mesh non-flat.

2. Now we are almost ready to launch World Builder and create an environment for the droid. In Max3, the Communicator utility is found by going to Rendering>Environ-

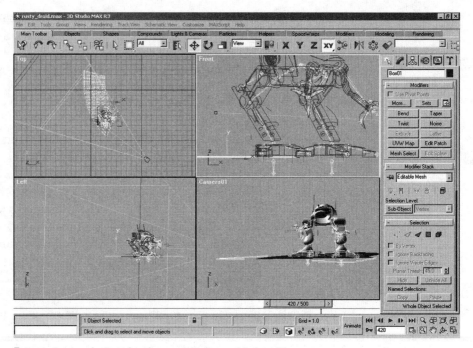

FIGURE *Import the Droid and create a Reference Mesh in Max.*

9.31

ment. In this dialog, press Add and select the AWB Communicator utility. Right after that, you will be prompted to launch World Builder if it is not running already. (See Figure 9.32.)

3. To complete the handshake, you need to create a Max Communication Object inside World Builder. This is very straightforward. Use the menu command Create>Communication Object>Max Communication Object. After that, you will see something like Figure 9.33 in the AWB window.

4. To the right, you can see the Property Editor that shows the interface for the Communicator object. There is a complete list of all of the meshes, cameras, lights, and gizmos that are present in Max scene. The list can be updated at any time and also allows the importing of objects from Max. Instead of static import, this function places fully functional 3D objects in an AWB scene, while keeping a link to the original object in Max. So, for example, when the animation is played back, AWB will ask Max about the current location of the meshes, cameras, etc., and will update corresponding items in the scene.

5. Let's import all the meshes and other objects into our AWB scene. Just press the Select All button and press the Apply icon on the Property Editor toolbar. For this tutorial we will make this operation address all the four object categories in Max. In the actual

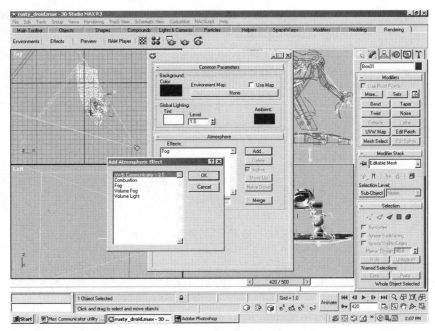

FIGURE *Launch the AWB Communicator utility from Rendering>Environment in Max.*
9.32

FIGURE *Here's what AWB will look like once Communicator is launched internally.*
9.33

production you might want to limit your import to only a few necessary reference objects. That will keep the AWB views less cluttered. (See Figure 9.34.)

6. Now we can select Max Camera, which is visible as a subnode of Max Communicator Object, and open the Camera window. If you move the time slider, you can see that the droid and camera inside World Builder move exactly as they do in Max. Also, if you move the slider to some frame in World Builder, Max will move to the same frame too.

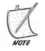

This type of exchange works for camera and lights in both directions. You can also import cameras and lights from AWB to Max. The only difference is that you have to initiate Import from the Communicator dialog inside of Max.

7. After completing these preliminary steps, we can render the droid from World Builder. While the Camera or any other viewport is active, click on the Render Phong icon in the main toolbar. Since the native World Builder scene is empty, it will immediately start rendering the droid in Max. In a few seconds, an image of the same quality and look as Max rendered it will appear in AWB! The output is displayed in AWB, not in Max. (See Figure 9.35.)

FIGURE *Import the selected Max objects.*
9.34

FIGURE *The Max rendering magically appears in AWB.*
9.35

If you try this experiment with the file from the Max IK Samples, make sure that you switch off the Fog Atmospheric filter in Max (Render>Environment). Otherwise, it will mess up the z-buffer before being passed to AWB, and the result will be a solid color image with no other objects visible. Also note that the Communicator utility requires a correct depth channel for images rendered in Max. The depth channel is enabled only if you switch on the Atmospherics option in the Max Rendering dialog. After switching it on, you need to render a test image in Max to apply the changed options.

From this point on, you will work mostly on the AWB scene, creating the landscape and vegetation, lights, etc. Note that this workflow, starting with Max models and animations and then proceeding to World Builder to make an environment, is more preferable than the opposite. Following this approach, you will create the landscape and other natural objects of the correct size and at the correct location from the very beginning. Rescaling and moving around inside a massive AWB scene could be a rather painful process. Matching scales, units, and locations from the start will save you a lot of time.

Making Footprints

The mesh that we created to outline the droid's path can be used to profile a terrain surface. We will use the *footprint* feature for this task. Profiling with *footprint* will ensure that the terrain is at the exact level wherever the droid goes in this animation. To apply this mesh as a

footprint, you need to explicitly export it into Max, then import it into AWB to ensure that you selected the correct units.

1. Add a footprint modifier to the Skin property node. In the Property Editor, you can right-click on the node to get the pop-up menu for this node. Select Add from the menu for Skin node, and select Footprint from the list of modifiers.

2. The Footprint modifier will display a list of all meshes that can be used to profile the terrain. The mesh that we need in this case is named box1. Select it. Then make the skin by pressing the corresponding icon on the toolbar. You can also rely on AWB's ability to detect the changes in the scene and rebuild the landscape surface automatically. The next time you render the viewport, you will see that the terrain surface sticks to the mesh box1. Now you can hide this reference mesh. (See Figure 9.36.)

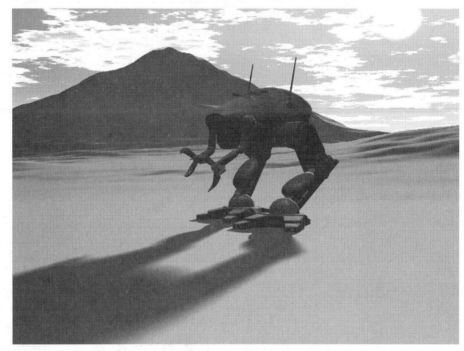

FIGURE *Results of the Footprint modifier.*
9.36

Exactly the same technique works if you need to make a footprint for a building or other 3DS Model.

The image here is intentionally left with z-buffering artifacts to show that the location of the meshes in Max, AWB, and the terrain surface are practically the same. Of course, after

you make sure that everything matches, you can hide these auxiliary meshes in Max and AWB.

Tuning the Camera and Lights

Up to this now we used the default Max lights and the Max Camera. Now we can tune or replace them both to achieve our artistic goals.

1. We need to adjust the Camera to show a more distant terrain. Right now, the Camera angle is too steep and does not show much of the terrain. To do this you can export the AWB terrain mesh as a reference object into Max, or just continue using Communicator, bypassing file import/export entirely.

2. After making changes to the Camera in Max, you can return to AWB, updating the Max objects from the main page of the Communicator Object and re-render the view. Or, you can create an entirely new animation Camera in AWB, using the Max Camera as a reference. Both methods lead to the same result. Communicator automatically sets active Camera parameters for Max rendering. You can also export the AWB Camera to Max.

Lighting

To make the lighting of the droid and the scene consistent, we need to use the same lights for both parts of the scene. We can either disable the original Max sources or import them into AWB. You can also remove the light sources from Max and import the Sun light source from AWB.

1. In AWB, set up a light source to generate shadows. Shadows in World Builder are very flexible, so you can have several shadow maps associated with the light source, each with a different resolution and behavior. For this tutorial, use a single shadow map that covers the droid and rebuilds the shadow every time you render an animation frame. You can use a separate map to generate shadows from static objects, like mountains, and that map can be generated only once for the animation. Shadows can also be softened, as when the sun is partially hidden by clouds. You can use an additional directional light to simulate scattered bluish light from the sky.

2. Reflections can be composited in exactly the same manner as the shadows. If there are shadows visible in the reflections, they would composited as well. (See Figure 9.37.)

With an additional skeleton we can dig a hole in the World Builder terrain. Then we can add a small pool in front of the droid to show its reflection. The "water" is still and close to a perfect mirror.

The Final Rendering

To make the scene come alive, we placed a texture on the terrain and some objects, including fir trees, right behind the droid. Notice that the shadows from the trees and the droid are

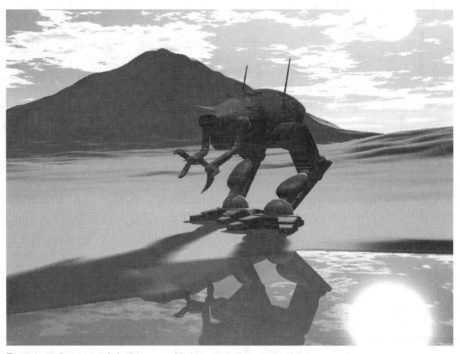

FIGURE *Reflection and shadow are added.*
9.37

composited automatically. The droid is anti-aliased against the background, and the AWB objects are also anti-aliased against the droid. Imagine how much effort would be required to achieve the same result with traditional z-buffer compositing. With the Max Communicator Utility, you get the finished image in one rendering pass.

A few more advanced AWB features were used in the final image: a little bit of volume light, ripples to the water, and an exposure correction filter that simulates THE chemical process in film. For the final rendering, the ambience in Max was made somewhat closer to the overall bluish tint of the scene in AWB. (See Figure 9.38.)

This tutorial project was created on a Dual Pentium III 500 MHz with 512MB of RAM and a Tornado 3000 video board, running Max 3, and AWB release 3. Windows 2000 was the operating system. The entire project was completed within four hours, including the time spent making notes and a little snack :-). The final rendering took 45 minutes for the image (800x600 with anti-aliasing 2). The scene is quite rendering intense because of the reflections, shadows, and volume light.

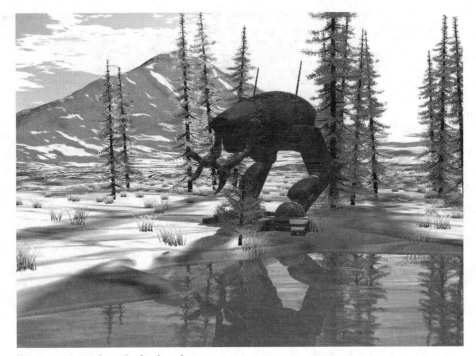

FIGURE *A frame from the final rendering.*
9.38

AWB PLANT CREATION

By Eddie Christian

There are many options when it comes to plants in WB3. You have a variety of pre-built plants in the libraries, or you can use the Plant Wizard to make mutations of base plants. All these options are perfectly viable, but at times, you need to actually construct a tree from scratch. Here's how to do it:

1. Start World Builder 3.0. The application will open with the default start-up scene. (See Figure 9.39.)

2. The next step is to go to Create>Plant on the main menu in the upper-left corner of your screen. (See Figure 9.40.)

3. Now you will be able to draw the tree's trunk. Place the cursor somewhere in the Front viewport, and draw the trunk by holding the left mouse button and dragging out a line. You may add additional segments to your trunk by letting up on the left mouse button and repressing the button and continuing to draw. Each time you release the

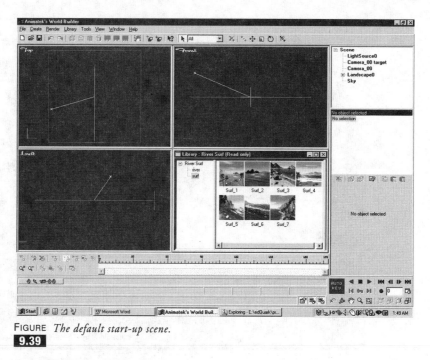

FIGURE *The default start-up scene.*
9.39

FIGURE *Go to Create>Plant.*
9.40

left mouse button, you create a new anchor point on the trunk's spline. You end the trunk creation by pressing the right mouse button. (See Figure 9.41.)

The cursor will have a small tree icon when you are in plant creation mode.

4. Now we can begin to add branches. In order to do that, we should zoom in on the Object. Zooming in will automatically deselect the tree. If the tree ever does become

FIGURE *Draw the Trunk Spline.*
9.41

deselected, you may pick it in the Object Tree or use the Selection Cursor to reselect the tree. You can always use the standard Selection Cursor to pick objects by clicking on them with the left mouse button.

5. Click the Viewport Select Zoom tool and, using the left mouse button, click-drag a box slightly larger than the tree (in the Front viewport). What this tool does is zoom into an area that you pick when you click-drag. As soon as you release the left mouse button, the viewport will zoom into the area you selected. (See Figure 9.42.)

FIGURE *The Viewport Select Zoom tool on the left, and*
9.42 *the Standard Selection Cursor on the right.*

6. Now we can edit the tree trunk. We will be adding two branches in the Front viewport and two branches in the Left viewport. If you wish, you should zoom in to the Left viewport as well. Before we proceed, you should save the scene file. Go to File>Save As and save your file as Mytree.awb. The extension is added automatically if you don't type it yourself.

7. At this point, you are now ready to add branches to your tree. The principle behind creating branches is the same as the tree trunk. You draw segments of the branch by dragging with the left mouse button. You can always add additional segments by releasing the left mouse button and dragging out a new segment. Last but not least, you end the branch's creation by clicking on the right mouse button. (See Figure 9.43.)

NOTE

There are only two things you must remember if you want to edit your tree. The first is that the tree must be selected, and the second is that you must be in Plant Editing Mode. Plant Editing Mode

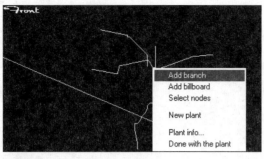

FIGURE *Add branches to the tree.*
9.43

allows you to alter your tree. You can tell if you are in Plant Editing Mode by making sure the button is pressed. The button is located in the upper-right corner of your screen. The Plant Editing button only appears when a plant is selected. (See Figure 9.44.)

8. Now all you have to do is right-click over the tree trunk and select Create Branch from the pop-up menu that appears. You can adjust the placement of your branch by just sliding it up and down the tree trunk. Remember to right-click when you are finished drawing your first branch. Create at least two branches in both the Front and Left Side views.

9. At this point, you should have four branches and a tree trunk. Now we are going to edit the points that make up the splines for the tree's branches and trunk. You have the options of bending or moving any section of your tree. This allows you to create objects with a more organic feel to them. To edit the tree just right-click the tree and pick Select Nodes from the pop-up menu. You will see all the points that make up the tree's branches and trunk. (See Figure 9.45.)

10. At this point, you can just play with your tree until you get the look you want. The first thing you want to do is to pick some points on the tree. You do this by holding down the left mouse button and dragging a selection box around the points you want.

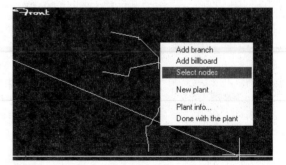

FIGURE *The Plant Edit Button.*
9.44

FIGURE *Pick select nodes.*
9.45

If you wish to change you selection, you can deselect points by left-clicking any blank area on the viewport. You can tell which points you picked because they will turn red. After you have picked some points in either the Left or Front viewport, you must right-click you mouse to activate the plant editing pop-up menu. For the purpose of this tutorial, we will only use the Bend Selection option. You can also move any selected nodes. Feel free to experiment with both options. Adjust your branch and trunk until you are happy with its shape. At this point, you may wish to test render the tree and save your scene again.

Bend Selection and the Move Selection commands are toggles that you can turn on or off at any time. If either command is currently active, you will see a small check mark on the left-hand side. (See Figure 9.46.)

11. The last step is to add some "Billboards" for the leaves. Billboards are just flat surfaces that always face the camera. They usually have a solid colored background as a mask (or an alpha channel mask). Adding them to your tree is similar to creating branches. You right-click to active the Plant Editing pop-up menu and choose Add Billboard. (See Figure 9.47.)

12. The only tricky thing to remember about billboards is that they can float in mid air if you wish. As soon as you choose Add Billboard, you will see a line that slides up and down the branches as you move your mouse. Drag the line around until it is where you want to place your billboard. Click the left mouse button once. Now you have placed the location of the base of your anchor line. Move the mouse until the line is as far out as you wish. As soon as you press the left mouse button a second time, you will see a square appear. The square will increase or decrease in size as you move the mouse. The square represents where the foliage will appear. The anchor line shows you how far out the image is from the tree branch. When the square is the size you want, just left-click the mouse once. Now you have leaves. If you don't like the default

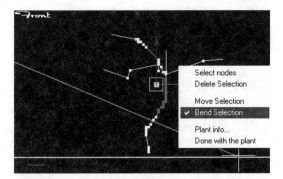

FIGURE *Choosing Bend Selection from the pop-up menu.*
9.46

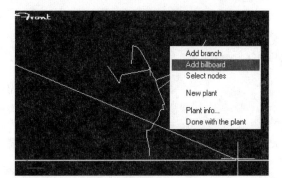

FIGURE *Select Add Billboard.*
9.47

leaves, you can always go to the Properties Editor and select a different image file. (See Figure 9.48.)

Final Notes

This tutorial is a beginner-level lesson. It does not cover advanced selection, translation, or rotation of objects. Also, it is assumed that you know how to use the object and property panels. The last thing I will mention is that the raw ASCII data for a tree can be exported and used by game developers and third-party vendors. Just select the tree you wish to export and go to File/Export/Plant Skeleton. (See Figure 9.49.)

This will create an ASCII file with a .pls extension. See the technical manual for further information.

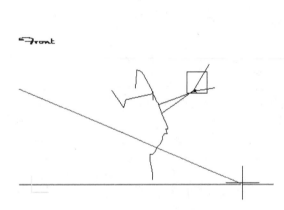

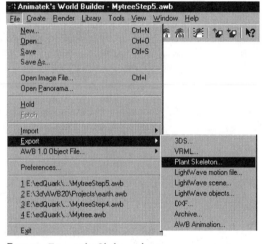

FIGURE *Placing a Billboard on a tree.*
9.48

FIGURE *Export the Skeleton data.*
9.49

WHAT'S IT ALL ABOT?

Remember the poem . . . "I think that I have never got, a stranger thing like a TreeBot?" Well, maybe I've modified it a bit, but you get the idea. Take the skills you've honed in this chapter, and build a Linked TreeBot. Use any of the Tree plug-ins you have to craft the parts. One possibility is shown in Figure 9.50 .

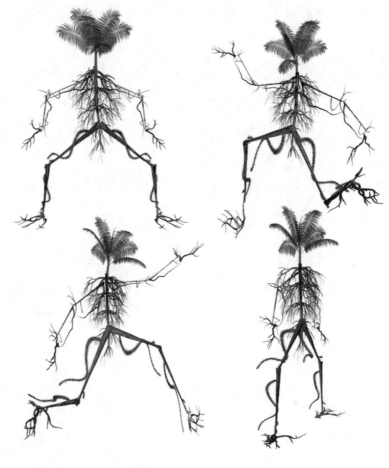

FIGURE *The TreeBot has true poseable "limbs."*
9.50

MOVING ON

We devoted this entire chapter to what you can use and what you can do to create natural-world content in Max. The next chapter begins a new section that details many of the Share-ware and Freeware plug-ins available for Max, how to find them, and what they do.

Shareware/ Freeware Modeling Plug-Ins

10
On the Port Side

There are some Max plug-ins that as of this writing were not ported over from Max 2.x. Some or all may be by the time this book is on the shelves, and some may not. In order to access their modeling options, you'll either have to be running Max 2.x on your system or another system, or you'll have to know someone who is. After these plug-ins are used to create 3D geometry, the models can be saved in a format that Max 3.x can understand, so you can port the models over. Create a 3DS object file, port it over, and resave it as a 3.x scene file. The only problem with 3DS files is that they are size limited. The plug-ins in question are *Stairs*, *Gear*, *Spider*, and *Greeble*.

The plug-ins in this chapter were all downloaded as freeware from the www.max3d.com website.

I'm pretty sure that if enough Max users took the time to write the developers of these 2.x plug-ins to admit their interest in seeing them ported to Max 3.x, the developers would probably feel motivated to do something about it.

STAIRS

The *Stairs* plugin is from EffectWare (www.effectware.com). Once installed, it can be located by going to Create>Geometry>EffectWare Stairs. See (Figure 10.1.)

This is a very full-featured Stair plug-in. You can input the standard Stairs parameters numerically, or click and drag in the Top viewport to create them. You can select whether the Stairs are to have handrails, and if so, whether they should be placed on either or both the left and right sides. Once created, all of the parameters are available for alteration in the Modify panel. (See Figures 10.2 and 10.3.)

FIGURE *The EffectWare Stairs Rollout in Max 2.x.*
10.1

FIGURE **10.2** *Standard Stairs are just a mouse step away with this Freeware plug-in from EffectWare.*

FIGURE **10.3** *Spiral Stairs, a model that normally takes a lot of planning and time, can be created in seconds with the Stairs plug-in.*

GEAR

Gear was written by Antonio Cabezuelo (cabezuelo@gepd.es). You control all of the radial dimensions, number of teeth, and the H and V taper of the teeth. This is a basic little plug-in, but the results are fast and definitive. Use it to create clockworks or anything that a Gear model is suitable for. (See Figure 10.4.)

FIGURE **10.4** *Gears of all shapes and sizes can be created quickly with Antonio Cabezuelo's Gear plug-in for Max 2.x.*

SPIDER

When I first came upon the name of this plug-in, I couldn't imagine what it was meant to do. Would it create arachnids? The result was surprising, and I wish it was available for R3.x (and it may be by the time you read this). It was created by Habware (www.habware.com). Map

the resulting spider web with a Wireframe Material. The neat thing about this little plug-in is that with Snap switched on, you can snap the web's strands to any object's vertices. (See Figure 10.5.)

FIGURE **10.5** *"Tell all your friends bye-bye," said the spider to the fly.*

FIGURE **10.6** *Greebled objects feature extensive intricate details.*

GREEBLE

If there is one plug-in that I am most interested in seeing ported from 2.x to 3.x, it is definitely *Greeble* from Ishani. There is no other plug-in like this, anywhere I can find. What Greeble does it to displace the geometry of a selected object, creating dozens of extruded faces, and sometimes extrusions on extrusions. All of this has the look of a *Star Wars* Death Star, or a futuristic cityscape. There are parameter controls for the height of the "Greebles," and even their tapering. The result is good enough for film, but there is a caveat: On a 2.x Max system, Greeble demands huge amounts of processor time. My 2.x system runs at 200Hz, and only has 128MB of RAM, so Greeble challenges it severely. Nevertheless, I long for it to be ported to 3.x as a modeling option. (See Figure 10.6.)

MOVING ON

In this introductory chapter to the Shareware/Freeware section, we looked at some Max 2.x plug-ins that we wish could be ported over. In the next chapter, we'll look at a collection of Max 3.x plug-ins.

CHAPTER 11

Plug-ins Are Free at Max3D

Here are a few Freeware plug-ins you'll want to add to your R3.x or higher collection from the max3d.com website. Included are Polychop, Mountain, Airfoil, Helicoid Generator, SQuadratic, SuperEllipsoid 2, and Wing Maker.

POLYCHOP

Here's a free plug-in from Stan Melax and Bioware (www.bioware.com). This is a very basic plug-in, but it can be very valuable when you need to cut down on the number of polygons in a mesh. Though it's not as full-featured as Digimation's MultiRes (Chapter 25), PolyChop can serve in a variety of situations. It is far more functional than Optimize, because Poly-Chop allows you to set boundaries and protected areas where chopping will not occur. These include Edge Length, Curvature, and Smoothing Zones on your model. Most models can easily be PolyChopped by 25% and more without suffering any noticeable loss of feature detail. (See Figure 11.1.)

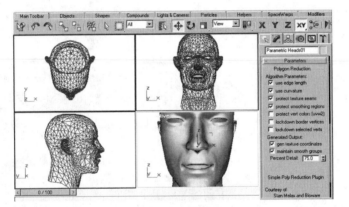

FIGURE *PolyChop is fast and efficient, responding to whatever value less than 100% that you*
11.1 *indicate. Complex anatomical models are good targets for this plug-in.*

MOUNTAIN

This free plug-in is from EffectWare (www.effectware.com). Just activate it by going to Create>Geometry>EffectWare Objects, and click-drag to create a mountain in the Top viewport. Aside from the expected dimension parameters, Mountain features other options that can alter the look of this terrain object. (See Figure 11.2.)

- **Mesh Size**: This parameter determines the sharpness or curvature of the peaks. Set to a value of 2, the result is spectacular Egyptian pyramids.

Color Page 1: **TOP:** *The Star.* **BOTTOM:** *Triptych.*

Color Page 2: **TOP:** *Dharma Wheel.* **BOTTOM:** *Rushed Hour.*

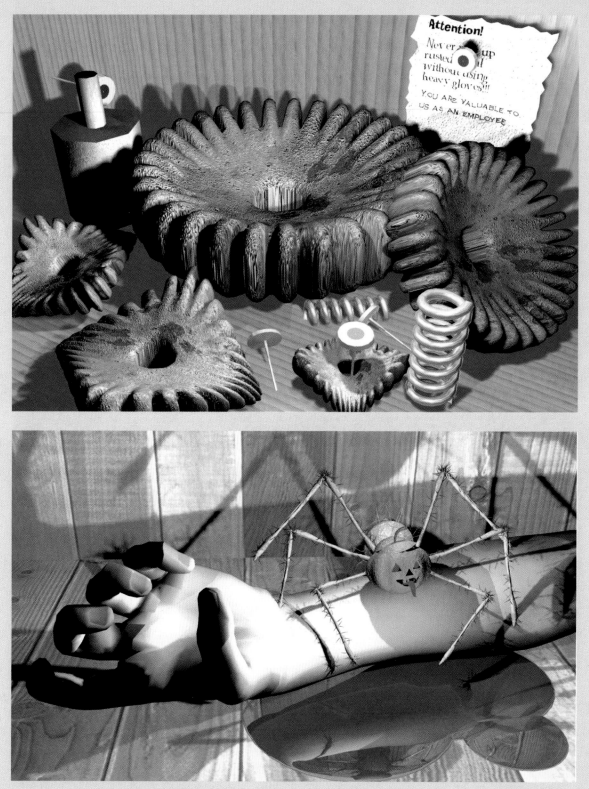

Color Page 3: **TOP:** *Rusted Gears.* **BOTTOM:** *Jack 'O Rachnid*

Color Page 4: **TOP:** *Kachinas.* **BOTTOM:** *Columns.*

Color Page 5: Warpheads

Color Page 6: ClayBot poses.

Color Page 7: Al Eon, from somewhere else.

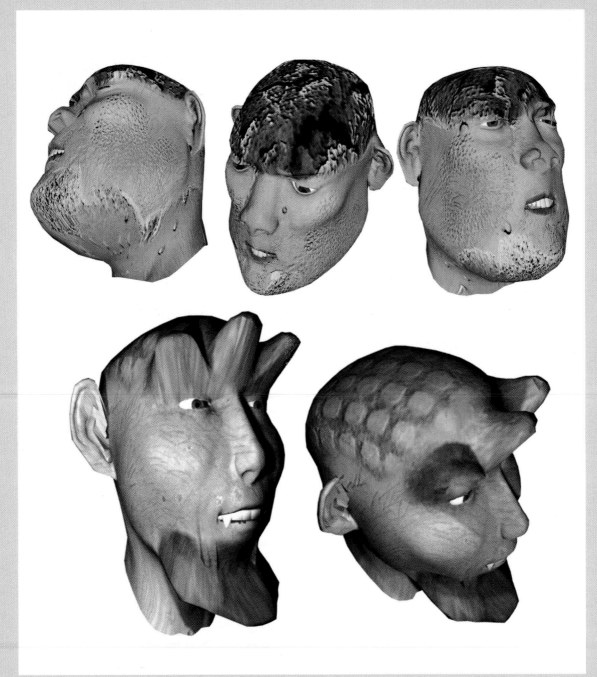

Color Page 8: Deep Paint 3D examples.

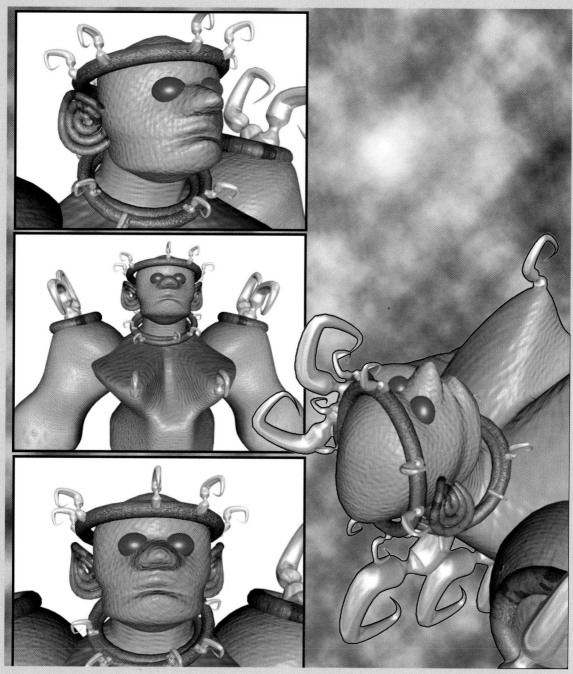

Color Page 9: The NurBot.

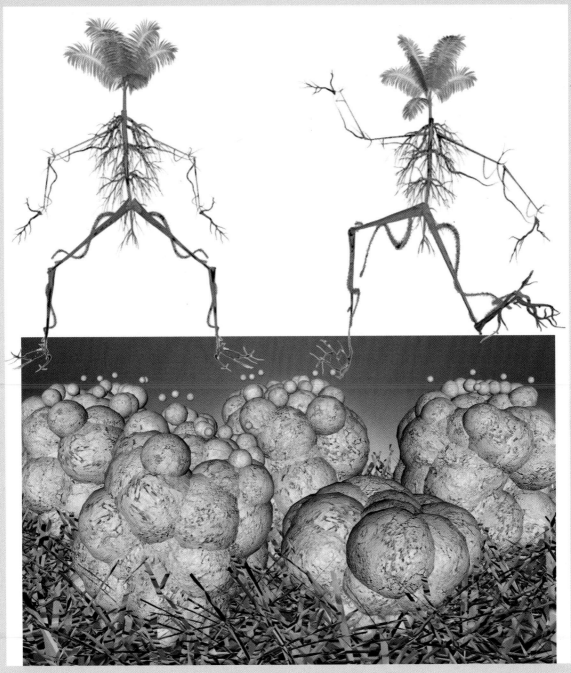

Color Page 10: **TOP:** *TreeBot.* **BOTTOM:** *Spore Pods.*

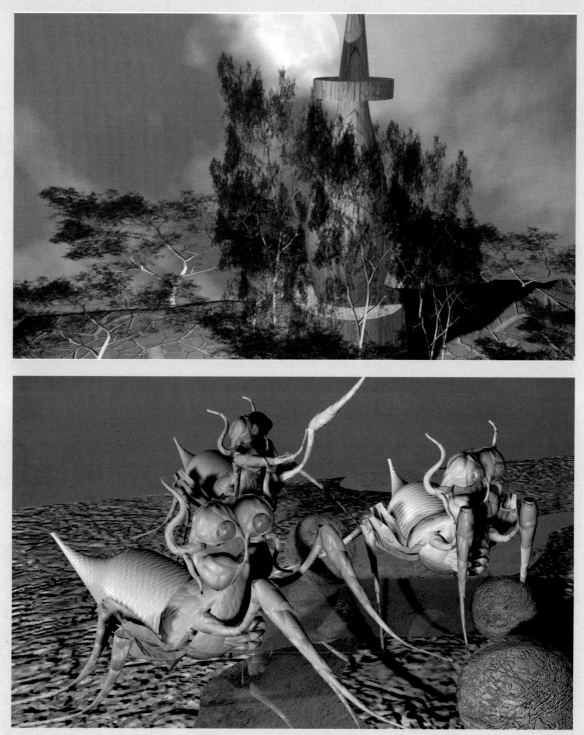

Color Page 11: **TOP:** *Moon Temple.* **BOTTOM:** *Cosmic Dung Beetles.*

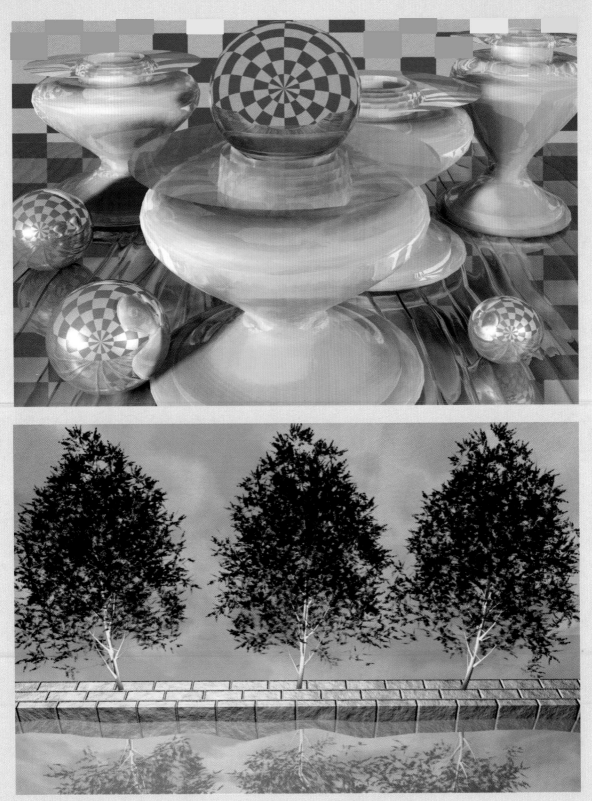

Color Page 12: **TOP:** *Reflectorium.* **BOTTOM:** *Morning.*

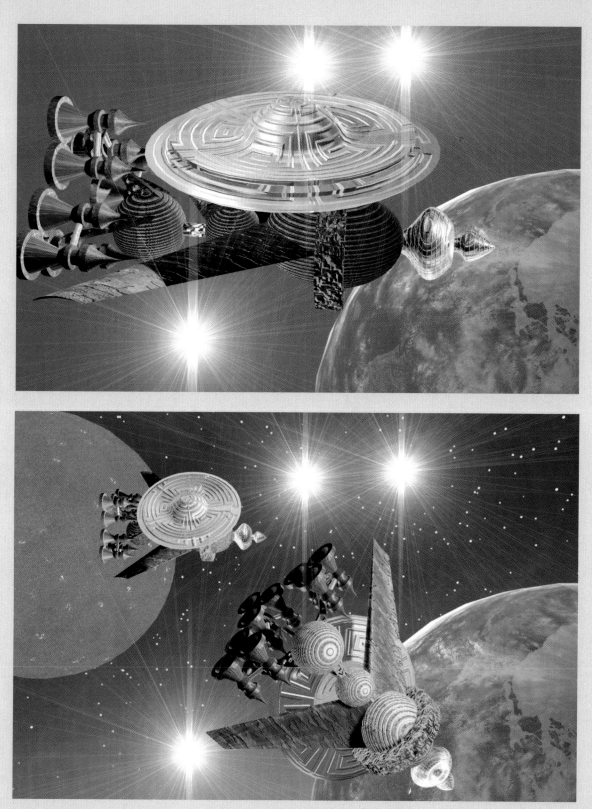

Color Page 13: Ship.

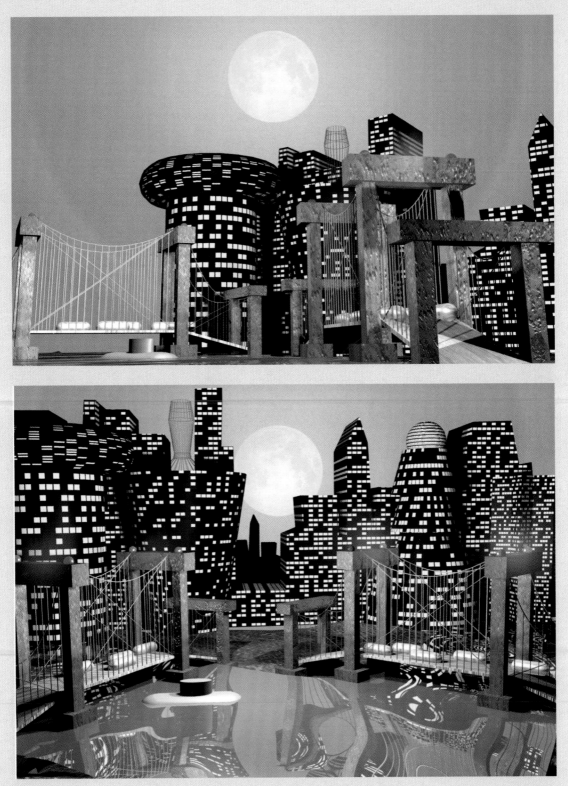

Color Page 14: Two views of Urbania.

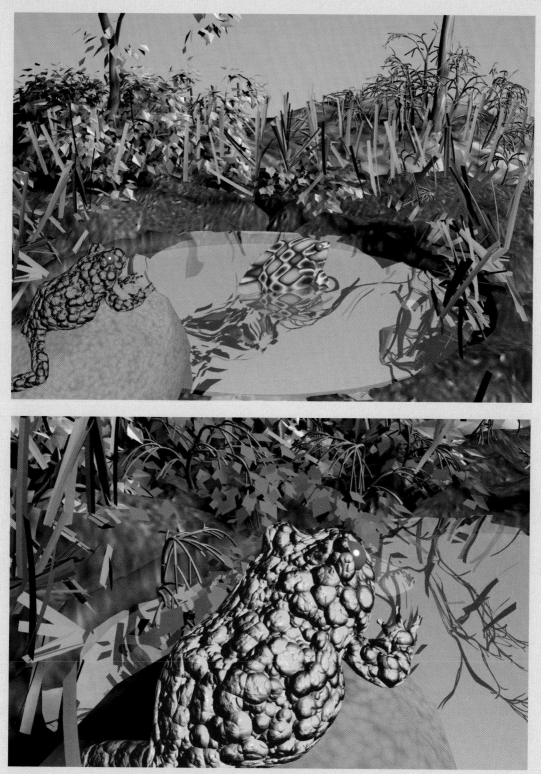

Color Page 15: Two views of the Woodscene.

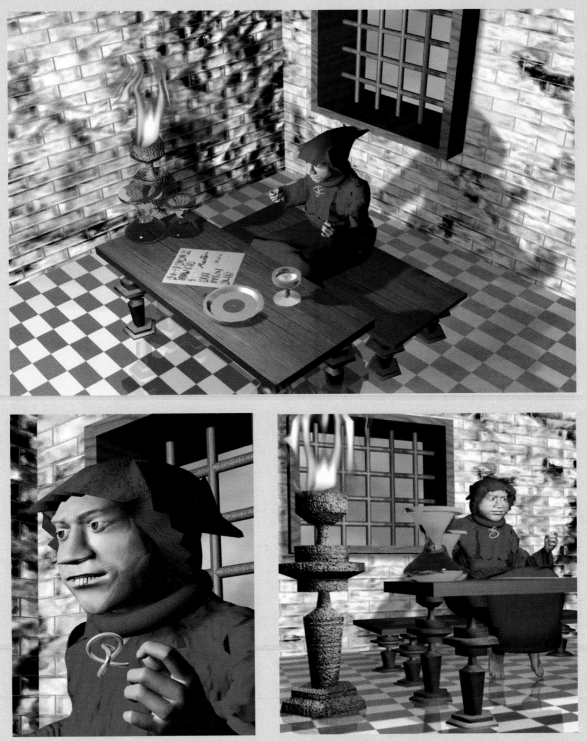

Color Page 16: Monk's Home.

- **Fractal Dimension**: Setting this value (0.0 to 4.0) has a major effect on the general landscape contours, and how many peaks are involved. Explore different values and watch the Perspective viewport.

- **Power Scale**: Depending upon other settings, values higher than 1 tend to create craggy separated peaks. Values higher than about 25 are not suggested.

- **Random Seed**: This number sets the general parameters of a Mountain terrain object.

There is no rule that says you are limited to placing this object in a scene in the standard fashion. Place a group of Mountain objects on their side, and Boolean-Union them together to create an interesting cliff face. Place a Mountain object upside down to create a sculpted valley.

FIGURE *Using a Limestone Material on the X-axis, a Mountain object can be made to look like an*
11.2 *old ruin.*

AIRFOIL

This is an EffectWare plug-in, and can be found by going to Create>Shapes>EffectWare Shapes. Airfoil is a closed Spline meant for extrusion, although you may also select to render the Spline in the General Rollout. Based on the rigorous specifications of real-world airfoils,

parameters include value settings for Chord, Chamber, Position, Thickness, and Node. Three types of Airfoil cross-sections can be emulated: Joukowski, NACA 4-digit series, and NACA 5-digit series. (See Figure 11.3.)

FIGURE *A rendered Airfoil cross-section shape.*
11.3

HELICOID GENERATOR

EffectWare. When you think of this object, think of daVinci's helicopter designs. It's shape can also be compared to a drill-bit with ends that can be resized. It is truly a form to be admired, and as a creative Max modeler, you can explore all manner of uses. You can control the radius of both the base and tip, the number of turns, and the fineness of the mesh. (See Figure 11.4.)

FIGURE *Mapped with a metallic Material, this is a truly beautiful object d'art.*
11.4

SQUADRATIC

EffectWare. Free. If you enjoy exploring mathematical models, than this is definitely a plug-in for you. Go to Create>Geometry>Effectware Objects>SuperQuad. You will see two options for creating a base object: Ellipsoid and Toroid. Each can be used to create diverse forms by modifying the U-Shape and V-Shape parameters. Values for each start at 0.0, with no upward bounds. Effectively, however, using values higher than 10 isn't very productive as far as generating new 3D forms. The generated forms result from mixing the U-Shape and V-Shape parameters for each base object. (See Figures 11.5 and 11.6.)

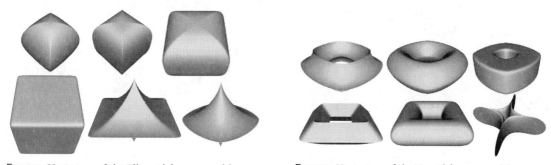

FIGURE **11.5** *Variations of the Ellipsoid form created by varying the U-Shape and V-Shape values.*

FIGURE **11.6** *Variations of the Toroid form created by varying the U-Shape and V-Shape values.*

SUPERELLIPSOID 2

This free R3 plug-in was written by Cuney Tozdas and Sinan Vural (www.cuneytozdas). Once installed, it can be found by going to Create>Geometry>More Extended Primitives, and clicking on SuperEllipsoid. Click-drag in any viewport to create the object. SuperEllipsoid is a first-rate plug-in that you may find yourself using more than any of the standard primitives. That's because it not only replaces many of the standard primitives, but also gives you access to forms not otherwise available. It does this by giving you access to two control parameters: S1 and S2. The following objects can be created by setting these parameters at specific values. (See Table 11.1.)

These forms are especially useful in an animation, because you can morph from one to the other. (See Figure 11.7.)

Table 11.1 Use These S1 and S2 Values to Create Specific SuperEllipsoid 3D Forms

S1 Value	S2 Value	Resulting 3D Form
1.0	1.0	Sphere
0.0	1.0	Cylinder
0.2	1.0	Rounded Cylinder
0.5	1.0	Very Rounded Cylinder
0.0	0.0	Cube
0.2	0.2	Rounded Cube
0.5	0.5	Very Rounded Cube
2.0	2.0	Tetrahedron 1
2.0	0.0	Tetrahedron 2
2.0	1.0	Two Mirrored Cones
3.0	3.0	Star
0.0	10.0	Extruded Form
0.0	2.0	Box

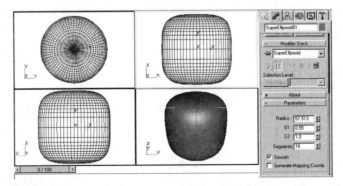

FIGURE *Using one plug-in to create a variety of 3D forms can save you time and energy.*
11.7

WINGMAKER

WingMaker (or just plain Wing as it is called in the Rollout) is another offering from EffectWare. WingMaker is actually an extension of the Airfoil plug-in we started this chapter with. The difference is that instead of just an airfoil cross-section, this is a full 3D object gen-

FIGURE *A variety of wing designs can be generated by tweaking a few parameters in EffectWare's*
11.8 *WingMaker.*

erator. You can control all of the parameters that Airfoil does, plus the differential size of the root and tip, extruded dimension, and a few more sculpting parameters. (See Figure 11.8.)

MOVING ON

In this chapter, we have explored some of the modeling plug-ins available free for download from the Max3D.com website. In the next chapter, we'll investigate more Freeware/Shareware modeling plug-ins from 3D Cafe.

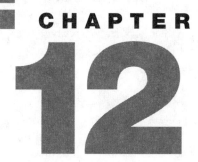

CHAPTER 12

The Corner Cafe

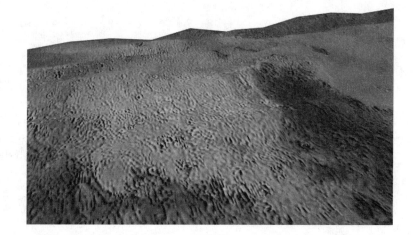

I n this chapter, we will look at the R3 plug-ins available from three Max developers whose modeling plug-ins are downloadable from the 3D Cafe website (www.3dcafe.com). The developers are *Blur Studios, HabWare,* and *Peter Watje.*

BLUR STUDIOS

Blur Studios (www.habware.com) creates a wealth of Max plug-ins. I want to mention two: *Decay Noise* and *Twist-O-Rama.* Although these are found in the Modify list, I consider them primary modeling add-ons. Web address: www.blur.com.

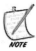

You should download and install the Blur Library, because it is required by most of the Blur Filters.

DECAY NOISE

Decay Noise is a good alternative to the Max Noise Modifier, for modelers who want to Snapshot an existing modified form, and for animators. It allows all of the standard XYZ influence and Fractal parameter settings as the standard modifier, but its real magic lies in the ability to move the center of the Noise forces anywhere in the scene (Sub-Object option). For a Snapshot operation, this allows you to move the force center in order to get exactly the Noise deformations you require before Snapshotting the result. The value of the Noise force and its influence perimeter can be set. (See Figure 12.1.)

Decay Noise is also found as a Space Warp once installed, which is good news for animators.

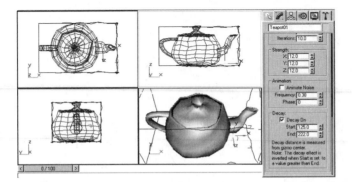

FIGURE *Applying Noise to a model causes it to be disturbed with chaotic movement on any or all of*
12.1 *a selected model's axes.*

- Use Decay Noise to give objects a used and battered look. This works well for hard objects like teapots and spaceships, as well as for anatomical body parts.

- Begin with a Start Decay ON value of 125 and an End Decay ON value of 150. Move the Sub-Object Center to apply the effect to the selected object. Stop when you see a good Snapshot, and don't forget to save the resulting object to disk.

TWIST-O-RAMA

Blur's Twist-O-Rama can be found in the Modifier list and as a Space Warp. The magic of Twist-O-Rama centers on the exact same capability as that included in Blur's Decay Noise: the ability to apply the effect at any distance by moving the Sub-Object Center, with user-selectable areas of influence. Other than that, the Twist-O-Rama modifier works in the same way as the standard Twist modifier. Move the Sub-Object Center until the effect you are applying looks right for a Snapshot. (See Figure 12.2.)

With both Decay Noise and Twist-O-Rama, the best results are obtained when applying them to finer meshes.

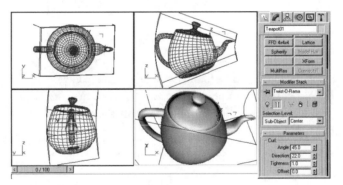

FIGURE *Twist-O-Rama lends a cartoony deformation look to selected models.*
12.2

HABWARE

HabWare (www.habware.com) creates many plug-ins for Max. We will look at four that are valuable for creating models: *Moebius, SoapFilm, Sticks 'n Balls,* and *Terrain.*

MOEBIUS

Long an object of reverence and speculation by artists, scientists, and philosophers, the *Moebius Strip* is faithfully reproduced by this HabWare plug-in. To access it, go to Create>

Geometry>Fascination, and select Moebius. Click and drag in any viewport to generate the object. Aside from the expected Length and Width parameter settings, you can also set the Number of Loops and their Angle. Normally, a Moebius Strip is shown with just one loop, but that need not be the case. (See Figure 12.3.)

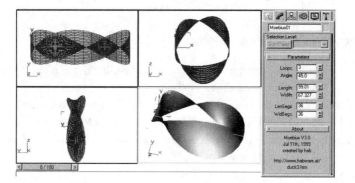

FIGURE *You can design Moebius Strips with any number of loops with HabWare's Moebius.*
12.3

SOAPFILM

The SoapFilm objects can be found by going to Create>Geometry>Minimal Surfaces, and selecting one of the three options: *Helicoid, Catenoid,* or *Costa Surface.* These surfaces describe the surfaces formed on SoapFilm, like that generated when you blow through the common bubble-maker toy.

HELICOID

The Helicoid can be used to create a basic drill bit, or even a futuristic building. Do the following:

1. Create a Helicoid by click-dragging in the Top viewport. Make it about ¼ as wide as the viewport, and as high as the view seen in the Front viewport. Give it three turns.

2. Create a Cylinder that is positioned at the center of the Helicoid, with a diameter about ½ as wide and a height equal to the Helicoid.

3. Use an Editable Mesh on the Helicoid to Extrude the polygons in the Y-axis direction by a value of 12.

4. Group both items, and map with a suitable material. See Figure 12.4.

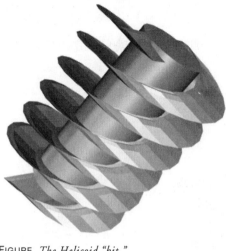

FIGURE *The Helicoid "bit."*
12.4

CATENOID

The Catenoid, especially when Mesh Extruded, can generate an array of interesting bowl-like forms. In fact, the art used for the cover of this book features a Catenoid on the left of the table. See if you can spot it. (See Figure 12.5.)

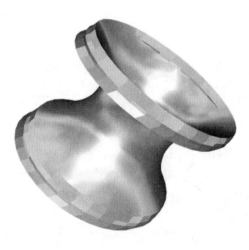

FIGURE *An extruded Catenoid object.*
12.5

COSTA SURFACE

Exactly how and where you might use a Costa Surface is up to you, but it sure qualifies as a complex object. (See Figure 12.6.)

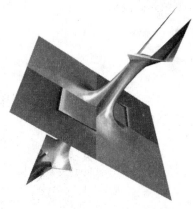

FIGURE *The Costa Surface is a verifiable complex 3D object. Perhaps it could be used as a*
12.6 *futuristic space station, or a pair of bizarre earrings.*

STICKS 'N BALLS

This Object Modifier can be located by selecting More from the Modifiers panel. Its task is simple: to turn any selected object's edges into "sticks," and vertices into either boxes or spheres. You have control over the Sticks and Balls dimensions. Create elements for a cityscape with this Modifier. (See Figure 12.7.)

FIGURE *A Torus Primitive after a Sticks 'n Balls Modifier has been applied.*
12.7

TERRAIN 2

This is another alternate Terrain generation device, found by going to Create>Geometry> fascination. Dimensional parameter values are included, plus settings that influence Peak Definition and Perturbation. Perturbation values above 0.9 are not advised, unless you want to create extremely sharp peaks. (See Figure 12.8.)

FIGURE *With a Perturbation of 0.9, and a Mars material, an interesting low-hilled terrain can be*
12.8 *created.*

PETER WATJE

Peter Watje () has written a large number of Max plug-ins. In this chapter, we'll look at a few.

HAIR

Go to Create>Geometry>Particle Systems>Hair once you have installed the plug-in. This plug-in is more of an experimental application than an actual Hair generator. The controls are complex, and the results often disappointing and slow for hair. However, there is a bright side. For creating objects that display spikes and spiny protrusions, the plug-in works wonders.

To create hair on a model, I prefer the Grass-O-Matic *plug-in from Sisyphus covered previously.*

When using this plug-in attend to the following:

- Use Distribution maps for a more random distribution of the hairs.

- For creating images, keep viewport particle numbers low (25 to 50) for fast previews. Set Render particle quantity higher for finished displays.

- When creating a Snapshot, set viewport particle quantity as high as the needed hairs are to be. Snapshot relates to viewport settings, not Render settings.

- After Snapshotting the Hair Object, Select the Mesh. Then Select>Invert to choose everything but the new mesh, and delete it. Now you have a Hair Mesh that can be joined to any object, and is open to Modifying (Twist, Bend, and more). (See Figures 12.9 and 12.10.)

FIGURE **12.9** *A selection of Hair objects attached to a Cylinder.*

FIGURE **12.10** *After Freeform Deformation (Modify panel>More), the simple hair Snapshot takes on a new complex character.*

MESHER

Mesher turns a selected Spline or Particle System into a visible Mesh that can be seen in the viewports and rendered. Do the following:

1. Place a Particle system on the screen.

2. Place a Mesher Gizmo (Create>Geometry>CharityWare) on the screen.

3. In the Mesher Modify panel Rollout, select the particle System as the target of Mesher.

4. Snapshot the Mesher particles at any frame, after perhaps applying Materials.

Particle Systems can create a lot of geometry, so be aware and be careful about processing times needed.

(See Figure 12.11.)

FIGURE *Mesher translated these particles (instanced geometry) in a Snapshot-worthy object.*
12.11

ONE MORE FROM BLUR . . .

Here's one more from Blur Studios: *Path Cylinder Object.* After installing, go to Create>Geometry>Blur's Objects, and do the following:

1. Click-drag the basic Cylinder in a viewport.

2. Create a Spline Shape.

3. With the Cylinder selected, go to the Modify panel.

4. In the Path Cylinder Rollout, select the Spline as the required path.

5. Explore the Thorn parameters, watching the Perspective viewport for the preview.

6. When you get something you like, render it. (See Figure 12.12.)

Set the Wavelength low, between 1 and 8, to give the Thorns some curvy character.

FIGURE *The truth is, even though this plug-in's use can be questioned at the start as to any viable*
12.12 *use, it allows you to create branches like those from a dead pine tree for your digital nature scenes.*

MOVING ON

In this chapter, we explored some of the freeware modeling plug-ins available from 3D Cafe. The next chapter begins Section D on *Particle System Modeling*.

SECTION

Particle System Modeling

CHAPTER

13

Sisyphus Climbs Again

In this chapter and the next, we'll look at Particle Systems as modeling alternatives. Particle Systems are thought of as animation generators 99% of the time, but with the ability to capture a Particle System as geometry with a Snapshot, we also have the capability to use the objects created by a Particle System at any selected point in an animated sequence. This chapter looks at two Sisyphus Particle systems that can be used in just this manner: Halo and Phasor.

SISYPHUS HALO

Halo sets up a Particle System that revolves around a center point. Used in a standard manner, this might be useful in creating a ring of revolving asteroids around a center, or a ring of revolving smoke or debris. The following parameter settings are available: *Basic, Wave Formation, Particle Generation, Particle Type, Particle Rotation, Bubble Noise, and Load/Save Presets*. Let's look at these as they apply to creating geometry for modeling purposes.

BASIC

This Rollout covers the basic settings, especially those that govern the way particles are displayed in the viewports. It is suggested that you set the Viewport Display to Ticks, and the Percentage of Particles in the viewport to 50% or lower. That will allow you to get quicker preview results. Before doing a final rendering, you can set the Viewport Display to Mesh, and the Percentage of Particles to 100% to see what you have, and to determine which Frame in a sequence to Snapshot. Select to Hide the Emitter as a default, since it makes your preview clearer.

WAVE FORMATION

Remembering that we are speaking about modeling and not particle F/X, use the following values in the Wave Formation Rollout:

- **Main Orbit**: Here you set the global Radius of the particles. Set the radius larger if you are going to use larger meshes as particles, but base your judgment on preview renders. As a default throughout attempts at Particle System modeling, set variations to nine or the lowest possibility. This allows you more order in a modeled element. Of course, if you are modeling a somewhat chaotic structure, then raise the variation levels to get more randomness.

- **Axial Distribution**: Set Spread at 0 if you want a particle mesh to hug the ground. Set Spread at the max, 100%, if you want to spread the particle mesh vertically, which is good when you use Halo to build a circular wall. Your setting will eventually depend on how many particles you are using, and what look you are trying to achieve.

- **SubOrbit**: For Particle System modeling, set all of the values in SubOrbit to 0 except for Scatter, which should be set at 1 (its lowest value). You can explore a larger Scatter amount as you get more accustomed to what you are doing.

- **Angular Distribution**: For modeling, the most important settings here are *Clumps* and Clump-related values. If you switch Clumps on, Halo will divide the circular particles into segmented strings, using whatever Number of Clumps you input. Two Clumps, for example, will create a ring of particles that is separated into two arcs, with spaces between them. Leaving Clumps off sets the system at a full circle of particles, or at least it tries to create the circle based on the quantity of particles being used.

PARTICLE GENERATION

For modeling, the most important settings here are *Quantity*, and *Particle Size* and *Size Variation*.

- **Quantity**: Click on Total in the Quantity area, and decide how many particles to use. Be very careful with a quantity above 100 if you are selecting a Mesh as the particle. If the Mesh has 100 polygons, for example, a setting of 100 will create a Snapshot object that has a potential for having 100,000 polygons. Such large objects can quickly bog down any system.

- **Particle Size/Size Variation**: This value depends upon what you are trying to create, and how many particles are involved. A wall created from cubes, for example, will look less mechanical if you set larger sizes and a 50% or more variation. Setting no variation and a small size would, in this case, create a wall built of orderly pebbles.

PARTICLE TYPE

For modeling purposes, the most vital items in this Rollout are clicking on Instanced Geometry, and selecting the Source geometry from the list of possibilities (or clicking on the source geometry in a viewport). Remember the polygon rule: If the geometry has a lot of polygons, keep the quantity low. If not, you'll wait forever as it renders . . . or tries to before hanging up Max.

PARTICLE ROTATION

For modeling variations, the most important parameter setting in this Rollout is under Spin Axis Controls. Selecting *Random* sets the object geometry in its expected orientation, while selecting *Direction of Travel* often works better when you are trying to create walls and barriers for Snapshot operations. Direction of Travel lays the geometry out so that it lies flat, which is absolutely perfect for a circular wall of masonry.

BUBBLE NOISE

Under this Rollout, set Amplitude to 120 and Period to 90 to create particle geometry that displays wide variation from Frame to Frame as far as particle separation on the Y-axis.

LOAD/SAVE PRESETS

When you create an interesting Frame for Snapshotting, save the preset configuration here.

Creating a Castle Turret with Halo

To use Halo to create a circular castle turret, do the following (obviously, you'll have to have Sisyphus Halo):

1. In Max, create a Box from the Standard Primitives list. Give it a Length of 13, Width of 17, and a Height of 20. UVW Map it with a cubic map, and place a rocky Material on it.

2. Go to Create>Geometry>Sisyphus Particles, and select Halo from the options. Place a Halo Particle System in the Top viewport and center it.

3. In the Halo Rollout in the Modify panel, click on Instanced Geometry as the Particle Type, and select the Box as the source.

4. Use the following values for parameter settings: Hide the Emitter and select Mesh for viewport display with a 50% particle display. Set Use Rate Quantity to 300, and Travel Time to 225 with a Normal option, with zero Variations. Leave Particle Timing at the defaults. Set Particle Size to 4 with a Variation of 100%. Set the Uniqueness Seed to 10701. Select the Birth option under Instancing parameters. Set Spin Axis Controls to Direction of Travel. Use an Amplitude of 120 for Bubble Noise, with a Period of 90, and set all other options under Bubble Noise to 0.

5. Manually move the Frame Slider until you see an interesting formation. Snapshot it. Do this several times to create a number of Stone Circle Meshes. Use these meshes to build a castle Turret. Place a Cylinder inside to create a solid backdrop for the "stones." (See Figure 13.1.)

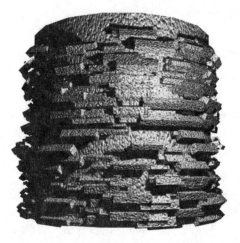

FIGURE *Use the stacked Snapshots of Halo geometry to build a castle turret. Displayed is one under*
13.1 *construction.*

SISYPHUS PHASOR

Sisyphus Phasor creates particle systems that can resemble froth or foam. As a modeler, especially with an Instanced Spherical shape, Phasor can be used to generate globby structures like spore balls. Phasor is definitely more organic model oriented than Halo when it comes to Snapshot Geometry.

PHASOR PARAMETERS

Phasor has the same basic parameter setup as Halo. Pay attention to the following parameters when using it for Snapshot geometry:

- Keep the quantity of particles in the 10 to 25 range.

- Set viewpoint previewing to about 25%, except when ready to render final output.

- Select an Instanced geometry source that doesn't have too many polygons.

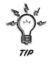

TIP

If you need to cut down the number of polygons in an object, and can't invest in Digimation's MultiRes at the moment, get PolyChop. PolyChop is freeware from Stan Melax and Bioware (www.bioware.com), and the plug-in can be found by searching the various Max websites. Just input the percentage of polygons you'd like to have, and preview the resulting object.

- Use both Random and Directional of Travel Spin Axis settings with the same parameters to explore the creation of very different geometry.

Pregnant Spore Pods

Here's an object just right for Phasor geometry. Do the following:

1. Place a Standard Sphere in a scene, and reduce its number of polygons as much as possible without losing the character of the spherical shape. Use a Spherical UVW map on it and a light veiny stone material.

2. Go to Create>Geometry>Sisyphus particles, and select Phasor. Place a Phasor gizmo in the Top viewport.

3. Select Instanced geometry for the particles, and select the Sphere as the source.

4. Use the following parameters for Phasor in the Phasor Rollout in the Modify panel: Mesh Viewport Display set to 50%. Waveform Formation Number of Cycles at 6, with an Amplitude of 3, particle generation Use rate of 15, Normal Speed Travel Time of 30, Particle Size of 2 and a Spin Time of 55, Spin Axis Controls set to Random, Bubble Noise Amplitude and Period of 5, with a Phase of 90.

5. Manually move the Frame Slider until you see interesting formations, and Snapshot them. Do this several times to create a number of organic forms that I call Pregnant Spore Pods. Use these meshes to build a scene. (See Figure 13.2.)

FIGURE *Pregnant Spore Pods created by Snapshotting Phasor Frames.*
13.2

MOVING ON

In this chapter, we detailed how you can use two Sisyphus Particle Systems, Halo and Phasor, to create some interesting models by Snapshotting different animation frames. In the next chapter, we detail how the same process can use Digimation's Particle Studio.

CHAPTER
14
Particulate
Matters

T his chapter continues the topic of Particle Systems Modeling alternatives begun in the last chapter. This chapter looks at two additional Particle Systems that can be used in just this manner: Digimation's Particle Studio and RealFlow (www.re- alflow.com).

PARTICLE STUDIO MODELING

Particle Studio presents a new paradigm for generating Particles. Instead of being keyframe based, Particle Studio is event based. This allows you to alter the way the particles are gener- ated at different points on the timeline based upon the particles' behavior at that point. Al- though most of these features are animation oriented, a topic not targeted by this book, Particle Studio also has specific features of interest to the Particles modeler. Particle Studio places a special Snapshot option in the Utility panel: Particle Studio Snapshot. Since this util- ity is specifically geared toward Snapshotting Particle Studio particles, it has features not found in other Snapshot options. For instance, under the Multiple Objects selection, you can use the Particle Studio Snapshot utility to Snapshot particles as either Instances or Copies of an Editable Mesh. Custom Particles can be determined as Object Instances, Copies, or Editable Mesh. The alternative is to Snapshot everything as a single Editable Mesh, which is a better solution when using particles as modeling components. That's be- cause you'll avoid generating hundreds of separate objects.

Be careful when you use geometry in any Particle System that you plan to Snapshot. Keep the quantity at a minimum. Otherwise, you'll wind up with a complex object with so many com- bined facets that you will place extra strain on the system. Always optimize any geometry that is to substitute for particles for a Snapshot operation. Think about using 2D shapes instead of 3D geometry whenever possible.

In general, there are two ways to use Particle Studio. The first is to open the Event Map to set all of the parameters necessary for generating the exact particle configuration you need. (See Figure 14.1.)

Between the Event map and the associated Time Table windows, you can spend as much time as needed to craft arrays of particles that obey your directions to the letter. For model- ing purposes, however, and to become acclimated to Particle Studio so that you can use the more detailed Event Map operations later, it's best to select from one of Particle Studio's pre- set Particle Systems. These are accessed by selecting Quick Setup in the creation or modifi- cation phase. Quick Setup brings up a window of preset options. (See Figure 14.2.)

At the bottom-left of the Quick Setup window is a button marked Pick Object(s). For the Max artist using particles as modeling elements, this is an important part of a Particle Studio configuration. By clicking on this button and then on an object (or in some cases, more than one object) in your scene, you can transform the selected object into a collection of particles. This makes Particle Studio a prime candidate when it comes to Particle Snapshots.

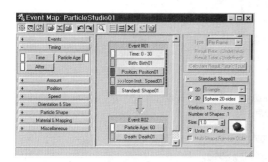

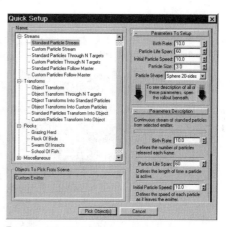

FIGURE 14.1 *The Event Map allows you to create extremely complex Particle Systems by defining what will happen at any selected place along the Timeline.*

FIGURE 14.2 *The Quick Setup window allows you to select from a number of Particle Studio presets.*

QUICK SETUP PRESETS

In the left-hand column of the Quick Setup window you will see the Presets list. Selecting any of the presets brings up its configuration parameters on the right side of the window. A detailed explanation of each parameter can also be called up, so you need not page through the documentation when setting up a preset. Because the presets are so important to particle modeling pursuits in Particle Studio, let's look at what is involved and what they do. That way, you can always use this book to refer to needed particle modeling alternatives with Particle Studio. Presets are divided into the following categories: Streams, Transforms, Flocks, and Miscellaneous. Some are more useful to Particle System modeling than others are.

Streams

Streams have little use for Particle System modeling, but require animated playback to be effective. Streams allow particles to target selected objects or to follow selected objects in their motions.

Transforms

Transforms can be very useful in Particle System modeling. Transforms allow an object to be constructed from particles, or to degrade into particles. Either way, any selected Transform frame in the transition can be Snapshot and translated into a mesh. Use a Transform to show an item that is deteriorated, or one recently struck by a laser blast or a projectile. Using more defined geometry, the Transformed object may be beyond common description. (See Figure 14.3.)

FIGURE *Using the TransForms particle operation, the Teapot is transformed into a number of*
14.3 *extruded circles.*

Flocks

Here's another extremely useful particle modeling alternative. There are actually four sepa-
rate Flock types: Grazing Herd, Flock of Birds, Swarm of Insects, and School of Fish. See the
fish tutorial at the end of this section.

Keep the quantity low when you are using these options, since they all incorporate cloned geometry.

CAUTION

Miscellaneous

The Miscellaneous Particle Studio presets offer two more options useful for particle model-
ing: Explode Object and Trail. Use Explode Object for the obvious reasons. This preset is es-
pecially useful if you are creating a 3D comic, and need to show the progression of an
explosion over several panels. Trail is especially useful if you are creating a meteorite streak-
ing across your scene, or any similar object.

BACK TO SCHOOL

If you have Particle Studio, here's a Flocking project to try. Do the following:

1. Open Max and create a new scene.

2. Go to Create>Shapes Line. Select Corner Initial Type and Smooth Drag Type. Create
 a shape in the Front viewport that resembles that shown in Figure 14.4.

3. With the shape selected, go to the Modify panel and extrude by 5. Use Shrink Wrap
 UVW Mapping, and place an interesting Material on the object. (See Figure 14.5.)

4. In the Modify panel, apply a Bend of 45 degrees on the X-axis to the fish. This gives
 it a bit more of a 3D personality.

FIGURE *Create a shape that resembles this one.*
14.4

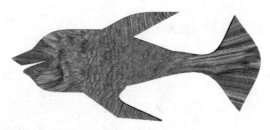

FIGURE *The fish object is mapped.*
14.5

5. Go to Create>Geometry>Digimation Particles. Select Particle Studio, and place a Particle System in the Top viewport.

6. Place two spheres in the Top viewport. One will be the place the fish are swimming from, and the other one where the fish are swimming to. Select the Particle System.

7. Open the Quick Setup window. Select School of Fish from the Quick Setup window under Flocks. Set the Amount at 25, Size at 45%, and check Prevent Particles from Colliding. Click on Pick Object(s), and select the following in order: the source sphere, the fish geometry, and the target sphere.

8. Select a frame in the animation, and go to Utilities>More>Particle Studio Snapshot. In the Rollout, make sure Multiple Editable Mash is checked. Leave the rest of the settings at their defaults. Generate Snapshot. Do this as many times as you need to create separate schools of fish. (See Figure 14.6.)

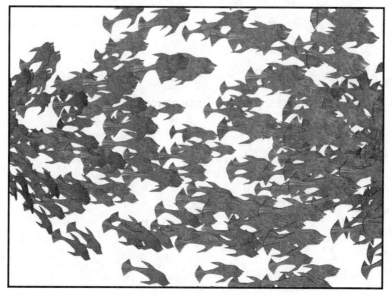

FIGURE *School days!*
14.6

REALFLOW

www.RealFlow.com

RealFlow is a unique stand-alone Particle System application that handshakes back and forth through dedicated plug-ins. RealFlow contains a scientifically accurate engine for developing flow dynamics, creating models of the actions and interactions of liquids and other viscous materials over time, and introduces a new fluid simulation algorithm for serious animators. Because of its advanced fluid dynamics engine and a robust collision detection engine, RealFlow is able to generate physics-accurate results. By using RealFlow, you can simulate effects such as expanding gases, liquids filling objects (like bottles or glasses), viscous fluids such as honey or jelly, and even the behavior of some nonfluids like sand. Effects like swirls, pressure shock waves, waves generated in a fluid because of the motion of the container—all of these and more can all been obtained with RealFlow.

RealFlow can send and receive data with Max by means of scene files in the SD proprietary format. Two auxiliary plug-ins are supplied with RealFlow that must be installed in Max to do this. These plug-ins are a link between RealFlow and Max, saving data to a SD file readable inside RealFlow. A second plug-in takes data from RealFlow (particles and/or meshes) into Max. The process is as follows:

1. The data is exported to RealFlow from Max, by means of scene data (SD) files. Objects can be animated or not, though non-animated objects are easier to import into RealFlow.

2. While RealFlow is calculating, you can switch data output on. Particles and/or meshes are saved as binary files for every frame.

3. You import the particles or meshes into Max by means of the SD loader plug-ins.

(See Figure 14.7.)

FIGURE *The RealFlow interface, displaying a mesh based upon a cylindrical Particle System.*
14.7

DOWNLOAD THESE 3D MAX PLUG-INS

Before running RealFlow with Max, you must download these MAX plug-ins from the RealFlow website and install them in the Max plug-ins folder:

- **RFPACK.dlo**: This file contains three plug-ins: a Particle System that reads RealFlow particle data in the form of .bin files into MAX, with MetaParticles support (note that particles can also be replaced with other objects, including Clay Studio metaballs); "MeshLoader," which loads RealFlow's binary mesh files; and a material called "RealFlow MeltMaterial" that will combine different materials and textures in the same RealFlow mesh.

- **RWPACK.dlm**: This plug-in contains one modifier that moves the objects reading DYN files saved from RealWave (a separate product). Another plug-in is a creator that will generate the surface and displace the points reading from BIN files.

- **SCENEDATA.dlu**: This is an utility that saves a 3DSMAX2 scene into a RealFlow readable SD file format.

CREATING A REALFLOW OBJECT FOR MAX

Do the following to create a particle-based object in RealFlow for export to Max:

1. Open RealFlow. Open Max.

2. In RealFlow, set the Fluid to Cylinder. This sets the global shape of the Particle System. Leave other settings at their default for this exercise. (See Figure 14.8.)

3. Under Daemons, select Limbo. This is a special force parameter. Set the parameters as displayed in Figure 14.9.

FIGURE *Set Fluid to Cylinder.*
14.8

FIGURE *Use the Limbo Daemon.*
14.9

4. Under the Meshes tab, set the resolution to 6%. Click on New Mesh, and RMB Click on the mesh name in the left column to bring up the Options menu. Select *Insert Fluids from Selection.*

5. Further down in the Meshes Rollout, click on the Primitive Properties button. Set the Blend Factor to 95% in the window that appears, and set the Radius to 37%. (See Figure 14.10.)

6. Click the Files button in the Mesh Rollout (it has a disk icon on it). Make sure the BIN Format box is checked. Set the Output Parameter path to tell the system where you want the BIN files to be stored. (See Figure 14.11.)

7. Under the Options tab, check the Max Frames box, and input the number 35. This sets the maximum number of frames to be rendered. (See Figure 14.12.)

8. Click the Action button to create the BIN files (not the Buzz button). (See Figure 14.13.)

9. After the BIN saves have finished, close RealFlow, and go to Max. Under Create>Geometry, open the Next Limit option. In the Rollout, select RF Loader.

FIGURE **14.10** *Set the Primitive Properties.*

FIGURE **14.11** *Make sure BIN is checked, and set the save path.*

FIGURE **14.12** *Set Max Frames to 35.*

FIGURE **14.13** *Click the Action button.*

10. Click Select File Sequence, and select the first BIN file from the place you stored the finished RealFlow files. Click Create Mesh in the Rollout. The RealFlow BIN files are loaded. To see the animated BIN files, click the Play button in the Animation Controller. (See Figure 14.14.)

11. To create your RealFlow object, Snapshot any selected frame of the animation that displays an object you like. Note that you may have to Optimize it because of the density of the mesh. UVW map the Snapshot and use whatever Material you like to add a texture. (See Figure 14.15.)

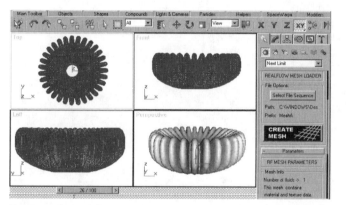

FIGURE *The RealFlow BIN files are loaded into Max.*
14.14

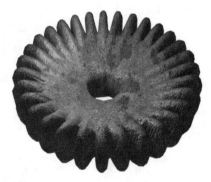

FIGURE *The completed RealFlow object in*
14.15 *Max.*

This tutorial represents only one simple example of how RealFlow Particle Systems can be used to create mesh objects in Max.

MOVING ON

In this chapter, we looked at two more Particle System modeling alternatives: Digimation's Particle Studio and Next Limit's RealFlow. In the next section, we'll explore how to use Lights.

SECTION E

Modeling with Fire and Light

15 Four Bright Spots

I n this chapter, we will look at four plug-ins that extend your ability to work with lights and light F/X in Max. It is assumed that you have some experience with standard lights and light placement from your understanding of the Max documentation, and also that you have already explored placing various light types, having gained some knowledge of what results can be obtained. This chapter introduces you to the following four Light plug-ins: Cebas' *FreePyro*, Digimation's *Shag Hair* (which uses a light as the basis upon which Hair is made visible on a model), Digimation's *Light Galleries,* and Digimation's *Phoenix*. We'll also look at how Max allows you to project bitmaps from a light source. You can browse this chapter to see if any of these plug-ins interest you if you do not own them, or you can do the tutorials if you already have them in your Max arsenal.

GYRO-PYRO

FreePyro transforms particle systems into a range of pyrotechnic effects. Here's a way to use it to generate a propulsion effect for rockets and missiles. Do the following:

1. Go to Create>Geometry>Particle Systems. These are the standard Max Particle System generators. Select the SuperSpray option, and place it in the Front viewport in the center.

2. Use the following settings for SuperSpray in the Modify panel: Particle Quantity 45, Speed 5, Emit Stop 100, Size 4, and Particle Type Standard. Leave all other values at their defaults.

3. Create a spaceship from basic Primitives. Center it over the particle stream so that the particles are emitted from the ship's engines. (See Figure 15.1.)

4. Go to Create>Helpers>PyroCluster. Click FreePyro. In the Modify panel, click Pick Particle System, and select the SuperSpray Particle System. You have selected a target system for the FreePyro effects.

5. Set the following values for the FreePyro attributes in the Modify panel (note that you can also set FreePyro values in the Render Environment window in the Atmosphere area): Under Fractal Fury, select the Gaseous type, and Light Illumination to Normal. You can also select Ultra Realistic, but that greatly increases render times. Ultra Realistic is OK for final renders.

6. Leave the other settings at their defaults. After you have some familiarity with Free-Pyro basics, you can always explore what tweaking the values produces. Render to see what you have. (See Figure 15.2.)

7. Return to the Fractal Fury area of the Rollout in the Modify panel. Select Fire as the type. Use an Intensity of 15 and a Density of 2.5. Render to preview. (See Figure 15.3.)

8. Configure another effect by selecting the Electric type. Electric does not mean light-

FIGURE
15.1
A Cone and a modified Tube are used here for the spaceship. The particles are positioned so that they seem to be coming from the nozzle.

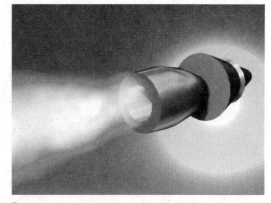

FIGURE
15.2
FreePyro Gas exits the nozzle of the ship.

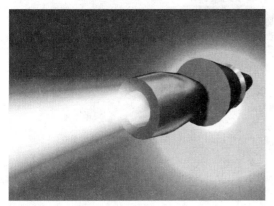

FIGURE
15.3
The FreePyro Fire effect.

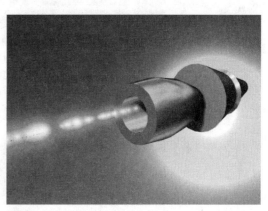

FIGURE
15.4
The FreePyro Electric type sprays from the ship.

ning bolts, but rather an Electric Plasma substance, like a pulsing laser. Render for effect. (See Figure 15.4.)

RINGS OF FIRE

Here's a neat effect, or rather, a group of effects. This tutorial requires that you own both FreePyro and Sisyphus particle effects. Do the following:

1. Place a sphere at the center of your scene, and map it with a Material that emulates a rocky planet or moon.

2. Go to Create>Geometry>Sisyphus Particles, and select Halo. Place a Halo Particle System so that it orbits the planet.

3. Open a FreePyro system (in the Helpers Rollout), and set the Halo particles to receive the FreePyro effects. By selecting Gaseous, Fire, or Electric types, you can render a revolving ring of pyrotechnics around the planet. (See Figure 15.5.)

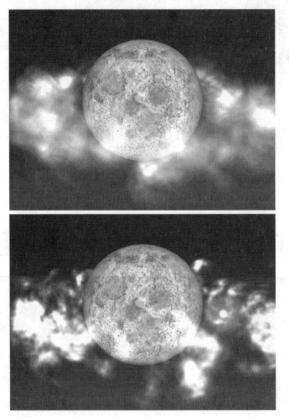

FIGURE **15.5** *Gaseous, Fire, and Electric FreePyro types orbit a moon in a ring of fire.*

OTHER USES

Use FreePyro effects to do the following:

- Create a spherical array of particles, and use a FreePyro Gaseous type to transform it into a boiling sun.

- By using FreePyro Electric on a widely scattered field of particles, you can create a galactic cluster backdrop.

- Use the Gaseous of FirePyro to create wispy clouds from confined particle volumes.

- Layer different FreePyro types and volumes to create complex chaotic environments. (See Figure 15.6.)

FIGURE *Scattered particles are used as targets for the FreePyro*
15.6 *Electric type with a size of .4.*

FURRY LIGHTS

The problem with creating hair on a model is that to look realistic, you have to work with hundreds and perhaps thousands of strands. If each of these strands is a piece of geometry, Max can easily be slowed to a crawl as your system memory is overloaded. The answer to this problem is to create a way of rendering hair and fur that avoids geometry altogether. One ingenious answer to this is provided by Digimation's Shag Fur plug-in.

Shag Fur creates hair and fur in the rendering process, through the use of special lights that allow the hair/fur components to become visible. Several items have to be present in a scene for the Shag plug-in to work:

- Two items in the Render>Environment window have to be added in the Atmosphere section of the Rollout: Shag Render and Shag Fur. They can be in any order you like. (See Figure 15.7.)

- The Shag Fur Rollout in the Render>Environment window is where fur/hair parameters are set (though these can also be tweaked in the Modify panel). The most important of these is to select the object or objects that are to be targeted for fur/hair.

- One of the viewports (usually the Perspective viewport) must be changed to a Camera viewport by adding a Camera to the scene. Shag Fur/Hair can only be seen in a Camera render.

- Shag Lights must be added to the scene. These can be standard lights translated to Shag Lights, or separate Shag Lights.

Once all of these basics are in place, you can tweak the parameters of the Fur/Hair until it looks like what you want. Here's a basic Shag Fur project example:

FIGURE **15.7** *Shag Render and Shag Fur must be added to the Atmosphere list in the Render>Environment window.*

FIGURE **15.8** *Place any mesh object in your scene to begin. This is a head model created with Digimation's Head Designer.*

1. Place an object in your Max scene. If you have a human head model, or have the Head Designer plug-in installed, use a head mesh as the object. (See Figure 15.8.)

2. Select Sub-Object>Face, and use the Selection tool to choose those parts of the mesh that are to evidence Fur or Hair. (See Figure 15.9.)

3. In the Render>Environment window, Add Shag Render and Shag Fur to the Atmosphere list. In the Shag Fur Rollout, click on Face Level under the Emitters heading. This brings up the Pick Face Selection window. Select Current Face Selection. Click on Pick and then on the mesh. (See Figure 15.10.)

FIGURE **15.9** *Select those faces on the object that are to be targeted for Fur or Hair.*

FIGURE **15.10** *Select Current Face Selection in the Pick Face Selection window.*

4. Under Create Lights, place a Shag Light Target Spot in the scene, aimed at the head. Place a Camera in the scene, and change the Perspective viewport to the Camera viewport.

5. Activate the Camera viewport and do a test render to see the results so far. (See Figure 15.11.)

6. From here on, it's pretty much a matter of exploring the parameters. In the Shag Fur Rollout in the Render>Environment window, alter Length, Thickness, Curliness, Color, and the other parameters until you get something you like. (See Figure 15.12.)

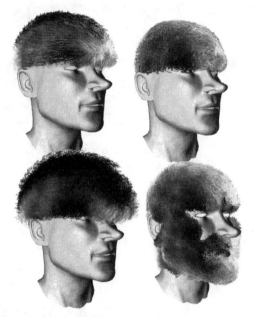

FIGURE *A test render reveals the initial hairy results.*
15.11

FIGURE *Select various options and do some test renders*
15.12 *until you create something that pleases your*
designer's eye.

Just as we used Sisyphus Grass-o-Matic to generate hair, we can do the opposite here. Explore the use of Shag Fur to create fields of vegetation. (See Figure 15.13.)

NOTE

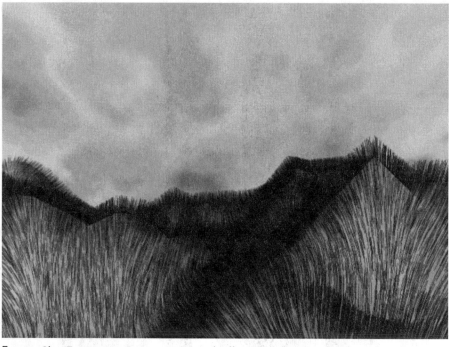

FIGURE *Shag Fur creates some awesome grassy knolls.*
15.13

GALLERY SHOWING

Light Galleries was created by Mitsubishi Electric and is marketed by Digimation. Lights have everything to do with modeling. The same model cast with two different light environments can appear totally different. Shading and shadowing display some attributes while hiding others. Light colors accentuate one feature while making other features vague. The color and brightness of the light sources also affects how we feel about the image content, how we respond to it emotionally. But, who has the time to explore dozens of possible options when it comes to variations on the lighting theme? That's exactly where Light Galleries comes into play.

Simply described, Light Galleries creates a series of rendered lighting variations as thumbnail images that can be later selected, manipulated, and then applied to your scene. The longer you set its runtime, the more variations it can produce. Here is a Light Galleries tutorial:

1. Create a scene with any content you desire. To explore Light Galleries, it's probably best to keep your initial scenes fairly basic. Use a couple of objects and two lights (any type of lights, though it's good to have at least one spotlight). Don't forget to open the

Modifier panel for the lights in the scene and to add the objects in the *Include* list, so they will be affected by the lights. If you don't understand what this means, see the Max documentation.

2. Once your scene is set, and you have saved a copy of it, it's time to bring in Light Galleries. Go to the Utilities panel and select Light Galleries from the list of options. When it appears in the Utilities Rollout, click New to add a new Light Galleries project. The Light Galleries project window will appear. (See Figure 15.14.)

FIGURE *The Light Galleries project window.*
15.14

3. Under Basic Parameters, set the following items:

 • **Run for *X* Minutes to Produce *Y* Images**: The longer the rendering time, represented here by *X*, the more images will be created, until you reach the maximum number represented here by *Y*. In other words, if you input 25 for the number of Images, but set the Rendering Time to 5 minutes, it will be doubtful that you'll get 25 images. You will get as many as the rendering time will allow.

 • **Save Path**: Set the path that represents where the rendered images will be saved.

 • **Image Size**: Set the size of the images that will be rendered. The smaller the image size, the more images that will render in the allotted time period.

 • **Production/Draft Rendering**: Select one of these two options. Draft is usually best since it is faster, and there is little need for Production rendering to see what lights do in a scene. (See Figure 15.15.)

4. Set the Hint Lights parameters. In this part of the Rollout, you can select any of the lights in the scene and decide whether to apply degrees of variation in position and angle, and how much. With one click, you can also bring up the Modify panel, allowing you to alter all of the basic light's attributes. (See Figure 15.16.)

5. Bring up the Advanced Parameters Rollout to tweak all of the finer parameters of the selected lights.

FIGURE
15.15 *The Basic Parameters settings.*

FIGURE
15.16 *Set each light's degree of variability.*

Important! *Light Galleries will use the active viewport to create the images, and there doesn't seem to be a way of stopping the process once it gets underway. Make sure you select the viewport you want to image beforehand, which is usually either the Camera or Perspective viewport.*

6. With everything set, click GO to start the rendering and saving process. Grab a cup of tea and cookies while the renders take place. Watch the viewports as your lights are placed at different positions.

7. When the rendering is complete, click the Viewer button to see all of the variations. Click the Compositor button to bring up the Compositor. RMB-drag images from the Viewer into the Compositor. Once in the Compositor, explore altering the light color of a selected Viewer frame. LMB-drag on the thumbnails to interactively alter the brightness. Click on Create These Lights in the Compositor, and that thumbnail will decide the lighting of the scene. (See Figures 5.17 and 5.18.)

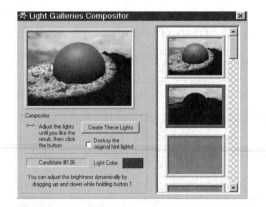

FIGURE
15.17 *Alter the lighting interactively in the Compositor.*

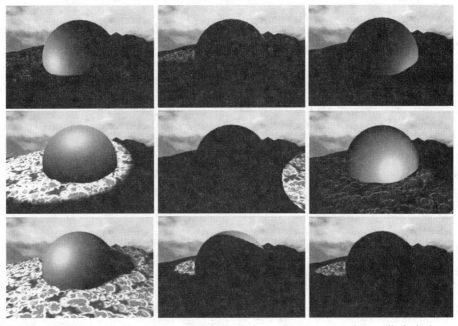

FIGURE *The Light Galleries plug-in provided these lighting variations on a theme, all of which*
15.18 *could have been targeted back to the scene.*

COMBUSTION CITY

If you go to the Create>Helpers panel and select the item Atmospheric Apparatus, you will be given four options for placing a gizmo: Box, Cylinder, Flame, and Air. These are special gizmos that enclose a volume of space, except for Air, which is just a target placement gizmo. The purpose of these gizmos is to target specific Atmospheric Effects: Combustion, Volume Fog, and Chaos Phoenix. Clicking the New button brings up a list of options for these three items. (See Figure 15.19.)

Let me demonstrate one example of using the gizmo container process to create a flame for a torch. Do the following:

FIGURE *Select an Atmospheric Effect from the list.*
15.19

1. Go to the Front viewport. Use the Create>Shapes Line tool to draw a shape that will be lathed to form a torch. Make sure the Pivot Point is moved to the center. (See Figure 15.20.)

2. With the shape selected, go to the Modify panel and select Lathe. The Torch mesh is created. (See Figure 15.21.)

3. UVW map it with Cylindrical mapping on the Y-axis, and apply any suitable Material you like. I used the Ground-Gray Dirt material from the standard Max Materials library. Set it aside after completion. (See Figure 15.22.)

4. Go to Create>Helpers>Atmospheric Apparatus, and select the Cylinder gizmo. Place a Cylinder in the scene, about the same width and height, and in the same orientation as the Torch mesh.

5. Go to the Modify panel with the Cylinder gizmo still selected. Click Add in the Rollout, and select Combustion from the Add Atmosphere list. When you see the word

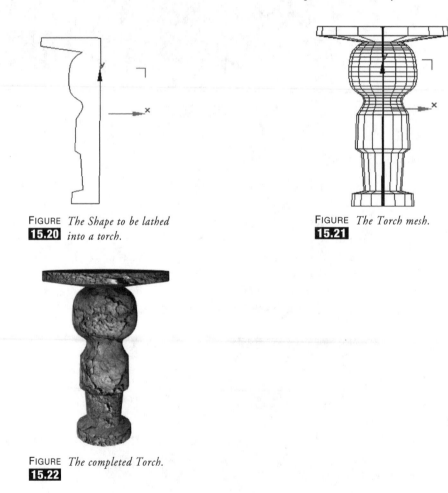

FIGURE **15.20** *The Shape to be lathed into a torch.*

FIGURE **15.21** *The Torch mesh.*

FIGURE **15.22** *The completed Torch.*

"Combustion" appear in the Modify panel for the Cylinder gizmo rollout, highlight it and click Setup. The Render>Environment window appears, with Combustion added to the Atmosphere Effects Rollout. (See Figure 15.23.)

6. Set the following Combustion parameters: Flame Type Tendril, Stretch 100, Regularity .5, Flame Size 100, Detail 1.0, Density 15, Samples 50, Phase 35, and Drift 70.

7. Do a test render, and if you like the results, save the file. (See Figure 15.24.)

FIGURE **15.23** *Combustion is added to the Atmosphere Effects list.*

FIGURE **15.24** *The finished Combustion Torch.*

Make sure you save the Torch object for later use.

ARISE THE PHOENIX

Now it's time to explore some Digimation Phoenix fire effects. Do the following:

1. Place a Particle System in the Front viewport. You may select any one you like. I used Sisyphus Halo. Set the particle parameters to whatever values you desire.

2. Go to Render>Environment. Add the Chaos Phoenix Atmosphere (obviously, you will have to have purchased and installed Phoenix first).

3. Highlight Chaos Phoenix, so that its Rollout appears.

4. Select your Particle System for Phoenix Effects.

5. Go to the Phoenix Presets in the Rollout, and pick one of the Preset effects. It's a good idea to have the Phoenix Preview screen open so you can see the effect immediately. The Preview is found under Miscellaneous in the Rollout.

6. Doing a render will display the fire effect mapped to your particles. (See Figure 15.25.)

FIGURE *Here, a Phoenix Gas Flame is mapped to particle in a Sisyphus Halo ring.*
15.25

ASTRAL PROJECTIONS

As you are no doubt aware, materials and textures can radically alter what we perceive a model to be. That is emphasized even more in the book in Section I, *Miracles with Materials*. Aside from your mastery of the Materials creation and customizing processes, there is one light-centered method of applying materials that should not be neglected. That is to use a light like a slide projector to target specific objects, and in some cases a whole scene, with a procedural or a bitmap texture. Here's how:

1. Place an object in your scene. For this exercise, it doesn't matter what it is. If you own the Head Designer plug-in, you can do this with a head mesh.

2. In the Top viewport, place one Target Spotlight on either side of the object. For each

light, go to the Modify panel and Include the object in the light's list, making sure that the Light Effects are applied to the selected object.

3. In each light's Modify Rollout, under Spotlight Parameters>Projector Map, click the button to assign any image or procedural texture you like to each light. Render and save. (See Figure 15.26.)

FIGURE *This Head Designer model is mapped from each side by a Target Spot that uses different*
15.26 *projected image content.*

If you want the projected texture to move with the object, now matter how the object is rotated or repositioned, simply Link the lights to the object. Otherwise, the object will "move through" the texture when it is moved. Also, consider giving objects to be projection mapped a white surface so the projected images are displayed clearly.

One standard use of projection mapping is to create the appearance of reflections on the object. This works especially well when the object is near a reflective water source, or when you want to project an image on a figure's eyes for an extreme close-up.

LENS OF POWER

Lens Effects options were added to Max version 3, so no matter what version you are using after that, they can serve to provide you with creative options for your projects. Lens Effects are accessed by going to Rendering> Effects>Lens Effects. Once accessed, you are presented with a list of Lens Effects options. (See Figure 15.27.)

Lens Effects in the real world are caused by what light does when a lens, like the lens of a Camera, is placed between a light source and the eye. The most common lens effects used in computer graphics are known as Lens Flares, a general term that includes many separate components. Lens Flare components are listed separately in the Lens Effects list, and include Glow, Ring, Ray, Auto Secondary, manual Secondary, Star, and Streak. Selecting any one of these from the list on the left of the Render Effects window with Lens Effects chosen, and moving it to the list area on the right, stacks the Lens Effect parameters for the chosen target. You can multiselect the same Lens Effect, applying different parameters to each, and you can stack as many separate Lens Effects for a single target as needed. (See Figure 15.28.)

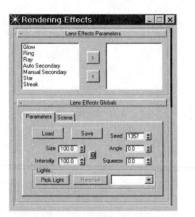

FIGURE　*After selecting Lens Effects, you can choose from*
15.27　*a list of options.*

FIGURE　*Separate Lens Effects are selected and moved to*
15.28　*the list area on the right to create a composite*
　　　　　effect for a selected target.

As you might suspect, Lens Effect targets are lights in your scene. Usually, lights are invisible in a rendering. All that you see are their effects. Using Lens Effects, the selected lights attain visible attributes, and add to the image content of a scene. Lens Effects are post-production effects, meaning that your scene will render first, followed by the calculations and rendering of the Lens Effects. Lens Effects blend perfectly over any background content in your scene.

In the Lens Effects Rollout, under the Globals heading and with the Scene tab selected, check Alpha to mute the Lens Effect and to blend it more realistically into your scene. Uncheck Alpha when you want to use a more strident Lens Effect, one that tends to write over scene content and is more intense.

To apply a Lens Effect to a light, do the following:

1. Place your light or lights in the scene that are to be targets for Lens Effects. Make sure they are visible in the Perspective or Camera viewport.

2. Go to Rendering>Effects, and select Lens Effects from the list. Note that unless you plan to clone a light for multiple Lens Effects targets, you have to reselect Lens Effects for each light in the scene that will be a target of the effects.

3. For each Lens Effect targeted to a specific light, select its options. Select the light to which the options are to be applied. One by one, select each of the options in the right-hand list to bring up its Parameter Rollout, and adjust the parameters as needed. Do this for each of the options for each selected target light.

4. Do some test renders, and tweak the parameters as necessary. When satisfied, do a final render and save. (See Figure 15.29.)

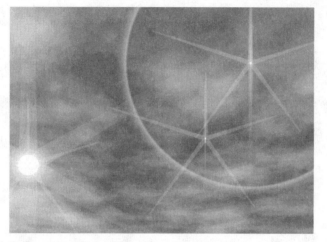

FIGURE *Lens Effects add sparkle and magic to a scene.*
15.29

Free Fire

Blur Studio's *Blur Fire* plug-in can be downloaded for free from any Max website that lists it. It's very easy to learn to use, and can create some very photographic fire models. Just do the following as an example:

1. Go to Create>Helpers>Atmospheric Apparatus, and place a Sphere gizmo at the center of the Front viewport.
2. Go to Render>Environments, and select BlurFire from the Atmosphere list.
3. In this example, there's no need to tweak any of the parameters; just leave them at their defaults. All you have to do is to click Pick Object under Source Apparatus, and select the Sphere gizmo in the scene. Render and enjoy. (See Figure 15.30.)

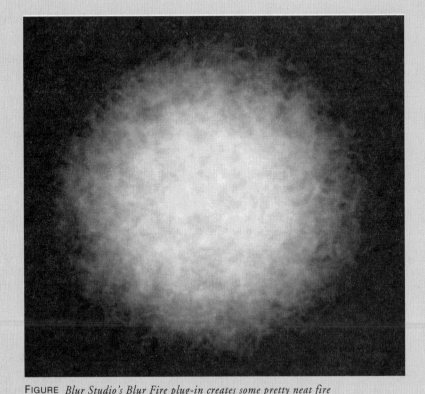

FIGURE *Blur Studio's Blur Fire plug-in creates some pretty neat fire*
15.30 *models . . . and it's* FREE!

MOVING ON

In this chapter, we looked in detail at many of the fire and light effects possible in Max. You can take time to delve into each of these options a lot deeper, playing with the parameter settings to create your own fire and light masterpieces. The next section of the book is dedicated to some of the options in the Modify panel, and how their use allows you to subtly and radically customize your models.

SECTION F

Twisted Reality

CHAPTER
16

Modify Me

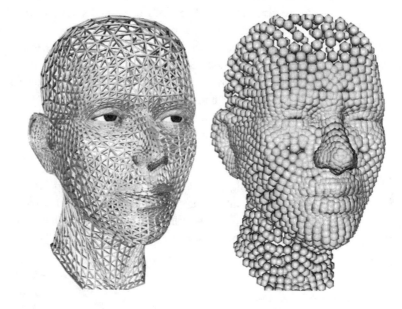

We have already covered quite a few of the Modifiers contained in the Modify panel in previous chapters of this book, so from working through these chapters (as well as from your own creative endeavors and explorations in Max), you are already aware of how important a modeling tool's modifiers can be. Truth is, the initial models you create in 3D in any application are seldom perfect or what you want at first. Every model usually requires some tweaking or modification, and some models require much more than that. Using modifiers is also a way to create unlimited variations from a single basic model.

In this chapter, we are going to allude to a selection of modifiers that are a great help when you need to adjust the parameters of your selected meshes. We don't have the space to include every modifier in the Modify list, so we'll concentrate on those considered to be high priority. The Twist, Bend, and Taper modifiers are essential, but not necessary for extra coverage, since their use is pretty self-explanatory. The UVW Mapping modifier will also be skipped, since we included it in modeling exercises throughout the book. As you are no doubt aware, modifiers can be used to reshape either an entire mesh, or just a Sub-Object selection. Keep this in mind as we look at some modification options.

You can use modifiers on editable mesh and editable patch objects, and on NURBS models. In some cases, a modifier will not work on one or more of these choices. Some modifiers also expect you to Sub-Select parts of a targeted object first, and won't work until you do. Although you can use any object in a scene as the target for modification in these examples, you will notice that we are using a model head from Head Designer, a plug-in covered in other places in the book. This is for illustration purposes, and because modifiers allow you to sculpt very interesting characters in the process. (See Figure 16.1.)

The modifiers we will be looking at as modeling tools include Face Extrude, FFD, Lattice, Noise, Spherify, Squeeze, Stretch, and Wave.

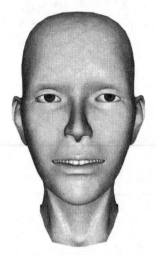

FIGURE *This is the unmodified Head Designer model we'll be using to experiment on.*
16.1

FACE EXTRUDE

Face Extrude only works best when you Sub-Select specific faces on the model that are to be extruded. In this case, "extruded" means moved away from the surface of the model on either a positive or negative Normal. If you select the entire model, nothing will happen. Face Extrusion takes place along each polygon's Normals (an imaginary perpendicular line extending from the center of the polygon). As an option, you can extrude the area from the center of the object. To use Face Extrude, do the following:

1. Sub-Select the polygons of the object that will be extruded.

2. Select the Face Extrude modifier.

3. Input the Amount of the extrusion (note that negative values will move the extrusion inward).

4. Input the Scale of the extrusion. Scale values move opposite to the Amount values most of the time, in order to help mask seams in the resulting model. In other words, decrease the Scale value below 100 if the Amount is set above 0, and vice versa. You have to play with the Amount and Scale settings to find the best paired values.

5. Decide whether you want the extrusion to occur along all selected Normals, or from the center of the object, and check or uncheck the Extrude from Center option. (See Figure 16.2.)

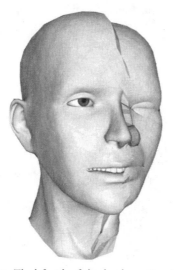

FIGURE *The left side of this head was Face Extruded by an Amount of 6 and a Scale of 88. Notice that the extruded eye and mouth are sealed shut. By selecting Extrude from Center, the eye and mouth would not have closed, and the creasing around the nose would be less evident.*

FFD

FFD means FreeForm Deformation. FFD modifiers allow you to apply forces to a selected model by moving selected lattice Control Points, instead of by working on selected polygons in the model. There are several varieties of the FFD modifier. FFD modification is the single best way to create facial expressions when targeted to a head model. FFDs can be 2x2x2, 3x3x3, 4x4x4, Box, or Cylinder based. When you select one of these FFD types, an FFD lattice with control points appears in all viewports. (See Figure 16.3.)

You can set the number of Control Points for the Box and Cylinder FFDs. Normally, an FFD is placed so that there is a space between the lattice and the selected object. You may select the Conform to Shape option, however, and then set your own offset distance. When working with complex models, this allows for better control over finer deformation movements. (See Figure 16.4.)

Do the following to work with an FFD modifier:

1. Make sure your target model is selected. In the Modify panel, select the FFD modifier you want to use.

2. On the FFD Rollout, Sub-Select Control Points.

3. Set the Number of Points if you are working with a Box or Cylinder FFD.

4. Adjust the Tension value, doing a test by moving Control Points and watching the Perspective or Camera viewport.

5. Move the Control Points to shape the model the way you want it. Render and save to disk. (See Figure 16.5.)

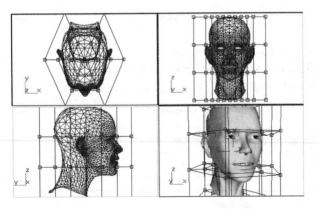

FIGURE
16.3
A Cylinder FFD is shown targeted to the head.

FIGURE
16.4
You can set the number of Control Points on the FFD Box and Cylinder Lattices.

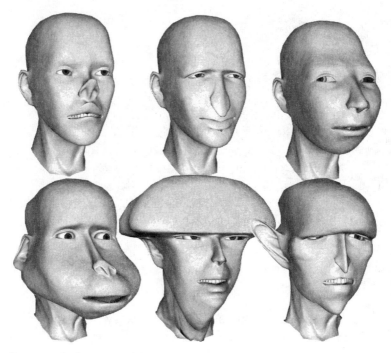

FIGURE *Cylinder FFD modifications applied to a Head Designer head.*
16.5

LATTICE

Lattice is a special modification that alters the very substance of a selected model. Instead of having a "skin" that stretches evenly across the model's surface, Lattice creates an appearance that makes the model seem to be constructed of a framework of struts. A Lattice is constructed from two elements, either or both of which may be used to transform the model. *Struts* are polygon edges. *Joints* are nodules at the polygon vertices. Joints and Struts can be resized separately. To apply a Lattice modifier, do the following:

1. Select the target model.
2. Go to the Modify panel, and select the Lattice modifier.
3. Select either or both Struts and Joints, and set size parameters.

(See Figures 16.6 and 16.7.)

Lattice does not work on Sub-Selections, and will ignore them if present.

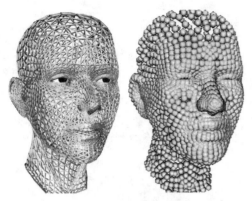

FIGURE **16.6** *On the left is the model using Lattice Struts only, while on the right the model is shown with Lattice Joints alone.*

FIGURE **16.7** *This example features both Struts and Tetrahedral Joints.*

NOISE

The Noise modifier jumbles polygons by adding waveform modifications of user-selected strengths to any selected X-, Y-, and/or Z-axis. To apply Noise, do the following:

1. With the model selected, go to the Modify panel and select the Noise modifier.

2. Set the parameters. Look at the Perspective or Camera view to see what your settings do, and tweak as necessary. (See Figures 16.8 and 16.9.)

FIGURE **16.8** *Noise applied at various strengths to the entire model.*

FIGURE **16.9** *Noise can be applied to Sub-Selections, as here where it addresses only the top of the head.*

SPHERIFY

Have you ever had that bloated feeling, the sense that you were billowing outward like a balloon? Well, maybe the fates were applying a Sphere modifier to you. Sphere has one parameter in its Rollout: Percent. At 100%, the modifier makes the selected mesh look as much like a sphere as it can manage. At lesser percentages, the effect is moderated accordingly. Applying this modifier is a no-brainer. Select the object, or Sub-Select a part of it, and input a percentage. (See Figure 16.10.)

FIGURE
16.10
On the left, a 75% Spherify is used on the top of the head. On the right, a 45% Spherify is applied to the entire object.

SQUEEZE

You can consider Squeeze to be the opposite of Spherify. Squeeze is applied by adjusting two parameters: Axial Bulge (vertical) and Radial Squeeze (horizontal). Other parameters are included for adjusting the Axial and Radial settings. (See Figures 16.11 and 16.12.)

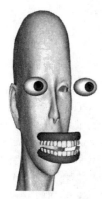

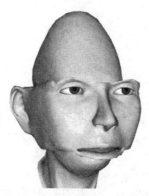

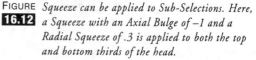

FIGURE
16.11
Yeow! That's gotta hurt. An Axial Bulge of .4 on a Curve of 12, and a radial Squeeze of –1 on a Curve of 3 are enough to pop out eyes and teeth.

FIGURE
16.12
Squeeze can be applied to Sub-Selections. Here, a Squeeze with an Axial Bulge of –1 and a Radial Squeeze of .3 is applied to both the top and bottom thirds of the head.

Although you can apply values of over 100 and lower than –100 to both the Axial and Radial parameters, it is seldom advisable to push this out of the range from –5 to 5.

STRETCH

The Stretch modifier is applied to only one axis at a time. If multiple axis stretches are needed, you simply add another Stretch modifier for that axis. The most useful values range from a Stretch of –1 to 1. (See Figure 16.13.)

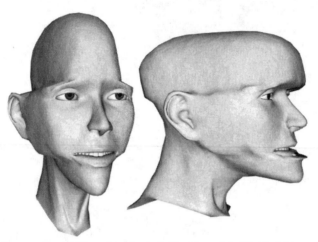

FIGURE **16.13** *On the left, a Stretch of –0.45 with an Amplify of –10 is applied to the X-axis of the top and bottom thirds of the model. On the right, a Stretch of .15 with an Amplify of 0 was applied on the Y-axis to the same model Sub-Selections.*

WAVE

The Wave modifier applies wave deformations to the X- and Y-axes of a selected model or Sub-Selected parts simultaneously. The Amplitude 1 and 2 parameters determine the depth range of the Wave, while Wave Length determines its size. For the most subtle results, keep the range within the limits of –7 to 7 for each of the Amplitude values, with one being set to either end of this range (in other words, if one Amplitude is negative, make the other positive). Set the Wave Length to values between 35 and 50 for a start. Wave Length values set between 1 and 10 create a larger number of ripples on the model. (See Figure 16.14.)

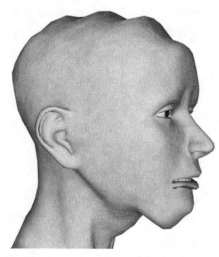

FIGURE *Here, the Wave modifier has been applied to the top and bottom thirds of the head model.*
16.14 *Amplitude values are –7 and 7, with a Wave Length of 40.*

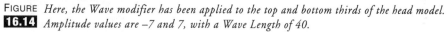

MOVING ON

In this chapter, we explored a number of modifiers that can help you add more variety and interest to your models. This theme is continued in the next chapter, as we look at freeware, shareware, and commercially available modifiers.

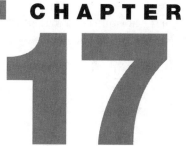
Plugging the Gaps

This chapter continues our investigation of Max modifiers, with our concentration shifting to external plug-ins. These will include more standard modifiers, freeware/shareware plug-ins, and commercially available third-party software. We will look at Grow, Push (from Terralux SDG), Slice, Sticks 'n Balls, Thaw, and Twist-O-Rama.

EDITING THE MODIFIER STACK

The order of your modifiers in the Modify Stack makes a great deal of difference as far as the results displayed for the selected object. To prove the point, do the following:

1. Place a Cylinder Primitive in the scene.

2. Select the Bend modifier. Input an Angle of 120 on the Z-axis.

3. Select the Taper Modifier. Use an Amount of –1 on a Primary Z-axis and Effect set to XY. (See Figure 17.1.)

4. Repeat the exercise again with a new Cylinder, but this time, transpose the modifiers, making the Taper modifier first in the stack and Bend second. Use all of the same settings. Save the project file. The result is quite different. (See Figure 17.2.)

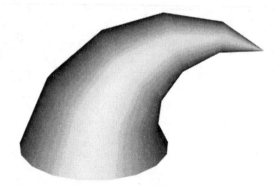

FIGURE **17.1** *The resulting object.*

FIGURE **17.2** *Using the modifiers in the opposite order creates a very different object.*

AN EASIER WAY

It would be a burden if you had to create objects and modifiers and their settings each time you wanted to explore a different arrangement in the Modifier Stack. Fortunately, you don't have to, since you can edit the stack when needed. Do the following:

1. If you don't have the last object you created still on the screen, load the project you saved that holds it.

2. In the Modifier Rollout, click the Edit Stack button. (See Figure 17.3.)

3. The Edit Modifier Stack window will appear. (See Figure 17.4.)

4. At the top of the list area, you will see your two modifiers: Bend (top) and Taper (bottom). Click Taper and Cut. Click Bend and Paste. Now Bend and Taper have changed positions in the stack, and if you look at your viewports, the modified object has been altered accordingly.

If you have a modifier stack loaded with different modifiers, you can create many object variations just by editing (moving) the selected modifiers in the stack.

5. With the Edit window still open, select the Taper modifier (which is now at the top of the stack). Copy, and Paste four times. The stack now contains five identical Taper modifiers. Look at the resulting object in Figure 17.5.

FIGURE *The Edit Stack button.*
17.3

FIGURE *The Edit Modifier*
17.4 *Stack window.*

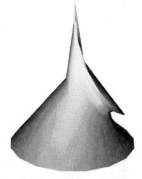

FIGURE *The resulting object*
17.5 *from multiple Tapers.*

Very Important Note! *Although the Max documentation doesn't allude to this, the Edit Modifier window can be thought of as a very powerful modeling tool.*

MORE MODELING MODIFIERS

Let's take a peek at another group of modification options.

GROW

Grow is a Digimation plug-in that must be purchased separately. The concept behind Grow, an animation application, is elegant and simple. Basically, Grow allows you to set how much

of a selected object is visible at the start of an animation, and from what direction progressive visibility will occur. We have already explored many examples that demonstrate that any Max animation process can be used as a modeling tool, just by using a Snapshot to capture a mesh at any desired frame, so it should be no surprise to you that we will engage in this same process once again. This example will make use of a Head Designer model, but you may use any object you wish if Head Designer is not available to you. What is important is that you understand the concepts involved.

Creating a Mask

We are going to use Grow as a special cutting tool to create a face mask. This tutorial calls for a Head Designer model head, but you can use any head model (or even a basic primitive object if you just want to get the hang of what's happening). You will, however, need the Grow plug-in from Digimation. Do the following:

1. Place your model in the scene so that it faces front in the Front viewport. Use the rotate view controls to get a profile view in the Perspective or Camera viewport. (See Figure 17.6.)

2. With the object selected, go to the Modify panel. Select the Grow modifier.

3. In the Grow modifier's Rollout, set the following parameters: Start = Front, Keep = Growing Ends, and Growth = 0.33. Note that you may have to alter the Growth number a bit, but it should be somewhere around ⅓ (which is 0.33). Look at the Perspective or Camera viewport. You should see a cut-away of the head model that resembles Figure 17.7.

4. Snapshot the model, and delete the original. Save the resulting mesh.

5. Access the Grow modifier on the cut-away view you created with the following settings: Start = From Top, Growth = 0.7. You may have to alter the Growth value somewhat depending upon your head model. The idea is to wind up with a nose and eyes, but cut away the mouth and chin. (See Figure 17.8.)

FIGURE
17.6 *Start by placing a head model in the scene.*

FIGURE
17.7 *The first cut is made.*

FIGURE
17.8 *The resulting cut.*

6. Snapshot again, and delete the original. Save the mesh. Keep it handy, because we'll work on it more a little later.

PUSH

There are a couple of modifiers called *Push*, but I am alluding to the one from Terralux SDG. It's free, and you can download it from any Max website that lists it. Push pushes selected faces out along their Normals, or pulls them in when the values set are negative. It has one setting: Amount. To demonstrate, let's use Push on our mask. If you have the mask saved, and also have Push installed in the Max plug-ins folder, do the following:

1. Load the mask mesh. With the mask selected, go to the Modify panel and select the Push modifier.

The Push modifier we are looking for will have Terralux SDG in parentheses next to the name.

2. Set the Amount to 2. The face will puff out a bit, just perfect for the mask. Snapshot and save the new mesh, and delete the original. (See Figure 17.9.)

FIGURE *On the left is the original mask, and on the right is the same*
17.9 *object after a Push of 2.*

SLICE

Slice is a cutter modifier that works by setting a cutting plane relative to a selected object, and then specifying how the cut is to take place. The neat thing about the Slice modifier is that the cuts are absolutely straight with no jagged edges. Let's use Slice to remove the jagged edges from the mask. Do the following:

1. If the mask is not on screen, load it into the scene.

2. With the mask selected, go to the Modify panel. Load the **Slice modifier.**

3. The Slice modifier places a cutting plane in the scene, parallel to the ground. Sub-Object>Slice Plane. Move the cutting plane so that it is just below the mouth area, and select Remove Bottom in the Rollout. The jagged parts of the bottom of the mask are cut away and disappear. Snapshot and delete the original. Save.

4. Rotate the object so that the back of the mesh is parallel to the ground (Left viewport), and the mask is staring upward.

5. Load another Slice modifier. Rotate it so that it is parallel to the ground plane. Use the same process to cut away and even up the back of the mask. Snapshot, delete the original and save it.

6. In the Editable Mesh Rollout, select Sub-Object Face. Zoom in on the Front viewport of the face, and select any stray jagged polygons in the eye sockets, and delete them. You could also use a Boolean cut with a cylinder to make them perfectly round if you wanted to. When you are satisfied, UVW Map and apply a Material. Save. Render to preview. (See Figures 17.10 and 17.11.)

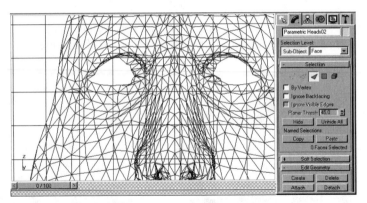

FIGURE *Zoom in to delete any unwanted polygons.*
17.10

FIGURE *The finished mask.*
17.11

STICKS 'N BALLS

At first glance, this freeware plug-in from HabWare looks like a duplicate of the Lattice plug-in we looked at in the previous chapter, but it's different enough (and it's FREE) to be worth-while to add as a modification resource. Similar to Lattice, it transforms your edges and vertices into a lattice arrangement, but it features some variable looks Lattice does not offer. "Sticks" refer to polygon edges, and "Balls" to vertices. You control the sizes of each, and whether the vertices are to be represented by spheres or boxes. See Figure 17.12 for some pos-sible variations.

FIGURE *Sticks 'n Balls modifications applied to a sphere.*
17.12

THAW

Thaw (Freeware from Effect Ware, which can be downloaded from any Max site that lists it) is a "Melt" modifier, allowing you to animate the melting of any selected object over time. By Snapshotting any frame of the resulting animated process, you can model some interesting forms. There are two basic parameters to set: Thaw (0 to 1.0), which flattens out the image starting from the bottom, and Spread, which enlarges the bottom area as the Thaw com-mences . . . similar to an ice cube turning into a puddle of water. When the Thaw parameter

is set to 1.0 and Spread is left at 0, the selected 3D model becomes a flattened mesh with the same shape as seen in the Top viewport. This is an easy way to create flat mesh shapes. Do the following:

1. Place a Torus Knot Primitive object in your scene.

2. With the Torus Knot selected, go to the Modify panel. Select the Thaw modifier.

3. Set Thaw to 1.0 and Spread to 0. You have created a flattened Torus Knot object that can be used as an element of a larger model construct. (See Figures 17.13 and 17.14.)

FIGURE **17.13** *The original Torus Knot is on the left, and the Thaw-modified flattened meltdown on the right.*

FIGURE **17.14** *A four-sided enclosure built with flattened Torus Knots.*

THE TWIST-O-RAMA RAMABOT

Twist-O-Rama (freeware download from Blur Studios via any Max site that lists it) is a wonderful modifier that can be used to create very organic convoluted forms from a basic primitive form. Twist-O-Rama differs from the standard Twist modifier by the added controls it features. Using a Sphere Primitive with Twist-O-Rama, for instance, is a great way to construct the parts for another member of out Bot family of characters (you thought we forgot about the Bots, didn't you?). The three most important parameters in Twist-O-Rama to explore for organic forms creation are Angle and Offset. Keep the Angle values above 100, and set the Offsets above 250. Figure 17.15 displays a finished RamaBot constricted by using Twist-O-Rama on spheres. If you have Twist-O-Rama, build your own unique Bot character.

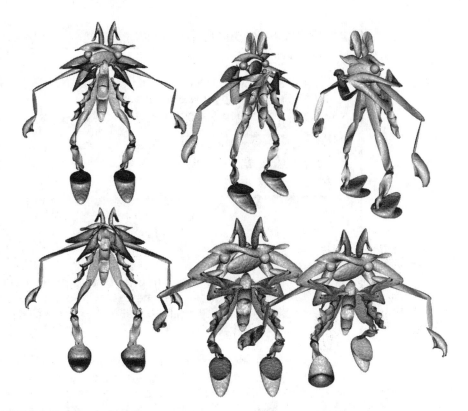

FIGURE *Hugging the RamaBot.*
17.15

Polygon Management

As a Max modeler, you realize very quickly that keeping the polygon counts of your models in a scene in check is extremely important. It becomes more so as the number of complex models in any one scene increase, since this increases the storage space needed for the scene and can negatively effect render times. Luckily, Max gives you the right tools, either built in or through external plug-ins, to handle polygon management effectively.

The Polygon Counter Utility
If you select the Polygon Counter from the Utility panel, a window will appear that allows you to set the maximum polygon count for any single object, and the maximum polygon count in a scene. You can also

(Continues)

Polygon Management *(Continued)*

see at a glance exactly how much your queue is already filled with polygons at the present time. If you have a platform with RAM memory over 512MB, you can increase the amount of polygons allowed in both any single object and in a scene.(See Figure 17.16.)

FIGURE *The Polygon Counter window displays both your total polygon parameters and how*
17.16 *much is presently in use.*

 When it comes to tools to subtract or add polygons to a selected mesh, Max excels. You will definitely want to explore the use of Optimize, PolyChop, Mesh Simplify, MultiRes, and Tessellate.

Optimize
Optimize is a built-in modifier (accessed in the Modify panel), and it offers you the quickest way to reduce the polygons in a mesh. Selecting the Optimize modifier automatically starts the process, and your polygons in the selected mesh are reduced. The single most important parameter to pay attention to in the Optimize Rollout is for Face Threshold. The higher this value, the more polygons will be removed from the selected mesh.

PolyChop
PolyChop is a BioWare plug-in, available for free download from any Max website that lists it. It's more refined than Optimize in that it lists a number of parameters that you can protect when polygon reduction commences. The actual polygon reduction process is very straightforward. You are presented with a Percent Detail control. 100% is the default, meaning no polygon reduction. Percentages less than that reduce the polygons accordingly.

Mesh Simplify
This is the most basic polygon reduction modifier of all. It works on the Vertex level of the selected mesh. The present number of vertices is displayed. Reducing the value lower than the one displayed results in a lower number of vertices in the mesh, and consequently, fewer polygons.

MultiRes

MultiRes is a Digimation modifier plug-in that must be purchased separately. It is a high-end tool for professionals, especially game designers who need to keep a quality look in a model while reducing polygon counts at the same time. Immediately upon generating the reference data, MultiRes organizes the mesh into a better arrangement of vertices and faces. This allows you to get reductions of 33% and more without any noticeable degradation in the model. You can also bring the mesh back up to its original face count, something other polygon reduction tools don't allow. Part of the magic of MultiRes is to allow multiple Normals for each vertex, so that you maintain a smooth look and reduce polygons at the same time.

Tessellate

Tessellation doubles the faces on a selected mesh. There are two reasons to do this. First, more faces create a smoother mesh. Second, more faces allow you more finely tune Mesh Editing, since there are more faces to push and pull to form a model. In the last case, the artist may tessellate a mesh, reshape it, and then reduce the polygons afterward. The Tessellate Max modifier allows you to use either three- or four-point faces in a mesh. The lower the Edge Tension value, the smoother the edges of the mesh. You can also set the Iterations from 1 to 4. Each value above 1 will double the polygons again. There is little reason to use a value of 3, and using a value of 4 can seriously effect the speed of redraw.

Make sure to consider the use of any and all of these tools as you craft your models.

MOVING ON

This chapter concludes our attention to modifiers. In the next chapter, we move on to Arrays and Space Warps.

CHAPTER
18

Arrays & Warps

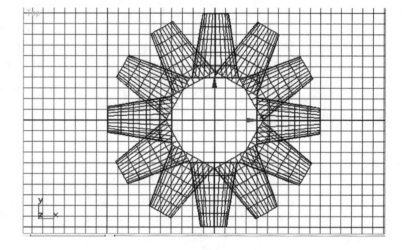

Max has more modeling tools and options than a lake has ripples. As you have already seen from the modeling process, tools, and techniques hinted at in this book, Max modeling takes advantage of both internal and external possibilities. Both the internal capacities and the external plug-ins are in a fluid state, meaning that over time, both are continually upgraded and enhanced. The growth of Max modeling alternatives is in part a response to vocalized user needs, and in part because of the evolution of the technologies involved. It wasn't that many years ago that a machine running at 72MHz was considered "cutting edge," and it won't be many years from now that a system running at a few GHz will be considered the standard. With the greater system processing speeds will come modeling capabilities and tools that can't even be imagined today. One thing remains constant, however, something that this book alludes to in every chapter; that is, the user's ability, your ability, to push the edges of the tools and processes currently available to you. As we continue with our exploration of modeling tools and processes, remember to remain in a state of "creative dissatisfaction," pushing these tutorials to places not imagined by the author, in order to continually challenge your creative horizons.

ARRAY OF HOPE

What is an *Array*? An array is a collection of similar items arranged in a specified order. The night sky is an array of stars and galaxies, whose order looks to be random except to the experienced astronomer's eye. The microcosmic world is an array of atomic particles and molecules, arranged in exacting patterns. If you need to model a molecule or a DNA chain, you need to create the array pattern that underlies the structure. You could do this by the time-consuming method of creating each component individually, and then deftly placing that component in the exact position it must occupy in the whole, or you could use a higher-order tool to place clones or copies of one modeled component in an array all at once. Obviously, if you value your time and sanity, the second method is more attractive.

MAX'S ARRAY OPTIONS

Let's walk through a few ways that you can evoke arrays in Max.

SHIFT-CLONING

If you are an experienced Max user, you are no doubt familiar with this array method. Shift-Cloning relies on your use of the three Transformation options: Move, Rotate, and Resize. Shift-Cloning depends upon one setting for the way it works, a setting you absolutely must be working familiar with to create arrays: setting the Center Point.

Setting the Center Point

The Center Point settings are accessed by selecting the Center Point tool in the Main Toolbar. Holding the LMB down on this tool on the small arrow at its lower right brings its three options into view. (See Figure 18.1.)

From top to bottom, the three options are Use Pivot Point Center, Use Transform Coordinate Center, and Use Selection Center. These same options are also important when you lathe a shape, since the lathing takes places around one of these centers. Let's do an exercise that will demonstrate the difference among these three Center options. Do the following:

1. Work in the Top viewport. Place a box primitive in the scene at the lower right of the grid. (See Figure 18.2.)

FIGURE **18.1** *The Center Point options icons.*

FIGURE **18.2** *Place a box primitive in the scene in the Top viewport.*

2. Select the Pivot Point Center option. Go to the Hierarchy panel and highlight Pivot Point. Click Effect Pivot Only. In the Top viewport, move the Pivot Point of the box to its upper-left corner. Click Effect Pivot Only to switch it off. Now we can demonstrate the differences among the three Center Point settings.

3. Select the box, and make sure the Use Pivot Point Center is selected in the Main toolbar. You will see the XTZ coordinate indicator in the upper-left corner of the box, where you just placed it. Rotate the box. It rotates around its Pivot Point as a reference. (See Figure 18.3.)

4. Undo the rotation. Select the Use Selection Center option in the Main toolbar. With the box selected, you can see that the XYZ coordinate indicator has moved to the center of the object. Rotate the box. You can see that it rotates around its center, and not its Pivot Point at the upper-left corner. (See Figure 18.4.)

5. Next to the Center Point tool is the Coordinate System list, which can display all of its options by clicking the down arrow. (See Figure 18.5.)

6. Select Grid from the Coordinate System list. Select the Use Transform Coordinate Center option. Now you can see that the XYZ-axis has moved to the center of the Grid. Rotate the box; it rotates around the center of the Grid. (See Figure 18.6.)

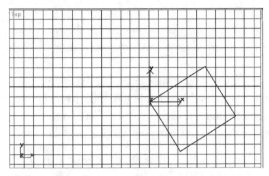

FIGURE **18.3** *With Use Pivot Point Center selected in the Main toolbar, the box rotates around the Pivot Point you set for it.*

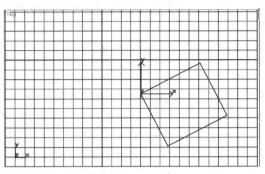

FIGURE **18.4** *Now the box rotates around its own center point.*

FIGURE **18.5** *The Coordinate Systems options when opened up.*

FIGURE **18.6** *The box rotates around the center of the Grid.*

7. OK. One more option has to be pointed out that has a major influence on Shift-Cloning, especially Shift-Rotation-Cloning: the Angle Snap Toggle setting. It is represented by the second icon in the Snap Tools menu at the bottom of your Max UI. (See Figure 18.7.)

8. RMB Click on the Angle Snap Toggle tool to bring up its settings window. Under the Options tab, leave everything at its default except for the Angle (Degrees) value. Set it to 30 using the Spinner, or manually. Close the window. (See Figure 18.8.)

9. Now, with the Angle Snap Toggle activated, rotate the box in the Top viewport. It snaps to rotations that are separated by 30 degrees. You are about to see why this is an important option . . .

FIGURE *The Snap Tools menu, showing the*
18.7 *Angle Snap Toggle highlighted.*

FIGURE *The Angle Snap Toggle*
18.8 *settings window.*

SHIFT-CLONING EXERCISES

The following Shift-Coning exercises demonstrate the use of the tools we explored at the start of this chapter.

GEARS

The creation of gears is a perfect place to start using Shift-Cloning. Shift-Cloning is useful when the duplications that occur make use of only one Transformation option. In the case of gears, that one option will be rotation. Do the following:

1. Place a Cone Primitive in the scene so that it appears in the Top viewport as shown in Figure 18.9. Make its dimensions Radius 1/Radius 2/Height equal to 22, 0, and 60, respectively.

2. Notice that it is created so that its Pivot Center is placed at the Grid center, which is true for all primitive objects when they are first created. Move the cone down on the Y-axis (in the Top viewport) by five grid squares. Now the object's Pivot Center is no longer at the Grid center. Select the Use Transform Coordinate Center tool. The co-ordinate axis jumps to the Grid center.

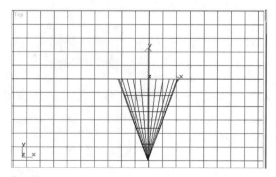

FIGURE *Create a cone that is oriented like this from the*
18.9 *Top viewport.*

3. Activate the Angle Snap Toggle, which you previously set to an angle of 30 degrees. Hold down the Shift key and select the Rotate tool. Rotate the gear until a clone snaps into position at 30 degrees. The Cone Options window appears. Select Instance, and set the Number of Copies to 11. (See Figure 18.10.)

4. Click OK and see the result in the Top viewport. (See Figure 18.11.)

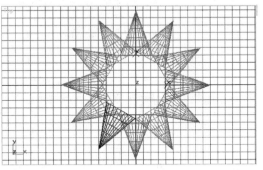

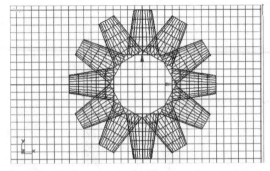

FIGURE **18.10** *Set Instance, and Number of Copies to 11.*

FIGURE **18.11** *The start of the gear model.*

5. A nice model so far, but it looks like a 12-pointed star, and not a gear yet. Select any one of the cones in the Top viewport. Since they were created by Instancing, altering one will alter all of the others. Go to the Modify panel, and set Radius 2 to 12 instead of 0. Now look at the model. It now appears to be a gear. (See Figure 18.12.)

A few more steps and we'll have a completed gear object. All of the conic "teeth" are separate elements at this point. If one were to be moved, it would leave the configuration. We can combine them all using several methods. This is the method I would use.

6. Select one conic element, and Convert To Editable Mesh in the Edit Stack option in the Modify panel. In the Rollout, use the Attach option, and click on each of the other conic teeth in turn. Now you have a single model. UVW Map (planar or Cubic) and apply any Material you like. (See Figure 18.13.)

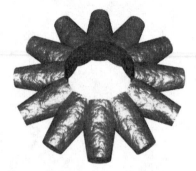

FIGURE **18.12** *Altering any one cone element alters all of the instanced copies.*

FIGURE **18.13** *A finished gear object*

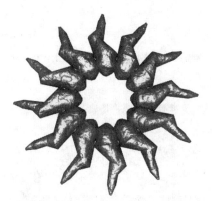

FIGURE **18.14** *A gear or sun symbol created by using Sub-Object editing on a cone.*

FIGURE **18.15** *A head gear. This seven-sided "gear" form uses an angle of 51.428571 as the Snap parameter.*

Far more fanciful designs can be generated by using a variety of different initial objects, or by Sub-Object editing the cone (or anything else). (See Figures 18.14 and 18.15.)

COLUMNS

Here is another example of a perfect place to use Shift-Cloning, this time with the Move tool. Do the following:

1. Create a lathed or lofted column of your own design. You can even use a common cylinder as an example if you're too tired to do the extra work. (See Figure 18.16.)

2. In the Top view, select the Move tool and hold the Shift key down. Move the column to create a clone in any direction. When the window appears, select Instancing, and input whatever number represents the number of copies you want to make. A row of columns is created. (See Figure 18.17.)

FIGURE **18.16** *A lathed column.*

FIGURE **18.17** *A row of columns, ready for the rest of the edifice.*

USING THE ARRAY TOOL

If you click on the Array tool in the Main toolbar, or select Array from the Tools menu, you will bring up the Array window. (See Figures 18.18 and 18.19.)

FIGURE
18.18
The Array tool.

FIGURE
18.19
The Array window.

Using the parameters in this window, you can create Arrays easier than using Shift-Cloning, and also generate Arrays not possible by the Shift-Cloning method. Why? Because by inputting specific values in the Array window, Arrays can have elements whose position, rotation, and size are altered and cloned all at once. Let's create a few objects with the Array window's help.

A Celtic Brooch

The Torus Knot primitive is very close in design to one of the main symbols used by the Celts to decorate armor and jewelry. Here's a way to use it to create a Brooch. Do the following:

1. Place a Torus Knot in the Top viewport as displayed in Figure 18.20.

2. Use the Grid Coordinate System, and select the Use Transform Coordinate Center option.

3. Click on the Array tool, and input the following values into the Array window: under Totals-Z, change 0 to 360. This indicates that a full circle of 360 degrees will be used to create the quantity of clones set as the Count input. Set Array Dimensions to 1D and a Count of 10. Click OK. The Celtic Brooch is created. All you have to do now is to use the Attach process to connect all of the members. (See Figure 18.21.)

4. You could have done this with Shift-Cloning, so let's create a spiraling variation. UNDO the Array, and Click on the Array tool again. Leave all of the previous settings as they are, except for the XYZ Scale values under Incremental. Change those from

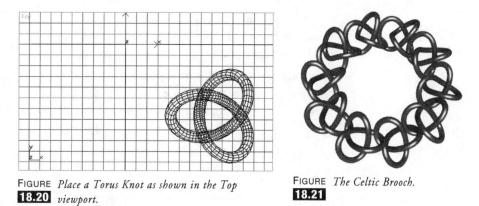

FIGURE **18.20** *Place a Torus Knot as shown in the Top viewport.*

FIGURE **18.21** *The Celtic Brooch.*

100% to 90%, and select OK. Now, as the object is cloned, it is also Scaled. (See Figure 18.22.)

5. UNDO the Array. One more variation. Click the Array tool and reset the Total Z Rotation to 640. Set the 1D Count to 15. Click OK. A tighter spiral is the result. (See Figure 18.23.)

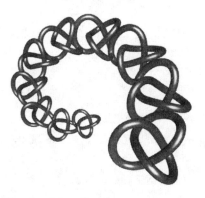

FIGURE **18.22** *A Spiraling design.*

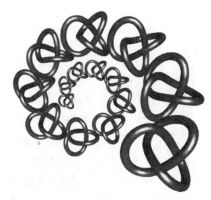

FIGURE **18.23** *Another spiral variation.*

Spiral Staircases

Let's create two versions of a Spiral Staircase, each relying on the use of an Array process.

The Lighthouse Staircase

I am calling this example a Lighthouse Staircase because of its tight spiraling dimensions. The staircase winds around a point very close to each step. Do the following:

1. Use the Create>Geometry>Standard Primitives>Box tool to create a box with these dimensions: Length/Width/Height = 100, 100, 15. This creates one step.

2. Set the Pivot Point of the step at the left center as seen in the Top view. Use the View Coordinate System and the Use Pivot Point Center option. Move the Pivot Point as displayed in Figure 18.24.

3. Open the Array window. Clear the settings by clicking Reset All Parameters. Use the following settings: Incremental Move Z = 50; Total Z Rotate 1080 (that's three full turns). Count = 50. Click OK. The Lighthouse Stairs are created. (See Figure 18.25.)

Using a Tube primitive to create the lighthouse walls, with the same inner radius as the staircase, would take the model to the next step.

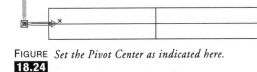

FIGURE *Set the Pivot Center as indicated here.*
18.24

FIGURE *The Lighthouse Stairs. Placing a Cylinder in*
18.25 *the middle secures them.*

Palace Spiral Staircase

To create a more palatial staircase, do the following:

1. In the Front viewport, create a Splined Line enclosed shape that resembles that displayed in Figure 18.26.

2. Extrude to 300 to create one stair. (See Figure 18.27.)

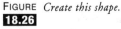

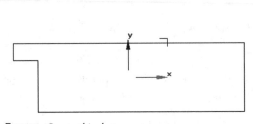

FIGURE *Create this shape.*
18.26

FIGURE *One completed stair after extrusion.*
18.27

3. Use the Screen Coordinate System, and the Use Pivot Point Center option. In the Left viewport, move the Pivot Point as displayed in Figure 18.28.

4. UVM Map as a Box and apply a Marble Material.

5. Open the Array window. Set the parameters as follows: Incremental XYZ Move = –125, 25, 55. Total Z Rotate = –90. 1D Count = 12. Render to preview. Translate step 1 to an Editable Mesh, and Attach the rest of the stairs. (See Figure 18.29.)

FIGURE *Move the Pivot Point.*
18.28

FIGURE *The Stairs.*
18.29

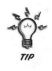
TIP

If you want to create a red carpet for the stairs, create it on the first stair before doing the Array, and group that step to the carpet object. If you want to do a banister, use the same Array window on a thin cylinder. Or better yet, create a loft path whose points carefully mimic the curve of a similar point on each stair, and loft a fancy cross-section to it.

Arrays on a Path

Let's create one more Array type. Using the Array settings, you can generate clones on all XYZ- axes at the same time. Here's how:

1. Place a Teapot in your scene in the Top viewport. Create a seven-pointed Star shape in the Front viewport.

2. Select the Teapot. Click the Spacing tool in the Main toolbar. This is on a flyout accessed by clicking on the arrow on the Array tool. This opens the Spacing Tool window. (See Figures 18.30 and 18.31.)

3. Input the following parameters in the Spacing Tool window: Click Pick Path, and click on the Star. Count = 40. Select Divide Evenly, Objects at Ends from the list.

FIGURE
18.30 *The Spacing tool.*

FIGURE
18.31 *The Spacing Tool window.*

Content = centers. Type of Object = Instance. Click Apply. You have created an Array of Teapots on the Star Path. (See Figure 18.32.)

Use this Array method to create any string of like objects on any selected Path.

> *You can also apply any Particle System to an Array, including a Path Array, and Snapshot a frame of interest to create some unique objects. (See Figure 18.33.)*

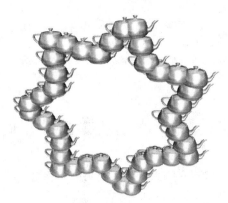

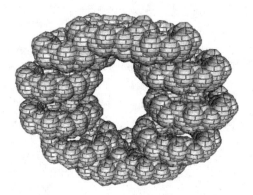

FIGURE
18.33 *A Spherical Sisyphus Halo Particle System Array attached to a circular Path. It would be impossible, or extremely time consuming, to create this object any other way.*

FIGURE
18.32 *An Array of Teapots on a Star Path.*

SPACE WARP SPEED

Space Warps are generally used as animation Modifiers, but as we explored previously, any object affected by any animation effect can be frozen into a mesh by using a Snapshot, and the resulting mesh used as a model. A Space Warp usually rests at a predetermined position

in XYZ space, and an object or objects that are *Bound* to it warp in whatever way the Space Warp is configured as the object passes near enough to be affected. To apply a Space Warp to an object or Particle System in order to create a new model (most Space Warps are meant for Particle System displacement), do the following:

1. Place the Target Object or Particle System in your scene, making whatever adjustments to it that are called for.

2. Go to Creation>Space Warps, and select one of the Space Warp selections from the list. (See Figure 18.34.)

3. Place the Space Warp on the scene.

Some Space Warps appear on the screen as a basic XYZ Coordinate axis, some appear as grids or 3D volumes, and some appear as Gizmos.

4. Select the Object or Particle System. Bind it to the Space Warp by selecting the Bind to Space Warp tool, and dragging a line from the Object or Particle System to the Space Warp. (See Figure 18.35.)

5. Now comes some exploration time. Move the Object or Particle System near or over the Space Warp. Watch what happens. Tweak the Space Warp parameters, and see what happens again. When you create something you like as far as model generation, Snapshot.

Explore all of Max' internal Space Warps, Space Warps provided with the plug-ins you purchase, and the long list of Space Warps freely available from any Max resource site on the Web that lists them. (See Figure 18.36.)

FIGURE **18.34** *The Space Warps panel is your first stop.*

FIGURE **18.35** *Activate the Bind to Space Warp tool.*

FIGURE **18.36** *A sphere transformed by passage through a Space Warp (Modifier Based Twist).*

ELASTIC SPACE

Rubber Space Warp, a Max plug-in created by Jeff Anderson (www.rubberflex.com) is one of the most interesting Warping mechanisms you can use in Max. Once installed and authorized, it appears in the Modifiers list, yet it is a true Space Warp. It operates a bit differently from other Space Warps or Modifiers, requiring a series of specific steps to perform its magic. If you have Rubber Space Warp, or are considering purchase, here are the initial steps that activate it:

1. Place any object you intend to rubberize in your scene. For this tutorial, I am using a Head Designer head. (See Figure 18.37.)

2. Place an object whose manipulation will control the warp over the to-be-warped object. I am using a Capsule primitive for this tutorial. You can actually place it anywhere in the scene, but I prefer it in this position so I can see what I'm doing. Change this object into an Editable Patch. (See Figure 18.38.)

FIGURE **18.37** *The object to be warped is placed in the scene.*

FIGURE **18.38** *The warp control object is placed in the scene. In this case, a Capsule primitive was used.*

3. Select your original object, and go to the Modify panel. Select RubberSpaceWarp from the Modifier list.

4. In the RubberSpaceWarp Rollout, under Control Objects, click Pick & Create to activate it. Now click on your control object. Two objects are created, one representing a Source morph and the other a target. The Source is frozen in place, and no longer available to you.

5. Click the Pick Src button (Source) and check Hide to make it invisible. The Source object represents your warping object in its original state. Click Enable at the top of the Rollout. This creates a connection between all of the elements.

FIGURE
18.39 *As you move and manipulate the Patches on the target object, the warping object changes shape accordingly.*

6. Select the target controller, and Sub-Object Patch. Edit the target object by selecting different patches and moving/rotating them, and watch as the warping object responds to your edits. (See Figure 18.39.)

If you have worked through this book's tutorials, especially the Modification chapters, you will instantly recognize what is happening. RubberSpaceWarp has changed the target object into a FreeForm Modifier, masquerading as a Space Warp.

7. Select the target object and Hide it, so that all that remains on the screen is the warping object.

8. Time for major fun! Select the warping object and move it. As it passes through the warping object at different points, it changes shape; that is, it warps out of shape. If you Snapshot any of these positions, you can create dozens of new models related to but different from the original. (See Figure 18.40.)

Granting Your Every Wish

Autonomous Effects (www.afx.com) is the developer of a Max plug-in called *SceneGenie,* an application whose complete boundaries of use have yet to be reached. That's because SceneGenie is best described as an overall master control panel for all of the operations you perform in Max, a fast way to integrate everything that's going on in a scene, to

(Continues)

Granting Your Every Wish *(Continued)*

control the levels of integration, and to make global and discreet changes.

SceneGenie's real forte is seamlessly blending real footage with Max components (lights, shadows, models...), so that everything looks like one environment. This obviously has implications for animating, but the creative possibilities for modeling alternatives shouldn't be overlooked either. You could easily, for example, create an integrated real-world/Max composite, and then turn around and use it as a background or a bitmap texture. That's only one idea of countless possibilities.

The CameraGenie utility in SceneGenie provides a powerful tool for measurement-free camera match-moves, when the Max camera has to remain coincident with a camera used to capture live integrated footage.

Here are just a few things you can do with Scene Genie:

- Track a moving camera and moving object(s)
- Match an object's rendered color to the original scene color
- Track a light's varying position, color, and intensity
- Track a puppet armature and animate a detailed Max puppet
- Remove puppet rods

SceneGenie is a suite of plug-in tools that implement the basic Genie idea. Some tools emulate gauges, knobs, and other control items. All of the tools are connected to the SceneGenie "solver," the main overseer behind the curtain.

The knobs are called *actuators*, and each actuator controls a targeted element in your Max scene. Commanding SceneGenie how far the knobs can be twisted, and what gauges it should look at to determine the setting for that knob, controls those elements in a scene. The

gauges are called *comparators* because they literally compare things and parameters. SceneGenie's wide selection of comparators allows very different things to be compared, and compared in different ways. Each comparator has one or more "needles," and SceneGenie keeps all the needles centered at zero. An example would be an orientation comparator that produces a zero output only when two objects are exactly aligned, while a position comparator would have three needles showing X, Y, and Z offsets.

Go to www.afx.com to get a much more detailed description, and a few tutorials, on the Max magic made possible by SceneGenie.

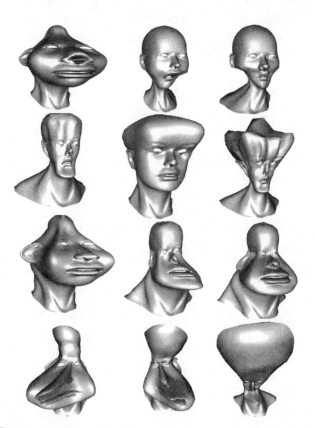

FIGURE 18.40 *RubberSpaceWarp is one of the most versatile modification tools available for Max users.*

MOVING ON

We investigated Array and Warp modeling in this chapter. In the next chapter, we will explore other software that handshakes with Max, and how to take advantage of its use.

SECTION

Shaking Hands

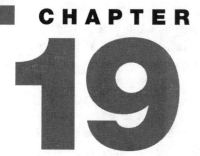

19 No Software Is an Island

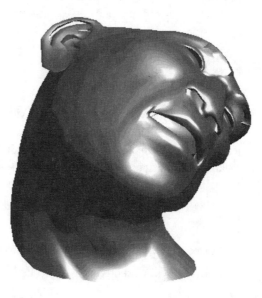

W hen you explore all of the 3D applications that support reading and writing the 3DS file format, you find that the reach of 3DS Max is much wider than even its huge array of plug-in capabilities. Most, if not all, professional 3D applications can handshake with Max through the 3DS file format highway, so you can pass files back and forth. What this really means is that all of the unique modeling tools that are contained in those applications are also available to Max users as well, as long as you have access to those applications. As the title to this chapter says, "*No Software is an Island.*" That means that no 3D graphics and animation pro depends on one application to do everything. Professionals have a wide range of software tools in the resource kit, because all of the different 3D packages offer something different in the way of modeling tools and customizing effects. Because so many of these diverse applications read and write the 3DS file format, in a sense, they can be thought of as dynamic plug-ins for Max modeling. Here are an important few you should consider adding to your library of resources, and why . . .

AMAPI

Amapi is a complete 3D application on its own, but because it also offers you full interactive handshaking with Max, it is an important Max-related accessory. Amapi has modification tools that are different enough from their Max counterparts to warrant their use for Max projects. When you install Amapi, you can also install a Max plug-in, making interactive handshaking with Max possible by bringing up a special Rollout in the Max Utilities panel. (See Figure 19.1.)

Here's how an interactive session between Amapi and Max might proceed:

1. Open Max and Open Amapi. Open the Amapi Rollout in the Max Utilities panel.

2. Place an object of interest in your Max scene. (See Figure 19.2.)

3. In Max, click Export Single Object in the Amapi Rollout. Click on the object.

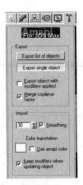

FIGURE **19.1** *The Amapi Rollout in the Max Utilities panel.*

FIGURE **19.2** *An object is placed in a Max scene.*

FIGURE *The object appears in Amapi.*
19.3

4. Go to Amapi. The object appears in the Amapi workspace. (See Figure 19.3.)

5. In Amapi, go to Tools>Modeling>Bender, and apply a Bender modification with the interactive Amapi slider. Edit>End Input.

6. Apply a Twister modification with the modification slider. Edit>End Input. (See Figure 19.4.)

Amapi's Bender and Twister tools are more interactive than similar modifiers found in Max.

7. In Amapi's File menu, make sure #DS Max Connection is checked. Go to File>Export to 3DS Max. This will bring up Amapi's 3DS Max Connection window. (See Figure 19.5.)

FIGURE *Bender and Twister modifications*
19.4 *are applied in Amapi.*

FIGURE *Amapi's 3DS Max*
19.5 *Connection window.*

8. Select the object(s) to be exported from the list, and click on Transfer Selection to 3DS Max.

9. Go to Max, and the modified object will be present. (See Figures 19.6 and 19.7.)

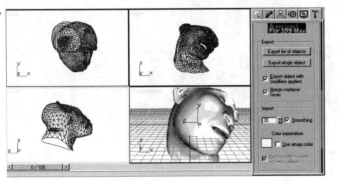

FIGURE *The modified object appears in Max.*
19.6

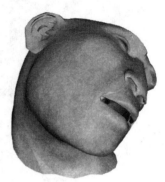

FIGURE *The rendered model.*
19.7

Obviously, you can also go in the opposite direction, using Amapi's modeling tools to create a model, and shipping it off to Max for further processing.

AMORPHIUM

Amorphium, from PLAY Inc., bridges a connection to Max through the Export/Import of the 3DS file format (and DXF and OBJ as well). Amorphium is an exquisite tool when it comes to interactive modification, with dozens of customizing features found nowhere else. These include a long list of unique modifiers, as well as "router bits" that give you the sense that you are truly shaping a clay-like surface, digging into and also extruding the model. If you have Amorphium, here's how a handshaking session might commence:

1. Open Max. Open Amorphium. Create or place a model in Max. Optimize it, and save it as a 3DS model. (See Figure 19.8.)

2. Import the 3DS file into Amorphium. (See Figure 19.9.)

3. Apply Amorphium effects as desired. Here, I have extruded three horns, extruded and rotated the chin, and stretched the ears. (See Figure 19.10.)

4. File>Export, which brings up the Export window. (See Figure 19.11.)

5. Import into Max, and apply Materials as necessary. (See Figure 19.12.)

FIGURE **19.8** *A Head Designer model in Max, optimized by using Digimation's MultiRes, and reducing the polygons by 40%.*

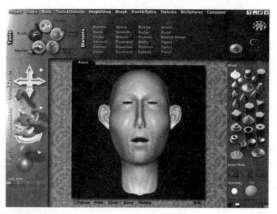

FIGURE **19.9** *The model is imported into Amorphium.*

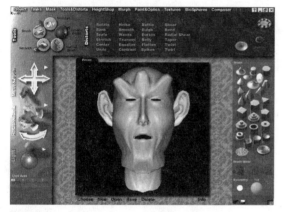

FIGURE **19.10** *Apply Amorphium modifications*

FIGURE **19.11** *Amorphium's Export window allows you to select the file format to export.*

FIGURE **19.12** *The finished Amorphium-enhanced model, rendered in Max.*

Amorphium offers Max users more than a wealth of unique modeling tools and processes. Amorphium also has the ability to handshake with many other 3D applications, so that models in a wide array of formats can be imported into Max, using Amorphium as a bridge.

BRYCE

Corel's Bryce is an exquisite rendering and animation environment that we touched upon in Chapter 9, "The Nature of Things." Bryce handshakes with Max by writing to the OBJ file format, which is also useful for exporting Bryce Terrains to Max. This requires that you download the OBJ2MAX plug-in, available from many of the Max websites for free. Bryce has an exclusive Terrain Editor, in which Terrains can be both created and customized. All manner of 3D forms can be created in the Terrain Editor, and any of them can make their way to Max via the 3DS file format bridge. (See Figures 19.13 and 19.14.)

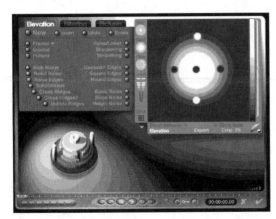

FIGURE **19.13** *An object is created in the Bryce Terrain Editor.*

FIGURE **19.14** *After export from Bryce as an OBJ file, the object is read into Max with the OBJ2MAX importer and rendered.*

ORGANICA

Impulse Organica (www.coolfun.com) is a very full-featured metaball application. Actually, Organica calls its components *MetaBlocks*, because there are so many different 3D shapes to build with. Organica writes the 3DS file format, so output is easily imported to Max. (See Figures 19.15 and 19.16.)

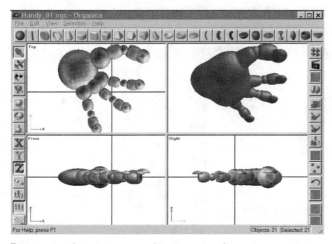

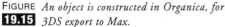

FIGURE **19.15** *An object is constructed in Organica, for 3DS export to Max.*

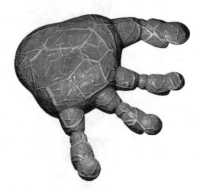

FIGURE **19.16** *Once in Max, the object can be mapped with any material and rendered.*

POSER

Poser, from CuriousLabs (www.curiouslabs.com) is a widely known and respected character development and animation application. Instead of thinking of Poser as a competitor for Discreet's Character Studio, it is better thought of as an enhanced way to develop characters for your Max pursuits. Single Poser models can be exported from Poser in the 3DS file format. Fully animated Poser models can be brought into Max via *Maximum Pose*, a Max plug-in that speaks directly to saved Poser animation files (www.ev.ca/konan/MaxPose). For developing non-animated models in Poser for Max import, do the following:

1. Open Poser, and create a posed figure from the Poser Figure Library.

2. Save out the model, or any selected parts of it, in the 3DS format.

3. In Max, import the saved 3DS Poser file. Select all of it and Group. Texture and render as needed (this can be accomplished by Ungrouping the imported figure and applying different Materials to selected elements, or applying a Material to the entire Group). (See Figures 19.17 and 19.18.)

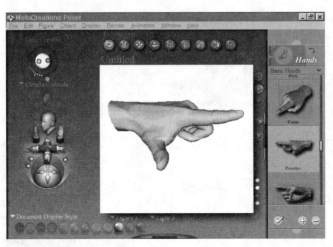

FIGURE *Develop a posed figure in Poser, and*
19.17 *export as a 3DS model.*

FIGURE *Import into Max, texture, and render.*
19.18

MAXIMUM POSE FOR FOR 3D STUDIO MAX (ALL VERSIONS)

By Konan the Barbarian

Maximum Pose takes a sequence of OBJ files that Poser exports and allows the user to optimize the animation by turning morphs on and off. The user can preview the animation via the real-time OpenGL viewer. Maximum Pose then exports a MAXScript that is about 10–20 times smaller than the original sequence of OBJs. Everything is automated by the resulting MAXScript such that all the user does is run the MAXScript and the animation is brought into 3D Studio MAX. What you see in Poser is what you get in MAX. Since Maxi-

mum Pose imports OBJ files, there are no "Missing Limbs" and other anomalies often associated with exporting 3DS files from Poser. Texture mapping is perfectly preserved.

USING MAXPOSE

By Konan the Barbarian

Here's how to use Maximum Pose:

1. Unzip the archive into the desired directory (e.g., c:\MaxPose\) and run the program MaximumPose.exe.

2. Execute Poser 3 or 4 (preferably 4) and load in a character file. To start off, use one of the low-resolution human figures.

3. Apply a BVH or an animated pose file to the figure.

4. Export the entire animation as a sequence of OBJ files in to the Poser Exports subdirectory of the Maximum Pose directory. Instruct Poser NOT to weld the body parts together—Maximum Pose will take care of that. You may wish to create a subdirectory called "Sample Animation" to keep things organized. Give it a simple file name such as "A," so you get a sequence of files names "A_0.obj, A_1.obj, etc..."

5. Enter Maximum Pose. Maximum Pose will scan these files and extract only the information required to reconstruct the animation. A typical medium resolution animation may yield a 400MB sequence of OBJ files. After Maximum Pose has processed the files, that sequence will be reduced by about 90%, resulting in a 40MB file.

6. Execute MaximumPose.exe.

7. Click on the menu heading Mesh Import.

8. Under the heading "Select Starting Mesh," click Browse.

9. Select any of the OBJ files of the sequence; however, it is recommended that you use the first "A_0.obj."

10. Under the heading Key Frames, click Load beneath the box. You will now be presented with the standard dialog box. Locate the directory in which you have exported the animation sequence. Notice that the "Files of type" box says "Vertex Data."

11. For the first time loading the animation, click on that box and select "Wavefront OBJ."

12. Select all of the animation frames, and click Open.

13. The animation will take a little bit of time to open the first time, since it has to read through all of those huge OBJ files. However, Maximum Pose is simultaneously converting those files into compact "Vertex Data" or "*.DAT" files. In the future, you may load those files and dispose of all but the first OBJ file "A_0.obj."

14. Click on Weld Identical vertices and enter 0.0001 as the Welding threshold.

15. Now, you have every keyframe loaded into memory and activated. However, not all of those frames are required to reconstruct the animation. For a slower walking sequence, as little as one in four frames is required, and for faster animations, one in two is plenty. So, under frame options, click 4. Select All Frames. Then click 2. Turn Off All Frames, 3. Turn On Every [N] Frame" and enter the number "2".

16. Click on the menu heading "Animation" to preview the animation. Click Play and see the resulting animation with the selected frames turned on. Now click the Export menu heading, and click Export half way down the page. Select an output file like "Test.ms," and click Save.

17. Execute 3D Studio MAX version 2.5 or greater.

18. Execute the MAXScript that you saved "Test.ms," and that's all she wrote. The animation is now ready to be rendered into Max. You may wish to apply features like Motion Blur to the figure.

19. Save the animation as a Max file for easy access the next time you need it.

By the time you read this, there may be a "wizard" that will convert the entire animation in one step.

LIFEFORMS

Credo Interactive's LifeForms is an application that allows you to apply BVH movement capture files to segmented models, including those found and originated in Max and Character Studio. This tutorial presupposes that you have LifeForms. Do the following:

1. To prepare for Max handshaking, put the 3DS plug-ins files, 3ds.in.dll and 3ds.out.dll, in the Plug-ins folder in the Life Forms program folder.

2. To open a 3DS file in Life Forms, choose File menu > Open.

3. In the Open dialog box, select 3DS in the File Types menu. Browse and select the 3DS file you want to open. Click Open.

Geometry, animation, and color information are preserved when a 3DS file is opened in Life Forms. Textures are also imported, but their positions may not be accurate.

4. To scale a model in Life Forms, scale down the model using Life Forms' Height and Scale command.

5. In the Stage window, select a figure by clicking on it. Choose Figure menu > Height & Scale. In the Height & Scale dialog box, enter a height for the model, or scale it by entering a percentage (for example, 80%). A suggested height is 1.7 m.

6. Click OK.

You can export to a 3DS file by merging or by exporting a new 3DS file. Merging allows you to insert only the keyframe motion data into the original 3DS file. The advantage of merging is that it adds motion data to the scene without affecting other elements. To merge keyframed animation to a 3DS file, do the following:

1. Choose File menu > Export.

2. Select the 3D Studio Max icon from the Export Format list.

3. In the Export dialog box, enter the range of frames you want to export. By default, all keyframes are exported.

4. Select the export options as follows:

 * Select the Merge checkbox to merge keyframed animation to the Source 3DS file.

 * Click the Merge File button. In the Open dialog box, select the Source 3DS file. This file must contain the same model and scene elements as the animation you are now exporting.

 * Select the Scale to Original Size checkbox if you have scaled any model using the Life Forms Height & Scale command.

5. You can export the motion data by exporting only keyframes, or by exporting all frames. For exporting motion to 3D Studio Max, it is recommended that you clear the Keyframes Only option and select the Position Frames option.

6. Click OK. Name and save the 3DS file.

When exporting an animation from Life Forms as a 3DS file, color is exported but textures may not be exported properly.

To export a 3DS file, do the following.

1. Choose File menu > Export.

2. Select the 3D Studio Max icon from the Export Format list.

3. **Keyframes Only**: Select this option to export only the keyframes in the animation. This option is not recommended for exporting to 3D Studio Max.

4. **Position Frames**: This option is available when the Keyframes Only option is cleared. When you select this option, the pelvis is keyframed at all frames, but other joints are not. This ensures that the location and altitude of the figure are independent of the interpolation method used. The motion will be accurately represented in 3D Studio Max when this option is selected. This option is recommended for exporting motion to 3D Studio Max.

5. In the Export dialog box, enter the range of frames you want to export. By default, all keyframes are exported.

6. Select the export options as follows:

- Select the Scale to Original Size checkbox if you have scaled any model using the Life Forms Height & Scale command.

- Ensure that the Merge checkbox is not selected.

- For exporting motion to 3D Studio Max, clear the Keyframes Only option and select the Position Frames option.

7. Click OK. Name and save the 3DS file.

8. In Max, import the 3DS file. Preview the animation, and Snapshot frames for required models.

More tutorials on LifeForms/Max handshaking are available at www.charactermotion.com.

Z-Brush

This is handshaking software to keep an eye on. It was in its 1.1 release during the production of this book, and was not yet able to export all of its many modeling layers to the 3DS format, but plans to do that are underway. By the time you read this, it may well be in version 2, so you should check it out. (See Figure 19.19.)

www.pixologic.com

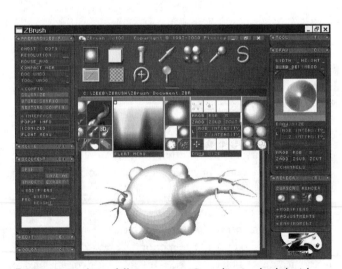

FIGURE **19.19** *Z-Brush is a fully interactive 3D application loaded with unique modeling tools. Future versions are promised to support Max handshaking.*

ILLUSTRATOR

Adobe Illustrator, or any software that supports the Illustrator format, is a must for Max users. Shapes created in Illustrator are Outlines, and come into Max as Splines. The only exception is text in Illustrator, which should be converted to Outlines before export to Max. Once in Max, imported Illustrator Splines can be used like any other Spline, as the basis for 3D object construction or as Path data for Lofting and other procedures. Illustrator Text is the most called-upon Max need, however, because in a few simple steps, you can translate it to 3D text. Combinations of Illustrator text and shapes can be extremely useful when you need to create a logo for 3D translation in Max. Here's how:

1. Open Adobe Illustrator, and use the Shape and Text tools to create your logo design. Save it in Illustrator format. (See Figure 19.20.)

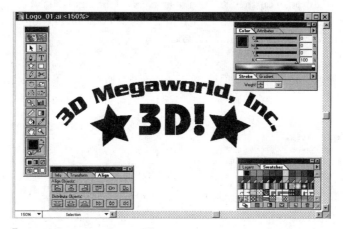

FIGURE *Create your logo in Illustrator.*
19.20

2. In Max, use the File>Import command to select the logo file and import it. Merge it into the scene if there are other 3D components already placed, or replace the scene if needed. The Illustrator data can be brought in as a single shape or as multiple shapes. (See Figure 19.21.)

3. Modify>Extrude to translate the logo to a 3D object. Give it as much depth as you like. UVW Map, add a texture, and render. (See Figure 19.22.)

FIGURE **19.21** *The Illustrator-designed logo appears in Max as an Editable Spline.*

FIGURE **19.22** *The finished Illustrator-designed logo as a 3D Max object.*

MOVING ON

In this chapter, we looked at a number of applications that can be used as modeling utilities for Max projects. We also mentioned Z-Brush, a package that is planning to offer extensive Max handshaking capabilities. We also investigated the translation of Illustrator data for Max 3D applications. In the next chapter, we'll look at a post-production application that every Max user should own: Impulse's *Illusion*.

CHAPTER
20
Real Illusions

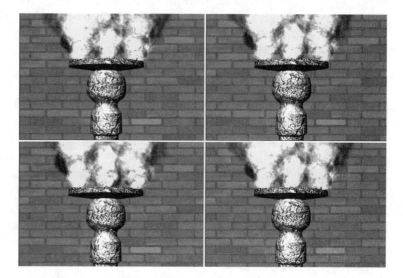

One of the most called-for effects in Max is the modeling of fire. Whether it's a flame for a torch, exhaust for a rocket, the flash from a muzzle, stars and suns, fireworks, or explosions, the need to incorporate fire and light into a Max scene remains high on the computer artist's list. We have covered a wealth of Max plug-ins that can be used to generate models of various types of fire, usually as part of a Particle System. We've also looked at additional ways of generating stars and suns for background imagery, from the Render Effects option to Sisyphus Digital Nature tools. Illusion is one of the most essential external applications you will ever run across for modeling fire in Max or any other 3D application.

Up until now, there has been no stand-alone application available that could create the high-quality pyrotechnic and other particle effects demanded by broadcast and film users, but here comes the twenty-first century. Impulse Software, best known for its Imagine and Organica 3D software, has developed a post-production FX engine it calls *Illusion*. (See Figure 20.1.)

What are *Post-Production Effects*? Post-Production Effects include any image data applied to a project *after* it is rendered. The options applied to a Max image or animation from the Render Effects list are post-production effects, as are Video-Post options. In Max, by using the rendering modes just mentioned, you can render the post-production effects and have them influence the 3D data, so that lights are generated that affect the 3D models in a scene. This is because the effect is usually applied to an object in Max 3D XYZ space. More commonly, post-production effects are applied as a 2D alternative, most commonly to a layer or layers in a stack. The software that has become the standard for post-production effects generation is Adobe After Effects and Discreet Effects. Illusion is a new member of the post-production crowd.

Illusion was in a 1.x release phase during the time this book was being written, but the film and broadcast industry have already been set aflame by its capabilities. Among its enthusiastic supporters are Foundation Imaging, Rainbow Studios, and Cage Digital. Illusion

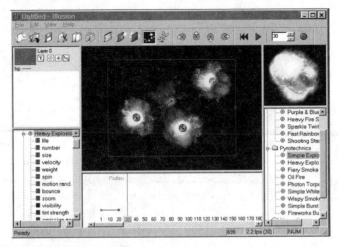

FIGURE *The Illusion UI.*
20.1

FX can be seen on broadcast television in such shows as *The Starship Trooper Chronicles, Star Trek Voyager,* Warner Brothers' *Max Steele, Lexx,* and *Superman.* You can also appreciate Illusion FX by viewing the Web movie *"405: The Movie"* by going to www.405themovie.com.

HOW ILLUSION WORKS

Readers familiar with using 3D particle systems in Max and other professional 3D software are already familiar with the term "emitter." An Emitter is a reference point used by a Particle System as the place from which the particles start. In 3D software, Emitters can be placed anywhere in XYZ space, while 2D post-production software like After Effects and Illusion limit Emitter placement to 2D coordinates. Illusion expands upon the word "Emitter," defining it also as the type of effect being generated. In Illusion, various Emitter FX are contained in an Emitter Library Directories. For example, a number of diverse explosion FX are contained in a Library called Pyrotechnics. Illusion also contains a Sparkles, Hypnotic, Water (yes, a water particles system), and other packed Emitter Library folders.

Applying an Illusion effect or effects is pretty straightforward, as follows:

1. First, you decide whether you are going to create an animation in Illusion alone, or whether you are going to superimpose Illusion FX over an imported movie file (AVI or single-frames). If you are going to use it on an existing Max animation, for example, the Max animation is imported into Illusion as footage content.

2. Then you decide what area is to be blocked from Illusion FX, if any, and you create a Blocker mask that protects areas from being over-written.

3. You can also apply a Deflector area that will act to deflect or bounce the particles away.

4. Then you select an Emitter type from one of the Library folders.

5. Next, you place the Emitter position placeholder over the area of the footage where the effect is to occur. The placeholder can remain stationary over time, or it can be Path animated (which is necessary when you need to create Photon Torpedo animations). All of the Emitter types are animated sequences of the effect, and you can create your own and store them, as well as use the Illusion Presets.

The animation is then previewed and tweaked where necessary, and then recorded to disk after frame number and FPS settings are configured. You can also save single-frame sequences, so a frame image can be imported back into Max and used as a background for any scene.

Illusion is a lot deeper than that if you want to take the time to learn to adjust all of its FX parameters, but the motivation for deeper mastery only comes after you have spent many sleepless nights being mesmerized by its more immediate possibilities. Illusion also has Layer capabilities, so placing an effect behind or in front of other image or animation content is a fairly simple task. What does this mean to Max users? You can generate all of the 3D Layer content in Max, using After Effects or Discreet's Effects to mask out unwanted parts of the layer for Alpha transparency. Illusion Layers create a true 3D look in a 2D environment. All

of the Emitter types create true 3D particles. Placing the same Emitter type twice never creates the same exact result, since Particle System generation always exercises a random factor.

As with most other professional animation software, Illusion contains a hierarchical list of every feature of every effect, which can be opened and customized. Emitter effects, for example, can be resized, rotated, and otherwise transformed, and the life/death cycle of the particles altered (similar to Particle Systems in Max). New colors can be assigned, and the resulting Emitter can then be saved as a new one to your own Emitter Library folder. Illusion has the capability to incorporate more 3D image sequences in a Library folder. This need not be limited to fire and light effects, but can also be sequences of a figure going through a walk cycle. Setting the figure on a Path then allows you to develop just the right ingredients for an animated comic production, and that's only one extended idea for use. Illusion can also store animated Logo frames, so you can call upon your Logo to appear and go through its motions at any point in a layered segment.

The Emitter Libraries included with the software are extensible. In addition to being able to create your own unique Emitters, you can also visit Impulse website (www.coolfun.com), and download a continuing series of new Emitters. Impulse runs a monthly contest, awards prizes for the best new Emitter collections, and then posts them for free download. A series of exacting tutorials is also posted online in HTML format.

Particle Systems gobble up memory, whether in Max or Illusion. You can place multiple Emitters on an Illusion stage, but doing this will bog down preview and rendering. The best solution is to use Layers for separate Emitters. However, there is an interesting effect that occurs when multiple Emitters are placed on the same Layer, in that they intermix and combine, creating even more random variety.

GENERATING ILLUSION EFFECTS FOR A MAX PRODUCTION

Pyrotechnics always look better against a black or very dark background. Take this into consideration when creating a Max image or animation that is to be post-processed in Illusion.

Do the following to handshake with Illusion:

1. Generate the imagery you want to have Illusion reference in a Max scene. Render and save. (See Figure 20.2.)

2. Import the image into Illusion. Resize the view screen according to your Max image.

3. Mask any areas of the image that are to be protected from the effects.

4. Apply the selected effect from an Emitter Library. Save the image or the resulting animation as needed. (See Figures 20.3 and 20.4.)

www.coolfun.com

FIGURE *The Max data is rendered and saved.*
20.2

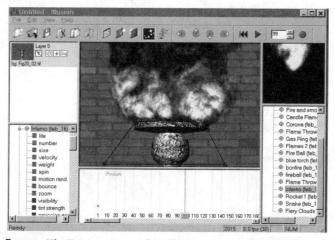

FIGURE *The Emitter is accessed in Illusion and the effect applied.*
20.3

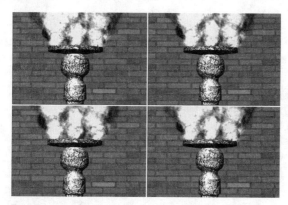

FIGURE *Rendered frames from the Illusion/Max image.*
20.4

Just as this book was going to press, Impulse released a separate renderer for Illusion, capable of handling much larger file sizes.

MOVING ON

Having explored the handshaking between Max and Impulse Illusion, it's time to move on to the next section and chapter, where we'll detail some modeling resource libraries for Max.

CHAPTER 21

CDs Galore

When we speak about Max modeling, it is important to consider what models are already available on the market. Only the purist, and never the working digital artist, demands that every component of every scene contains nothing but original models. A wealth of models is always supplied with every 3D application, and Max is no different. These models are for your use and enjoyment, as well as your work. Your creativity still enters the picture, however, when you use "canned" models. Each model represents a potential for unlimited tweaking and customizing with any and all of Max editing tools, modifiers, and Space Warps. Added to that is your ability to texture and retexture any of the models' components . . . and that's only the start of it. To be sure, the feeling and pride (and many times the necessity) to create a model from scratch enters the arena too. Depending upon where you work, what you do, and what your personal artistic temperament and corporate policies are, you will mix creating everything from scratch with customizing canned models to different degrees.

Many computer artists make a living developing models for free use by anyone who purchases them. Some of these packages come with the express condition, however, that the company or designer be given some line of credit if the model or models are used in a film or broadcast situation. That's only fair, since this gives them the needed exposure to stay in business. Some model collections come with no conditions at all, but even then, it's only courteous to give the designer some mention in the credits. The same is true, in fact, for the software you are using. To have a line somewhere in the credits for your production that references 3DS Max helps to sell more software, and that assures you that the company will stay on an upgrade path to protect your initial software investment. So, with all of these considerations in mind, here are some CD volumes of model collections that you should investigate, and possibly incorporate into your Max modeling life. This list certainly does not cover all of the modeling resource collections on the market, but it does mention some of the most prominent ones for your further exploration.

BaumEnt

www.baument.com

The BaumEnt "Meshes" collection is a must-have collection of CDs for the Max artist and modeler. Not only can you use any of the models involved copyright free, but these models are also a great teaching resource for aspiring modelers. Accessories, plants, clothing, background costumed figures, and more are contained on the CDs.

BBay

www.bbay.com

BBay lists a group of digital modelers and texture creators on its site, which is devoted to supplying the digital community with unique and high-quality models. Much of the site is

dedicated to Poser-related models, but since Poser and Max are so compatible, it makes sense to browse their offerings.

DIGIMATION

www.digimation.com

As you might expect, Digimation markets models as well as Max plug-ins. Their Tropical Plants remains of high interest to Max artists, and gives you a way to populate your Max and AWB environments with all of the flora you need to escape to your own desert isle. Digimation also offers a separate CD of Alien Materials for mapping your models.

DIMENSIONAL EXPRESSIONS

www.dimensionalexpressions.com

You should explore the *3D Bug Collection*. The models are created for LightWave users, but you can download a LW2MAX plug-in from any website it is available on and use these models. Besides, you might also be a LightWave user as well as a Max user, and so can save the models out from LightWave in a format Max can read.

EPIC MODEL LIBRARY

www.epicsoftware.com

The Fantasy Figures CD contains a group of models just right for children's cartoons in a Max environment. They also offer other CD collections.

GRAPHIC DETAIL

502-363-2986

Graphic Detail produces a multivolume series of CD-ROMs called "LightROMs." These were named after their LightWave modeling and texture content, but also offer the models in 3DS format. Each collection in the series contains multiple CDs, and the content is unlike any you will find anywhere else, provided by an array of professionals in the field.

GRUPPO IRIDE

Gruppo Iride
Via E. Mattei, 32
24050 Calcinate

Bergamo, Italy

mare3d@spm.it

Need high-quality dinosaur models for your Max scenes? This is the place to get them. There are 10 super-quality prehistoric meshes included on the CD: Tyrannosaurus, Gallimimus, Pterodactyl, Parasaurolophus, Triceratops, Brachiosaurus, Plesiosaurus, Velocoraptor, Mosquito, and Shark.

KETIV TECHNOLOGIES

503-343-4281

The *Blocks and Materials* CD collection is well worth your investigation. There is something here for everyone, including (literally) the kitchen sink. Exterior and interior models are included, with over 1000 seamless textures.

REPLICA TECHNOLOGIES

www.replicatech.com

Replica Tech offers model collections that include a complete castle, inside and out, Frank Lloyd Wright's architecture, Dolphins and Sharks, and a variety of other model collections. These are all high-quality meshes that can be further customized as needed in Max.

VIEWPOINT DATA LABS

www.viewpont.com

Viewpoint is known for their major film work, especially for designing the extremely complex Godzilla models used in the film of the same name. Viewpoint markets one of the largest collections of models in all formats, which can be purchased separately or in groups. They also send out a four-volume CD collection that you can browse at your leisure, and then after purchase and receiving an unlocking code, use any of the included models.

VISTA INTERNET PRODUCTS

www.vistainternetproducts.com/contact.htm

This small group of independent professional modelers (including Debra Ross, Ken Gilliland, and others) specialize in modeling human and animal figures. Their work is used widely, from Poser projects to film, and the models make excellent additions to Max projects.

ZYGOTE MEDIA GROUP

www.zygote.com

Your modeling collection explorations are not complete unless you have at least visited the Zygote site, and perhaps requested one of their catalogues. In addition to their more public modeling collections, they also do custom work for clients. Content ranges from human and animal to more mechanistic figures and accessories.

MOVING ON

In this chapter, we listed some of the developers you may want to contact in order to purchase their CD model collections. In the next section of the book, which includes three chapters, we'll look at ways to augment your Max Materials interactions.

SECTION

Miracles with Materials

CHAPTER
22
The Material World

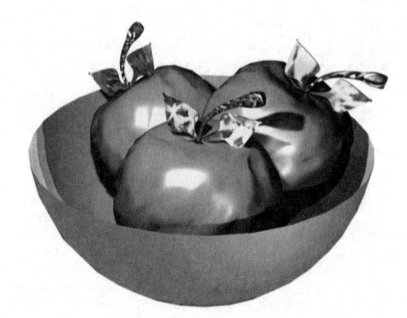

N o model in a 3D environment can have a personality without a texture/Material applied to it. An apple without its redness and shiny skin, a lizard without its rough, scaly surface, a spaceship without its metallic sheen and scratches of wear—every object in our perception is identified by not only its shape, but what it appears to be made of. The knowledge of how to apply Materials in Max is essential to every modeling enterprise, because it is Materials that bring a 3D object to life.

The three chapters contained in this section of the book assume that you have already attained a working knowledge of Materials in Max, including a degree of proficiency with their application and customization. At certain points in the text, hints and tips will be provided to enhance your knowledge. The purpose of these three chapters is to present you with alternatives, new plug-ins and processes, for expanding your ability to create the texture looks you need for your Max models. With that in mind, let's begin . . .

A SHORT REVIEW OF SOME BASICS

This review is not meant to be a complete regurgitation of the data on Materials found in the Max documentation, so if you haven't yet availed yourself of that information, please do it before continuing here. With that prior knowledge in hand, this material will make more sense.

Every 3D application on the market handles the assignment of textures/Materials in a different way, but there are underlying similarities amongst all of the high-end software. For instance, materials (called by whatever other name may be used in other 3D software) are composed of two general types: bitmap images and procedurals. Bitmap images are picture, and in some cases, movie files. Procedurals are formulas used to create image components that mimic real-world textures. The advantages of using procedurals is that their file size is far smaller than a bitmap image, they can be augmented and restructured almost infinitely, and they look good at any resolution, no matter how close the camera gets to the object.

Bitmap images and/or procedurals can be applied to different components, called *Channels*, of a final Material. Each of these Channels affects the final material in a different manner. In Max, these Channels are found under the Maps Rollout in the Material Editor. (See Figure 22.1.)

The Channel components in Max include the following:

- **Ambient Color**: This is the Ambient Channel of a Material. Ambient Color is sometimes called *Sun Color* or *Room Color*. It is the color of a global light source applied to a specific Channel of a Material. The actual hue of the Ambient component is set in the first section of the Material Editor Rollout, above the Maps Rollout. Under Maps, the percentage of Ambient Color is set. In Max, you are not allowed to set Ambient Color above 100%. No matter the color of your material's surface, Ambient Color will tint that color. That's why the default Ambient Color Hue is set to black. Use Ambient Color Hues other than black to tint the material.

FIGURE *The Maps Rollout in the Material Editor.*
22.1

- **Diffuse Color**: The components of the Diffuse Color Channel decide what general properties the material "skin" is to exhibit. This can be as simple as a color hue, or as complex as a bitmap image or procedural texture. Clicking the Map button in the Diffuse Color Channel brings up the Material/Map Browser, which lists all the different types of Maps that can be applied to your Material as part of the Diffuse Color Channel. Once in the Material/Map Browser, selecting Browse From>New gives you the best overview of Diffuse Color types. (See Figure 22.2.)

- **Specular Color**: If the Specular Color Channel is checked for the material, then whatever color you set Specular Color as at the beginning of the Rollout, and the level it was set at, will be part of the material. Specularity is best defined as the "hot spot" that appears when a light is shined on certain materials (like metals and other "hard

FIGURE *The Material/Map Browser, where you can select from a wide array of Map types for*
22.2 *Diffuse Color Channel data.*

edged" substances). You can also apply any Map from the Material/Map Browser to the Secular Color Channel.

- **Specular Level**: The Specular Level is set in the upper part of the Material Rollout. The higher the value, the more the hot spot spreads out across the material. You can also place a specific Map type here.

- **Glossiness**: The lower the Glossiness value (set at the top of the Rollout), the larger the Specular hot spot. You can also place a Map in this Channel.

- **Self Illumination**: This value can be based on a range from black (no glossiness) to white (extreme glossiness), percentage, or a Map type. Be careful about high Self Illumination, however, since it tends to smear the rest of the Material detail. Self-Illuminated materials make objects visible in the dark, even when no lights are present in a scene, and are sometimes used for ghostly effects.

- **Opacity**: At 100% Opacity, the object targeted for the Material appears in full view. At 0% Opacity, the object is invisible. Opacity Channels usually are used with Opacity Maps. An Opacity Map is a grayscale image or procedural. Where the image or procedural texture is black, the mapped parts of the material (and the object it is applied to) are invisible. Where the image or procedural components are white, the Material is completely opaque. Mid-range grays act in degrees of opacity.

This is different from rendering a Material that is designated as a WIRE type, which renders the edges and vertices of the targeted object only.

- **Filter Color**: Filter Colors, or Filter maps, are used to mask out areas of the Material.

- **Bump**: Bump Mapping is used to create fake-3D, by reading grayscale values of bitmap images or procedurals as height values. Black is lowest, and white is highest, with intermediate grays forming the height levels in between. Using the right Bump Map on an object can save a lot of object modeling time, because you can get 3D results without actually deforming the geometry. Bump Map values can be increased to 999 for extreme 3D looks.

- **Reflection**: A Reflection Map, or color, is always present in the mapped object at the same perspective. In other words, if you move the object, it moves "through" the Reflection Map, as if the reflection represented the global environment (which it is supposed to), at whatever percentage is set. Note that Reflection Maps are NOT reflections of your scene.

To use a Reflection Map to emulate the scene you are working in, do this: Render an image of the scene without the object that will receive the Reflection Map (make it invisible in the Display panel), and save the image. Then, after making the object visible, place the image you just rendered in the Reflection Map Channel of the Material it will be mapped with. By using the right mapping type, you can save a lot of Ray Tracing render time, and create very believable results.

- **Refraction**: Refraction values represent the ability of an object mapped with the refracted value material, to bend light. In order to notice the refraction artifacts, the object should be partially transparent. It is also best to use Refraction mapping on Ray Traced materials.

- **Displacement**: Displacement Mapping is the topic of the next item to be covered in this chapter.

To erase any map from a Material Channel, select a Map Channel that displays the NONE label, and drag it over the Channel Map you want to erase.

Please be aware that as we stated at the start of this section, there is far more about detailed Material customizing beyond what we have covered here. Every Channel's components can be edited far deeper than just applying a Map. Reference the Max docs for some hints and techniques in that direction. Full coverage of Materials editing in Max is very complex and page consuming, and would be best covered in a separate Max book (who knows . . .).

I LOVE DISPLACE

Image maps or procedural textures placed in the Bump Channel create a fake-3D appearance to the Material. It seems as if the material has "bumps" or indentations that follow the grayscale level of the Map. But if you look at the actual geometry of the object the Material is applied to, you see no changes. Placing Map data in the Displace Channel, however, is a different story. Maps in the Displace Channel slot actually deform the geometry of the selected object, according to the grayscale value of the applied Displacement Map and the Amount value. You can always tell the difference between Bump Maps and Displacement Maps by looking at the edges of the mapped object. Bump Maps do not affect the edges; Displacement Maps do. Although you can't see the result in any of your viewports, you can see some indication of deformation in the Material Editor's preview window for that Material. This makes Displacement Mapping more than a Material application, but instead makes it as definitive modeling tool. (See Figures 22.3 through 22.5.)

Here are some tips for Displacement Mapping:

- Increase the polygons in the selected mesh. Displacement results are higher quality on finer meshes. You can use the Tessellate modifier to do this, or specific Sub-Object editing.

- Negative Displacement values tend to shrink an object, and positive values tend to expand it. Negative values often look smoother.

- In general, use a range from –50 to 50 for Displacement Channel values. You'll get less distortion and better-looking results.

FIGURE **22.3** *A sphere mapped with the same Wood Procedural texture in the Material's Diffuse Color (100%), Bump(75%), and Displacement(-40%) Channels.*

FIGURE **22.4** *The apples in the bowl are Displacement Mapped with a 25% Dent procedural texture, making them look a bit less than edible.*

FIGURE **22.5** *A Head Designer head mapped with a Material that has a Stucco.jpg texture in the Diffuse Color (100%) and Bump (75%), and an Elemental Electricity procedural in the Displacement Channel (–20%),*

- Paint your own Displacement Maps in any painting program. Make sure to paint in 256 level (8-bit) grayscale for the best results.
- Use the same Map in the Displacement, Diffuse Color, and Bump Channels.

CLIMBING A DARK TREE

DarkTree Textures is a separate application that creates procedural shaders for Max. If you own it (or want to explore the available demo that can be downloaded), here's a neat tutorial from the DarkTree developers themselves.

CREATING AN ANIMATED ENERGY FIELD WITH DARKTREE TEXTURES

By Skyler and Leslie Swanson

In this tutorial, we'll use DarkTree Textures to create an animated energy field or plasma ball shader. Then we'll import it into 3DS Max's Material Editor using the DarkTree plug-in, SimbiontMAX. The plasma ball will consist of animated, colored, electrical arcs. Variations of this type of effect have been used in major movie productions. For example, remember the mutant energy field in *X Men*, and the energy beings in *Titan AE*? Usually these effects require specialized shader programming (and a big budget); however, by using DarkTree and 3D Studio Max, we can create the same effect quickly and easily.

For those of you not familiar with DarkTree Textures, it's a procedural shader-creation application that plugs in to 3D Studio Max (R3 and above). DarkTree lets you design procedurally based shaders by dragging, dropping, and linking procedural components together in a flow tree. The underlying principles are very similar to Max's own Material Editor, but are taken much further. The root of a DarkTree shader is equivalent to a Material in 3D Studio, and the components that are linked to that root are like Max's Channel Maps. DarkTree has 75 of these procedural components, and allows you to combine and layer them in any way you wish.

The skill level for this tutorial is intermediate. It requires some DarkTree Editor skills, plus basic object-making and material editor skills in 3D Studio Max as well. If you don't own DarkTree Textures, you can download the demo (http://www.darksim.com), so that you can follow along. You won't be able to save your results with the demo version, however.

The tutorial is split into three parts. In the first, you'll create an energy field shader using DarkTree Textures. In the second, you'll modify your shader, in DarkTree as well, to make a transparency mask for your energy field. And in the last, you'll use SimbiontMAX, the DarkTree material plug-in, to apply the energy field shader in 3D Studio Max. By the way, notice the several screen shots showing the shader and mask in various stages of completion. Refer to them anytime you wish to check your results.

Building the Animated Energy Field Shader

1. After opening a new DarkTree Editor, you'll need to do a bit of preliminary positioning. First open the Process folder in the component bin and drag out the Composite component. Plug it in to the socket directly to the right of the root socket. Paste it as a color type. Next, open the Natural folder and drag out the Pestilence component. Plug it in to the right of Composite, and paste it as color also. We'll work with these two components later. Leave ROOT empty for now.

2. The energy field is heavily based on the Fractal Noise component. So, next, open the Noise folder and drag out Fractal. Plug it in as a percent-type, to the right of Pesti-

The Fractal Noise component.
22.6

lence. Each component should be plugged in to the right of the previous one, unless otherwise stated. (See Figure 22.6.)

3. Moving on, open the Generator folder, fetch the Bell generator, and plug it in. Link Fractal's Blend_Function parameter to Bell. To link, right-click on the right side of the component frame to select a parameter for linking, and then drag the wire that appears to the child component frame. A pop-up will open and ask you to choose between Percent and Percent_Invert. Select Percent.

4. Our first trick is to use the Bell generator to cut a steep, narrow slice out of Fractal. This will provide the electrical arcs. To create the slice, double-click on Bell to open its component editor. Change the Frequency parameter to 15.0. Looking at the generator plot, you can see how the curve moves from 0.0 to 100.0 and back to 0.0 again very quickly. Change Phase_Scale to 15.0 as well. This last change will cause the slice to move once across the shader when we animate in a few more steps. Set the Phase parameter to 50.0 to keep the arcs visible in the Editor.

5. Open the Fractal component editor and set the Roughness parameter to 9.0 or less. This will keep the arc edges fairly clean cut, which looks the best. Higher values for Roughness make the arcs too fuzzy, and ultimately, too busy for our purpose.

6. Now we're going to animate the Bell generator's Phase parameter. To do this, drag out a Trigger (from the External folder) and link Bell's Phase parameter to it. Open the Trigger component editor and click the Edit Triggers button, located bottom left, to open the Trigger Bank. At the top of the Bank, set End Frame to 30. Go to the # 0 line (the one with the green light) and set the End Frame to 30 here as well. Be sure to hit the Enter key each time you reset an animation length in the Trigger Bank. Close the Bank and say Yes to the dialog window question. (See Figure 22.7.)

7. It's time to check the first animation—make sure it looks okay thus far. To proceed, open an Examine window and drag your subtree onto it. (Be sure to drag the subtree

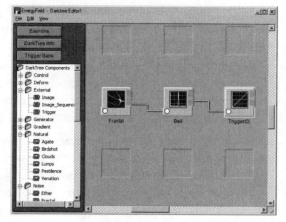

FIGURE
22.7 *Fractal, Bell, and Trigger components linked.*

by using the Fractal component image.) Paste it as Luminosity. You can use the arrow keys to step through the animation, or set the frame number to 1 and hit the "a" key on your keyboard. Don't expect to see anything until frame 8 or so.

8. We need another subtree like the one we just created so that we can add more arcs. Otherwise, the animation will look sparse (and dull). That being the case, copy the entire subtree you have so far (excluding the still-unlinked color components) and paste it as a second percent subtree directly below the original. You'll be working with this subtree copy for the next few steps. (See Figure 22.8.)

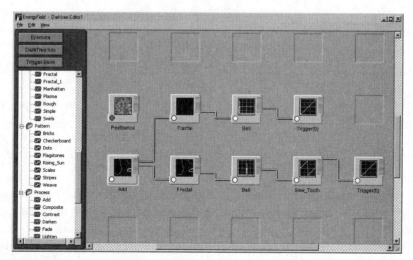

FIGURE
22.8 *The subtree is added.*

9. The subtree copy should be modified; otherwise, both sets of energy patterns will be identical. Then, open the second Fractal and change its seed to 11. This will change the noise pattern and, therefore, the arcs.

10. When you examined the first animation, did you notice that the energy pattern (electrical arcs) phased in and out during the earlier frames? We'll be changing the second Phase animation so that its energy pattern will phase in and out during later frames. To accomplish this, unlink and drag just the Trigger component one socket to the right.

11. Next, we want to shift the Bell generator's Phase parameter by one-half, so that the steep slice through Fractal happens at a different point in the animation. To accomplish this, go back to the Generator folder and fetch Sawtooth. Drag it onto the socket just vacated by the Trigger. Open the Sawtooth component editor and change the Frequency parameter to 0.5 and the Phase parameter to 25.0. When you link up the Phase parameter in the next step, open the Bell component editor, and you'll see that the slice has moved to the middle of the plot.

12. Link Bell's Phase parameter to the Sawtooth component as a percent, and Sawtooth's Input parameter to the Trigger component. You might want to run this animation now, just to check for problems.

13. The next task is to make the two Fractal subtrees into one DarkTree, so that you'll get continuous electrical arcs during the animation. From the component bin, open the Process folder again. Find and drag out the Add component. Paste it as a percent type, and plug it in directly to the left of the lower animated subtree. The Add component has two parameters, Percent_A and Percent_B. Link Percent_A to the first Fractal component, and Percent B _to the copy.

14. Now we want some color for the electrical arcs, so open the Pestilence component editor. You'll need to change the default colors to two that are contrasting and highly saturated. The colors we chose for this project are (violet pink) R190, G2, B253 for the Low parameter; and (acidic lime) R158, G252, B3 for the High parameter. While the component editor is open, set Contrast to 80.0 and Roughness to 25.0. The last two changes just make the two colors a little sharper where they intersect. (See Figure 22.9.)

15. Next, go back to the very first component you fetched, Composite, and open its component editor. Change the Color_A parameter to black. Close the editor and link the Color_B parameter to the Pestilence component. Link Composite's Mask parameter to the Add component.

16. To complete our color DarkTree, drag out the Basic Shader component (it's in the Shader folder). Plug it in as ROOT, and then open its component editor. We want to change some lighting effects so that the electrical arcs will be self-illuminated, but not shaded. Set both Diffuse_Level and Specular_Level to 0.0, and increase Luminosity to 100.0.

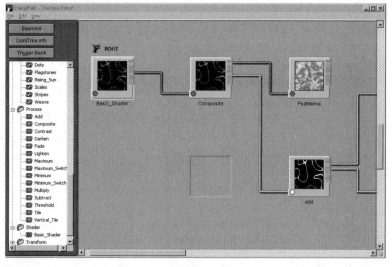

FIGURE *The next step.*
22.9

17. Link the Basic Shader's Surface_Color parameter to Composite. Use the screen shots to check the shader and its animation for any problems.

18. And finally, but very importantly, save the shader as "Energy.dst." Voilà, the color shader is complete and ready to load into 3D Studio Max.

Building the Animated Transparency Mask

The next few steps cover the construction of the transparency mask that matches Energy.dst. The mask is really just a subset of the color DarkTree, which makes this part much faster. Because you have saved Energy.dst already, you can go ahead and modify the same DarkTree. When it's complete, we'll save it under a different name.

1. First delete two components: Basic Shader and Pestilence.

2. Select the Composite component (make sure it's still linked). Using the Edit menu, select the Cut Subtree option. Next, paste the entire subtree back using Paste As Percent. When you paste the subtree back, move it to the left so that Composite becomes the new root component.

3. Next, open the component editor for Composite. We'll use this component to turn the DarkTree into a mask. Notice the two parameters, Percent_A and Percent_B. In SimbiontMAX, a value of 100.0 (white) will result in full transparency, and 0.0 (black) produces full opacity. However, we want the electrical arcs to be opaque and the background to be transparent, so switch Percent_A to 100.0 and Percent_B to 0.0.

4. Our transparency mask is completed. All that remains to be done is to save the Dark-Tree as "EnergyMask.dst," and move the two textures into 3DS Max. We'll do that next.

Using SimbiontMAX to Import and Apply Our DarkTrees

In this final section, we'll use the DarkTree Max plug-in, SimbiontMAX, to import the energy shader and mask into 3D Studio Max as animated procedural textures. The assumption here is that the plug-in has already been installed and made known to Max. We'll be instructing you on how to use SimbiontMAX, but not really giving any "how to's" that apply to the 3DS Max program itself, since that information is covered elsewhere. Once you've gone through the process of importing the DarkTrees into 3D Studio Max and specifying some additional parameters, you'll probably want to make changes of your own. There are plenty of additional things you can do—and we'll mention a few at the close of this tutorial.

1. After you have 3D Studio Max open, drag out a smooth sphere using the Max primitives. Specify a radius of 100.0 for your sphere.

2. Next, we'll load the DarkTree energy shader that we built and saved in the first section of the tutorial. First, open the Max Material Editor and click on Type button. This opens the Max Material/Map Browser. Find DarkTree on the list, select it, and close. That's all there is to opening SimbiontMAX. (See Figure 22.10.)

3. SimbiontMAX will open automatically displaying the Basic Parameters panel, which is just what we want. Click the long load button at the top of the panel (it will be labeled "None"). Browse and load Energy.dst now. Next, locate the 2-Sided option, and

FIGURE *Open SimbiontMAX.*
22.10

check the box. By specifying 2-Sided, you'll be able to see the back of the sphere as well as the front when you run the animation. Close the Basic Parameters panel.

4. Now, we want to overlay the DarkTree mask. Open the Shading Channels Rollout panel and scroll down until you see a section labeled "Extra Shading Channels." Locate the button labeled "Constant Value" that's a part of the Transparency option. Clicking this button changes it to New DarkTree, which is what we want. Now you can browse and load EnergyMask.dst.

5. You can see the two DarkTrees together on one of the test spheres on Max's Material Editor but you'll surely want to drag your material onto the sphere you made in step 1 and give it a quickie render just to get a real look at it. (See Figure 22.11.)

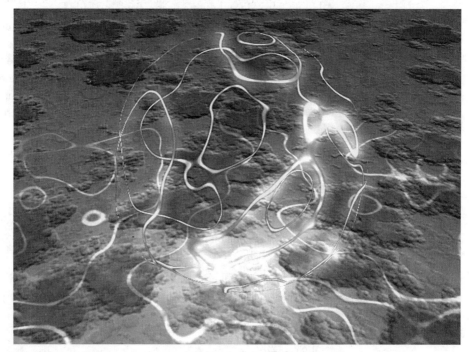

FIGURE *A test render.*
22.11

6. A good way to view the animation is to make an AVI in Max. If you want to make one, here are a couple of suggestions. Try an animation size of 300 x 300 for a start. It's big enough to look decent, but small enough to render the frames rather quickly. The resulting AVI animation runs rather quickly in Max. If you want to slow it down, go back into the Energy.dst Trigger Bank and change End Frame at the top to 60. Press the Enter key. Answer Yes to the pop-up question and Trigger #0 will be reset automatically. Don't forget to make the same change for the EnergyMask DarkTree as well.

Because the DarkTrees are procedural, you can make your final number of frames any size you want to.

SOME ADDITIONAL SUGGESTIONS

Now that you have a basic energy field shader running in 3D Studio Max, there are a number of tricks you can try, in both Max and DarkTree, to improve the overall effect. In DarkTree, why not try using other noise components for both the color and grayscale energy basis. You might try animating the color of the energy field also. The following are a few more touches you can try in Max to get real movie quality results.

- **Adding Glow**: Since this is an energy field, it should have a glow to give it that real quality. To add this, you can simply use Lens Effects Glow, found on 3D Studio Max's Video Post panel. One problem you'll run into here is that the glow effect will cover your entire sphere, instead of sticking to the energy tendrils, as you would like it to. You can easily fix this problem by going back to the Material Editor and opening the Special Effects panel on SimbiontMAX. Load the transparency mask DarkTree, EnergyMask.dst, into the Video Post channel. Now any Video Post effect you apply will stick to the energy lines.

- **Lighting**: An energy field would very likely affect the lighting of the surrounding objects. You can make this happen very easily by adding a light source to the center of your energy ball, and then projecting the energy field shader with the light source. Here's how to do it. Load the same energy field shader into an instance of the SimbiontMAX map plug-in. Now assign it to your light sources' Projector Map. You'll also want to set your light sources Decay Type to Inverse or Inverse Square, to limit the range of your lighting effect.

- **Motion**: Finally, you'll probably want your sphere to deform and move around. 3D Studio Max provides many ways to do this. But one quick-and-dirty method is to use the Free Form Deformation (FFD 44x4x4) modifier on your sphere. Then simply animate your lattice points over time, and you'll have a pulsing plasma ball! (See Figure 22.12.)

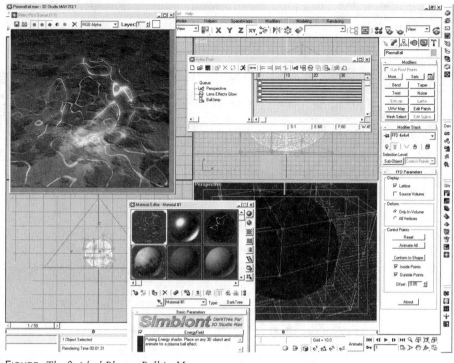

FIGURE *The finished Plasma Ball in Max.*
22.12

WHAT'S THE MATTER?

The MaxMatter Materials are distributed by Digimation, and they include *BrickLayer* and *TypeMapper*.

BRICKLAYER

Using BrickLayer, you can create a wide array of procedural brick and block patterns, and even generate a night window pattern for buildings. BrickLayer is best applied by clicking on the Map box next to the Diffuse Color Channel controls at the top of the Material Editor Rollout under Basic Parameters, and selecting MaxMatter:BrickLayer from the New Library list. After that, the BrickLayer parameter controls appear in the Material Editor Rollout. (See Figure 22.13.)

If you have BrickLayer, try these settings: Brick Width/Height 24/20, Mortar Width/Height 0.6/1.0, Row variation/Offset 35/45, Edge Roughness 75, Missing Percentage 8%, Hue/Saturation/Value variations 45/45/45, Brick Bump 45 with Standard Noise,

FIGURE **22.13** *The BrickLayer parameter controls appear in the Material Editor Rollout.*

FIGURE **22.14** *The results of applying one version of the BrickLayer Material.*

Mortar Bump 12 with Cellular, and Horizontal/Vertical Bevel 2/2. This creates a nice pattern for an old urban alley wall. (See Figure 22.14.)

TIP

Copy the BrickLayer Map from the Diffuse Color Channel to the Bump Channel, and set the Bump value to 200 or more to create very believable 3D bricks. You can even experiment with copying the same Map to the Displace Channel, but set the value no higher than about 15 if you do. Remember to increase the polygon count of the object if you are using Displace Channel data.

TYPEMAPPER

TypeMapper gives you the ability to place lines of text on any object, according to the UVW mapping coordinates. TypeMapper is best applied by clicking on the Map box next to the Diffuse Color Channel controls at the top of the Material Editor Rollout under Basic Parameters, and selecting MaxMatter:TypeMapper from the New Library list. After that, the TypeMapper parameter controls appear in the Material Editor Rollout. (See Figure 22.15.)

Here's how a TypeMapper session might proceed:

1. Create an object in your scene that you want to apply a type block to.

2. Open the Material Editor, and click on the Map box at the top of the Rollout, next to the Diffuse setting.

3. Open the New Library list, and select Max Matter: TypeMapper.

4. Click the Select Font button in the TypeMapper Rollout. (See Figure 22.16.)

5. Enter the typed message in the input area. Set Resolution, Kerning, and Line Spacing values.

6. Set Justification (Left, Center, or Right).

FIGURE *The TypeMapper parameter controls.*
22.15

FIGURE *The Font is selected, and a Style is chosen.*
22.16

7. Set Text Color and Opacity. Leave Background Color and Opacity at the default, allowing your original material Diffuse Color or Map to remain.

8. Place the material on the selected object in the scene. (See Figure 22.17.)

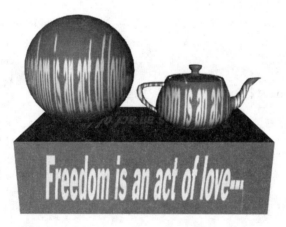

FIGURE *TypeMapper text appears on the selected object.*
22.17

TAMING THE ELEMENTS

Digimation's two Texture Lab material collections, Elemental Tools and Tiling Tools, are the last plug-in collections we'll look at in this chapter. Both contain a wide array of procedural textures.

ELEMENTAL TOOLS

The Elemental Tools Materials can be accessed by loading them in the top level of the Material Editor, or by using them in any desired Map Channel. They are named TLab.mat for top-level access, and contain 20 diverse materials. When added to a Material Map Channel, they can be found by going to the New Library. Once there, you will see six Maps listed: Elemental Electricity, Fire, Fog, Noise, Strata, and Water. Added to selected Channels in any Material, they provide high-quality procedural output. Once loaded, you can limitlessly customize the tiled components in the Mix Parameters section of the Material Editor Rollout.

TILING TOOLS

The Elemental Tools Tiling Materials can be accessed by loading them in the top level of the Material Editor, or by using them in any desired Map Channel. They are named Tiling Tools.mat for top-level access, and contain 51 diverse materials. Once loaded, you can limitlessly customize the tiled components in the Mix Parameters section of the Material Editor Rollout. All of the Tiling materials are composed of two Layers of data. You can select from 13 ways to combine the Layers, and also alter any of the colors involved. Combining these alterations with sizing and other parameter changes allows each Tile to become the potential parent of a wide range of children materials. (See Figures 22.18 and 22.19.)

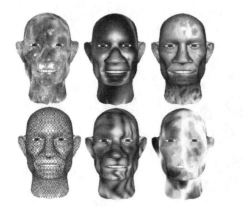

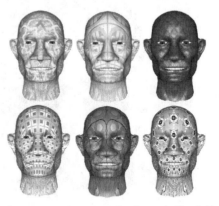

FIGURE **22.18** *Head Designer heads mapped with Texture Lab Elemental Tool Materials.*

FIGURE **22.19** *Head Designer heads mapped with Texture Lab Tiling Tool Materials.*

MOVING ON

In this first chapter of the section, we have explored in some detail a range of Material options. The same exploration is continued in the next chapter by focusing on Material-related plug-ins and CD resource libraries.

CHAPTER
23

Gimmee That Plug!

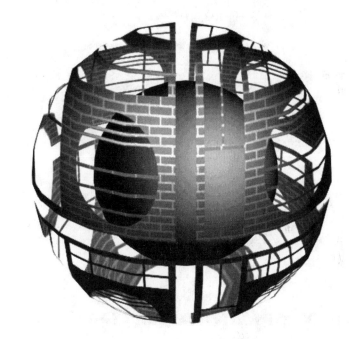

There are additional Max attributes and plug-ins that are important for Material mapping pursuits. In this chapter, we'll look at a collection of these items, and point out how and when they can be of use.

THE ASSET MANAGER

The Asset Manager can be found in the Utilities list. What the Asset Manager does is to let you view all of the Images, Max Scenes, Geometry, and Movie files anywhere in your system. This can be a tremendous help when you are working in the Material Editor and need to attach an image to a Map channel. Previewing is very fast. System assets can be sorted by type. (See Figure 23.1.)

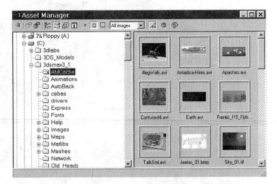

FIGURE *The Asset Manager can sort through your image files so you can see what they look like*
23.1 *before applying data to a Material Map channel.*

IMPORTANT MATERIAL-RELATED PLUG-INS

Here's a short list of plug-ins that are related to your Material mapping enterprises. Be aware that new Max plug-ins are being created all the time, so stay tuned to your favorite Max websites.

TEXPORTER

Texporter is Freeware from CuneyTozdas (www.cuneytozdas.com). You can download it from any Max website that lists it. Texporter allows you to capture an unwrapped bitmap of a UVW mapped object so that it can be ported to a 2D paint application, painted, and reimported to Max as data for a Map channel. This is especially useful when you want to use your favorite painting application to paint features on a face. Why not do a search and download it now? Here's how to use it:

1. Place or create a model in Max that you would like to develop a painted texture for. I used a Head Designer head model.

2. Select the object, and go to the Modify panel. UVW Map the model. In the case of this head, I used a Planar map on the Y-axis. Click Fit to fit whatever Map type you are using to the model.

3. Go to the Utilities panel, and select the Texporter item from the list. Leave all of the settings at their defaults for this exercise. Make sure Backface Cull is checked to prevent the Backface polygons from displaying. Click Pick Object, and select your object in the scene. Its unwrapped Map will appear. Save the Map file. (See Figure 23.2.)

4. Open Photoshop. Import the Map you just created, and use the Magic Wand to select the background around the Map, inside the mouth, and inside the eyes. Create a New Layer, and make the background Layer invisible.

5. You will see the selection marquee on the new Layer. Select>Inverse, and fill the selection with white. Now you have a white mask that shows the area to be painted. Make the background visible again. (See Figure 23.3.)

6. In the Layers window, set the Opacity slider to 40% for the new Layer. Now you can see the polygon mesh on the background through the new layer. Copy the new layer and make it invisible. We'll use it later.

7. The first thing we will paint on the 2nd Layer is a Bump map mask. Thanks to master modeler Bill Fleming for this advice. If you paint a Bump map first, it's far easier to decide how to paint the Diffuse Color map afterward.

8. Fill the masked area of Layer 1 with a 40% gray. This will be the Bump map base shading, allowing us to go darker and lighter in specific areas as we need to. Adjust the Opacity of the Layer as needed, so you can see what you are doing.

9. The lighter you paint, the more "height" the map will have at that point. The darker you paint, the deeper the cuts will seem to be. Explore the creation of darker lines

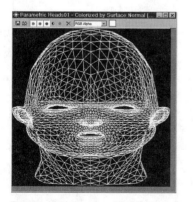

FIGURE *The unwrapped Planar map appears.*
23.2

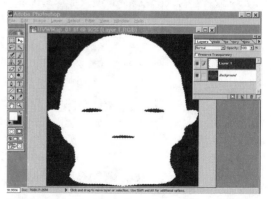
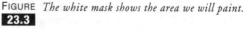

FIGURE *The white mask shows the area we will paint.*
23.3

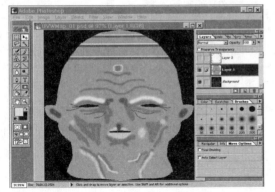

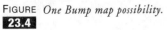

FIGURE *One Bump map possibility.*
23.4

FIGURE *The Color Layer is added.*
23.5

around the eyes and mouth, and maybe a scar or two. It's as if you are seeing the image as a color-blind person. Experiment. You can always undo what you don't like. (See Figure 23.4.)

10. Now add your color to Layer 2, making it transparent enough so you can see through to the Bump map on Layer 1. (See Figure 23.5.)

11. Add some Noise from the Noise Filter to the grayscale image, and save. Import the Color map into the Diffuse Color channel, and the Bump into the Bump channel, and Render. (See Figure 23.6.)

FIGURE *In this image, the Bump value is –225, muting*
23.6 *the shadows and the Diffuse Color a bit.*

ArchVision Maps

ArchVision has developed a unique way of placing objects in your scene. In some ways, it is similar to using an Alpha map to place objects on a plane, as discussed in earlier chapters;

however, the similarity ends there. The RPC ArchVision objects can be appreciated from any angle, which means that the Camera is not limited to a straight-on view. These objects include a number of RealPeople and RealTrees objects, all of which can be viewed in any of several rotations. The ArchVision technique is well on its way to becoming a new paradigm for computer graphics objects, one that is making complex scene creation extremely fast and memory friendly. On the way is a series of fully animated objects that follow the same idea.

Working with ArchVision CDs

Purchase the ArchVision CD volume of your choice. Download the ArchVision plug-in from www.archvision.com. After installing and authorizing your ArchVision plug-in in Max, do the following:

1. Create a folder on your system for the images you want to use.

2. In Max, go to Customize>Configure Paths>Bitmaps>Add. This is where you include the path directions for the ArchVision objects. Input the path. For instance, if you placed the ArchVision content in a folder called *Goober* on the C drive, you would input C:/Goober.

3. Go to Create>RPC. Click the RPC button, and place a selected object from your ArchVision folder in the Top viewport. All you'll see is the silhouette until you render it. Render. (See Figures 23.7 and 23.8.)

FIGURE **23.7** *ArchVision RealTrees/Bald Cypress with Reflections switched on, and Raytraced Water.*

FIGURE **23.8** *A double ring of Japanese Pagoda trees, randomly resized, encircles a temple.*

CREATING OPACITY MAPS

Opacity maps are useful for creating cages, windows, and anything else that needs to look like there are empty areas on the model. When you create an Opacity map, work in 8-bit images. White areas create a solid surface, and black drops out. Intermediate grays become semi-opaque areas on the targeted model. (See Figures 23.9 and 23.10.)

Figure **23.9** *Create an Opacity map in Photoshop by using only black and white to form a pattern.*

Figure **23.10** *Use the saved bitmap as a Map in the Opacity channel of the Material Editor. This Opacity map was applied to the outer sphere as a Planar map on the Y-axis and with UVW Tiling values of 2.*

RubberMap

Although we don't have enough space in this book to cover it in detail, you should be aware that the same company that brings you RubberSpaceWarp (www.rubberflex.com) is also responsible for another product: *RubberMap*. If you have ever tried to map a photographic image of a face on a 3D model, and have paid the heavy frustration dues involved, you will appreciate this Max plug-in. Using RubberMap, you can align any bitmap to any desired parameters on any object.

Now Playing on CD

There are countless CD volumes with exquisite bitmap images available for adding lush textures to your Material Editor mapping channels. Here are some to pay special attention to:

- **ArtBeats**: www.artbeats.com. ArtBeats offers the widest collection of high-quality single-frame sequences of natural-world and computer-graphics image content for background and texture applications around. Water, fire, clouds, explosions, tiled textures, and a lot more can be found on the ArtBeats CDs.

- **Corel: Religious Stained Glass** (www.corel.com): Corel has developed dozens of image and texture CDs. This is a truly beautiful collection, for Diffuse Color maps.

- **Texture Farm: Terra Incognita and Terra Firma** (415-284-6180): Two unique volumes of images. You can crop the images to create hundreds of texture maps.

- **MegageM: The FractalPro Image Library** (www.megagem.com): Hundreds of images of Mandelbrot and Julia set renderings, captured in high resolution.

- **Accents Images** (Accents in Stone / 3123 Lee Place / Bellmore, NY 11710): Over 100 hi-res diverse stone samples.

- **Photodisk: Industrial Side Streets** (www.photodisk.com): Full of the nasty, rusty textures that digital artists love.

- **Direct Imagination: The Grammar of Ornament** (www.directimagination.com): A complete library of classical ornamental imagery.

- **Vivid Details: Old Paint Volume 11** (www.vividdetails.com): Cracked, peeling, weathered painted surfaces, all in hi-res at extreme quality and resolution.

MOVING ON

In this chapter, we covered more Material-related information for you to ponder and apply. The next chapter, the last in this section, deals with an application every Max user should attend to: DeepPaint.

Deeper than Paint

When it comes to creating and customizing Materials in Max, there is one external application that can be 10-star recommended: *Deep Paint 3D* from Right Hemisphere. Deep Paint 3D is really two applications in one, *Deep Paint* and *Deep Paint 3D*. Both have features that the Max user will find absolutely inspiring when it comes to working with textures and images. Deep Paint and Deep Paint 3D take their names from the fact that the painting and texturing options can be applied to emulate paint thickness or depth; hence, the 3D reference.

Both Deep Paint and Deep Paint 3D are covered in some tutorial detail in this chapter. If you own Deep Paint/Deep Paint 3D, you can use these tutorials to acquaint yourself with the software. If you don't own them, browsing these tutorials may convince you to do so.

DEEP PAINT

Deep Paint was developed to interact with 2D image files, bitmap image data, the same way that Photoshop does. In fact, Adobe Photoshop is an integral part of Deep Paint. When Deep Paint is installed, a Photoshop plug-in is also installed in the Photoshop plug-ins directory. This allows Photoshop and Deep Paint to interact in real time, developing image data together. Each one has 2D painting tools and options the other lacks, and Photoshop adds to this by allowing you access to all of the other plug-ins it features, and others you may have added.

TALKING TO DEEP PAINT

Here's how to transfer images back and forth between Photoshop and DeepPaint. Do the following:

1. Open Photoshop, and create or import an image file. Add a second layer, and place some painted content on it. (See Figure 24.1.)

2. In Photoshop, go to Filter>Right Hemisphere>Image to DeepPaint 3D. A window will appear. (See Figure 24.2.)

3. Click Send Mode, and then Send. Do this for each Layer.

4. In Deep Paint 3D (which we'll refer to as DP3D from this point to save my sore typing fingers), you will see two images that have been imported, one for each layer. Go to the top layer image, Selection>Select All, and Edit>Copy. Delete the image.

5. Go to the remaining image, and Add a Layer. Go to Edit>Paste, and the second Layer's content is now a second layer in DP3D. Move it into position. (See Figure 24.3.)

6. DP3D version 2 is actually called Deep Paint 3D: Texture Weapons. That's because of the tremendous amount of F/X and painting options present, as we will see. In DP3D, make sure the second layer of the image is selected. Go to the Presets panel,

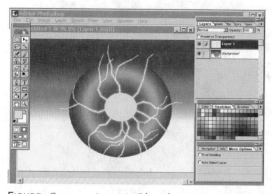

FIGURE *Create an image in Photoshop, or import one.*
24.1 *Give the image two layers of content.*

FIGURE *The Photoshop/Deep Paint 3D handshaking*
24.2 *window.*

and select Natural and Landscape from the pull-down menu. Select Butterfly+. Use the Paintbrush tool to paint a circle of Butterflies on the second layer of your image. (See Figure 24.4.)

5. Go to Photoshop. The Deep paint Plug-in manager should still be open. Click Receive Mode>Fetch, and then click OK. The image is brought into Photoshop with Layers collapsed. If you wanted to affect just the previous layer 1, then you would have sent it to DP3D as just that Layer, and not combined it with the background image. That way, the Photoshop Layers would have been preserved.

6. Save the image in a format that Max can read. Import into Max as a background. (See Figure 24.5.)

FIGURE *Your two layers are now present in DP3D.*
24.3

FIGURE *Paint a circle of Butterflies on the second layer*
24.4 *of your image.*

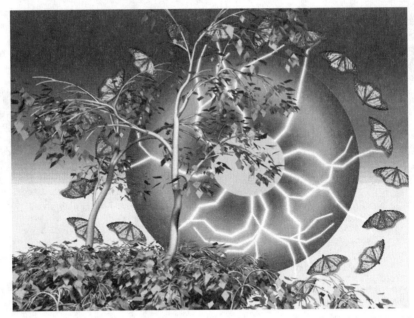

FIGURE *With a few 3D trees from Onyx TreeStorm in the foreground, the Deep Paint 3D image*
24.5 *creates an interesting backdrop.*

DEVELOPING A MAX TEXTURE IN DP3D

You can use DP3D to create a wide array of images for use as Max Material Editor Map
Channel content. Here's one example:

1. Open DP3D. Create a New image, 640 x 480.

2. Go to Presets>Skin, Fur, and Hair>Lizard Skin. Use the Paint Bucket tool to fill the
 image with the Lizard Skin preset texture. (See Figure 24.6.)

3. Go to the Lights tab in the Command panel. Set the Angle to 60 degrees and check
 Custom. Set Ambient to 40 and Spot to 80. Make sure the C button (Color) is se-
 lected under the Fill Options. (See Figure 24.7.)

4. File>Save As. Select a TIF format, and save the images to your 3DS Max Images
 folder. Select Yes when asked if you want lights folded in.

5. Open Max. Create or import an object for the texture you just created, preferably
 some anatomy. Open the Material Editor, and import the texture as a Diffuse Color
 map. Copy the map from Diffuse Color into the Bump channel. Set the Bump value
 to 225. Render for preview. (See Figure 24.8.)

FIGURE 24.6 *The image is filled with the Lizard Skin preset texture.*

FIGURE 24.7 *Lighting is added.*

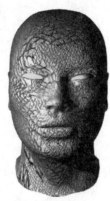

FIGURE 24.8 *The texture, now as both a Diffuse and Bump map, is applied to a Head Designer head. Cylindrical mapping (with caps) on the X-axis was used here.*

DEEP PAINT 3D: THE REAL DEAL

So far, we have looked at a couple of ways that you can use the connection between DP3D and Photoshop to create material content for Max. What we'll do now is detail DP3D's most exciting capability, handshaking directly with Max. Using this option, you can pass full 3D models back and forth from Max to DP3D. Do the following:

1. Open Max. Place any object you'd like to paint in 3D in the scene. For this tutorial, I am using the head developed with the help of Head Designer and Amapi. (See Figure 24.9.)

2. In the Modify panel, click on UVW Map, and apply a mapping type to the object. In this case, I used Shrink Wrap Mapping.

3. Place a material on the object. Make it just a color material with no maps assigned, but check Diffuse and Bump in the Maps list.

4. In the Utility panel, select the Deep Paint 3D option. It will appear in the Utility panel Rollout. (See Figure 24.10.)

5. Pick the model and start DP3D by pressing the button in the Rollout. DP3D starts immediately, and a Material Import window appears. (See Figure 24.11.)

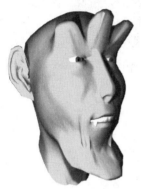

FIGURE **24.9** *The model to be painted.*

FIGURE **24.10** *The DP3D data appears in the Utility panel Rollout.*

FIGURE **24.11** *The material Import window in DP3D appears.*

6. In the Material Import window, under Material, highlight the Material # selection, and click Channels. The Material Channels window appears. Highlight the C and B options (Color and Bump). When asked what is to be in these Channels, select Nothing. You now have a blank Diffuse Color and Bump channel to paint in DP3D! (See Figure 24.12.)

7. The model appears in DP3D. You can move, rotate, and zoom on it interactively. (See Figure 24.13.)

8. Now for the fun part. Use any of DP3D's "Texture Weapons" to interactively paint your model in 3D. Rotate, zoom, and move as needed to see the areas you are working on. Spend some time exploring different options. Notice that as you select various painting options, the software makes a decision as to what Mapping channel will be affected. You can always override those decisions. (See Figure 24.14.)

9. Export to 3DS Max. Select a folder to store your new bitmaps in. When the object appears in Max, render it. All of the Mapping channels will be intact. There is no other application that can touch DP3D Texture Weapons, and no other way you can create multiple materials on any object. Enjoy! (See Figure 24.15.)

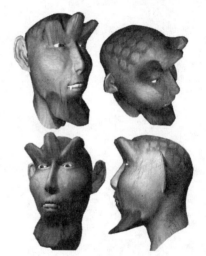

Material Channels

C	New Blank Map
B	New Blank Map
G	No Map
S	No Map
D	No Map

OK Cancel

FIGURE **24.12** *Set the C and B channels to Nothing, so you can paint in them with DP3D's tools.*

FIGURE **24.13** *The model appears in 3D in DP3D, and is fully interactive!*

FIGURE **24.14** *Paint the model with any of DP3D's Texture Weapons.*

FIGURE **24.15** *The handshaking between DP3D and Max is more like a marriage made in heaven!*

MOVING ON

This chapter urged you to explore, and hopefully purchase, Deep Paint 3D: Texture Weapons for your Max material creation exploits. In the next chapter, we visit the realm of rendering, a topic of vital interest to the Max modeler.

Render My World

CHAPTER
25
Picture Perfect

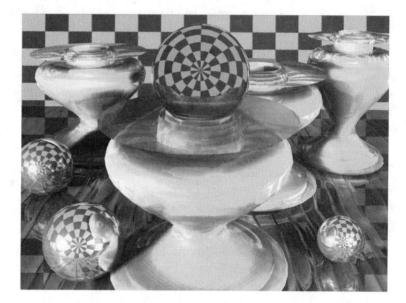

Finally, when your scene is complete, and all the objects and materials are configured as they should be, it's time for the final step: rendering. Even at this stage in Max, there are a number of ways to proceed. This chapter assumes that you have read the Max documentation on basic rendering, and that you have already rendered objects and scenes on your own. We will provide a few tips on basic rendering, but then it's on to another topic: alternate rendering plug-ins and utilities.

A SHORT RENDERING OVERVIEW

Although you should be working familiar with the rendering process at this point, because you have read the Max documentation and explored rendering on your own, here are a few basic tips to keep in mind. Experienced Max users will want to skip these paragraphs:

1. The first place to go when you are ready to render is not the Render window, but to Render>Environment. The single most-important parameter to set once you are there is whether the background of your rendering will be just a color, or an image. (See Figure 25.1.)

2. Clicking on the Color Swatch brings up the Color Selector: Background Color window. Just select a background color, and click Close. (See Figure 25.2.)

3. Selecting a background image is a bit more involved. Under Common Parameters in the Render>Environment window, check the Use Map box.

4. Next, click the Environment Map button, which reads None by default. This brings up the Material/Map Browser. (See Figure 25.3.)

5. You can select any item from this list, though most choices are procedural textures meant for mapping an object. Explore the list of options, so you can get some idea of the diversity of the possible backgrounds. (See Figure 25.4.)

Your list of available procedural textures will vary according to the plug-ins you have installed.

6. The most common list item for background use is Bitmap, allowing you to select any bitmap image on your system as a background for your Max project. Selecting Bitmap

FIGURE *The Render>Environment window.*
25.1

FIGURE *The Color Selector: Background Color window.*
25.2

FIGURE 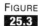 *The Material/Map Browser.*

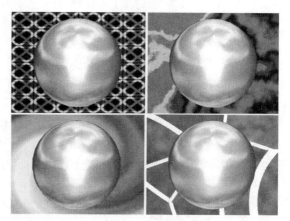

FIGURE
25.4 *Procedural textures used as Environment Map backgrounds. Top left to bottom right: Tiling Geometry, Perlin Marble, Swirl, and Flagstones.*

FIGURE
25.5 *When you select to use a Bitmap for an Environment Map background, you can select from any bitmap images available on your system, or from a CD-ROM collection.*

takes you to a standard file window, where you locate the image you need to use as a background. Any image is possible, including previous renderings of Max scenes. (See Figure 25.5.)

RENDER TIME

After your background options are set, it's time to bring up the Render Scene window by going to Rendering>Render. (See Figure 25.6.)

FIGURE *The Render Scene window.*
25.6

7. Before going ahead with rendering, be aware of the following considerations:

- Make sure the correct viewport is selected.

- Make sure that you have selected either Production or Draft mode.

- Under Common parameters, check Force 2-sided.

- Set the needed Output Size, and one of the Time Output selections.

- Under Max Scanline A-Buffer, consider leaving all of the defaults in place until you have done enough experimental renders to understand what happens when you alter one of these parameters. The main exception is whether Image Motion Blur is to be applied to the Environmental Map. By applying Motion Blur to the Environmental Map, you can enhance the apparent 3D depth of the scene in many instances. Test renders are called for in order to decide whether to check it.

- If you are saving the image or animation to a file, make sure that the data path is correctly configured for Render Output.

That's it. Render away and look at the results. If for any reason they are not satisfactory, fix what is needed and render again.

USING THE RAYTRACE MATERIALS

When you select the Raytracing Materials library to develop a texture for your object, there is one component in the Material Editor that is of primary importance: setting the Mix Curve. (See Figure 25.7.)

How Do I Get to the Mix Curve?

Once you have selected the Raytrace Material library, and have assigned one of the material Presets, the Material Editor will display the parameters for the Raytrace Material. Clicking

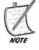

FIGURE *The Mix Curve graph.*
25.7

on the Maps heading in the Material Editor Rollout will display the Map Channel settings. The Map setting for the Reflection Channel should read Map #1 Falloff. Clicking the Reflection Map button will display the Falloff Parameters Controls. Scrolling down below Falloff Parameters will display the Mix Curve graph. Do that now.

How Do I Configure the Mix Curve?

As you can see from the Mix Curve graph (refer to Figure 25.7), the default curve is a straight line that has two controls, one on the left and one on the right. The control range (displayed on the left vertical side of the graph) ranges from 0 to 1. You can add other control points along the curve, but you must first understand exactly what it is you are controlling, and that is best done by working with just the two points at the start.

Think of the left control point (the white one) as a way of controlling how much the reflection parameter dominates the Diffuse Channel component of the Material (whether color or Map based). Set at 0, the Diffuse Channel component rules over the Reflection capacity of the Material, so that all of the reflections will be affected by the Diffuse Channel color and/or Map. At a value of 1, the Reflections seen in an object mapped with this Material will override the Diffuse Channel components, so that the result will be an object that has more interest in reflecting everything in the environment than it does in its own Diffuse Channel settings.

The right control point (the black one) controls what happens to the edge of the object mapped with this Material. Set at 0, the edge becomes a discernible line around the mapped object. Set at 1, the edge disappears, and is defined by the contents of the reflective map of the environment being reflected. These two control point parameters, how the graph is configured, make a world of difference in the renders. Images tell the story much clearer than words, so look at the graph curve settings and the resulting images in Figures 25.8 to 25.11, and how an image with multiple reflective surfaces is affected.

If you plan to do oversized renders that will require longer processing times because of the size of the image, do a test rendering at a smaller size first and observe the results.

FIGURE **25.8** *Diffuse rules, blocking out the reflections.*

FIGURE **25.9** *Reflections rule, blocking out the Diffuse Channel components. A dark line is placed around the objects mapped with the Material.*

FIGURE **25.10** *Reflection rules, but there is no object edge to hold the object intact.*

FIGURE **25.11** *A more balanced approach. Reflection dominates, but does not override all of the Diffuse Channel settings, and some edge is displayed.*

THE ILLUSTRATED MAN

What does Illustrator! do? Illustrator!, a major Max rendering tool used by Hollywood and broadcast production houses, transforms Max 3D output into "flattened" images and image sequences that are ready for cartoon enterprises. Flattened images look as if they were drawn in 2D, similar to the traditional cartoon animation look.

If you have purchased the Illustrator! plug-in from Digimation (or directly from David Gould at www.davidgould.com), then you can use this basic tutorial to generate Illustrate! renders.

USING ILLUSTRATE!

Unlike other Max plug-ins, Illustrate! is accessed by selecting its name from the menu list at the top of the Max interface. Doing that produces the Illustrate! interface. (See Figure 25.12.)

The easiest way to activate Illustrate! is from the Rendering Wizard as follows:

1. Select the Rendering Wizard by clicking on its name in the Illustrate! interface menu at the top of the interface. The Rendering Wizard appears. (See Figure 25.13.)

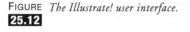

FIGURE *The Illustrate! user interface.*
25.12

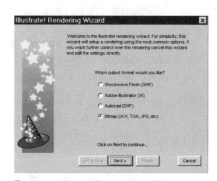

FIGURE *The Rendering Wizard appears.*
25.13

2. The next step is to go through the Rendering Wizard options one by one, selecting from the options. The first is to select an output file format from the four possibilities (Macromedia Flash, Adobe Illustrator, AutoCAD DXF, or Bitmap). Then click Next.

2. Next, you select a Max Renderer. The choices are Production, Draft, or both. The wisest idea is to select Draft, since that allows Production rendering to remain for full 3D renders in case you need it. Then click Next.

3. Select what background the Illustrate! files are to incorporate. The options are a Custom Color, the Max Environment Color, or the Max Environment Map. Click Next after you make your choice.

4. Drawing Style is selected next. Clicking on the drawing style image on this page presents you with the Drawing Style Options. Just click on one to activate it. (See Figure 25.14.)

5. Click Next, and select your preference of either a single image or an animated sequence of images. Set the resolution, and the file path to save to. Last, select whether to output to this file by checking the box. Click Next.

6. This brings up the last page in the Wizard, which gives you some important information. Click Finish to end the basic Illustrate! process.

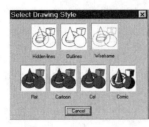

FIGURE *Drawing Style Options.*
25.14

COMPLEXITIES

The Render Wizard does not give you access to the fine adjustments and options Illustrate! can address. For more detailed options, you have to become working familiar with the Illustrate! hierarchical Tree view on the left of the Illustrate! interface. For instance:

- Clicking on the Canvas icon at the top of the Tree view allows access to the background texture options, which add a textured look to the Illustrate! rendering. Open any image file, and select it as a background for the Illustrate! renderings. (See Figure 25.15.)

- **Brushes**: Brush looks are used to paint the edges of Illustrate! objects. Clicking the Brushes item in the list brings up its interface. You can set Brush (Edge) Size and select an oval or square as the Brush Style. (See Figure 25.16.)

- **Paints**: Selecting any color parameter from this list changes the color of the Brush used for the image edge.

- **Strokes**: Setting the Stroke Style from any item in the list (or any new Stroke Style you create), alters the style of the Brush used for object edges (See Figure 25.17.).

FIGURE *Select any bitmap image as a background*
25.15 *texture. It's translated into a Bump map, and used as a texture for the Illustrate! renderings.*

FIGURE *Brush options.*
25.16

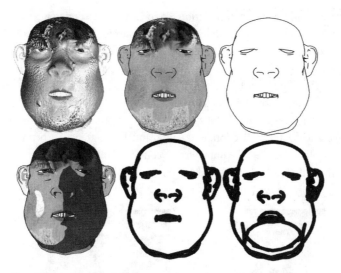

FIGURE *A selection of Illustrate! styles used to render a Max object*
25.17 *(original at upper left).*

VERSION 5

While this book was in production, version 5 of Illustrate! was released.

Some of Version 5's New Features:

- Variable line weights using intuitive and easy Paint On modifier.
- Highest quality anti-aliasing and faster line calculations.
- Lines become thinner with distance, and scale automatically when the output size changes.
- New advanced CelShader that supports shadows, reflections, refractions, and all 3DS Max renderer features.
- Complete control over how individual edges will be drawn using the new Edge ID modifier.
- Multipass rendering. Render lines and surfaces to separate images and in separate passes.

GOTCHA WITH MY RAYGUN

Right Hemisphere, the same company that brings you Deep Paint with Texture Weapons, also distributes a rendering plug-in called *RayGun,* meant to give you high-quality raytrace

renders very quickly. After installation, go to Customize>Preferences and select the Rendering tab. Click one of the Assign buttons in the Current Renderer section. RayGun 3 will appear as an option along with Default Scanline Renderer and other installed renderers. Double-click RayGun 3 to select it. RayGun 3 can be used as either the production or draft renderer. (See Figure 25.18.)

RayGun needs you to select the RayGun Material in order to affect the renderings. RayGun rendering results in higher quality and faster render of the three most time-intensive rendering attributes: Reflection, Refraction, and Transparency. When you select the RayGun Material, all of the needed parameters are contained in the Material Editor, and are arranged somewhat differently than a standard Max material is. (See Figure 25.19.)

FIGURE 25.18 *Set RayGun as the Production and/or Draft renderer in the Customize>Preferences> Rendering tab.*

FIGURE 25.19 *The RayGun Material parameters in the Material Editor.*

As you might expect from a raytrace renderer, RayGun requires lights in the scene so the rays can be traced.

NOTE

RayGun also has its own configuration controls in the Render window. (See Figure 25.20.)

RayGun zaps the clock when it comes to multiple objects in the scene that evidence reflections, refraction, and transparency, and renders great shadow maps too. (See Figure 25.21.)

www.righthemisphere.com

FIGURE
25.20
RayGun's Render controls.

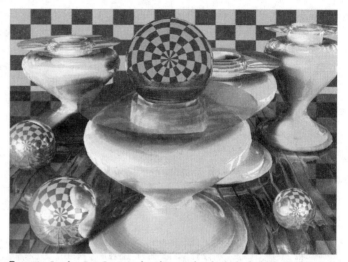

FIGURE
25.21
In this RayGun rendered example, the lathed objects have a Glass shader, the spheres are Metal, and the floor has a RayGun Phong shader. The floor also has a Bump map. The background has a Checker Environment Map.

UP, DOWN, AND ALL AROUND

When it comes to posting graphics on the Web, nothing is more attractive and crowd pleasing than interactive 3D. This can be achieved through posting a VRML file, or by using an interactive Panorama. Max offers both possibilities . . .

VRML

VRML (Virtual Reality Markup Language) is a Web-sensitive file format, a way of placing 3D scenes on the Web. Many, if not all, of the models in VRML scenes are URL targets thus meaning that they are triggers that allow the Web surfer to instantly jump to other pages or sites (URLs) by triggering the objects. Create a VRML version of your scene file in Max by doing the following:

1. Go to the Helpers panel and select the VRML 1.0/VRBL option.

NOTE

VRBL is a version of VRML that allows more elements of a Max scene to be incorporated in the 3D VRML file, but it may not work with some VRML Browser plug-ins.

2. In the Helpers Rollout, you will now see four buttons: LOD (Level of Detail), Inline, and VRML/VRBL. (See Figure 25.22.)

FIGURE *The Helpers Rollout after*
25.22 *VRML 1.0/VRBL is selected.*

NOTE

Since it is not this book's policy to repeat information that the Max documentation adequately covers, you are directed to the Max documentation to read about configuring the VRML 1.0/VRBL data types.

Exporting Your Max VRML Scene

When you have finished configuring the VRML Max scene, go to File>Export, and select the WRL format. Clicking Save brings up the Export VRML 1.0/VRBL File window. (See Figure 25.23.)

FIGURE *Save VRML 1.0/VRBL parameters window.*
25.23

iMOVE PANORAMAS

www.imoveinc.com

iMove is a plug-in that creates QTVR-like renders for Max. iMove files are completely navigable and interactive, allowing you to move in and out of a 3D scene, and to turn the field of view a full 360 degrees. After the installation of the plug-in, a basic iMove operation would proceed as follows:

1. Place a Camera (Free or Target) at the center of the scene (Front viewport). Place objects, whatever you like, around the Camera. Change the Perspective viewport into the

Camera 01 viewport. Place Materials on each of the objects. Place an Omni light at the center of the scene, and make sure Include lists all of the objects for the light (Modify panel). (See Figure 25.24.)

2. Go to the Utility panel and select iMove Panoramic Media from the list. The Rollout displays the iMove parameters.

3. Make sure the Camera viewport is selected. Under Move Panoramas in the Rollout, click Render. The Render window appears. For your first exploration, leave all settings at their defaults. The Panorama renders, and the iMove viewer appears on screen, allowing you to interactively navigate around your 3D scene. (See Figure 25.25.)

FIGURE **25.24** *Place a Camera at the center of a group of objects, as displayed here.*

FIGURE **25.25** *Interactively navigate around your scene with the iMove viewer.*

A Neat iMove Background Solution

If you use an Environmental Bitmap as a background, no matter how it is mapped, you will see clones of the image mapped to six separate surfaces. To create a smoother background map for an iMove project, do the following:

1. Create the project as outlined previously, but before rendering, place a large sphere around the entire scene (with some space between the sphere and the objects). (See Figure 25.26.)

2. Create two more lights, so there is one at the center and one at each of the two poles (inside the sphere). Cut the brilliance of each of these alternate lights to 0.8.

3. Place a bitmap material on the sphere with Shrink Wrap mapping (a cloud scene works well). Add a Bump map to it with a value of 125. When the rendering is fin-

Figure
25.26
Place a sphere around the scene.

ished, you will see that you have a seamless backdrop with an interesting texture of its own.

Other Possibilities

You can create more intricate iMove projects by doing any of the following:

- Use a resolution setting of 1536 x 768 or higher. This gives you far sharper images of the objects and more texture detail.

- Create a Panoramic Video file by selecting Active Time Segment or Range in the Render window, and save the file. You now have a Panoramic movie.

- Create a Panoramic object, one that can be interactively manipulated in 3D. Use a Target camera whose target point is set to a selected object's Pivot Point. Set the Render parameters (frame count, etc.) and Render.

The iMove documentation also walks you through ways of using iMove in a series of non-Max situations, including embedding iMove on a Web page.

RETAS PRO

Animation magazine, a bellwether of the animation industry, has named RETAS Pro as one of the top animation applications in the world today. The object of using RETAS Pro is to wind up with animation Cels (frames) that have the look of professional film animation pro-

ductions. RETAS Pro works with standard hand-drawn animation Cels by connecting your system to a scanner, and translating hand-drawn artwork into digital media. RETAS takes you from the input process, to Tracing images in order to achieve a more traditional animated look, through Cel painting, to the creation of in-betweens, to the final product ready to port to film or broadcast media, including *X-Sheets*. RETAS does all of this by relying on several separate modules, each dedicated to a step in the process.

RETAS also can be used to translate electronic 3D graphics and animation frames, such as those created in Max, into traditional-looking animation Cels. Illustrate!, which we detailed earlier in this chapter, can be used as part of a total animation system together with RETAS. For example, you could create an animation, or a single graphic, with Illustrate! tools, and then port the image or image sequence to RETAS to take the work the rest of the way.

There are at present (at the time this book is being written) four separate RETAS modules, with more on the way. The present components are Core RETAS, TraceMan, PaintMan, and RenderDog. We will spend a few moments on two of the RETAS components: TraceMan and PaintMan, and how they can be used to create Max imagery.

 As we have stated, this is not a book about Max animation. RETAS Pro does, however, possess tools that can be used to effect any image, either scanned or digitally created. For that reason, a mention of RETAS in this chapter is appropriate. Besides, perhaps you might appreciate a more animation-centric book in which RETAS will play an important core role, and (perhaps) one may be on the way.

TraceMan

TraceMan's task is to translate images and image sequences from scanned or electronic file sources into a traditional "flat" cartoon look. To do this, the image loses everything but its outlines. Outlines can be modified in TraceMan, so that the resulting image or image sequence can be painted in PaintMan. Here is an example of how a RETAS TraceMan process might proceed vis-à-vis Max:

1. Create an model in Max against a white background, and save it out as a TIF file. (See Figure 25.27.)

2. Open RETAS TraceMan, and import the file. (See Figure 25.28.)

3. Open the Mono Trace window, and adjust the controls until the preview looks like something you like. (See Figure 25.29.)

4. Select OK to see your image rendered in black and white. Use the Pencil tool to close any gaps in the drawing. Go to Trace>Mono Trace. (See Figure 25.30.)

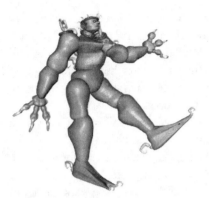

FIGURE
25.27 *Create a model in Max, and save out the image.*

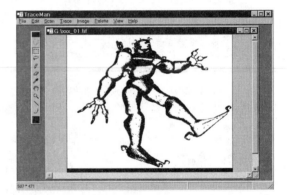

FIGURE
25.28 *The RETAS TraceMan Open window, allowing you to preview the importable file.*

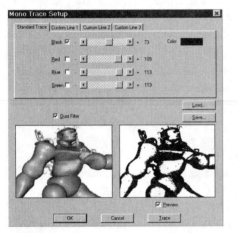

FIGURE
25.29 *Adjust the controls in the Mono Trace window.*

FIGURE
25.30 *The Traced image.*

PAINTMAN

Now we'll import the Traced file into PaintMan. Do the following:

1. Open PaintMan. Import the saved file from the TraceMan operation.

2. Use PaintMan's color tools to add color, and save it out again. You can import the painted file into Max as a Channel texture or background. (See Figure 25.31.)

If you have any plans to use your Max work to create professional animations, or images that have the traditional look that can be incorporated back into a Max scene as a texture and/or background, be sure to keep RETAS Pro in mind.

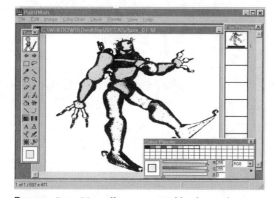

FIGURE *PaintMan allows you to add color to the image.*

25.31

Non-Max Rendering Options

Discreet LIGHT: Port your Max scenes to Discreet's Light software when you need more advanced lighting options. Light works with a high-end Radiosity rendering engine to offer you the highest-possible realism for your Max scenes. Use Light when the project calls for this level of light reflectivity, refractivity, and transparency detail.

NuGraf: The NuGraf Rendering System from Okino Computer Graphics (www.okino.com) has a wealth of rendering and modification tools not present in other software. Check out their website for details. NuGraf imports Max scenes.

MOVING ON

In this chapter, we explored a number of rendering options that can provide different media output for your Max scenes. The next chapter details the plates in the Color Gallery of the book.

SECTION J

Color Plate Details

26 In the Gallery

VISITING THE COLOR GALLERY

When you first purchased this book, one of the first things you probably did was to go immediately to the color plates and browse through them. That's what most of us do, because color is so seductive. When it comes to computer graphics, grayscale illustrations just don't pack the punch that color does. Whether you develop your Max scenes for output to paper, film, TV, interactive CD-ROM, or Webcast, color will play an important role for your audience. Color transmits more than eye candy, but emotional impact as well. This last chapter of the book takes a look at the color plates. Many of these plates reference the tutorials you have been guided through in the other chapters, giving you an opportunity to see the results in color, lending a different perspective to the grayscale art used in the other chapters. Four of the color pages at the end of the gallery contain images not referenced in other parts of the book, separate projects that will be covered in a bit more detail to expand your appreciation of all of the modeling tools and processes we have walked through. As you read this chapter, flip to the color section, and to the color plate being described. In many cases, there are two color illustrations on a single page, so we will reference both the page in the gallery and the color plate (top or bottom) on that page.

COLOR PAGE 1

FIGURE *Top: The Star. Bottom: Triptych.*
26.1

Top: The Star

A Render Effects flare adds a rayed effect to the scene. Sometimes a very simple image is best.

Bottom: Triptych

Three imported Poser models add realism to a scene. Exactly what is being said here will be interpreted differently by every viewer.

COLOR PAGE 2

Top: Dharma Wheel

Head Designer models around a Tube primitive.

Bottom: Rushed Hour.

Figures created with Sisyphus Proteus. These articulated models are all clones of each other, but different Materials were used on each.

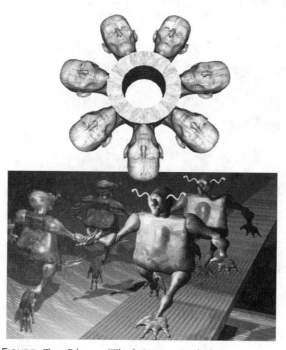

FIGURE *Top: Dharma Wheel. Bottom: Rushed Hour.*
26.2

COLOR PAGE 3

Top: Rusted Gears

A group of gears created with the RealFlo plug-in. This image also shows the power of Arrays and the Bend modifier.

Bottom: Jack 'O Rachnid

A nasty little vampire spider has his day. Although no tutorial on this scene is provided in the book, you will find a very detailed one on the Charles River Media Graphics Resource Club site for October 2000 (www.graphicsresourceclub.com).

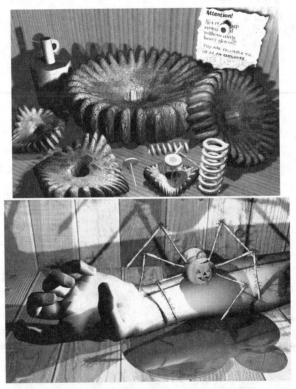

FIGURE *Top: Rusted Gears. Bottom: Jack 'O Rachnid*
26.3

COLOR PAGE 4

Top: Kachinas
Objects created entirely from Extended Primitives. When you restrict your modeling elements to a few basics, as is the case here, you challenge your creativity.

Bottom: Columns
An array of columns flanked by a TreeStorm tree. The Columns are formed by linear arrays. The TreeStorm tree is a Romulan variety. Always optimize your trees and plants.

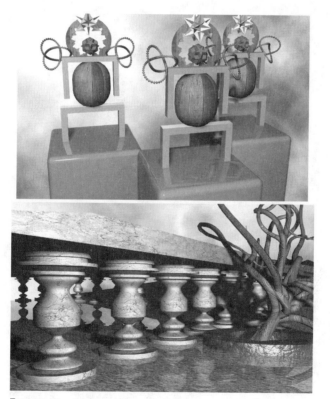

FIGURE *Top: Kachinas. Bottom: Columns.*
26.4

COLOR PAGE 5

Warpheads

All of these models were differentiated by modifying a single Head Designer model with RubberSpaceWarp from RubberFlex, and using a Snapshot on the resulting Mesh.

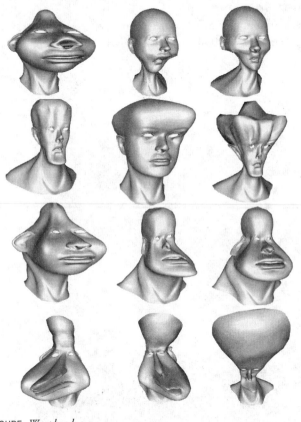

FIGURE *Warpheads*
26.5

COLOR PAGE 6

ClayBot

Boolean and other processes were used to create this model. There is no limit to the anatomical experiments you can create in Max.

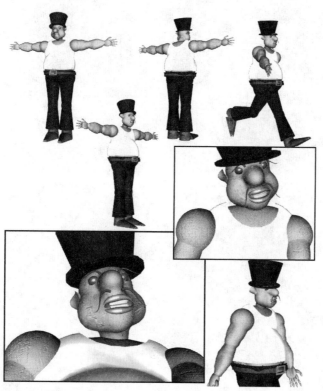

FIGURE
26.6 *ClayBot poses.*

COLOR PAGE 7

Al Eon

A creature from somewhere else built by using Max Compound Object methods. Note the details in the color gallery image.

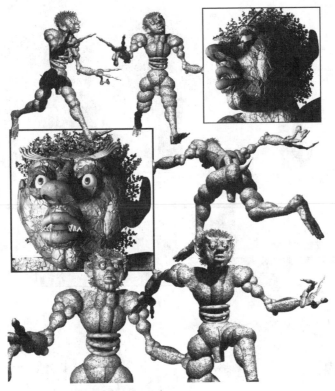

FIGURE *Al Eon, from somewhere else.*
26.7

COLOR PAGE 8

DeepHeads

Two heads whose textures were created in Right Hemisphere's Deep Paint 3D. If you're Deep Paint 3D challenged, you should at least explore this magical painting application.

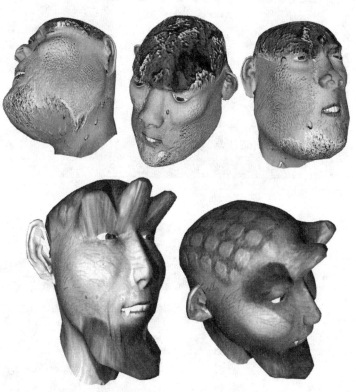

FIGURE *Deep Paint 3D examples.*
26.8

COLOR PAGE 9

NurBot

A model based on NURBS elements. NURBS create extremely smooth models.

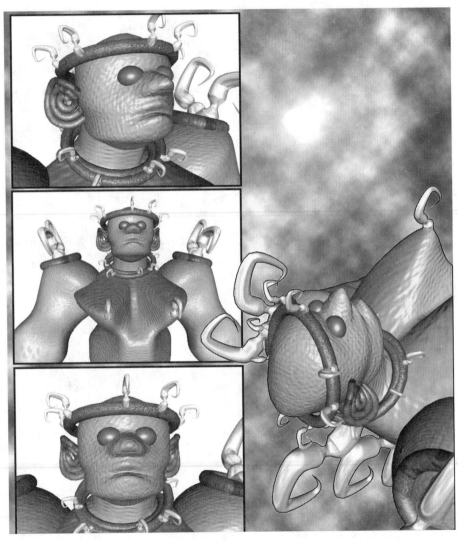

FIGURE *The NurBot.*
26.9

COLOR PAGE 10

Top: TreeBot

An articulated poseable character built with TreeStorm parts.

Bottom: Spore Pods

Models constructed by using Snapshot on a Particle System frame. Again, this is an extremely simple construct. Sometimes a model is completely defined by the Material used to texture it.

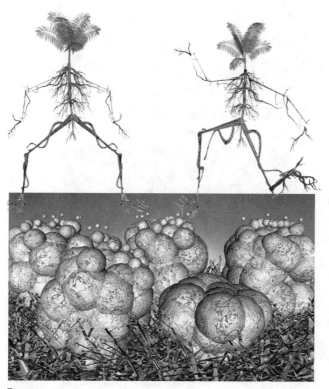

FIGURE *Top: TreeBot. Bottom: Spore Pods.*
26.10

COLOR PAGE 11

Top: Moon Temple

ArchVision tree models surrounding a lathed shrine. Although there are numerous trees used in this scene, hard disk space is very low for storage. That's because all of the ArchVision models are images mapped to planes.

Bottom: Cosmic Dung Beetles

Strange insect models based on lofting processes. All of the parts of these models were created by using Lofting, along with the Loft Deformation tools.

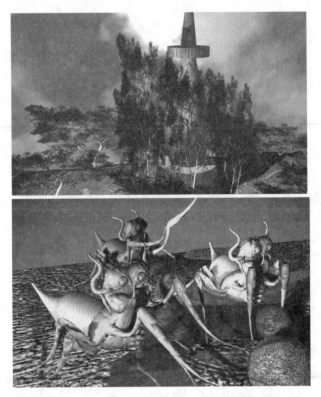

FIGURE *Top: Moon Temple. Bottom: Cosmic Dung Beetles.*
26.11

COLOR PAGE 12

Top: Reflectorium
A study in object reflections, using the Right hemisphere RayGun material. RayGun gives you exacting control over object reflections, refractions, and transparency.

Bottom: Morning
ArchVision tree models reflected in a Wave modified surface. Simplicity rules here.

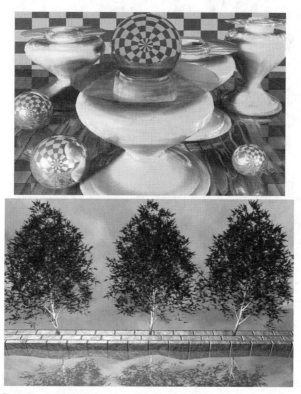

FIGURE *Top: Reflectorium. Bottom: Morning.*
26.12

COLOR PAGE 13

If you would like to create a space-faring ship similar to this one, do the following:

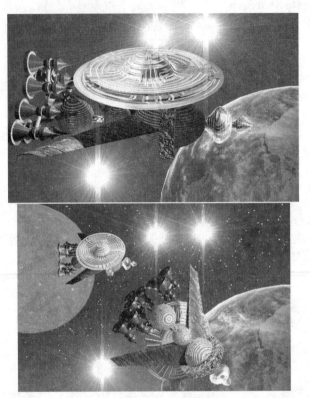

FIGURE *Ship.*
26.13

1. Lathe an engine form, and clone it to form the engine clusters. Use a Galvanized Metal map from the standard Max library. Use a value of 425 in the Bump channel. Shrink Wrap the UVW at 7, 7, 7. (See Figure 26.14.)

2. Clone the engine twice and move it to form a cluster. The Struts are added to tie the top engine to each of the other two. Group. (See Figure 26.15.)

3. Use the Line Shape tool to create a Support Girder. Draw circles in the middle, and use Attach in the Modifier Rollout to attach circles to the shape, which cuts holes in it. Extrude at 22. (See Figure 26.16.)

4. Move the Support Girder into place. Group everything as "Cluster_01." (See Figure 26.17.)

5. Do a Test render. (See Figure 26.18.)

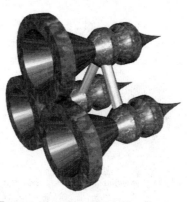

FIGURE
26.14 *Lathe an engine form.*

FIGURE
26.15 *Create an Engine Cluster.*

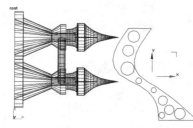

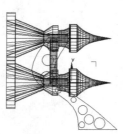

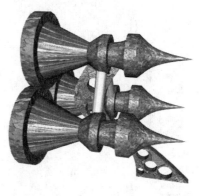

FIGURE
26.16 *Create a Support Girder.*

FIGURE
26.17 *Move it into place and group.*

FIGURE
26.18 *Do a test render of your work so far.*

6. Create an arrangement of three spheres connected by a central cylinder, as shown in Figure 26.19.

7. Add a Tube primitive that wraps around the front section as shown. Map everything with your choice of materials. The Dark Tree textures work very well for spaceships if you have them. Group everything and name it "Body_01." Clone the engine clusters, and place them at the rear of the ship. You should now have a model that resembles Figure 26.20.

8. The important thing to remember about this ship is the drive system, which is everything on the ship we have constructed so far. It has to be separated from the crew quarters for safety reasons, so we are going to construct the crew quarters and the control deck somewhat removed from the drive system. To do that, create another Girder, and place it on top of the center sphere. Extrude at 22 and UVW Map (Planar), and apply the Galvanized material. (See Figure 26.21.)

FIGURE
26.19
Create this form, composed of three spheres and a cylinder.

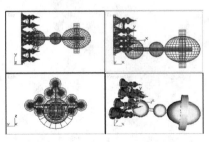

FIGURE
26.20
Now the ship is really taking shape!

FIGURE
26.21
Create the main Support Girder.

FIGURE
26.22
Add the control quarters and some wings.

9. Lathe a saucer-like shape, and place it on top of the Support Girder. Create some wings. You can either Extrude a closed Spline shape, or use the freeware from Effect Ware called Wing Maker, available from most Max download sites. (See Figure 26.22.)

10. This can be the finishing step of your model, or you can go on to add other doodads. The creative choice is up to you. Save the model. (See Figure 26.23.)

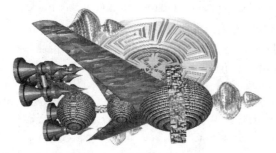

FIGURE *Voila! You're ready for exploration.*
26.23

COLOR PAGE 14

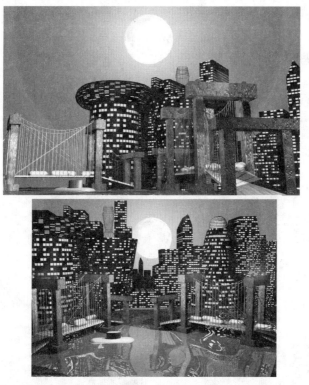

FIGURE *Two views of Urbania.*
26.24

Urbania centers around the buildings and the reflective water surface. To create the Urbania model, do the following:

1. Create a Splined meandering shape in the Top view, using a Smooth/Smooth closed Line. This will be a river. Extrude to 20. From the New Library, select the Raytrace Material. Use a Planar UVW Map. In the Material Editor, set the Raytrace Shader to Blinn. Set the Raytrace color to a medium gray. Use a Bump map of your choice. This breaks up the reflections nicely. I used an Elemental Textures Ripples Bump of 35. Add an Omni Light in the scene, and Include the water model. Place a test sphere above the "water" and render for preview. Delete the sphere if all is satisfactory, or play with the settings a bit if it is not. (See Figure 26.25.)

2. Create a Patch Grid to act as the ground. Tessellate it twice to increase the detail. Use a Noise modifier on it with X and Y values of 35. Use UVW Planar Mapping on it. This deforms the geometry, making it more believable. Include the Patch in the Omni Light's list. Do a similar test render with a sphere, then delete the sphere. (See Figure 26.26.)

3. Widen the water and move your Perspective or Camera viewport so that the water extends from the bottom of the view. Note that this may alter the reflection a bit. (See Figure 26.27.)

4. OK. Time to build a bridge or two. Create a closed Line shape (Corner/Corner) in the Front viewport that resembles Figure 26.28, and Extrude to 95. (See Figure 26.28.)

5. Use Box primitives to create the Columns. (See Figure 26.29.)

6. Now for the cabling. The best way to create the cables is to use curved paths and a small circular shape. Use cloning to create multiple cables where necessary, and use the X-Form Modifier to resize cables on their Vertical (Y) axis. This is a rather time-consuming process, but when you've finished, you'll have a bridge model you can use

FIGURE *Do a test render of the reflective water.*
26.25

FIGURE *The ground is in place.*
26.26

FIGURE
26.27 *Make sure your Camera or Perspective view resembles this one.*

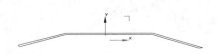

FIGURE
26.28 *Create this shape and extrude.*

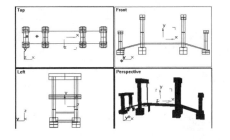

FIGURE
26.29 *Use Boxes to create the columns as shown.*

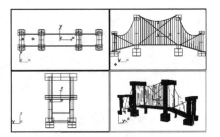

FIGURE
26.30 *Follow this illustration for cable placement.*

in any scene. When finished, Group all the parts of the bridge together. Clone to create two bridges, and place over the water. (See Figures 26.30 and 26.31.)

7. Add some buildings created from Standard primitives. Create a skyline for the background by drawing a closed Corner/Corner Spline and extruding by 25. This allows you to fill in the city without excessive 3D detail for background objects. To create windows for the buildings, use Digimation's BrickLayer. When you install BrickLayer, a Night Windows Material is installed in the BrickLayer Materials library. UVW Map as either a Cube or Cylinder. Add more details if you like, until Urbania looks habitable. (See Figure 26.32.)

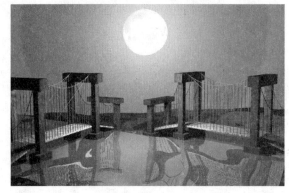

FIGURE *The finished cabled bridge with a sky background.*
26.31

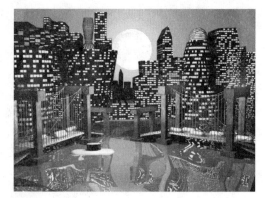

FIGURE *Urbania beckons.*
26.32

COLOR PAGE 15

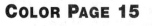

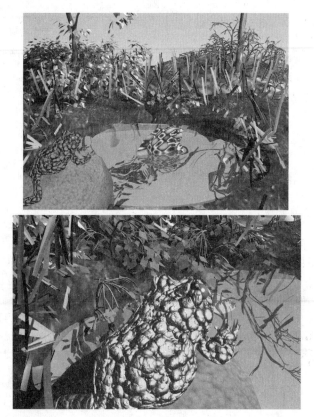

FIGURE *Two views of the Woodscene.*
26.33

To create this scene, you will need CuriousLabs' Poser and at least one "Tree maker" plug-in, or a CD collection that has trees and plants (like the Meshes: Plants CD from www.bau-ment.com). Do the following:

1. Open Poser, and save the Small Fish model in the Animals library as a 3DS object. Do the same with the Frog model.

2. In Max, import the Poser Fish model, and UVW Map it (Shrink Map and Fit). I used the Ocelot map from the Dark Tree Simbionts collection. (See Figure 26.34.)

3. Import the Frog. UVW Map it with Shrink Map and Fit. Use a texture Material. I used the Dark Tree Simbionts Toad Material, and changed the diffuse color to green. (See Figure 26.35.)

4. Move both the fish and toad out of the way for now.

5. Create the ground terrain. You can use a mesh and add noise to it to generate a bumpy surface, or start with the Terrain plug-in from HabWare (download it for free from any Max site that lists it).

6. We are going to have to make a pond space in the terrain. There are two general ways to do this. The first is to create a warped sphere and Boolean-Subtract it from the terrain mesh. The second is to do some Sub-Object editing, and pull the mesh down at the required spot. Whatever your choice, do it now.

7. Next, place a flat plane over the depression, and map it with a reflective surface. This is our water element. You can use Raytracing for environmental reflections. Explore different materials.

8. In the Render>Environment window, activate the background Map function. If your water is reflective, it will reflect the color and image detail of the Background Map, so select a map that will enhance the scene.

FIGURE **26.34** *The Mapped Poser fish in Max.*

FIGURE **26.35** *The mapped Toad.*

9. Set a light in the scene pointing down on the water. Use any light type you wish. Make sure to return to the Light object in the Modify panel to Include all of the elements that are to receive light and shadow, or they will render as solid black. (Sometimes, you can allow this to happen consciously, especially when objects are in the far background. This can enhance believable depth.)

10. To create the flora objects, you are on your own. Use whatever modeling resources you possess, either plug-ins or models on CDs. Whatever you use, here are some general rules:

 • Whatever flora you use, run it through Optimize (or Digimation's MultiRes if you have it) to decrease the polygon count. Tree and other flora objects usually have dense polygons, which can jam up your system when the polygon count is too heavy in a scene.

 • Clone/Copy some of your flora objects and rotate them in the Top viewport. This allows you to create many different object looks from one model.

 • Do a series of test renders from radically different angles and/or perspectives. Select the best ones for final renders.

11. When the scene looks ready, place the Frog and Fish in relation to the water. Save, and render. (See Figures 26.36 and 26.37.)

FIGURE **26.36** *Onyx TreeStorm and Sisyphus Grass-O-Matic was used to create the flora.*

FIGURE **26.37** *The frog basks on a rock while the fish frolics.*

COLOR PAGE 16

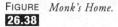

FIGURE *Monk's Home.*
26.38

I used Poser, Head Designer for this scene. You may substitute Poser with applications and utilities that offer the same or similar results. The important thing is the concept involved. Do the following:

1. Pose a seated male or female figure in Poser. Export the figure as a 3DS file.

2. Open the model in Max. Note that 3DS Poser models come into Max ungrouped, so you'll have to be careful not to accidentally move any of the elements. What I did in this case is to create a number of Groups, since I was not interested in having a poseable model in this scene. Select the head and delete it (this scene demands a Head Designer head). Group the Shoulders, Chest, and Abdomen as "Body_Upper." Group the elements of the left and right arms as "Left_Arm" and "Right_Arm," respectively, but group the hands separately. Do the same with each leg. As long as you are not going to need any renders of the monk's feet, you might want to delete them as well. Don't do this, however, if there is any chance you may want to create a rendering later that displays the feet. (See Figure 26.39.)

3. To create sleeves for the robe, select each arm in turn. Group>Open, so you can select just one part of the arm. Sub-Object Polygon, and select parts of the lower arm element. Use the Move tool to stretch them downward. Do this to the upper and lower part of each arm in turn to sculpt the robe's arms. Do the same with the upper body elements. This creates random folds, as in cloth. (See Figure 26.40.)

4. Create a Spline path that follows the general curve of the torso and legs as seen in the Left viewport, and assign an ellipse to it. Sub-Object edit the polygons to fit the body. Use a deep purple material on everything but the hands and feet. (See Figure 26.41.)

5. We could have left the Poser head in place, but this gives us a chance to add a Head Designer head to the composition. If you have Head Designer, do that. Modify the parameters any way you like. If you don't have it, you must create a head or import one from another application. Add teeth and eyes. (See Figure 26.42.)

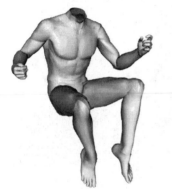

FIGURE **26.39** *The Posed Poser model is brought into Max and elements are grouped.*

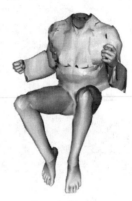

FIGURE **26.40** *Stretch the polygons of the arm and upper-body elements downward.*

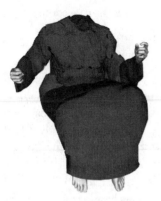

FIGURE **26.41** *The robe is complete.*

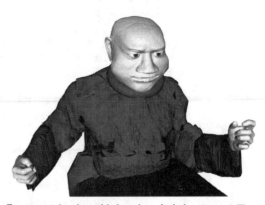

FIGURE **26.42** *A head is added to the robed character. A Torus was also added to the top of the robe to hide some ragged polygons.*

6. Add a coweled hood. Create it from a Cone primitive, using a Bend of 65 degrees. Use Sub-Object editing to give it some randomness, and Tessellate to smooth it. Link to the head. (See Figure 26.43.)

7. Add a Torus Knot as a symbol on the neck. (See Figure 26.44.)

8. Lathe a fancy furniture leg. We'll use it for both the chair and table. (See Figure 26.45.)

9. Use a flattened Box for the table top. Attach to the cloned legs and UVW Map as a box. Use a Wood material on it. Clone the finished Table, reduce in size by a Uniform Scale, and shorten again on the vertical axis. This creates a bench. Place Table and Bench relative to the character. Create a floor from a Box primitive, and UVW Map with a tiled texture. Do a test render or two. (See Figure 26.46.)

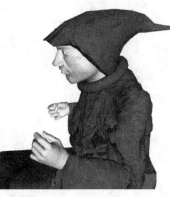

FIGURE **26.43** *A coweled hood is added and Linked.*

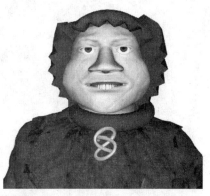

FIGURE **26.44** *This makes the character look like a Celtic monk.*

FIGURE **26.45** *A chair and table leg.*

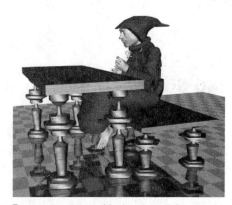

FIGURE **26.46** *Create a table, bench, and floor in the scene.*

10. Create and texture some walls, and consider cutting a Boolean window in one of them. Add some other errata as you desire. Place some items on the table as shown in Figure 26.47.

FIGURE *The finished Monk's Home scene.*
26.47

AND SO . . .

"Parting is such sweet sorrow," as the bard said. But don't take that to mean that you are through with this book. Work through it little by little, returning to the exercises and details that may take another reading or two. As you father more Max plug-ins, return to those parts of the book where they are featured. Not only is it true that Rome was not built in a day, but you have the rest of your life to explore your creative endeavors farther and deeper.

What's on the CD?

Explore the contents of the folders on this book's CD-ROM. The diverse content amounts to a huge value-added extra for your Max work.

AMAPI FOLDER

Look in the Amapi folder for a super value-added application for Max handshaking.

What Is Amapi?

www.tgs.com/amapi
Template Graphics Software, Inc.
5330 Carroll Canyon Rd., Suite 201
San Diego, CA 92121
FAX: +1-858-452-2547

Amapi is a fast 3D modeler from TGS, Inc. for polygonal and NURBS design. It is both a standalone application (for PC and Mac) and available with a plug-in connection to 3DS Max. Typically, you will find that it is an excellent companion to 3DS Max, in that it significantly speeds up the creation or modification of 3D geometry. An Interactive Training CD is available from Animhouse: www.animhouse.com.

Amapi Resources, Tutorials, and Other Users

www.staigerland.com/amapi
www.17hours.com
www.chris-stocker.co.uk

www.smart3d.com
www.multimania.com/bretagnolle
http://perso.club-internet.fr/odrion/
www.deepcold.com
http://o.ffrench.free.fr/
www.martindeblois.com

Amapi on the CD?

The CD contains:

- A full version of Amapi 4.1
- A trial edition (TE) of the latest Amapi 5.15.

There's also a large collection of 3D models, materials, tutorials, and HTML documentation (user/reference manual).

Using the Full Version of Amapi 4.1

In order to use the full version of Amapi 4.1:

1. Register online at www.tgs.com/amapi (look for "Register Online").

2. Enter this registration serial number: A3D10690CRSM1 (serial number on registration form).

3. When starting Amapi, you will be prompted for a license password. Enter the following: 22410db31347d5c2d

This will give you full access to Amapi 4.1 for *free.*

Using and Evaluating Amapi 5.15 TE

In order to evaluate the many new powerful features of Amapi 5.15, install and run the trial edition of Amapi 5.15, also included on this CD, along with an extensive presentation of the new features, tutorials, documentation, and links to other Amapi users. When using the trial edition (TE) of Amapi 5.15, you can operate in demo mode (which is the default) for as long as you want without a trial password.

In Demo mode, saving or exporting is disabled; however, all other features are enabled, such as rendering to image files, animation files (AVI), and all modeling tools. You can learn the new features of Amapi at your leisure without rushing into a buy/don't-buy decision. You'll need a trial password when you need to test the exports, or want to save your current 3D model on disk, or use the 3DS Max plug-in to move data from Amapi back to Map. To obtain a trial password, which is good for several weeks:

1. Go to www.tgs.com/amapi.

2. Select "PC Demo."

3. - Enter your registration info.

4. Make sure your e-mail address is correct. The trial password will be sent automatically by the server via e-mail to that address.

5. After registration, an e-mail message is sent to your e-mail address, with a temporary trial password. You'll then see a choice of sites from which to download the Amapi Demo (Trial Edition). You won't really need to continue at this point, unless a newer version of Amapi is available by that time.

6. Check your mailbox for an e-mail from TGS after a few minutes. It will contain a trial password that is good for a few weeks.

What About the 3DS MAX Plug-In for Amapi?

You can find the installer for the 3DS Max plug-in to Amapi at this Web location:

http://www.tgs.com/Support/Tutorials/Amapi/Amapi-3DMax.html

If the location has changed from the time of this printing, go to www.tgs.com/amapi and look for Import/Export options, where you should be able to find a link to the 3DS Max plug-in. The plug-in installer (for Amapi 5.1) is available for Max 2.5 or 3. Amapi 4.1 works with the Max 2.5 plug-in only. The plug-in installer for Amapi 4.1 is provided on the CD.

Amapi Support

If you have questions on the use of Amapi, please contact support@tgs.com (In Europe: support@europe.tgs.com). Their dedicated support staff is ready to help. Other contact details are available on their website at www.tgs.com.

ANIMS FOLDER

Animations are included for your viewing pleasure in either or both AVI and QuickTime formats.

BACKGROUNDS FOLDER

Fourteen background images are included in this folder, ready to use in your Max projects. The subject matter is clouds, created with the help of Corel Bryce for use in Max. You can use these images as backgrounds by assigning them as such in the Environment window. You can also use these images as bitmap content for any Material in a Diffuse, Opacity, Bump, or any other Material channel.

COLPLTS FOLDER

The complete TIF files used for this book's Color Gallery are located here for your viewing pleasure. The color plates are included, so that you can study them at your leisure on your

color monitor. It's also possible to crop any of the color plates and use the resulting image content in a Material channel to develop unique textures.

IMAGES FOLDER

This folder holds many of the images used to create the grayscale art used for the tutorials in the book. They are included in the folder in blazing color. You are free to use them as backgrounds, or to chop them apart for texture channel use in the Material Editor.

MODELS FOLDER

Over 50 3DS models used in the book are presented here for your enjoyment and use. You can use them as is in a Max project, or augment and deform them with any of Max's filters.

PLUG-INS FOLDER

You'll find an exe file in this folder that allows you to install a large number of Digimation's plug-in demos. The demos represent most of the plug-ins explored in the text. This gives you a chance to try before you buy. When you start the install script for the Digimation plug-ins, you'll be presented with a list of choices. If you already have installed some of the items on the list, uncheck them. Max does not automatically refuse to install a duplicate plug-in, although it will present you with a permanent error flag if duplicates are installs (until you correct the problem).

There are 38+ MB of Digimation plug-in demos on the CD, so make sure you have enough hard drive space before you install them. Here are the Digimation plug-in demos contained on the CD:

Freebies:
Muybridge Variations
RealModels
Xeno-1 Textures

Particle Systems:
Sand Blaster
Particle Studio
Spray Master

Animation:
Illustrate! 4.1
Bones Pro 2

Modeling:
daVinci3D v1.5
Clay Studio Pro
MultiRes

Map Types:
TLab: Elemental Tools
TLab: Tiling Tools

Atmospherics:
Shag: Hair
Phoenix

Audio:
FlexSound
Foley Studio Max

Freeware:
(To use "as is" at your own risk)
Pandora
TLab: Eyes
TLab: Mandelbrot
Wave Scrub
DigiNoise

Scenes Folder

There are almost 50 Max scenes in this folder. You can use these scenes to reference many of the tutorials. Some Max users even prefer to do a quick read of a tutorial, and then investigate the actual finished result before attempting the tutorial themselves. The scene data is not listed by chapter, but rather by the name of the constructs involved (Cubot, etc.). Most of these scene files require a minimum amount of RAM. If your system has less than 128MB of RAM, however, some of the scenes may not load.

Some of these scenes are plug-in dependent, and will not load all of the content unless you have the plug-in called for. In some cases, a texture was used that also relates to a commercial texture application. In that case, the scene will load, but you'll have to apply your own texture, Material, or bitmap. Give them a try if you're not sure what plug-ins are involved.

Contributor Biographies

Igor Borovikov of Animatek has a Ph.D. in applied mathematics from the Moscow Institute for Physics and Technology. For the last 7 years he has worked for AnimaTek where he is one of the main authors of World Builder, with the plants modeling engine as his main contribution.

Eddie Christian is a seasoned film and video production professional. Before joining AnimaTek in 1999, Eddie taught classes in Maya and World Builder at the San Francisco Academy of art.

Paul Bloemink is currently Creative Director and Designer at GHOST 3D, LLC, a California based 3D technology developer and production studio. Paul has acted as consultant to several computer entertainment and 3D technology developers including Autodesk, Kinetix, Saffire, Immerson Sega, Radical Entertainment, Spectrum Holobyte, Microsoft, Stormfront Studios and others.

David John Fielder (Konan the Barbarian) recently graduted from the University of Western Ontario with an H.B.Sc in Physics. He is the sole proprietor of Innuendo Software, developing software for the 3D graphics community. He plans to go back to university to study physics at the Masters and PhD levels.

Skyler Swanson Founder and lead software engineer for Darkling Simulations. For the last 5 years he has worked on design and implementation of the user interface and shading algorithms used in *DarkTree* Textures.

Index